*Et quivi si fanno li sovrani tappeti
del mondo et a più bel colore*

(Marco Polo, *Il Milione*)

Sovereign Carpets

Sovereign Carpets

Unknown Masterpieces
from European Collections

edited by
Edoardo Concaro
Alberto Levi

Cover
Pillar Rug
Tibet, XIX Century
70 × 150 cm, cat. no. 142

Graphic Concept
Marcello Francone

Editing
Emanuela Di Lallo

Layout
Sabina Brucoli

Translations
Andrew Ellis
Alberto Levi

Photographs
Fabrizio Catalano

First published in Italy in 1999
Skira editore S.p.A.
Palazzo Casati Stampa
via Torino 61
20123 Milan, Italy

Printed and bound in Italy.
First edition

ISBN 88-8118-630-6

Distributed in North America
and Latin America by
Abbeville Publishing Group,
22 Cortlandt Street, New York,
NY 10007, USA.
Distributed elsewhere in the
world by Thames and Hudson
Ltd., 181a High Holborn,
London WC1V 7QX,
United Kingdom.

Introductions
Murray Eiland, Jr.

Entries
Alberto Boralevi
Steven Cohen
Edoardo Concaro
Hans König
Alberto Levi
John Mills
Robert Pinner
Jürg Rageth
Carlo Maria Suriano

Technical Analyses
Luisella Belleri
Giovanna Maragliano
Franco Roveraro

*For the section
'The Turkmen Wedding.
Carpets from the Collections
of the State Russian Museum
of St. Petersburg'
text and technical analyses by*
Irina Boguslavskaya
Elena Tsareva

*The first edition of this book has
been published on the occasion
of the exhibition 'Sovrani
Tappeti. The Oriental Carpet
from XV to XIX Century. Two
Hundred Masterpieces of Textile
Art', which was held in Milan
from September 7 to November
7, 1999, under the patronage
of ICOC - International
Conference on Oriental Carpets*

We're up-to-date! Even the small 'tapetological' village has become global; its population of a few thousand souls, instantaneously linked-up electronically, feel the need to expand: the surrounding soil is prolific, and cultivating it requires a resolute interdisciplinary application, barring no members, and its beginners have no need to knock down walls, on the contrary the main door is wide open to them. But how do you go about approaching new adepts, how do you spread the contagion (once caught, as we know, the disease is incurable) to those receptive people who do not even have a clue to their susceptibility? The individual mission is lost amidst the assault of information, whereas mass proselytism informs but does not educate.

What remains, and cannot be wiped out, is the printed word. In 1977 M.E. Enay and S. Azadi took the trouble to systematically formulate Einhundert Jahre Orientteppich-Literatur, 1877–1977 *(that is the title they gave to their effort); the listing included over a thousand books. In the twenty-three years that have gone by since, many other works on the subject have been printed; the new numeric data is actually not as important as the fact that, among these books, a good amount have become an equal number of supporting pillars to the 'tapetology' library, which in the meantime was enriched by outstanding specialised magazines: the English* Hali, *the Italian* Ghereh *and the American* Oriental Rug Review, *spreading a broader horizon of knowledge, yet still far from achieving the humanly inaccessible, but insistently sought-after, 360 degrees.*

Among objects of exotic figurative art, the Oriental rug is basically known to everyone, universally wide-spread, widely imitated, but often viewed as a furnishing accessory distinguished by its intrinsic colour exoticism. But what is all too-often neglected is its innermost nature, the millenary evolution which occasionally determined it, the combined values which it prodigiously concentrates — the formal ones not least, which to be fully understood require a patient instruction that, alone, allows to thoroughly appreciate it, since the intuition of feeling is indeed a means, but if not enriched by knowledge, by the constant education of taste, it becomes a limitation.

In the general history of textile, the Oriental rug has a paramount relevance, and presenting a complete,

exhaustive survey of it would be a titanic work, ideally conceivable, but concretely, at least today, beyond anyone's reach.

The textiles illustrated here span broad areas of time and space of the worldwide 'tapetology' scene, their sole claim being to present an introductory anthology, a treasury offering a perception of the differentiated vastness of the topic. Each of the weavings is representative of a category or sub-category of origin, without claiming to illustrate all those defined up to now; for the most singular or representative examples we provided a technical analysis that completes knowledge with objective data.

These carpets and rugs were shown in an exhibition in connection with the 9th International Conference on Oriental Carpets (ICOC), that took place in Italy in September 1999, an exhibition held at the Palazzo Reale of Milan, and aiming at arousing the interest of the scholar, as well as involving a wider public receptive to manifestations of art popularisation. The subtlest ambition of the Committee that selected the works to be shown was to reconcile that divergent, dual orientation. The iconographic sum is enriched by brief caption comments that do not claim to exhaust the themes related to each article, but instead to highlight their singular traits against a background of general information. Frequent bibliographic references are given in order to provide assistance to those who wish to explore the matter in depth, quoting both general and specific studies. Among these, the ones concerning the Turkmen rug contain a wealth of local terminology, transliterated according to the widespread, accepted method, the same standard being followed for the other terms pertaining to the subject. In particular, for the term gul *we chose to adopt this spelling, leaving out* gül, gol *and* göl.

Last we should point out the rhapsodic aspect of the figurative catalogue that we agreed to offer in a discursive form, with colloquial simplicity, not lacking in specialised and scholarly references, but devoid of the fairy-tale interpolations that are often detrimental to an essential perception of the vast and complex symphony that an Oriental rug represents.

Edoardo Concaro

Contents

Introduction

Alberto Levi

One of the main objectives of this book is to illustrate to the many potential neophytes the manifold facets of the oriental carpet universe. Often, for the layman, the word 'carpet' is synonymous with something fleeing, in all its connotations, probably because of a promotional strategy that always preferred to disinform a decidedly receptive public with legends from the *One Thousand and One Nights*, thus emphasising the more indefinite side of the rug, in the belief that this would somehow make it more precious. If from the one hand the carpet was being presented as a work of art, worthy of the most prestigious public and private collections, from the other it was being sold off without pity by merchants that took us back to the most colourful representations of the bazaar.

The carpet that once flew, when it landed became available also on television.

We can therefore fully comprehend that sort of confusion that gets into the minds of people whenever they approach the rug world for the first time. It is essential at this point to draw the clear differences between carpets as works of art and carpets *tout court*. The former are worthy of our attention in that they are potential carriers of messages of art, history and poetry, while the latter represent, at their best, works of honest craftsmanship. Secondly, it is essential to enunciate in the most accurate way possible what are the fundamental qualities that enable us to differentiate between antique carpets as works of art and rugs that are antique only because they have been woven over one hundred years ago. To establish these differences is another of the aims of this book.

Differently from many works of art which are destined to hold also a considerable functional aspect, the oriental rug was object of belated critical attentions. The appreciation manifested by the mighty and the monarchs, the consideration demonstrated by historians, chroniclers and travellers, the deep involvement shown by painters and decorators, witness the acknowledgement of generic formal values, yet do not constitute a proper enquiry aimed at a more organic definition, connected to a characterisation of the expressive procedures and of their placement within art history's palimpsest.

It is only during the last quarter of the 19th century that the oriental rug began to be addressed by a somewhat more systematic attention. In 1877, Julius Lessing, who at the time was the head of the Kunstgewerbe Museum in Berlin, wrote the first book entirely dedicated to carpets, *Altorientalische Teppichmuster*. The intent is purely functional (the undertaking of decorative models destined for industrial production), however the attention offered for what was available in terms of antique rugs in the market as well as their pictorial representation was related in a scientific manner. A similar stand was taken by William Morris, one of the chief advocates of the Arts and Crafts movement. The oriental rug represents for Morris a great source of inspiration, and will give rise to an autonomous production of handknotted carpets: thus in 1878 the famous 'Hammersmith' carpets were born, named after the area of London where his looms were located. Meanwhile, in 1876, the South Kensington Museum (later known as the Victoria and Albert Museum) begins to acquire its first antique carpets, among which a celebrated 17th-century Persian carpet belonging to William Morris himself. Today, this museum boasts a world reknown collection that has inspired generations of both dealers and scholars. In 1891 the Österreichisches Handelmuseum of Vienna hosts the first exhibition focused on the oriental carpet from the 16th to the 19th century. Alois Riegl, director of the textile art department of the museum, publishes *Altorientalische Teppiche*, with the objective of analysing the carpet from the point of view of its legacy with the other decorative arts, and of establishing a common denominator between oriental carpet designs and the Greek and Egyptian architectural motifs, thus underlining the fundamental role of the carpet towards the transmission and perpetuation of a vast iconographic wealth.

Towards the end of the century, carpets began to generate a considerable amount of interest. In 1892, Wilhelm von Bode, a famed art historian specialised in Italian Renaissance painting, wrote a very influential essay on a so-called 'animal' carpet, decorated by two octagonal compartments each containing a dragon and phoenix in combat. This extremely rare weaving, destined to become one of the milestones of the oriental rug, was found by Bode in a Central Italian church, and is just one of the many treasures he discovered and bought on behalf of the Berlin Museums, of which he would soon be appointed director. In 1902 his essay became a monograph, *Vonderasiatische Knupfteppiche*, the first analytical treatise on period carpets, still considered one of the most important contributions to the subject. Bode's great

merit was that of being able to instantly recognise the importance of a carpet thanks to an innate intuition and an unrivalled sensibility, perfected through the study of pictorial representation.

European paintings were for Bode a remarkable means of identification: his frequent trips to Italy were an important factor for the elaboration of a critical apparatus that brought him to consider the oriental rug as a fundamental element in the chromatic layout of much of 15th-century painting. Anatolian rugs are subdivided according to typologies named after the painter who represented them: thus the carpets with arabesque patterns are called 'Lotto' and those with octagonal medallions 'Holbein'. The Persian carpets from the Safavid period, his true passion, were grouped according to their design, establishing a nomenclature that is still employed nowadays by oriental rug scholars.

Bode's work will be determinant for the whole first part of the 20th century, and his teachings will be further developed by his assistants, Ernst Kühnel and Friedrich Sarre. The latter will follow up on the research initiated by Bode on Safavid carpets, publishing in 1926 and 1928, together with Hermann Trenkwald, two monumental and fundamental volumes, *Altorientalische Teppiche*, representative of the methodology of the Berlin school: the first was dedicated solely to the Safavid carpets shown during the great Vienna exhibition in 1891, while the second, based on the same analytical subdivision of the Safavid typologies of the preceding volume, extended to encompass many of the most important examples in the world. During the entire Second World War period Kurt Erdmann, one of the main contributors to that work, focused on the principal themes of carpet study through thorough investigations, publishing a series of important essays that provided an analytical compilation whose foundation would be at the base of all the further developments elaborated by the English-speaking scholars. The latter, strong of the important museum and private collections formed between the two wars (such as, for example, the Ballard and McMullan collections, later on donated to museums, particularly to the Metropolitan Museum of Art of New York), direct their approach with highly scientific methods, which make use of collaborations and interdisciplinary mediations. Among these activities one can include archaeological research, from the one conducted in the early part of the century at Lou-lan in East Turkestan by Sir Aurel Stein, who uncovered a group of carpet fragments dated to the 2nd–3rd century, to the discovery of the *kurgans* of Pazyryk, in the Altai mountains of Southern Siberia, by Serghei Rudenko, which led to the retrieval of a well-preserved carpet dateable to the Scythian period (5th–4th century B.C.), still the oldest known, getting to more recent achievements such as the finding of the Neolithic civilization of Çatal-Hüyük in Central Anatolia, with its wall paintings depicting elements seen on Anatolian kilims of our age and connected to the Mother Goddess cult. This controversial discovery finds its supporters, who underline its anthropological and psychological connotations, whose values will en-

dure — despite the loss of the symbolic meaning of the designs — in the coercion of repetition, in the choice of colours and in their specific reiteration.

The analytical method of the art historians is enriched by a comparative empiricism that is an inexhaustible source of data and which invites the scholar towards scientific rationalisation. With the aid of information technology, many archives and inventories that make some reference to carpets are being studied; chemists are developing sophisticated laboratory techniques for analysing wool fibres and dyes; physicists are refining their research instruments in order to improve their ability to date a textile by the radiocarbon method.

These changes take us to the second half of the seventies, almost the beginning of a new age: in 1976 the first International Conference on Oriental Carpets (ICOC) takes place in London, a congress that gathers for the first time all of the main textile art scholars, publishes proceedings and establishes comparison dynamics that will characterise all the future venues. Museums and private institutions begin to assign to eminent scholars the task of a scientific presentation of the works collected over the course of many years; the Textile Museum in Washington, D.C., publishes a yearly *Journal* that contains among the most important essays on the subject; the spring of 1978 sees the birth of *Hali*, the first magazine entirely dedicated to oriental carpets and textiles, soon to become a pole of attraction and information about the many events that will follow. It will promote a new generation of dealers who will become enlightened propagators, supplying each of their important acquisitions with information drawn from accurate bibliographic research, often presented in the form of a monograph. Many of them dedicate themselves to the search of pieces that are still unknown in the West, finding in the most hidden corners of Anatolia and Tibet objects of mysterious significance characterised by an uncontaminated beauty. Anatolia becomes an apparently inexhaustible source for kilims and village rugs woven before 1800, often in fragmentary condition, distinguished however by a fascinating palette and a graphics where the classical motif is reinterpreted with individual skill, giving rise to weavings of rare poetry and magic. Tibet is the source for a group of Chinese silks and brocades from the Song and Ming dynasties, of certain unusual carpets from East Turkestan, but especially for a very rare group of rugs, decorated by rows of quadrupeds, also called 'animal' carpets, radiocarbon dated to the 13th century. The collapse of the Soviet Union has favoured the introduction in the market of Caucasian and Central Asian weavings that up to then were unknown or poorly regarded in the West, such as *ikats* and *suzanis* from Uzbekistan, felts from Daghestan and of the Kirghiz, as well as a group of flatweaves ascribed to specific Caucasian tribes. Thus new collections are born, marked by a more refined aesthetics, capable of tracing the deep roots and to exploit any concealed meaning. At the 6th ICOC, which took place in San Francisco in 1990, are shown the McCoy Jones Collection of Anatolian kilims, donated entirely to the De Young Museum, and

the Alexander Collection of early carpets, which includes many Anatolian village rugs of great visual impact; both of them will have a decisive influence on the market as well as on the imagination of certain collectors. At the 7th ICOC, which was set in Hamburg in 1993, one of the most important groups of early carpets was exhibited, exceptional for both the quality and quantity of the pieces included, that is the renowned Orient Stars Collection, belonging to Heinrich Kirchheim. It is composed of the most beautiful Anatolian village rugs and other very important objects, including one of the famous 'animal' carpets. Antique kilims are also properly represented by the Vok Collection, which comprises also some of the most important *suzanis* to have appeared on the market over a considerable lapse of time.

The carpets illustrated in this book are in many ways the 'sovereigns' for each type; they are essentially subdivided in two groups, where for 'carpet' it is meant also kilim, *sumakh* and consequently all flatweaves, in addition to embroidery and velvet. The first group is composed of rugs or rug fragments dated before 1800. These are sometimes referred to as 'classical', meaning that they represent a specific period of the history of the oriental carpet; they are in turn classified as rugs woven in artistic workshops, whose output was directed at satisfying a Court demand, and village rugs, woven far from the urban areas and inspired, in most cases, by the Court stylemes. 'Classical' carpets are among the noblest, being historically documentable and connected to other coeval forms of art, also because they were often conceived within the same cultural context. The main feature of the 'classical' Court rug is its ability to conform to a prevalent style within a specific period; conversely, early village rugs are appreciated for their capabilities of creatively interpreting the Court styles, placing themselves along an hypothetical borderline between an area of tribal influence and one governed by the commissioning of the nearby urban settlements.

A particularly illustrative example of a Court carpet is the so-called lobed-medallion Ushak (cat. no. 9). The infinite repeat arrangement of the design, composed of star elements with lobed outlines, is included among the decorative modules developed by the great Ottoman Court artists. The concept of the carpet as a window over the infinite is rendered at its best by means of a main border lacking the typical guard stripes, clearly delineating the two dimensions of reading; the relationship between the geometry of the medallions and the curvilinear trait of the floral motifs creates the elegant balance that distinguishes the most precious Court weavings. These qualities can be found on fragmented examples as well, which are included in this catalogue whenever they represent at their best those aesthetic values that characterise certain early pieces. The Persian Safavid carpet fragment (cat. no. 51) is unique in its infinite pattern of polychrome cartouches, belonging to a typology seen on Timurid Court miniatures. The exceptional rarity of this fragment is in its 'enunciation' of those high imperial stylistic elements that connect the carpet to the other forms of art conceived within the sophisticated workshops directed by court artists.

The second group is that composed of tribal, village and town rugs woven between 1800 and 1900. The magic of 19th-century tribal rugs is in their ability to harmonise a design, composed of highly significative elements representative of an ancestral tradition, with an elaborate chromatic scheme. The open-field Anatolian kilim (cat. no. 94) is a clear expression of this harmony. The majestic aubergine-coloured background — a rarely employed hue characteristic of earlier weavings — is framed by an elaborate hooked motif, played on the positive/negative reciprocity, that is a typical tribal styleme; the two end panels (the so-called *elems*) are decorated by elements that could quite possibly be taken back to an origin connected with Neolithic cults. Like their historical antecedents, certain village rugs are capable of astounding us with their stylistic innovations and bold colour contrasts. A particularly significative example is the *vaghireh* attributed to the Kurds of the Garrus district, in West Persia (cat. no. 65). Although it is essentially a design sampler intended to satisfy a Western demand, this weaving maintains a decidedly tribal imprint in the organisation of its components, arranged in such a way as to remind us of the decorative scheme seen on the *chuvals* (storage bags) of the Turkmen tribes. The skilful rendition of the floral motifs, originating from the iconography of Safavid Court carpets, is typical of the best 19th-century village weavings. The rug attributed to the town of Senneh (cat. no. 64) offers an interesting parallel with the preceding one: although they both belong to areas characterised by a large Kurdish presence, the former maintains a tribal matrix in the organisation of a design to be proposed within a town weaving structure, thereby showing all the 'borderline' elements of the village rug; the latter presents the qualities that we normally associate with town rugs, such as a very fine weave, obtained by employing precious wools, a sophisticated design and a refined palette. Since rugs of this type are among the most easily recognisable and celebrated among neophytes, it was decided to include them in the catalogue, connoting them with all their specific characteristics and especially with their relative importance with respect to the domain of the oriental rug.

The material illustrated in this book has been traditionally subdivided according to geographical areas, each being an expression of a textile tradition that often overlaps with the neighbouring one; this structure encompasses the presence of numerous authorities on the subject, and is enriched by the experience and competence of each. References to other works are essential for direct comparisons, and represent a further enlargement of the critical horizon. The plurality of the points of observation refer to variously addressed trends of opinion and contexts of enquiry, to finally constitute a body of diverse critical attitudes, while condensing a positive approach towards a wider scope method of action. The aim is that of representing a dynamic and propulsive state of the art, adequately placed within the spirit of textile art research at the end of the millennium.

Sovereign Carpets

The Rugs of Anatolia

The rugs of Anatolia were among the first — along with those of Egypt and the Levant — to be sought by Europeans, and by the 13th century they begin to appear in Italian paintings. There is good reason for labelling many of the early rugs depicted here as having been woven in Ushak, while there are others, also well represented here, which have acquired the traditional 'Transylvania' label. While neither of these labels is particularly controversial among carpet collectors, both could be studied more extensively. Ushak is a particular case in point, as the town and probably a number of nearby towns were obviously engaged in a major carpet weaving industry from no later than the 15th century. From the beginning of the 16th century, a type of rug almost unanimously attributed to the Ushak region of Western Anatolia began to appear in large numbers in Europe. Cardinal Wolsey of England placed an order for 100 of these 'Damascene' carpets, as they were then known, from the Signory in Venice.[1] In 1520 he received 60 rugs, some of which may have been among those that began to turn up in paintings. If Henry VIII of England could be painted standing on a medallion Ushak[2] then it seems safe to theorise that rugs of this type had been woven as early as the second half of the 15th century. Judging from the size of some surviving rugs that appear to be among the earliest, one could assume that this had become an enormous undertaking, with large looms and the processing of major quantities of wool and dyestuffs. Clearly such an industry did not arise overnight.

It is interesting to speculate as to whether there had been a tradition of carpet weaving in this area before the arrival of the Turks, as the region inland of Smyrna and which encompassed the area around Ushak was a rather tenuous part of the Ottoman state as late as the early 15th century, and its population remained primarily Greek for some time after the Ottoman conquest. There are numerous references in the literature to suggest that pile carpets were used by the Byzantines,[3] and there has long been a question as to the origin of carpets in Italian Renaissance paintings

that date as early as the 13th century.[4] Quite possibly the Ushak area was also a centre of carpet production during Byzantine times. Without making any unsupportable assumptions, it would probably be fruitful to explore the history of the Ushak region, particularly as it relates to the beginning of the carpet industry there. We know that the Ottomans, who occupied the Byzantine textile production centre of Bursa in 1326, continued its textile tradition, and Barbaro[5] in 1474 noted that Bursa was a source of rugs. As for pile carpets from the Balkans, this is both plausible and not altogether established in reference to particular types of rugs. Considering that the Huns, who first appeared in the 4th century, surely included a large Turkic component, as did subsequent infusions of Bulgars, Avars, and Khazars, Turks were clearly a presence in the Balkans even before they were in Anatolia. Indeed, the Ottomans had become a power in what are now parts of Bulgaria and the former Yugoslavia by the 14th century, and the current recent political events in this area involving substantial populations of Islamic peoples are a reminder that at times Ottoman power extended nearly to Vienna. The likelihood of these Balkans people weaving pile carpets must be considered high, but just which of the surviving carpets could be identified as their work? This becomes particularly problematic when one examines rugs thought to be Balkan work and recognises features which also suggest a Western Anatolian origin. The question would seem to be a fruitful one to study, as, for example, dye testing might reveal the use of plants that do not grow in Anatolia. In the meantime the term 'Transylvania' is used with the understanding that it does not mean that the rugs literally were woven there.

[1] D. King, 'The Carpet Collection of Cardinal Wolsey', in *Oriental Carpet & Textile Studies I*, London 1985, pp. 141–50.
[2] 'Portraits of King Henry VIII' and 'The Inventories of the Carpets of King Henry VIII: Part I, Windsor Castle', unsigned, in *Hali*, vol. 3, no. 3, 1981, pp. 176–81.
[3] J. Ebersolt, *Les Arts somptuaires de Byzance*, Paris 1923, pp. 11, 14, 46.
[4] J. Mills, 'Early Animal Carpets in Western Paintings', in *Hali*, vol. 1, no. 3, 1978, pp. 234–43.
[5] J. Barbaro, *Travels to Tana and Persia*, transl. by W. Thomas and S.A. Roy, London 1873.

1

Double-Niche Ushak
West Anatolia
16th-17th Century
119 x 152 cm

Unlike their larger counterparts from the same period, in these small Ushaks the width of the border remains unvaried. The proportions are therefore strikingly altered, though not to any detriment: the generous expanse of the empty field lends balance to the overall composition, which is further enhanced by the elegant cloudband elements of the corners (note how within these lies a blue *yun-chien* symbol) and by the colouring of the small medallion. One cannot help admiring how the unusual but accomplished chromatic arrangement lends a fiery dynamism to the whole, a factor that elevates this rug to the highest ranks of this particular type.
E.C.

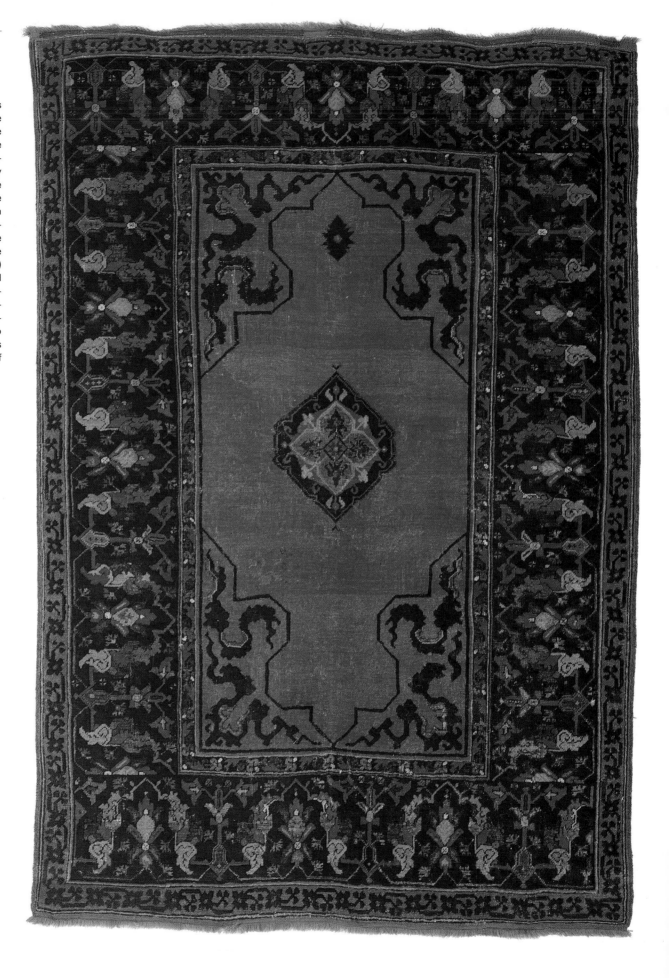

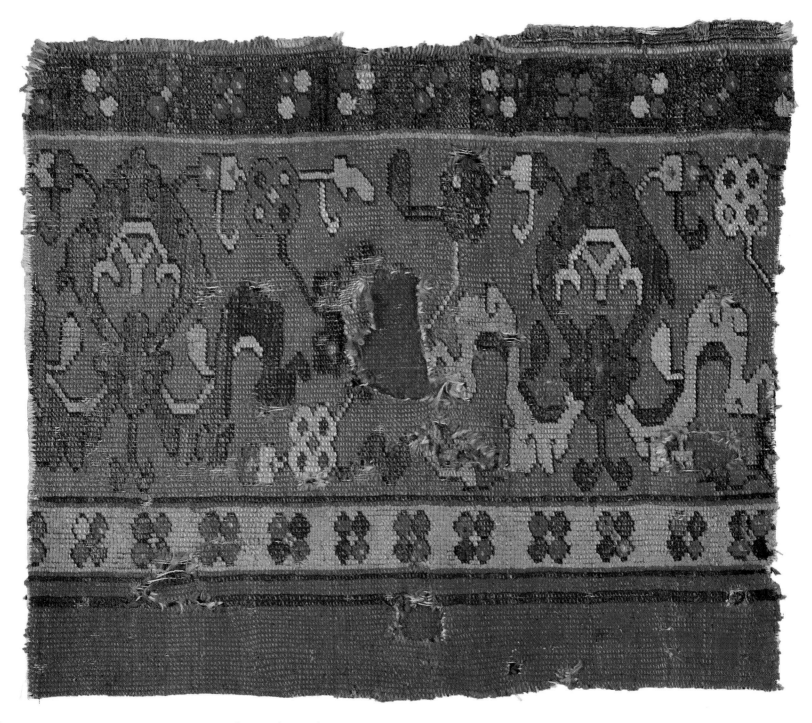

2

Cloudband Border Fragment

West Anatolia
17th Century
41 x 48 cm

For centuries, the cloudband was not only popular as a carpet theme, but it also constituted one of the favourite border elements. Its presence is quite varied due to its adaptation to the local means and evolving trends, especially in Northwest Anatolia.

This delightful border fragment has a very vibrant and unusual colouration, and guessing by the small monochromatic portion of the field, it is probably the border of a double-niche Ushak (see cat. no. 1) or of a prayer rug (an exemplary sample is at the Musée des Arts Décoratifs in Paris, published in Various Authors 1989, p. 87). Further comparisons will determine how colour once again is the dominant creative and compositional element, which is indissolubly compounded with the design.

E.C.

Shield-Pattern Ushak

West Anatolia
15th–16th Century
95 x 158 cm

The slightly rounded outline of the heptagons allows the allover honeycomb pattern arrangement.

An almost complete carpet of this type (published many times, including Aslanapa 1988, pl. 93; and Ertug in Various Authors 1996, pl. 110) is at the Museum of Turkish and Islamic Art in Istanbul (T.I.E.M., inv. no. 699). The heptagonal carpet's pattern is similar to that of another very well-known fragment (Levi in *Ghereh*, no. 2, 1993), although the design of the one illustrated here is in many respects much more intricate. In fact, the carpet's daunting complexity could have effectively brought about its rapid extinction as a type (see the delightful, supposed final epigonus in Berlin; Spuhler 1987, pl. 30).

E.C.

4

Ottoman Velvet
Bursa, Northwest Anatolia
16th Century
47 x 51 cm

The sculptural qualities are probably among the main stays of the aesthetics of the Turkish peoples. This is seen in the reciprocity established between the negative image and its positive counterpart, the two merging in the observer's eye, who in the more complex and articulated examples may find himself faced with interpretative hurdles. This does not apply in the case of this velvet, which exemplifies the full gamut of the innovative *saz* style in its more purely 'Ottoman' vein, the only surviving legacy of the Central Asian steppes being a derivation of the *yun-chien* cloudband element.
E.C.

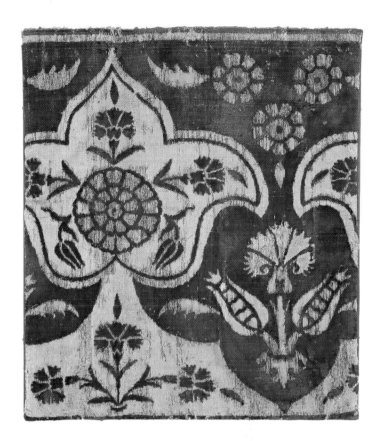

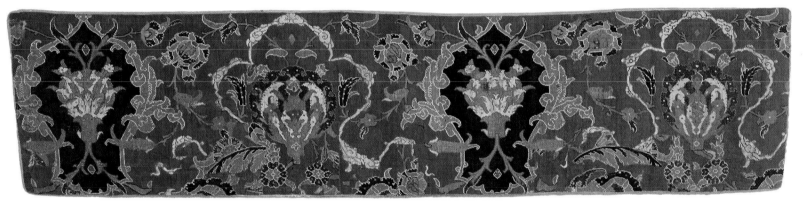

5

Bursa
Northwest Anatolia
Circa 1600
38 x 170 cm

The technical analysis accompanying this fragment endorses the view that the piece originates from the sophisticated looms of Bursa (where the Ottoman Turks settled before overpowering Constantinople in 1453), rather than Cairo, where, with the defeat of Egypt in 1517, their style gradually imposed itself; but not from those looms run by Egyptian weavers who had moved to Bursa with their materials (Kühnel and Bellinger 1957, p. 57). Indeed, the available historical data would cast doubt on the attribution, were it not for the evident technical peculiarities.

The dimensions of this fragment would seem to suggest a border of a large carpet, although it could more likely be a narrow runner similar to the one in the Textile Museum in Washington, D.C. (Kühnel and Bellinger 1957, pl. 37), perhaps intended to decorate the steps of a *minbar* (pulpit). See technical analysis in *Appendix*.
E.C.

Bohca

Northwest Anatolia
17th Century
85 x 89 cm

Without overemphasising the
predominant presence of the
tulip and the *chintamani* motifs
with their myriad interpreta-
tions, one notes that in this tex-
tile the latter is represented
twice, conveyed in a complex
floral orchestration (vying with
the finest Iznik ceramic works)
and (perhaps) as an unaffected
filler of forceful symbolic sug-
gestion. Lending rhythm to the
adroitly arranged ornamenta-
tion is the iridescent and flam-
ing volute with its crowned ter-
minations.

A unique *bohca*, pulsating with
an opulent Ottoman redolence.
E.C.

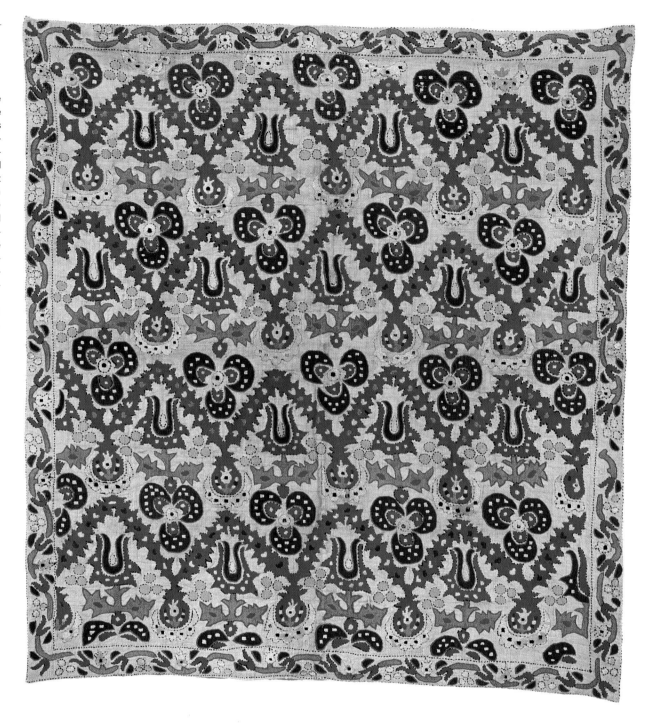

7
Medallion Ushak
West Anatolia
16th Century
245 x 585 cm

This type of border is common in double-niche Ushaks (see cat. no. 1), but much rarer in medallion Ushaks, appearing only in those with a blue background. This complex border pattern was produced in highly organised workshops, and was later simplified in the course of the 17th century. The blue background tends to appear on large carpets, characterised by a particularly high knot density, yielding a quality that could be compared to that of the earliest red-ground examples. The very rare blue-ground medallion Ushaks are especially recognisable from their somewhat individual borders. Among the best examples are the 'Cassirer' carpet (*Hali*, no. 86, 1996, p. 73) and the one in the Thyssen-Bornemisza Collection (Beattie 1972, pl. 14), bordered by this pattern only on one of the short sides. A half of a carpet belonging to this rare group is in the collection of the Philadelphia Museum of Art (Ellis 1988, pl. 20).

Our example should be considered a fragment as well. A closer look reveals that half of the carpet was completely rewoven, not in the recent past, with a great deal of attention paid to detail. However, the knot density (slightly less compared to the original), the undyed wefts (unlike the typical red hue of the Ushaks) and the stiffness of the wool, which was more coarsely worked, reveal a lack of softness to the touch immediately denoting a remake. Though this factor may depreciate the work for the more scrupulous connoisseur, the carpet's spirit of noble antiquity and sinuous immensity is outstanding, especially for the explicit continuity of its design, consisting of two halves of the central medallion set lengthways, where usually there is only a hint of a continuation of the pattern. The uniformity of colour in the remade section is outstanding, except for the lesser elements of the composition, in which the blue hue has faded slightly. Published in Jacoby 1952, pl. 19.
E.C.

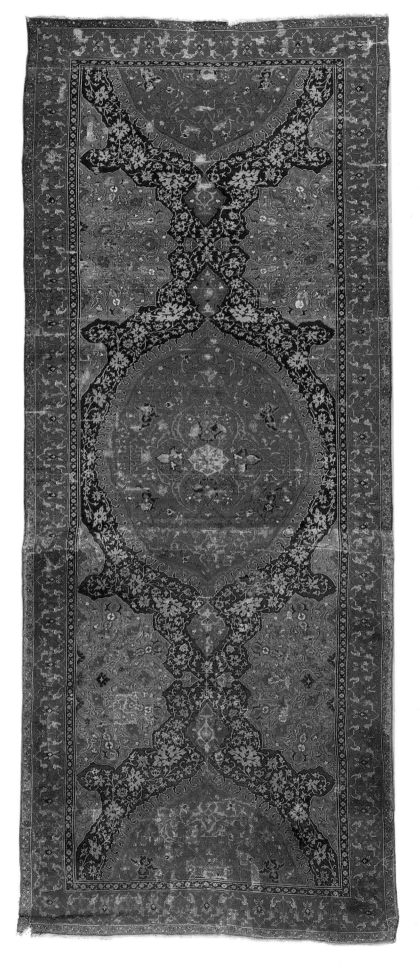

Star Ushak

West Anatolia
Circa 1700
120 x 195 cm

The so-called star Ushak earned
widespread and lasting appre-
ciation, albeit rather uncon-
trolled, allowing the weavers'
inspiration to unfold with a cer-
tain degree of licence. This may
be seen here where the design
reveals a botched attempt to-
wards corner solutions. The
idea of the field as part of an in-
finite arrangement is less ap-
parent, sustained only by the
weak links towards the minor
ornaments. However, the cre-
ativity of the weaver transpires
in the peculiarity of the com-
position — a highly seeked fea-
ture for many connoisseurs.
Published in Schürmann 1979,
p. 55; Tolomei 1983, pl. 47.
E.C.

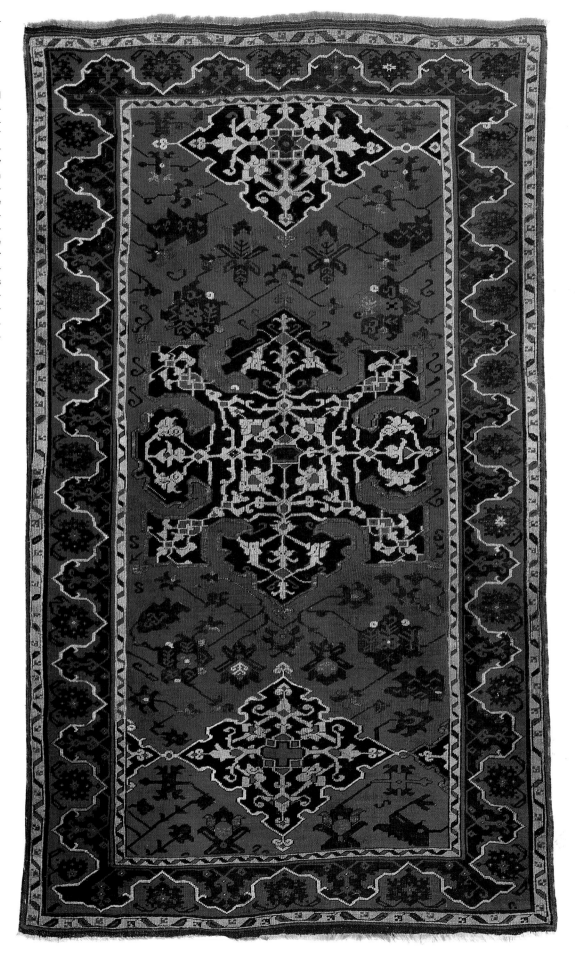

Lobed-Medallion Ushak
West Anatolia
16th–17th Century
147 x 291 cm

Lacking a naturalistic idiom or central reference point, the Turkish carpet finds expression in an infinite number of patterns that are undoubtedly rooted in remote traditions that were stratified over time and endorsed by the artists of the court. The popularity of the star-shaped device has tended to prevail over other themes — undoubtedly influenced by contemporary Persian stylistic elements (Boralevi 1987, pl. 7) — which are now grouped under the heading 'star variants'. However, as M. Franses has noted (Franses 1993, p. 285 ff.), they deserve a more detailed critique, owing to their idiom being condensed into an eminent style. J. Eskenazi presents an example similar to ours (Eskenazi 1981, pl. 11), while a large fragment conserved in Berlin (Spuhler 1987, pl. 10) illustrates how an inversion of background colours (red/blue) was applied to this type of carpet. The Textile Museum owns an incomplete example of this typology bearing a stiffer 'minor star' (Yetkin 1981, pl. 55). Published in Boralevi 1987, pl. 7.
E.C.

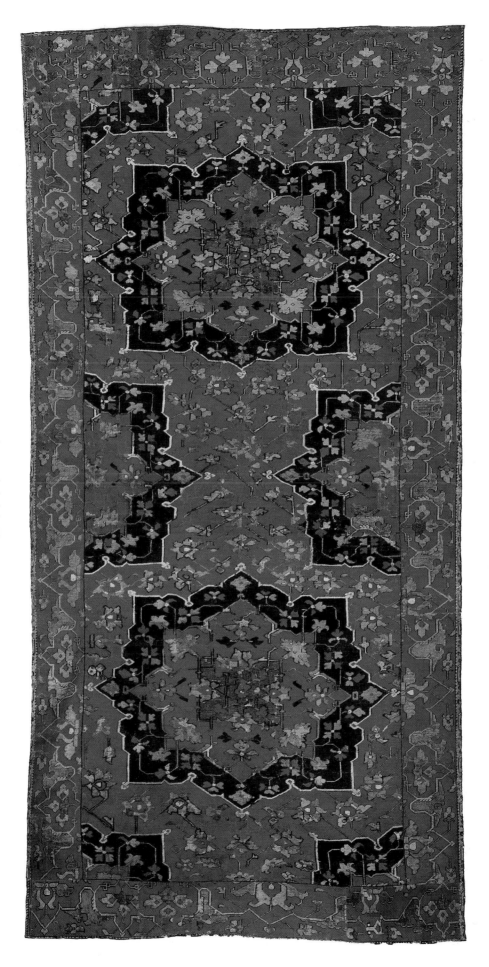

'Lotto' Ushak
West Anatolia
16th Century
155 x 290 cm

Much has been investigated and
written on the 'Lotto' variety,
with its sophisticated and pen-
etrating allure, and its formu-
laic but vibrant layout, deter-
mining an apt illustration of the
sensibility and aesthetics of the
Turkish peoples.
The example illustrated here
belongs to the earlier period, as
can be noted from the neat and
forthright execution of the 'Ana-
tolian' style (C.G. Ellis' distinc-
tion into three types for this kind
of composition is now widely
accepted; see Ellis in *Festschrift
für Peter Wilhelm Meister*, Ham-
burg 1975), and by the 'Kufic'
border on a deep green back-
ground.
E.C.

11

'Lotto' Ushak
West Anatolia
17th Century
110 x 185 cm

The 'Lotto' composition was so appreciated that for over two centuries it ushered in countless compositional variations. The 'Lotto' repeat pattern can be seen reiterated many times on large workshop carpets as well as one or one and a half time on smaller, so-called 'village' versions.

Another characteristic of this design module is the single-colour treatment of both the cruciform and the octagonal components. This scheme is rarely altered, except as an elaborate and somewhat cerebral exercise (Spuhler 1987, pl. 7), or with a spontaneity that adheres to the design, as shown by the rug illustrated here and, similarly, by the 'Lotto' in the Transylvanian church of Petersberg (Schmutzler 1933, pl. 19), and by that in the Detroit Institute of Arts (Gantzhorn 1991, pl. 387). Its charm and rarity are enhanced by the border's green ground, decorated by two systems of vine-shoots executed with brisk liveliness, this being another departure from the traditional ornamental style of Ushak.

It is worth remembering that a similar 'Lotto' has been published since 1911 on several occasions (Bode 1911, fig. 61; Erdmann 1970, fig. 58; Yetkin 1981, p. 61), always incomplete and in black and white. It is reputed to have belonged to W. von Bode, and was lost without trace until recently, when it was published in its entirety — and in colour (Rageth in *Hali*, no. 98, 1998, p. 88). Now its uniqueness can be fully appreciated; it is the only existing 'Lotto' with a border that appears to have been used exclusively for white-ground prayer rugs with the *chintamani* design. Published in Boralevi 1987.
E.C.

'Lotto' Ushak Variant
West Anatolia
17th Century
125 x 191 cm

The need for conciseness prompts us to label the design of this rug as a 'Lotto variant', which uniquely summarises the intrinsic elements of the 'Lotto' style, reorganised here with a pondered inventive assisted by a self-assured interpretation. It may be an imitation of a richer and more important carpet from a larger centre of production, a design that may have suffered from the competition of the more canonical 'Lotto' pattern, the latter being often jeopardised by inept interpretations. Published in Various Authors 1991, p. 51.
E.C.

13

Bird Ushak
West Anatolia
17th Century
108 x 175 cm

The schematic rigour of the bird design allows the weaver creative licence to elaborate only the minor decorations, which are interposed both vertically and horizontally with the coupled leaves, the latter stylised in a manner that suggests an ornithological coupling. For some time, this has been the standard way — albeit somewhat simplistic — of interpreting the main element of the pattern; a more critical examination of the motifs that generated this design could in fact give rise to new observations as to its iconographic expression. Batari (1994, p. 17) and Alexander (1993, p. 202 ff.) rightly suggest that the bird variety stems from the so-called 'pinwheel' design, the latter being present on the field of the rug in the Museum of Applied Arts in Budapest (Batari 1994, pl. 23).
The unique border is made up of elements present on other Ottoman rugs, although they have been thoroughly reinterpreted (see the border of the white-ground so-called 'crab rug' in the Museum of Applied Arts, Budapest, illustrated in Vegh and Layer 1977, pl. 7; see also Batari 1994, pl. 29). It frames the field as if it were a portion of an infinite repeat — a commonly encountered trait on small rugs from domestic looms having a design that is not scaled down to their proportion. The colour palette on bird rugs is usually toned down, perhaps owing to poor-quality wool. This would seem to endorse the idea of a single centre of production that remained active for less than a century. Some experts have located the focus of manufacture as the town of Banaz, near Ushak, although this remains to be confirmed. Published in the catalogue for the Oriental rug exhibition held at the Austrian Museum of Commerce, 1891, pl. 338.
E.C.

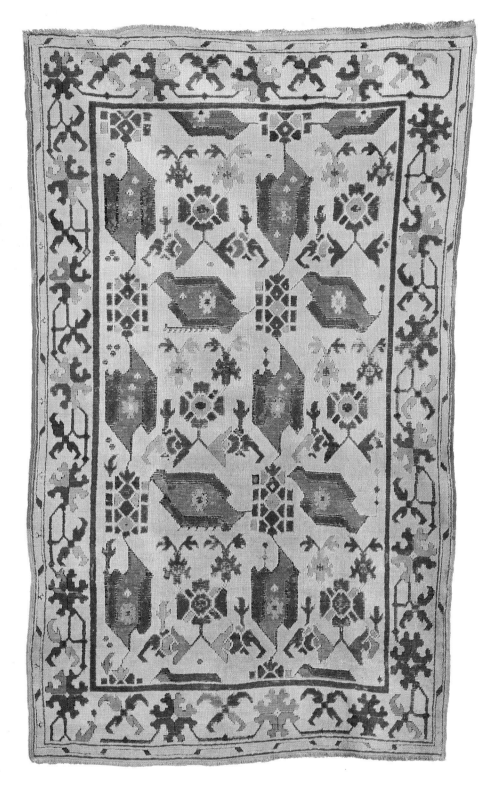

Smyrna
West Anatolia
18th Century
159 x 230 cm

Generous floral forms inspired
by the Ottoman court style, laid
with liberal swirling strokes in
vibrant colours of predomi-
nantly warm hue, decorate the
central field of a certain group
of rugs, commonly of square
format and generically attrib-
uted to Izmir (Smyrna), which
undoubtedly served as the port
for outbound trade to the West,
where the elegant naturalness
of these carpets, and their im-
mediacy and easy adaptability
to European interiors, made
them popular.
Balpinar and Hirsch (1988, p. 114)
have identified Güre, near Ushak,
as a possible place of origin for
such rugs, though other villages
of the area may have contributed
to the coordinated production of
this type, which has been dated
by some scholars to the 17th cen-
tury. The maturity of the style,
anyway, suggests the following
century as a more likely date for
this typology. The example il-
lustrated here could very well be
one of the earliest for this group,
given the restrained opulence of
the ground, the breadth of the
colour palette, and the border
design that so handsomely
frames the main field.
E.C.

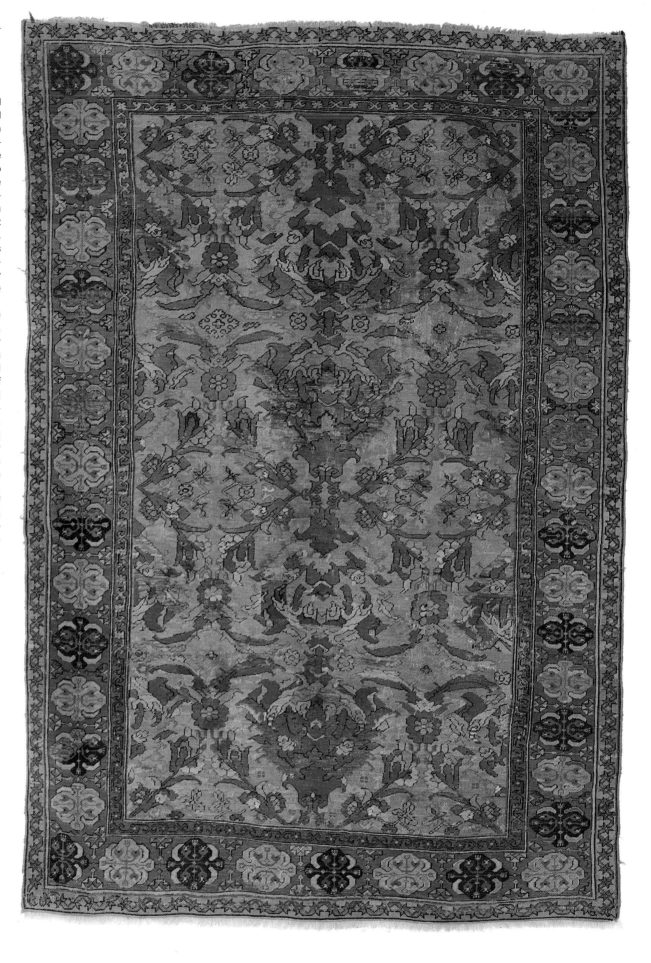

**Double-Niche
'Transylvanian'**
West Anatolia
17th Century
125 x 170 cm

Notwithstanding the debunk-
ing of the myth that 'Transyl-
vanian' carpets were produced
in the geographical area of that
name (thanks largely to the doc-
umentary evidence provided by
Hungarian scholars), the label
ascribed to this type has re-
mained, and perhaps also a
need for more detailed parti-
tion of this large family of rugs.
One of the principal distinctions
among 'Transylvanian' rugs is
in the arrangement of the car-
touches in the border, either di-
rectly connected to one anoth-
er or, as in our case, alternated
to a star-octagon element. We
have no proof for assuming that
one type is earlier than the oth-
er: their appearance in paint-
ings cannot be substantiated as
evidence as both types are
known to have existed well be-
fore.
The double niche is decorated
by floral motifs derived from
the Ottoman court iconography,
although the vases from which
sprout these motifs are absent,
as often seen on similarly con-
structed rugs.
E.C.

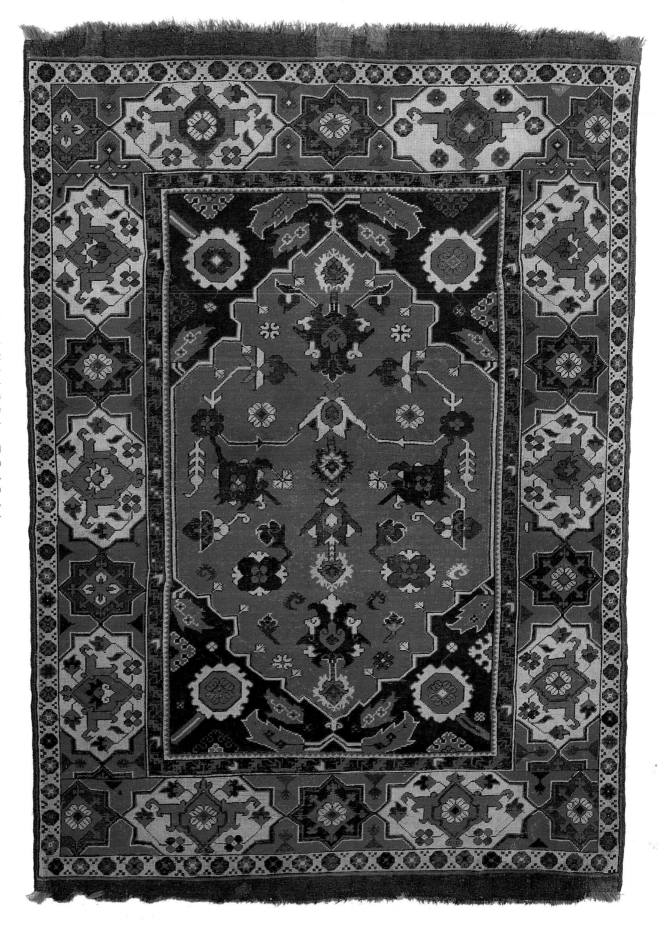

**White-Ground
'Transylvanian'**
West Anatolia
17th Century
117 x 177 cm

On rugs belonging to the so-
called 'Transylvanian' category
one rarely encounters the ivory
background. This contributes
not only to enlighten the whole
field, further accentuated here
by the use of an ivory border,
but lends clarity to the entire
composition. This harmonises
perfectly with the choice of flo-
ral ornamentation favoured by
the Ottomans to achieve a clear,
lean stylisation proper to the
'Transylvanian' canon. The field
design is characterised by a
lozenge with acutely cornered
vertexes ornated by *saz*-style
flowering motifs, with vases
from which sprout pairs of tulips
on rigid stems, lending vertical
thrust to the composition. The
same applies to the red-crest-
ed carnations laid at both ends
of the lozenge, identical to the
blue ones arranged at the cen-
tre of the composition. The
whole is executed with keen de-
scriptive skill.
E.C.

17

**Double-Niche
'Transylvanian'**
West Anatolia
17th Century
120 x 180 cm

The popularity attained through the centuries by one of the most frequently encountered types of 'Transylvanian' rug is amply justified both by its presence in Flemish paintings and by the fact that many of these carpets were originally found in Italy. One of these, formerly in a Milanese collection, was chosen by W. von Bode as representative of an entire sub-class (Bode and Kühnel 1970, p. 56) to which belongs our example, with its strong yellow central lozenge and the saturated blue within the corner spandrels which, together with the smooth patina, informs it with depth and substance.
E.C.

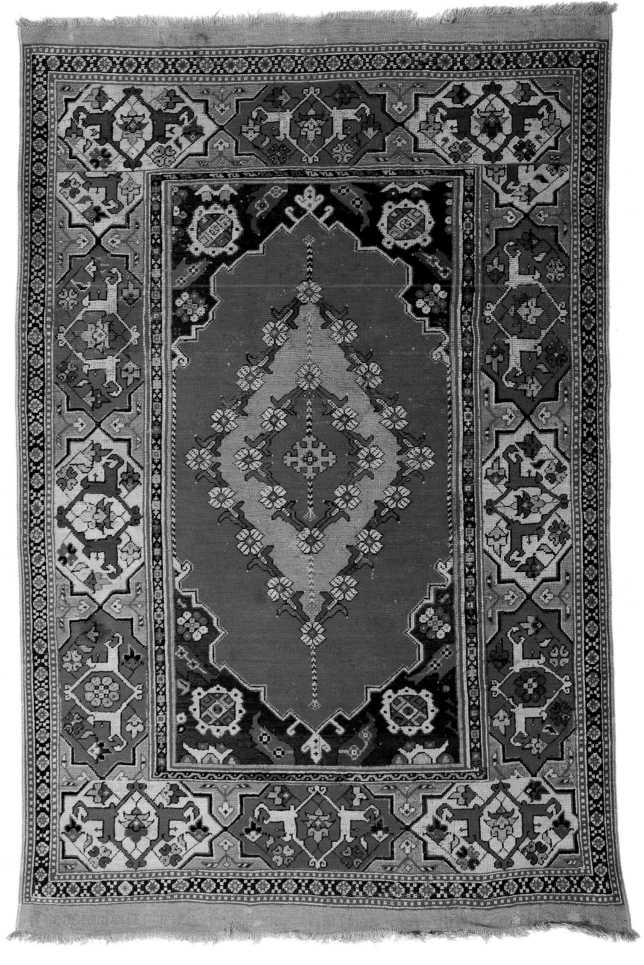

'Transylvanian' Prayer Rug
West Anatolia
17th Century
125 x 170 cm

A number of single- and double-niche 'Transylvanians' are characterised by a main field showing lateral indentations, giving rise to a series of connected rigid volutes smoothened by clever corner solutions. This particular trait is greatly beneficial towards the rendition of the overall design, as seen here, especially if we compare it to a rug with a similar rare border of palmettes and hyacinth blossoms (see cat. no. 31) in the Museum of Applied Arts in Budapest (Batari 1994, pl. 86). The predominantly yellow hues add warmth to the discreet complaisance of the composition.
E.C.

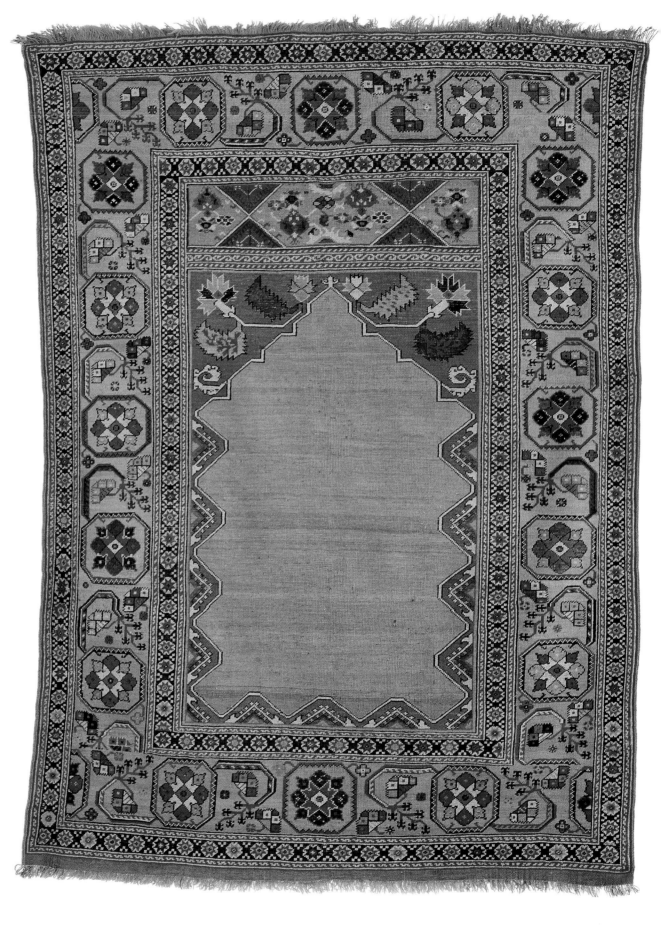

19
Five-Column 'Transylvanian'
West Anatolia
17th Century
123 x 179 cm

The famous Islamic scholar Friedrich Sarre was deeply involved in the study of carpets, curating, among other things, the 1910 Munich exhibition catalogue and, together with H. Trenkwald, in 1926 and 1928 the two famous volumes of the carpet collection in the Museum of Art and Industry in Vienna.

The fact that this prayer rug once belonged to his private collection testifies to the eminent scholar's discerning eye.

In this 'Transylvanian' rug the *mihrab* has become a vivid architectural metaphor with a structurally unusual central column that visually emphasises a vertex, while fostering a sense of spiritual elevation. This unique invention, circumscribed and completed by stylistic devices characteristic of this type, executed here with a skilled and confident hand, is found in only two other rugs, both in Transylvanian churches, published by E. Schmutzler (1933, pls. 25–6): one is characterised by single columns on either side of the niche and by other details that are essentially identical to our rug; the other one, also with five columns, appears less slender and prominent, and is framed by a cartouche border containing a different motif. Published in Lefevre 1980, pl. 2.

E.C.

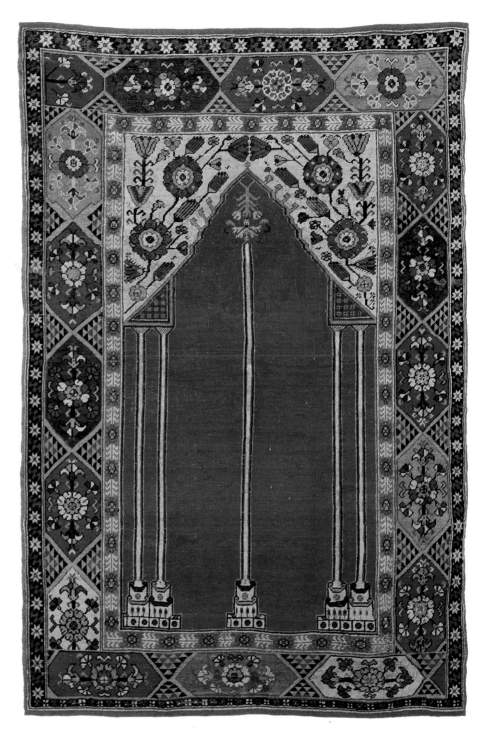

**Coupled-Column
'Transylvanian'**
West Anatolia
18th Century
125 x 170 cm

The relatively large group of what M. Beattie (1968, pp. 243–58) defined as 'coupled-column Transylvanian' rugs had been long ascribed to Ladik, until H. Inalcik supplied evidence for Kula as the more likely provenance (Inalcik 1986, p. 58). The latter attribution matches in fact with the West Anatolian styleme of translating the Ottoman court iconography into a more concise, provincial language. The closest comparable piece is the so-called 'Ballard Prayer Rug' in the Metropolitan Museum of Art in New York (Dimand and Mailey 1973, pl. 188. Additional comments in Boralevi 1987). Apart from their common occurrence in churches throughout Transylvania, the largest number of 'coupled-column' rugs can be found in the Museum of Applied Arts in Budapest (Batari 1994, pls. 66–76). The blue background is one of the most attractive features of the piece illustrated here, with its combination of border cartouches and naturalistic designs. Published in Boralevi 1987, pl. 11.
E.C.

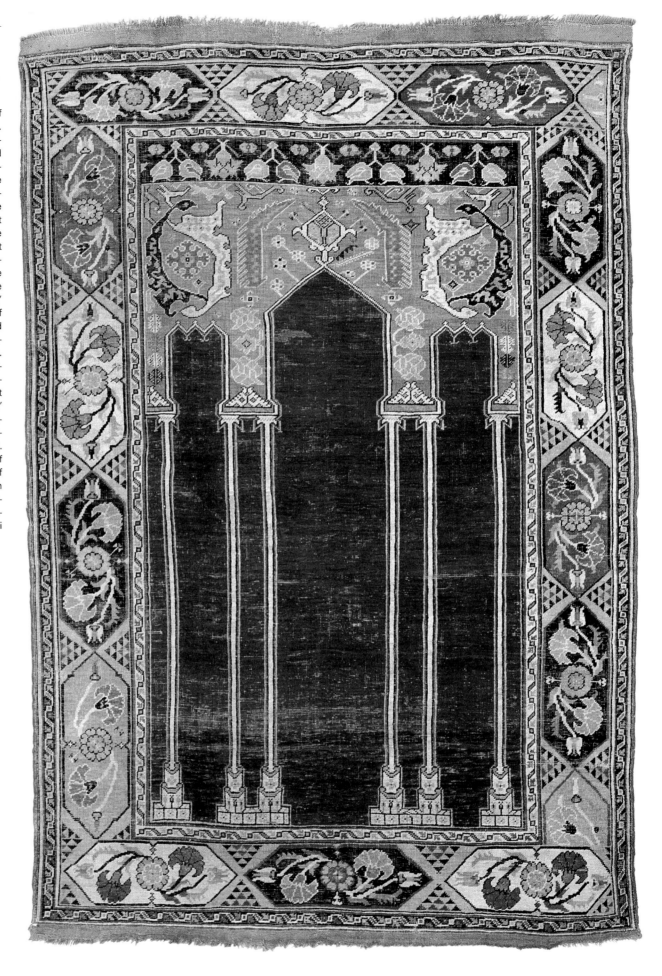

21
White-Ground Prayer Rug
West Anatolia
Circa 1700
120 x 166 cm

The rugs from Ghiordes and Ku-la show a great receptivity towards the prayer rug design style as devised during the Ottoman court period (Dimand and Mailey 1973, figs 187–91, attrib. Istanbul or Bursa; Spuhler 1987, pl. 69, attrib. Cairo; Herrmann 1981, pl. 1, attrib. Istanbul or Bursa), maintaining the roundness of forms and a compositional posture that allow us to date the specimen illustrated here at the beginning of the 18th century. This is evidenced further by comparing our rug to the one published by Schmutzler (1933, pl. 33; Kertesz-Badrus 1985, fig. 42), credibly dated 1736, the latter being stiffer in design and showing an overall weakness that is typical of later weavings.

Special mention should be made of the light blue tonality employed to define the vine-shoots in the deep red spandrels: the use of these colours, together with that of the rare ivory background, imprints much depth to the overall composition.

Light blue is commonly employed in Kula throughout the 19th century as a background colour both above and on the sides of the niche (see Batari 1994, pl. 119 ff.). Published in Herrmann 1989, pl. 7.
E.C.

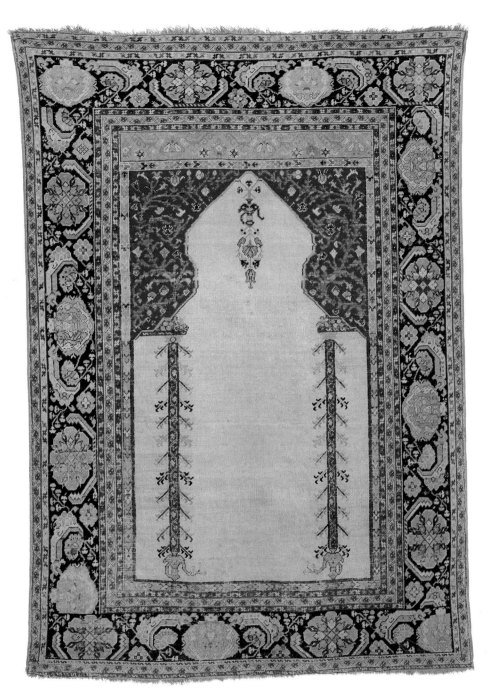

Karapinar
Central Anatolia
18th Century
105 x 146 cm

What we say about the 'rein-
ventions' of Karapinar (see cat.
nos 24 and 25) applies to this
prayer rug as well, which is an
evident stylisation of the so-
called 'coupled-column Tran-
sylvanians', inspired in turn by
the weavings from Cairo-Bursa
(see cat. no. 20). This design
scheme will then reappear on
19th-century village and tribal
rugs from the vast Konya area
(see cat. no. 34). Most evident is
the reworking of the architec-
ture, the perspective tempered
except to stack niches above
columns, an idea borrowed from
the archaic idiom determined by
the kilims of this area.
E.C.

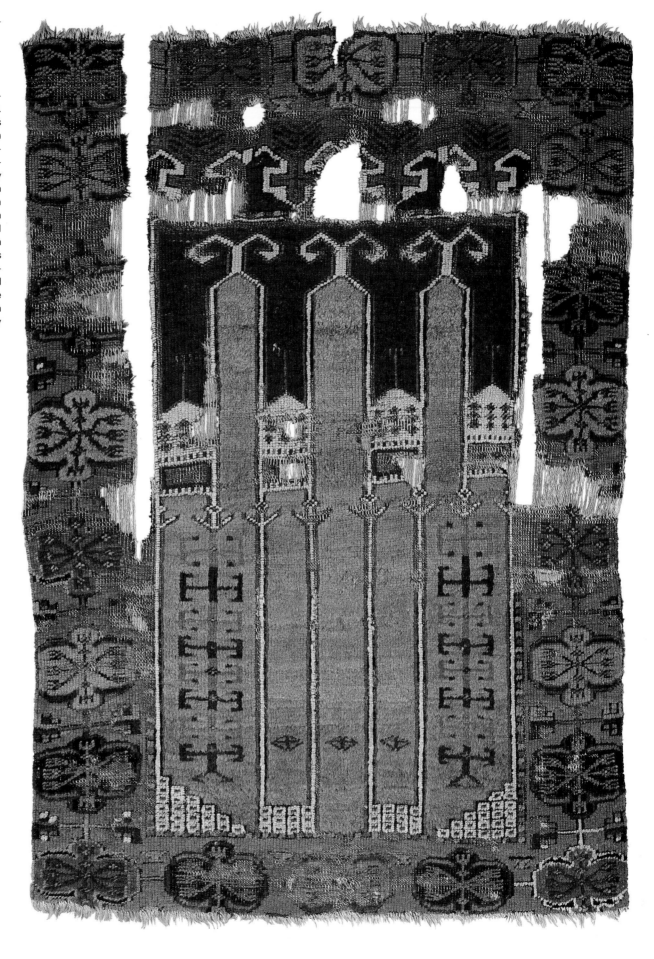

23
Octagonal Medallion Rug
Central-Eastern Anatolia
15th Century (?)
137 x 237 cm

Apart from few minute details, this carpet is very similar to the one in the Alexander Collection. C. Alexander (1993, p. 193) ascribes it to the Konya area and underlines its close links with the so-called 'Large-Pattern Holbein' carpets and makes note of the dynamic flowering border, 'the near-to-perfect corner solutions', the primal construction of the elements of which it is constituted, the uniqueness of all the details in the composition, the solemn, pure immobility of the field, concluding that we are in front of a typology in its formative stage. Rather than classifying this carpet as a 'Large-Pattern Holbein', however, we prefer to consider it as an early East Anatolian village rug (Balpinar and Hirsch 1988, pl. 14, p. 70), also because this design appears throughout the 19th century on rugs from the eastern part of Turkey (Balpinar and Hirsch 1988, pl. 82). So, one could ascribe a common lineage from a remote archetype for both typologies, thus enabling their parallel development through time.

Alexander also sees it as a precursor of the prayer rug design, particularly by looking at the intricate configuration of the border, which interplays with the actual shape of the field. Published in *Hali*, no. 96, 1998, p. 61. E.C.

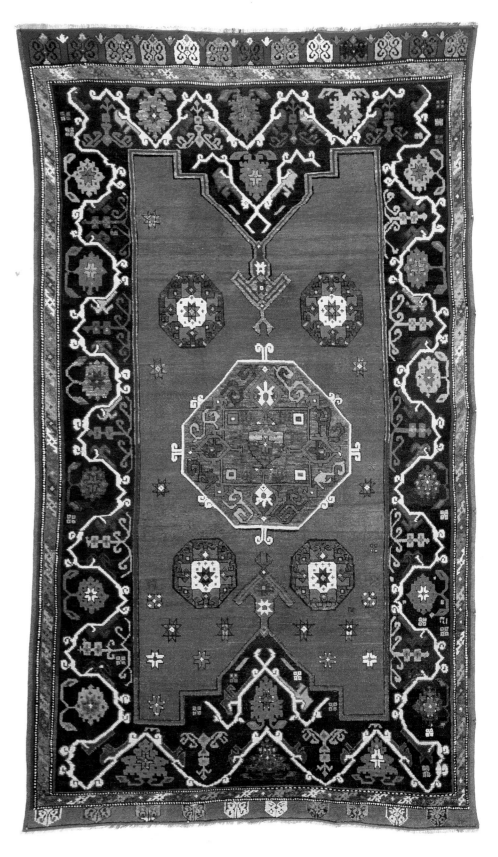

Karapinar
Central Anatolia
18th Century
170 x 235 cm

The dynamic centrifugal force that transferred inventions and styles from its centre to the outer perimeters was always strong in Anatolia. Many Anatolian carpets should also be considered highly personal reinventions, characterised by bright hues with ribbon-like painterly strokes.

Since May Beattie (Beattie 1976[2]) singled out the Karapinar area as the centre of production for rugs such as ours, new discoveries have been made and the critical commentaries have multiplied. Consequently, many different specimens (unfortunately, many of them incomplete), free from stylistic rules, are currently known and can be attributed to the Karapinar area with certainty.

This is a splendid example of the type, its beauty enhanced by the large medallion. Alberto Boralevi noted that the weavers of Karapinar adapted in their language many elements originating from Ushak rugs. Published in Boralevi 1987, pl. 15.
E.C.

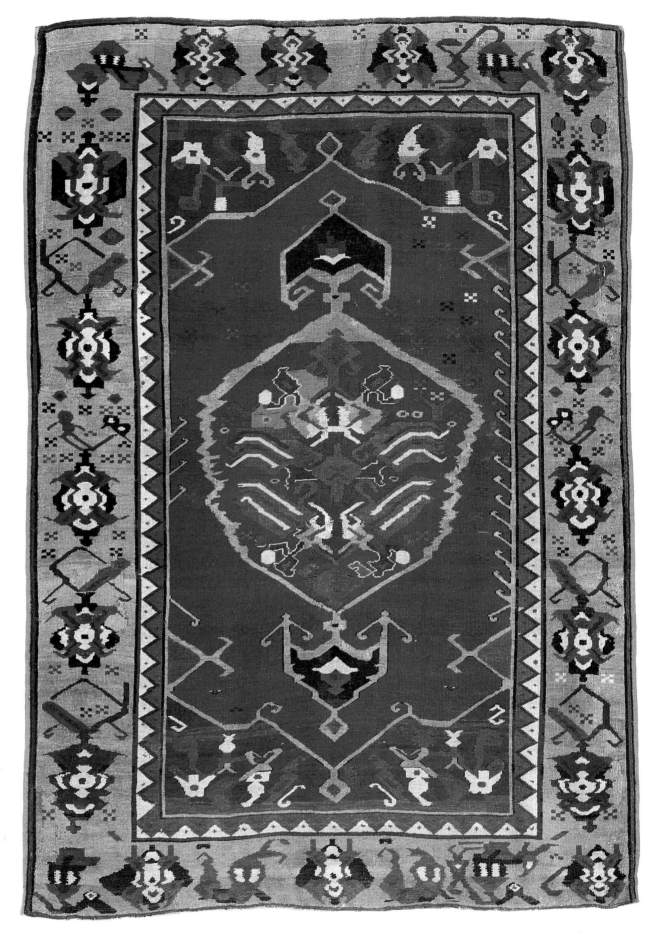

Karapinar
Central Anatolia
18th Century
120 x 205 cm

In his analysis of a carpet that
is basically the twin to this one,
E. Herrmann (1990, pl. 6) delved
into the primeval elements re-
sponsible for the emergence of
certain court motifs. May Beat-
tie's research is highly relevant
to this topic, as is M. Franses'
discussion (Franses 1981, pl. 5)
of a knotted version of an Ot-
toman court kilim. The rug il-
lustrated here derives from this
tradition, as well as being in-
fluenced by the *saz* style. The
outer border can be seen on
earlier rugs, where it is better
executed (Balpinar and Hirsch
1988, pl. 34).
E.C.

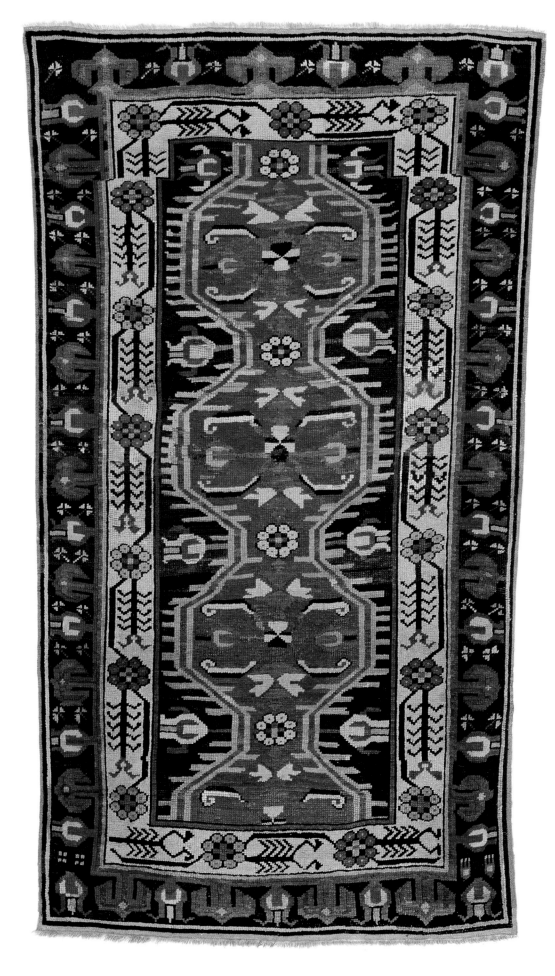

Demirji
West Anatolia
Second half 18th Century
131 x 287 cm

Describing it in his fundamental 1983 book, J. Eskenazi underlines the elegant execution of this carpet's floral elements, insisting that 'the specimen is still drenched in that redundant opulence that permeates ancient Ottoman production'. No other carpet better exemplifies the precise and painstaking execution of this rare type, examples of which can be seen at the Museum of Islamic Art in Berlin (Spuhler 1987, pl. 58), and at the Metropolitan Museum of Art, New York (Dimand and Mailey 1973, no. 145).
The precursors of this family of carpets are the group of rugs referred to as 'Smyrna' (see cat. no. 14). Of particular significance is the specimen at the Musée Jacquemart-André in Paris (Various Authors 1989, p. 107). Published in Eskenazi 1983, pl. 36.
E.C.

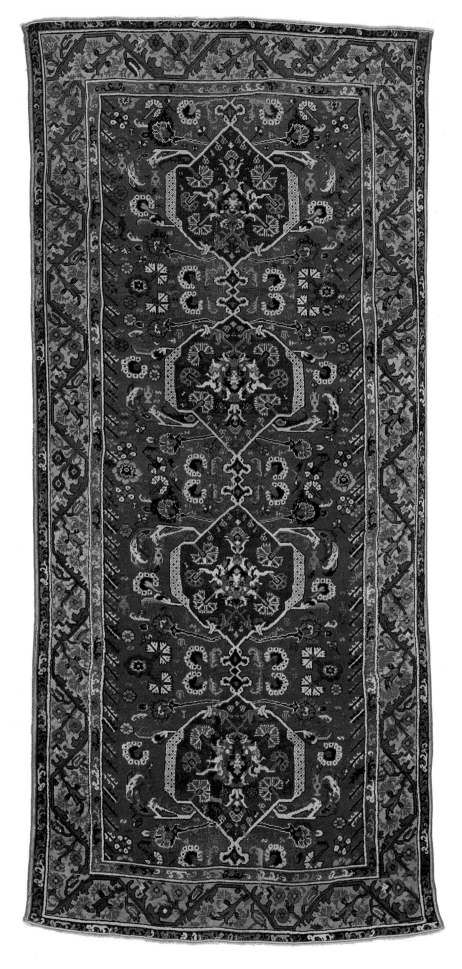

So-called 'Ghirlandaio' Rug
West Anatolia
19th Century
130 x 175 cm

This is one of the points of arrival of a historical composition dedicated to Domenico Ghirlandaio, who placed it at the feet of his *Virgin Enthroned* (circa 1484, Uffizi, Florence); it is decorated by an endless repeat pattern, not unlike the 18th-century rug published by Brüggemann and Böhmer (1983, pl. 52). In our case, the centralised composition appears to be definitive, as in the 'Ghirlandaio' carpet in the McMullan Collection (McMullan 1965, pls 96–7. For a more detailed discussion on the theme of centrality, see J. Thompson, *Centralised Design*, in Herrmann 1980, p. 7 ff.). The octagon inscribed within the square derives from the so-called 'Large-Pattern Holbein' type. The lozenge is described as an 'exuberant floral form' (McMullan 1965), while the corners extend in an irregular fashion into asymmetrical spaces. A discontinuously coloured background sets the stage for this arrangement of patterns, while the borders follow the 'Transylvanian' style. In its entirety, the composition is a graceful union attesting to the spontaneity of 'village' productions, which express tradition in a well-orchestrated manner. E.C.

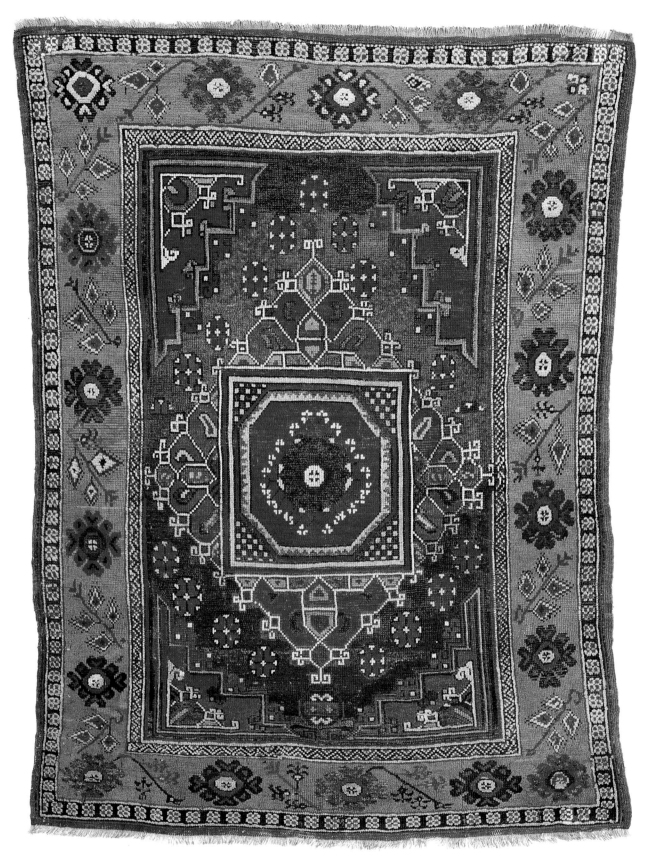

Melas

Southwest Anatolia
19th Century
33 x 130 cm

Though sometimes arbitrarily
dated, carpets from Melas, pro-
duced in large quantities since
the mid 19th century, are char-
acterised by their joyful and ex-
pansive colouration, which is
articulated through clearly de-
fined and formal composition-
al patterns. Many scholars have
endeavoured to identify the pre-
cursors of this particular style.
One of the most probable an-
cestors is the 'Transylvanian'
prayer rug, with usually red or
mustard-yellow background
and jagged indentations at the
sides (a typical stylisation of the
niche, referred to as horse shoe
mihrab, devised during the Ot-
toman court period).

This unusual fragment has
many features which suggest
that it could be a *vaghireh*, rep-
resenting a transitional style be-
tween the late 18th-century
'Transylvanian' rugs and the in-
novative experimentations of
the 19th century. Published in
Hali, no. 94, 1997, p. 108.
E.C.

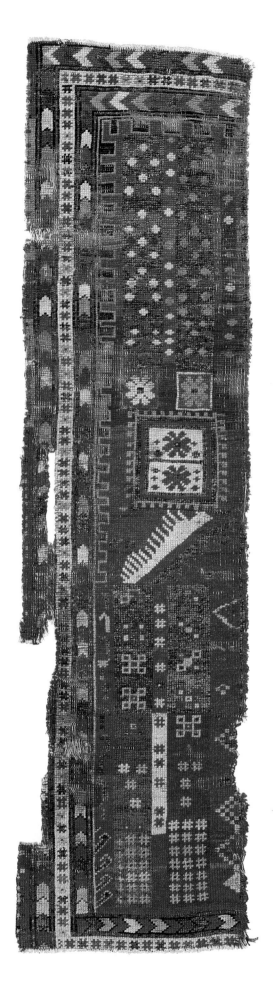

29
Bergama Area
Northwest Anatolia
Second half 19th Century
116 x 118 cm

There is a category of small-sized, typically square rugs predominantly with prayer designs. Owing to their technical and structural features, these are generally attributed to the Bergama region. Numerous scholars (*Textile Art Research*, Vienna 1983, pl. 26) have associated the origin of these rugs with the village of Kozak, situated not far from Bergama. These compensate for the reduction in size with an immediately appreciable simplicity of design.

There is a notable similarity between the rug shown here and the one published in Vienna, the latter being also dotted in the white background areas, in a manner typical of Ghiordes and Kula rugs.

The outer border shows a motif of Seljuk origin (Ertug in Various Authors 1996, pl. 7). Another small rug, attributed to the Kozak area (Benardout 1975, pl. 3), shows a simplified version of this motif.
E.C.

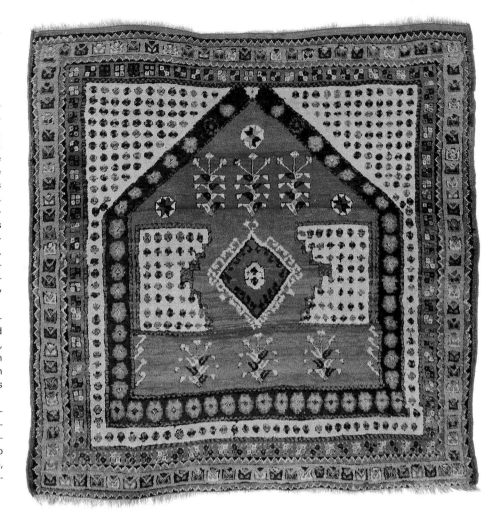

30
Yastik
Central Anatolia
19th Century
71 x 91 cm

Given *yastiks*' (cushion covers) small size, one often notes the close links between the field and the frame enhancing it. Such is the case here, in which the narrow border underlines the visual impact of the single central element (once again, an octagon) which is less stiffly ornated with respect to other pieces of similar age (Brüggemann and Böhmer 1983, pl. 37; Morehouse 1996, pls 69–72). The origin of this design can be traced back to that of 17th-century silk velvet *yastiks* (Scott 1993, p. 123).
E.C.

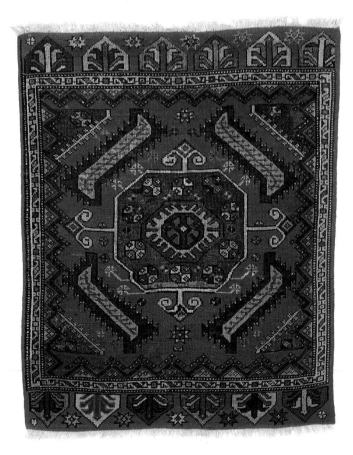

31

Megri
Southwest Anatolia
19th Century
113 x 144 cm

Multiple borders borrowed from
the classical repertoire, injected
with a Mediterranean glow of
intense yellows typical of the
area, enclose the red niche in a
perfectly balanced interplay of
volumes and colours. The main
frame is strewn (almost blithe-
ly, echoing the *saz* style) with
stylised hyacinth flowers (see
cat. no. 18), a device not fre-
quently encountered in rugs
from this area; these are also
within the niche as well as on
its apex, above which we see a
motif of archaic flavour.
The knot density, higher than
that generally found, plus the
exacting execution of the care-
fully studied scheme, togeth-
er with the sheer liveliness of
the colours, suggest that this
delightful prayer rug dates
from before the successive
standardised works from this
town. Published in *Hali*, no. 93,
1997, p. 116.
E.C.

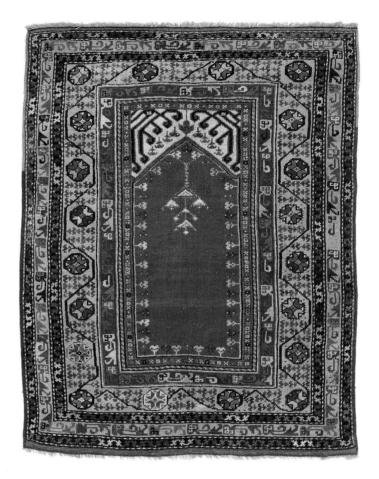

32

Dazkiri
Southwest Anatolia
Mid 19th Century
122 x 160 cm

A well-known group of carpets,
undoubtedly in the 'Transyl-
vanian' tradition, is charac-
terised by a longitudinal com-
pression of the design. Many of
these rugs, which are attributed
to Dazkiri, have a double-niche
pattern, with their corners dis-
tinguished by two different
colours for the background, laid
diagonally (Morehouse 1996,
no. 16). The prayer layout, such
as the one on this rug, is much
rarer. Here, the niche, which pri-
marily occupies the whole in-
ner area, is adorned with sin-
gle elements that are ideally
joined with a nicely rhythmical
symmetry, so as to prevent —
also taking into account the nar-
rowness of the borders — the
large *mihrab* from overwhelm-
ing the overall design.
E.C.

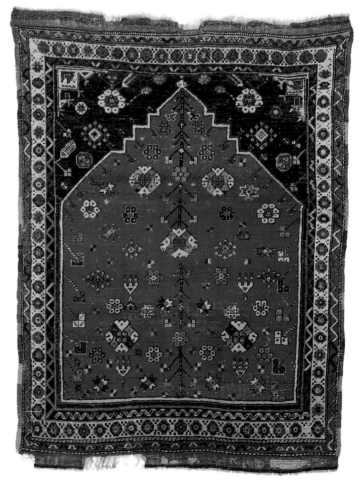

Kirshehir with Landscapes
Central Anatolia
18th Century
81 x 83 cm

The effects of the westernisation that began to make itself felt from the later 1700s, permeating every branch of art and expression in Turkey, could hardly elude carpet production. At first the descriptive naturalism borrowed from Europe was influenced by the art of manuscript illumination, and gradually succumbed to the imprint of western culture. Thus the initial 18th-century 'village' productions represent a delightfully ingenuous synthesis of chromatic vigour (in contrast with the didactic pallor of their urban counterparts) combined with a landscape outlook containing out-of-scale elements fixed in an infantile perspective. Later versions confine a debased variant of this design within the boundaries of a *mihrab*.

Regrettably, of the early examples only the one in the Victoria and Albert Museum (*Hali*, no. 2, 1979, cover and p. 123 ff.) has survived, formerly in the collection of George Mounsey (Kendrick and Tattersall 1922, vol. 1, p. 56; vol. 2, pl. 58), along with three fragments: one published by Herrmann (1985, cover); another in a private English collection, and our example here, whose pile — which has been miraculously preserved despite severe mutilation — displays the original chromatic exuberance typical of Kirshehir, a quality that disappeared in the later imitations, which are often attributed to the Kula area.
E.C.

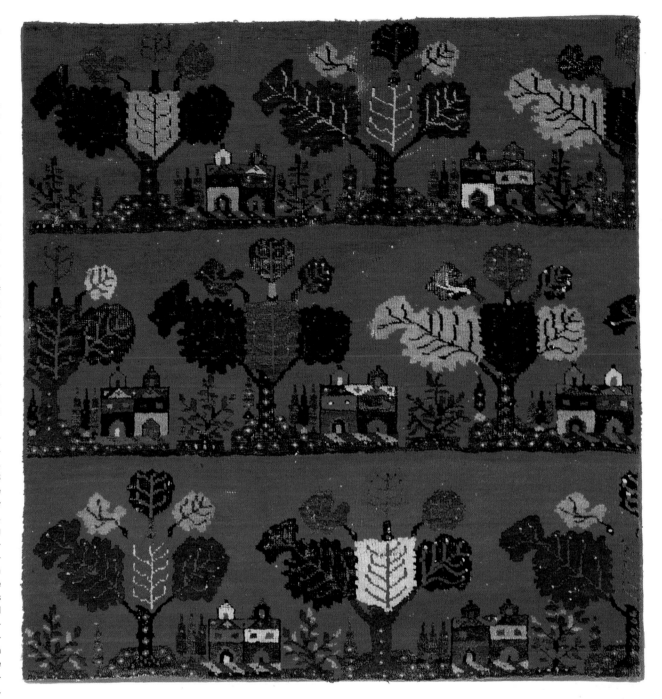

Konya Area
Central Anatolia
19th Century
119 x 148 cm

As the nomadic peoples gravitated towards a more sedentary existence (often a forced settling, as nomadic life defies any form of census), and developed a vocation for farming, we can more appropriately speak of a domestic village production. This new form of output is evinced by the unaffected, spontaneous stylistic simplification of certain primordial codes diluted down through generations, and an unremitting reference to the composite iconographies elaborated by the 'inventions' of the sophisticated court artists. This process, prompted by the enduring pressures of continuity and a sense of common belonging, gives rise to a new class of weavings.

The formal predilections pivot on a specific repertoire expressed through colours standardised by the availability of local dyestuffs, originating recognisable products whose success depends on the innovative fusion of all the components. What is yielded from this process is an instantly recognisable weaving (see cat. no. 22), with taut but not contracted lines; the architectural elements have meanwhile become mere pretexts, while the recurring floral details — often of a symbolic nature — become almost totemic. The subtle device crowning the niche has come to fill a third of the field, and, with deft inventiveness, becomes a second prayer niche, quite independent from the other, with boldly reworked proportions. In a discreet way, the border now occupies a surface double that of the field. The overall effect is resolved in a surprising, rustic balance achieved through an uninhibited but well-considered palette, typical of village rugs.
E.C.

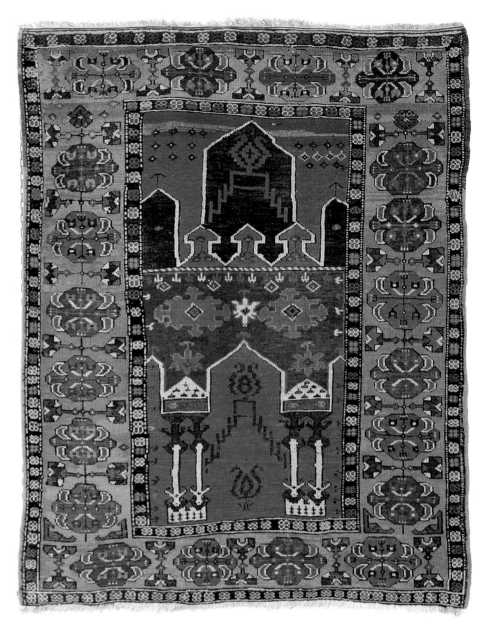

35
Konya Area
Central Anatolia
19th Century
130 x 157 cm

A brilliant assemblage of forms
wrought by a relaxed, compe-
tent hand complemented by the
concise animation of the
colours.
One might say that the niche
has been designed to lend em-
phasis to the cruciform (inten-
tionally?) directional element
placed at the vertex, designed
to induce reflection and a sense
of elevation in the user.
E.C.

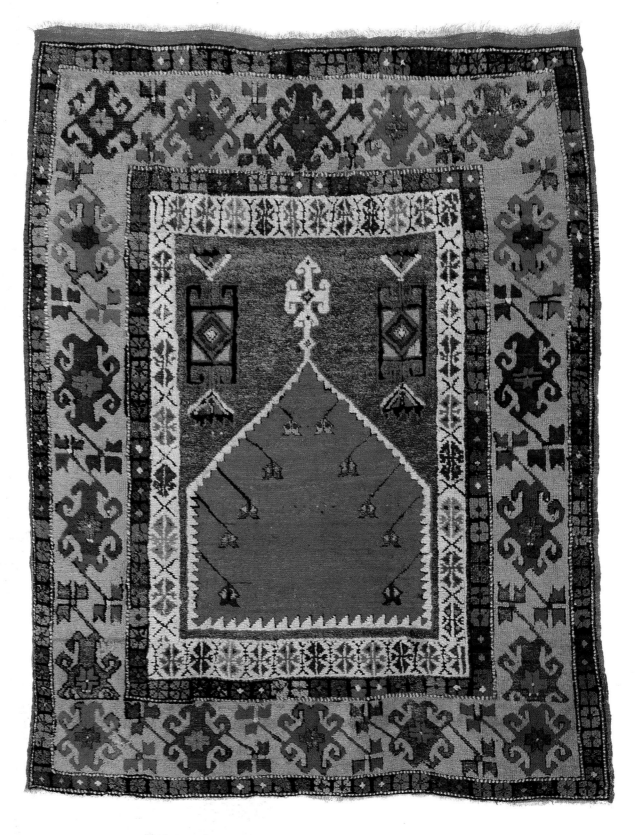

Mujur
Central Anatolia
19th Century
142 x 270 cm

This type of compositional lay-
out is widely used in Central
Anatolia, and stems from the
17th-century rugs of Karapinar.
It was later taken up as much
by workshops (Kirchheim 1993,
pls 170–9) as by domestic looms
(Brüggemann and Böhmer
1983, pls 21–2). The present ex-
ample testifies to the popular-
ity attributed to Mujur (both for
structural reasons and for its
typical border elements), which
rarely produced rugs that
strayed from the classic niche
formula.
E.C.

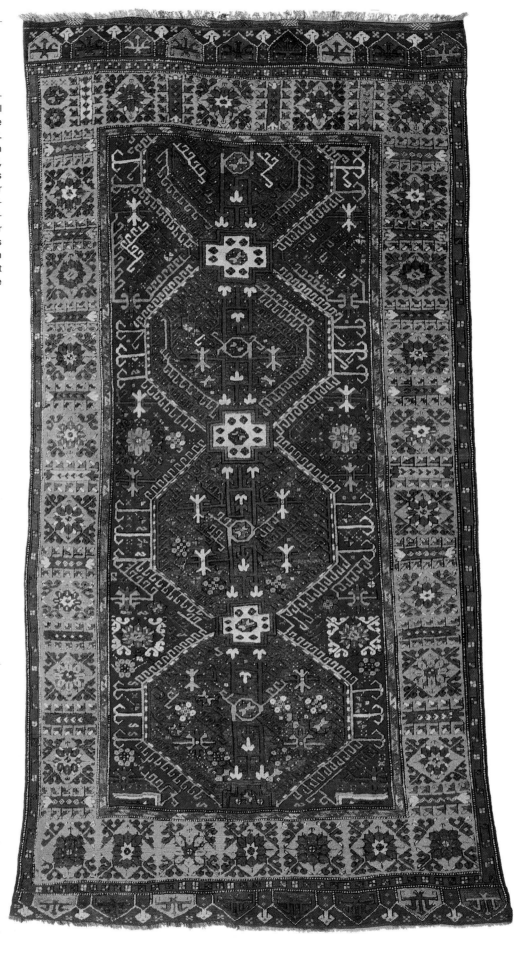

Yellow-Ground Konya
Central Anatolia
18th–19th Century
137 x 220 cm

Brüggemann and Böhmer
(1983, p. 204) have correlated
the origin of the motif decorat-
ing this rug to that of the *yun-
chien*. The authors also trace an
even more remote source, in a
Chinese bronze mirror from the
so-called Warring States peri-
od (475–221 B.C.), proving once
again just how ancient are the
origins of carpet imagery, and
how slowly they evolved given
the necessary perpetuance typ-
ical of peoples isolated by the
solitary reality of nomadism.
This type of ornamentation is
found variously across Turkey,
although it is in the so-called
'yellow-ground Konya' group
that we see it manifested
through a chromatic explosion
and expressed as a cruciform
element.
Two fragments of one carpet in
the Kirchheim Collection (Kirch-
heim 1993, pl. 149) lack the grid
pattern which in our case sep-
arates each element of the de-
sign, making the composition
seem less compact, more iso-
lated — an impression born
from the greater impact of the
spacing obtained from the neg-
ative component.
E.C.

Yellow-Ground Konya
Central Anatolia
18th–19th Century
140 x 240 cm

Not surprisingly, this category of rugs has earned itself the label of 'yellow-ground Konya', though it must be said that a sizeable percentage of them are endowed with a yellow thread that verges on red. This type boasts uniform and unvarying structural elements. They originate from Cappadocia, a region whose frontiers have always been historically very variable, and which, for the present purpose, we can identify with the upper plain lands of Central Anatolia. But while this geographical enclave can be defined with some certainty, the chronology of production is less clear, as it spreads over centuries of nomadic habits: the 'yellow-ground' type is an isolated phenomenon, equal unto itself and therefore ascribable to any century, depending on the observer's personal cognitive faculties. Consequently, an objective critique is impossible. Here, the *guls* are closely akin to those painted by Hans Memling (whence their name), but far less 'exact', bursting in graphic and chromatic exuberance and subdividing the space with an almost obsessive rhythm. See Kirchheim 1993, p. 10; in the same volume (p. 187 ff.), see the analysis and classification of this category by F. Spuhler; the accompanying illustrative material is exhaustive. More recently, in 1997, a new volume was published in Turkey dedicated exclusively to the 'yellow-ground' type: 61 rugs are illustrated here, most belonging to the impassioned author, Ayan Gülgonen; the remainder are the property of the Museum of Turkish and Islamic Art in Istanbul.

Regrettably, this example manifests the onset of that decadent *horror vacui* which was to transpire in many examples that followed, especially through the use of the amulet motif as a filler (see cat. no. 46). Some commentators see this surge of flair as naive, in contrast with the lucid phrasing of elements transmitted in centuries of complex and anguished iconographic development.
E.C.

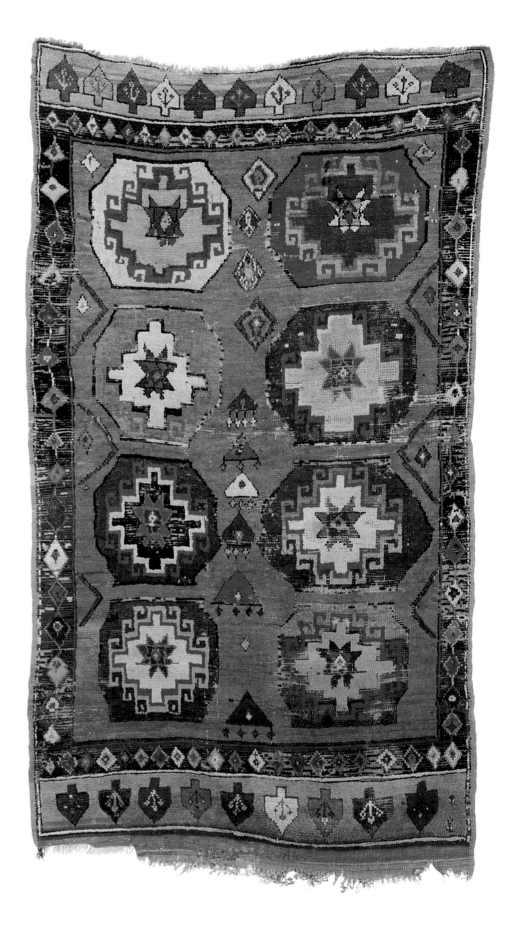

39

Yellow-Ground Konya
Central Anatolia
19th Century
124 x 435 cm

There appear in different times and places signs and designs that can be traced back to primeval elements which are rooted in every racial group and have matured over time. The pattern enclosed within the octagons in this long rug seems to issue from early Chinese imagery, thereby transmitting a sense of indelible archetypal authority, of some immutable heroic heraldry. Certainly, the original meaning has faded from the minds of the weavers, but somehow continues to flow, fixed in an octagon whose basic colour varies its phrasing of negative-positive patterns to create a highly sophisticated and complex language, inherent in the finest works of the Turkish peoples. In the rug illustrated here, the process is pared down to the lowest common denominator. This pattern is among those less frequently encountered on 'yellow-ground' rugs. For other illustrative examples, see Brüggemann and Böhmer (1983, pl. 8), Herrmann (1992, pl. 31), Kirchheim (1993, pls 123–5), and Gülgonen (1997, pls 19, 28, 30–1).
E.C.

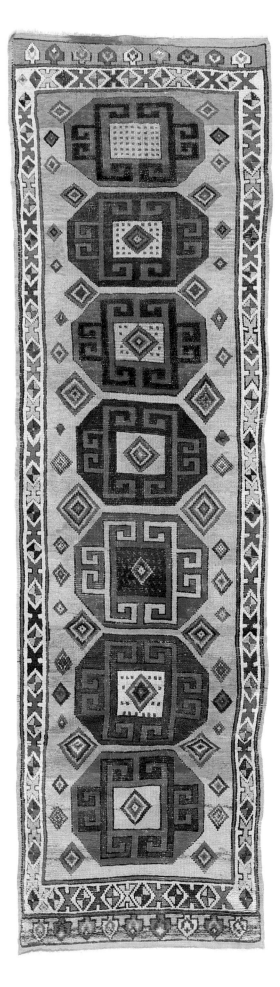

Yatak
Central Anatolia
19th Century
142 x 200 cm

The carpets woven by Central Anatolian nomads in many ways share the fate of kilims: created for purely personal use, completely free of outside influences and therefore unique, despite the powerful restrictions imposed by the imperious continuity of tradition, they have rarely survived complete, reaching us in a state which cannot transmit the personality that makes them so distinctive. The high number of weft shoots likens this example to the *tulu* rugs of the same region, to the *gabbeh* of Southern Persia, and to the various other peculiar shaggy weaves of West and Central Asia. What sets this rug apart is the heedless lack of consistency in the size of the simple basic elements, and their vivacious palette against a colour changing background. In a recent article published in *Hali* (no. 100, 1998, p. 86 ff.) J. Wertime analyses in depth the so-called primitive productions of the near past, linking them to more distant times, and enquiring into their possible paths of evolution. Wertime's study affords us a broader vision of this type of carpet, helping us grasp the technical and aesthetic background that led to the creation of this family of rugs.
E.C.

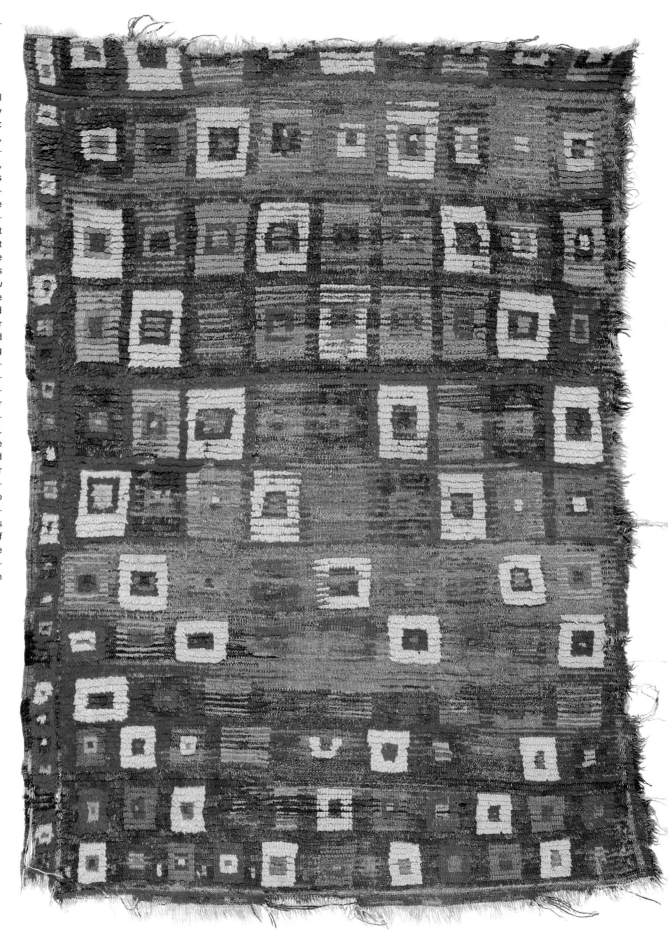

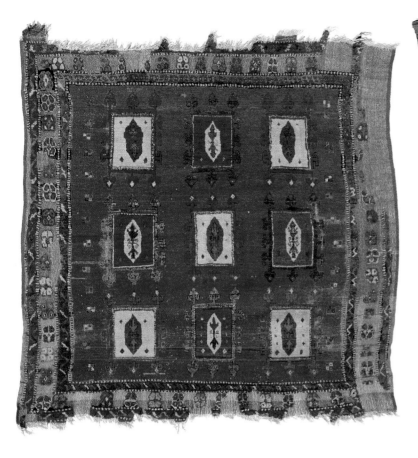

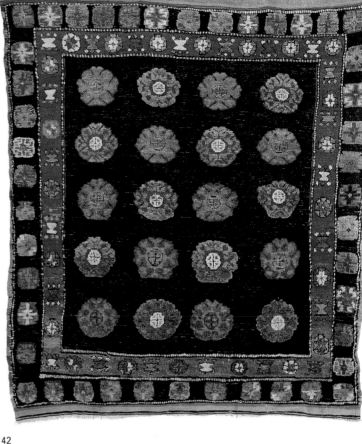

41

Yatak
Central Anatolia
18th–19th Century
198 x 200 cm

In Turkey the word *yatak* (bed) is used to refer to rugs of square format which are notably distinguished by a rather coarse workmanship. Their principal features include a soft type of wool with a high lanolin content, loosely plied (in the cases where it is actually plied), with sparse knotting fixed by weft shoots that are inconsistent in both number and tension (such features are often found in carpets made for domestic use by the Anatolian nomads). These traits conspire to produce a warm, pliable fabric that could be suitable for clothing, but susceptible to the rigours of everyday tribal wear and tear. J. Es-kenazi published an example similar to the one here (1983, pl. 44; Benardout 1975, pl. 7), stressing the Seljuk imagery of the archaic motif adorning it. The three-petalled motif — iterated twice within the hexagon, placed inside a 'holy ground' which is in turn protected by a *yun-chien* element — synthesises in a meaningful immobility centuries of slow evolvement.

The persistence of this imagery, as well as the fact that these *yataks* have been produced over a long time span make it difficult to date.
E.C.

42

Yatak
Central Anatolia
19th Century
170 x 190 cm

The use of black for the background and the outer border is a bold choice that may have been motivated in part by the availability of materials. Alternatively, it may stem from the artist's intention to endow the work with symbolic meaning. Whatever the case, it is certainly also a manifestation of a vigorous ploy to exalt the visual counterpoint between the ornamentation and the somewhat shallow polychromy.

The outer border is once again decorated by an amulet pattern, coupled here by a triangular motif.

The floppy texture allows us to perceive its full tactile qualities.
E.C.

**Rug with Three
Octagonal Medallions**
Central Anatolia
18th Century
114 x 173 cm

Some time ago, a connoisseur dealer wittily suggested attributing any carpet of unidentified origin to the Kurds. He was not far off the mark. The suggestion is borne out by the 'Kurdish dispersion', which has guaranteed their presence throughout most of the Middle East (albeit in varying numbers). This claim is also endorsed by ethnographic factors, as well as by sundry technical traits, including the prevalent use of dark-coloured wefts made from both sheep and goat wool, side selvedges of strong consistency over pairs of warps and a soft, pliable handle. Colour is treated creatively, being acute, clear-cut, vigorous, boldly juxtaposed, of dazzling brightness: precisely the impression given by this carpet. It has many elements which are reminiscent of the 'Large-Pattern Holbein' type, framed by characteristic borders, the whole composition being wrought with an agitated flood of colour.

The Kurds have continued to live prevalently in the eastern part of Anatolia, although there are two enclaves in the country's interior: Çankiri (north of Ankara), known for its divan covers which are distinguished by their lack of longitudinal border, and Cihanbeyli (north of Konya, near the great salt lake called Tuz Gölü), which did not produce many rugs, the few being characterised by the use of a distinct green — a focal ingredient of this carpet, with its fierce chromatism. Published in Butterweck and Orasch 1986, pl. 7; *Hali*, no. 30, 1986, p. 45. E.C.

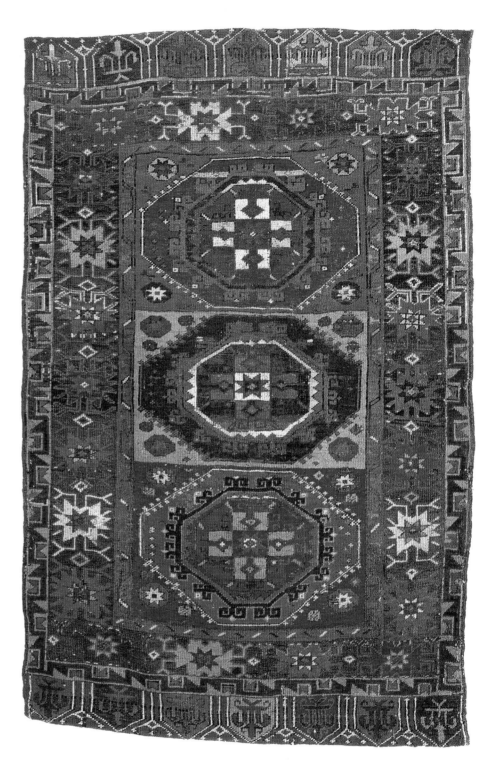

**Carpet with Empty
Field and Border**

East Anatolia (?)
18th Century (?)
230 x 415 cm

This unique and enigmatic carpet is difficult to place in a historical and geographic context. With the exception of West Turkestan, down through history all of the Orient has produced carpets with empty fields, though it is reasonable to assume that this occurred in 'prehistoric' eras as well. This creative tendency is the fruit of the absolute magical symbolism held by colour, and of a highly tuned spirituality in which everything and nothing overlap: from pure abstraction to fervent religious imagery, from the strict compliance with Koranic precepts (however misconstrued) to the banality of an unresponsive performance.

Here, it is not only the field, but also the border that are presented in primitive spareness. The only 'impure' area is formed by a reciprocal continuum of a *medachyl* pattern, shaped in the Ottoman style with curvilinear peaks.

Given its size one might assume that the carpet must have been made for some important house or temple, while the relatively coarse workmanship as well as the mediocre materials used for the foundation (although the pile is of excellent quality) suggest that it was probably intended for a provincial aristocracy.

The inscription (purposely cryptic?) may be in a (forgotten?) Georgian dialect, and a better appreciation and understanding of the piece can only be gained through a more precise deciphering.

Undeniably, many carpets with a monochrome background, whose colouring varies only through a gradual change in tone, emanate a sense of impassive metaphysical calm, fostering an ecstatic, transcendental detachment. This is especially true when they are situated in a quiet, minimalist context. See technical analysis in *Appendix*.
E.C.

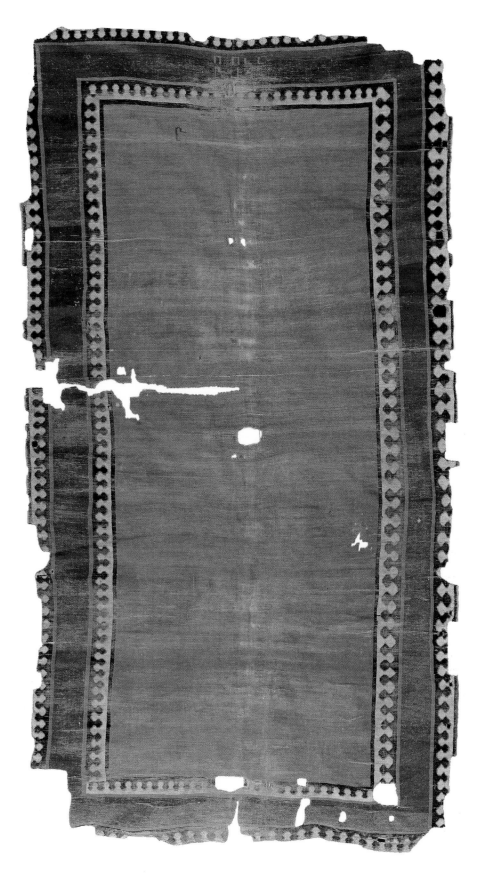

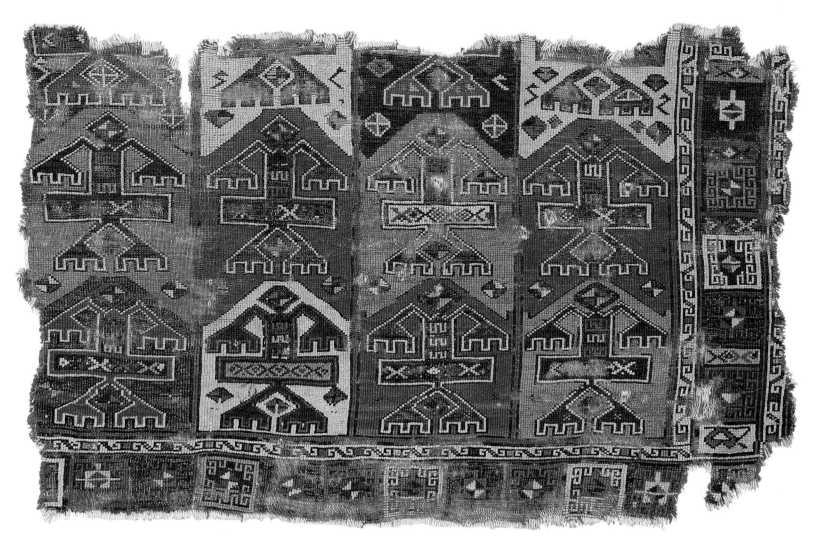

45

Mother Goddess Fragment
Southeast Anatolia
18th Century or earlier
89 x 138 cm

While it is easy to determine the geographical origins of this carpet fragment, its historical background is a little more elusive. The use of colours and materials is typical of the Kurds from Southeast Anatolia, as well as the decorations of the border, both the major (which is markedly archaic) and minor ones, resembling those of a rug in the Vakiflar Carpet Museum in Istanbul. This latter carpet is attributed to East Anatolia and dates back to the 15th or 16th century (Balpinar and Hirsch 1988, pl. 14).

The lower part of the main motif on this fragment recurs on a number of other pieces — one of which illustrated here (see cat. no. 46). This element appears as enclosed in a simple rectangle. In our case, howev-

er, the upper part has been fashioned into a powerful and ominous anthropomorphic figure, and contained within a polygon, which could be interpreted as a cave, a niche, or a tabernacle.

Large amounts of pottery, possibly dating before the first millennium B.C., have turned up in the area where this carpet originates. These ceramics feature what may be the Great Mother or Mother Goddess, as the figure has large hips connoting a pregnant woman — is this what the band that traverses the hypothetical human figure here is supposed to represent? Does this mean that the thread of continuity was not broken over the centuries? Is it right to raise again the issue that was so in vogue in the early 1990s? What other interpretations can be made of this unique figure? Does this bear out the hypothesis that such design derives from 15th- and 16th-century shield-shaped carpets (see cat. no. 3)?

A (marginal?) consideration must be made concerning the putative size of the entire carpet. Unfortunately, too many knots are missing from the left side of the fragment to substantiate the existence of at least one more vertical row of anthropomorphic figures. Considering the four rows that remain, the carpet could not have been less than 160 cm wide, a width that already exceeds the standards for the region in question. Given the monumental nature of this carpet, however, the possibility of additional vertical rows cannot be ruled out. See technical analysis in *Appendix*.
E.C.

46

East Anatolia
19th Century
125 x 220 cm

In widespread use among the Turkish peoples is an amulet, known as the *muska*, usually made of metal, forming an isosceles triangle whose longer side shows three or more pendants, a trait of unforgotten totemic religiousness. The talisman serves to ward off ill fortune, and its powers are transferred to the carpet pattern, the 'holy ground' of the *yuruk*, the rootless nomad (the meaning of the term is investigated by Halil Inalcik in *Oriental Carpet &Textile Studies II*, London 1986). This would seem to be the matrix behind the four amulets arranged diagonally on a central figure, a device that varies from carpet to carpet and which, set inside a rectangle, provides a running ornament for the carpet illustrated here (see others listed in *Textile Art*

Research, Vienna 1983, pl. 51). It is furthermore present in the niche and border of prayer rugs from East Anatolia pertaining to this and to the ensuing period (Brüggemann and Böhmer 1983, pls 106–7).

It must be said that the appearance of the fragment reproduced in cat. no. 45 prompts new and stimulating conjectures of interpretation, as to the origin of this design.
E.C.

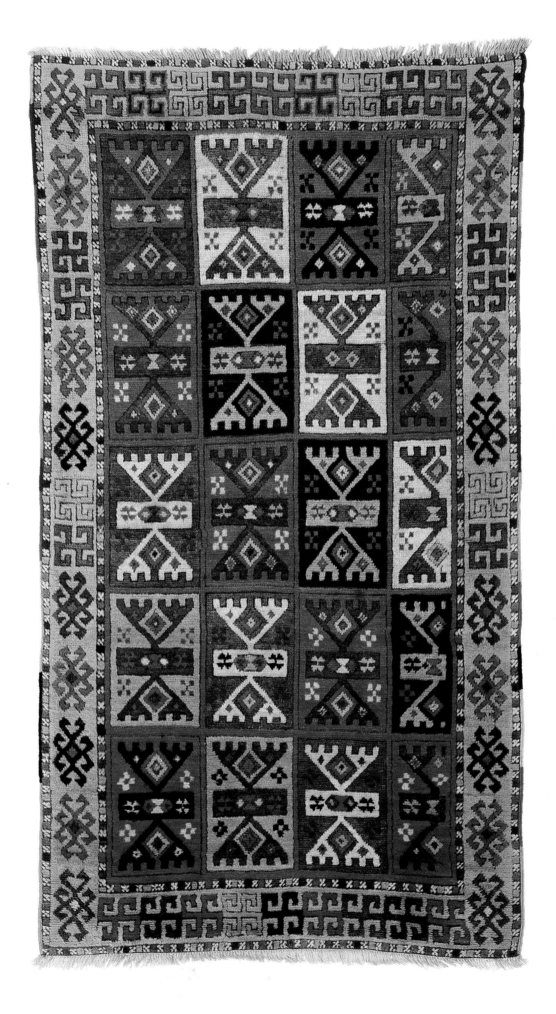

Sarkislar
Central-Eastern Anatolia
19th Century
88 x 180 cm

The vibrant and intense colouring of this large fragment suggests Kurdish influence, and the implementation of offset knotting enables us to pinpoint its provenance, namely, Sarkislar, which gave rise to an ancient tradition of weaving often characterised by this technique, that allows for better definition of the diagonal lines, of which this fragment exemplifies the final phase of an ongoing process of simplification.

W. Grote-Hasenbalg (1922, pl. 23) dated a complete example that is similar to the one illustrated here to the beginning of the 19th century. The Vakiflar Carpet Museum in Istanbul possesses a more articulated and vibrant precursor (*Turkish Handwoven Carpets*, Ankara 1990, vol. 4, pl. 350).

Brüggemann and Böhmer make no mention of offset knotting in the structural analyses of the two rugs belonging to the same group as ours (1983, pls 89–90): the lozenges of this rug are in fact much more flattened with respect to those typically ascribed to Sarkislar, and this may indeed be obtained through offset knotting.

E.C.

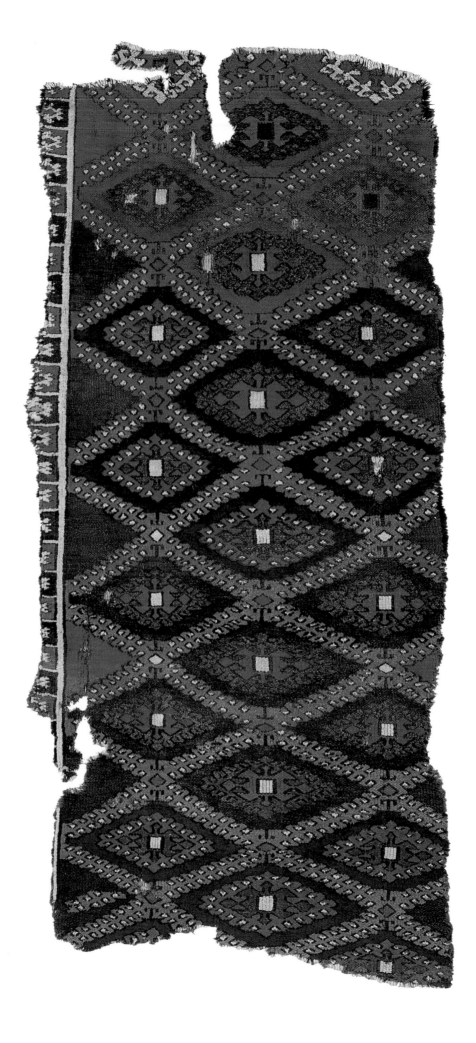

Kurdish Rug
Southeast Anatolia
19th Century
90 x 190 cm

The fragmentary conditions of this rug should not prevent someone with a minimum of experience to reconstruct a mental picture of this typical 19th-century Kurdish rug from Southeast Anatolia. This area characteristically gleaned classical elements filtered down through the centuries and rehearsed with vibrant self-sufficiency in a robust and full-bodied graphic manner that is conveyed by means of the bold use of colour and the consistency of the materials. Such is the rugged elegance of this carpet, a type for some reasons rarely found intact.

The most comprehensive coverage for this group of rugs is found in the five volumes published by the Turkish Ministry of Culture, under the title *Turkish Handwoven Carpets*, and detailed in the volume by Brüggemann and Böhmer (1983, pl. 108), who published a piece with an almost identical border to ours, providing convincing argumentation about its origin.

E.C.

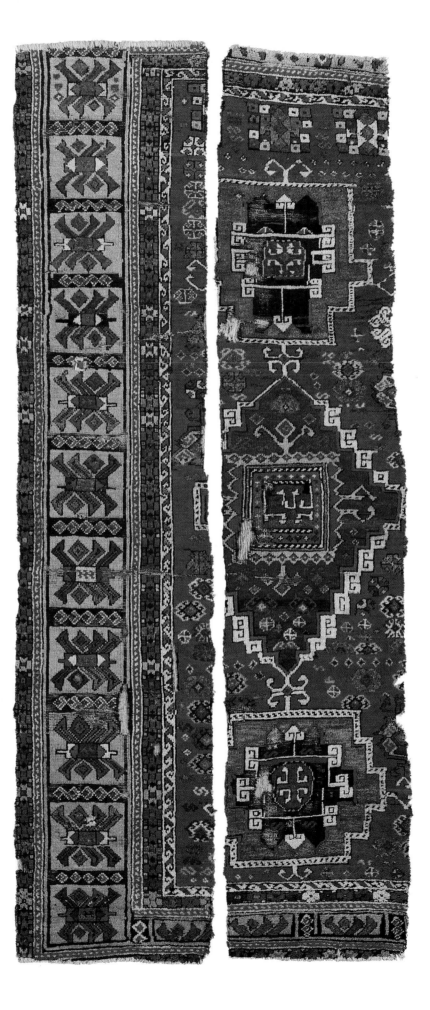

49

Rug with Palmettes
East Anatolia
First half 19th Century
128 x 250 cm

The loose treatment of materials together with the large dimensions of this example provide a characteristic enveloping softness, coupled with a bold counteraction of hues — these being convincing indications of the Kurdish origin of this carpet.

Although Southeast Anatolia is a vast area, steeped in ancient history with historically uncertain borders rich in cultural diversity, a comprehensive research into the region's rug weaving tradition has never been undertaken. Such a study is well overdue.

The Kurds reinvented carpets largely through their creative use of colour. The hexagons and eight-pointed stars present in the border are typical Kurdish features, as are the vibrant and lively palmettes, inspired by the so-called 'dragon rugs' (perhaps with the Armenian influence of Gohar; Lefevre 1977, cover and p. 31). The twin to this piece was published by F. Bausback (Bausback 1978, p. 81). Also noteworthy is a later version very much prized by U. Schürmann (1979, p. 81) and published many times (*Textile Art Research*, Vienna 1983, pl. 60); an interesting example of similar style was also published in Italy (Pagnano 1983, pl. 52). What should be considered the prototype for this family of rugs is found in McMullan (1965, pl. 44). Published in *Hali*, no. 2, 1979, p. 72.
E.C.

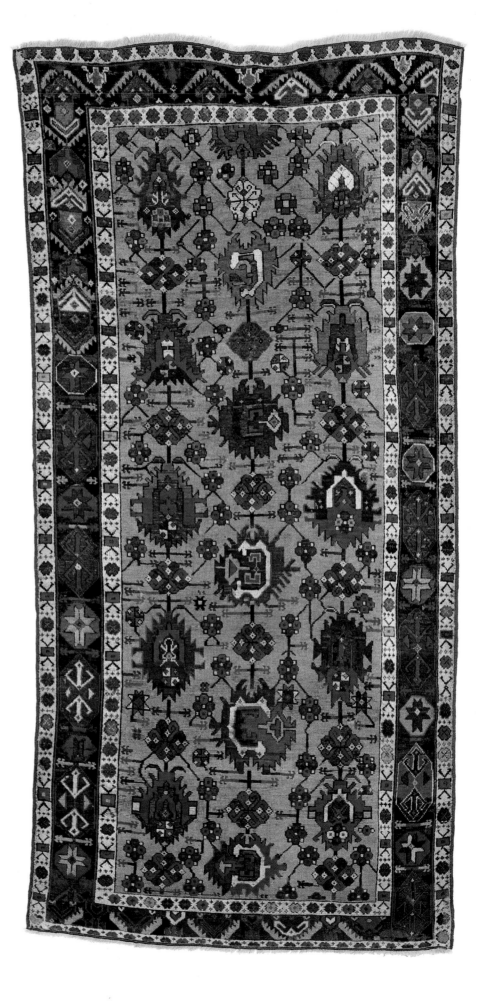

Kilim-Style Rug
East Anatolia
Second half 19th Century
180 x 290 cm

An expert eye will easily perceive the stylistic osmosis that transpired between kilims and knotted carpets. The wholesale transfer of the stock kilim compositions to the knotted carpet is very rare, though in the 17th century this practice was fairly widespread owing to the consummate skill of the Karapinar weavers (Ellis 1988, pl. 36).

In this unique and attractive carpet, the field replicates a decoration that was very popular in the kilims of the people of Anatolia and the Caucasus, as well as on those of Shahsavan tribe, while the border draws markedly on the canonical repertoire of flatweaves.

In 1983, J. Eskenazi noted that 'the presence of original motifs might confirm a hypothetical attribution to the nomadic Kurdish tribes migrating between Southwest Caucasus and East Anatolia'. Further studies (even of a structural nature, including the analysis of the natural dark wool for the weft and border finishings, as well as for its soft texture) confirm Eskenazi's hypothesis.

Regarding the transposition of compositional styles from the kilim to the knotted carpet, M. Franses' study in *Il tappeto orientale dal XV al XVIII secolo*, Milan 1981, is very instructive. Published in Eskenazi 1983, pl. 85.
E.C.

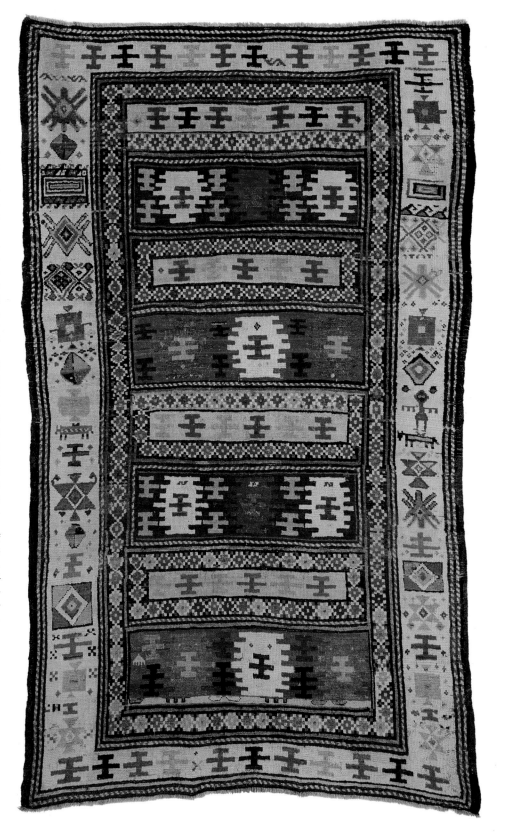

The Persian Carpet

The vase carpets depicted here focus on a group that has received substantial attention during the last three decades, as May Beattie[1] related a number of apparently diverse carpet types by their structure and formed a coherent group of rugs in what she described as 'vase carpet technique'. It seems, however, as though there is still more to be revealed by continuing study of both the carpets and the manner in which they are made. Although there have been occasional references in the previous literature to thickened wefts at intervals throughout the rug,[2] little has been made of it, and yet this observation may have some bearing on a relationship that has long been suspected between the dragon rugs of the Caucasus and the vase carpets. It has long been recognised that a fragment in the Museum für Völkerkunde, Munich[3] in vase carpet technique shows a curvilinear version of the most common vase carpet border, along with well drawn animal figures and traces of the kind of sweeping bands that divide the dragon rug designs into compartments. The Bingham carpet in the Metropolitan Museum of Art[4] — also in vase carpet technique — shows other traces of dragon rug design, and there are borders on other vase carpets that seem to be precursors of a number of dragon rug borders.[5] Thus it seems particularly interesting that the Caucasian dragon rugs and a number of vase carpets — which differ in the type of knots used — share the odd feature of using cabled wefts at intervals in the rug. Not surprisingly, these thickened wefts are closer together on the vase carpets, but in both types of carpets they can best be seen on the surface of a worn rug, and I have recently found this feature again on two fragments in the Jim Dixon Collection. The presence of some Kerman structural peculiarities and some design elements leads to speculation that when Shah Abbas directed the establishment of a manufactory in the Karabakh region,[6] those directing the operation may well have been from Kerman. Another feature of the vase carpets that might eventually prove to be more useful in dating is the appearance of the backs of these rugs. Recent examination of the sixteen fragments in the Dixon Collection revealed a surprising variety of types. The most dramatically different are those carpets with what Beattie referred to as 'backshag', with rows of uncut yarn protruding across the back of the rugs.[7] This was prominent in one rug in the Dixon Collection, although it seemed to be the earliest. The next type showed a back with virtually no trace of design. Yet a third type showed the three wefts characteristic of Kerman, but with the first and third of dark brown wool visible on the backs of the rug in a manner allowing the design to be seen. Yet a fourth type appears in vase carpets which may be late, as the wool here has been replaced by cotton, leaving a back similar to the Kerman of the 19th century. While it is tempting to suggest some kind of chronological order for these types, more work should be done to confirm whether this is indeed valid.

Another aspect of the questions around the vase carpets was recently raised by this author as it would apply to carpets commissioned from the Kerman area whose elaborate designs required finer knotting than the typical 180 to 220 of the vase carpets.[8] As this theory was developed, it appeared that such examples as the Schwarzenberg carpet[9] could still be Kerman work even if they have silk first and third wefts rather than wool or cotton. Clearly the finer the carpet — and the Schwarzenberg piece averages about 340 knots per square inch — the less likely wool is to be found suitable for the wefts.

[1] M.H. Beattie, *Carpets of Central Persia*, Sheffield 1976.
[2] *Ivi*, p. 14.
[3] *Ivi*, p. 56.
[4] M. Dimand and J. Mailey, *Oriental Carpets in the Metropolitan Museum of Art*, New York 1973, fig. 119.
[5] M.L. Eiland, Jr., *Oriental Rugs from Pacific Collections*, San Francisco 1990, p. 171.
[6] T. Mankowski, 'Some Documents from Polish Sources Relating to Carpet Making in the time of Shah Abbas' I, in *A Survey of Persian Art*, edited by A. U. Pope and P. Ackerman, pp. 2431–2.
[7] Beattie, *op. cit.*, p. 15.
[8] M.L. Eiland, Jr., 'Rethinking Kerman: a New Look at Some Safavid Carpets', in *Hali*, no. 100, September 1998, pp. 98–103.
[9] *Ivi*, p. 99.

51

**Cartouche Carpet
Fragment**
Tabriz, Northwest Persia
15th–16th Century
300 x 315 cm

This rare fragment of a medallion and cartouche carpet, a type of design that we have come to know through Timurid miniatures, belongs to the same piece as the fragment in the Kunstmuseum in Düsseldorf (published in Meister and Azadi 1981, n. 5) and is characterised by an infinite repeat of polychrome cartouches on a particular orange-brown background. It is one of a group of seven known pieces, all of which have the same field design and border but differ for the most part in their colour background (1. The Beghian Indigo-Ground Carpet, Museum für Angewandte Kunst, Vienna, published in Pope 1938, pl. 1125; 2. The Beghian Indigo-Ground Carpet, the pair to the Vienna piece, published in Herrmann 1992, vol. 4, no. 3, pp. 14–7; 3. The Topkapi Harem Yellow-Ground Carpet, Topkapi Saray, Istanbul, published in b/w in *Hali*, no. 64, August 1992, p. 97; 4. The Bernheimer Ivory-Ground Carpet, published in *The Bernheimer Family Collection of Carpets*, Christie's, London, February 14, 1996, lot 101, p. 106; 5. The Cassirer Orange-Ground Carpet, formerly in the E. Simon Collection, a detail of which is illustrated in Auktionskatalog, 1929, lot 242; 6. The Boston Orange-Ground Carpet, Museum of Fine Arts, Boston, unpublished).

A second group is decorated by a field design of cartouches only, and is distinguished by its silk foundation. See technical analysis in *Appendix*.
A.L.

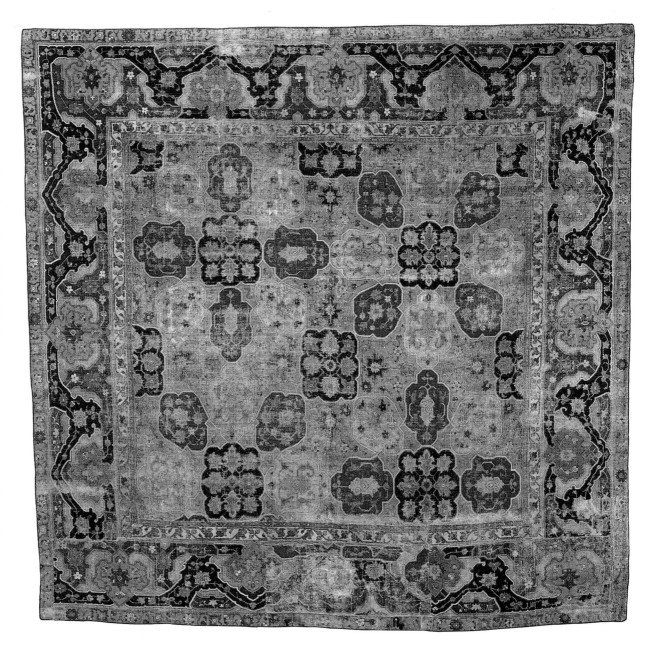

66

**Palmette and
Cloudband Carpet**
Esfahan, Central Persia
17th Century
210 x 490 cm

The origin of the carpets char-
acterised by this grandiosely
elegant pattern of scrolling pal-
mettes connected through a
vinery, alternated to majesti-
cally drawn cloudbands, has
been the subject of much de-
bate among rug scholars.
These have been variously as-
cribed to Herat or Esfahan. The
latter became the capital of the
Safavid Empire under Shah
Abbas in 1598, and in the 17th
century was an active weaving
centre producing, among oth-
ers, the renowned 'Polonaise'
carpets in silk and gold or sil-
ver thread.
Ellis assigns the group of car-
pets to which our specimen
belongs to Agra, located in
Northwest India, on the basis
of the use of a more delicate
colour palette with respect to
their Persian models (Ellis
1988, p. 211). Both the field
and border designs survive al-
most intact on certain 19th-
century Agra carpets of very
fine quality.
A.L.

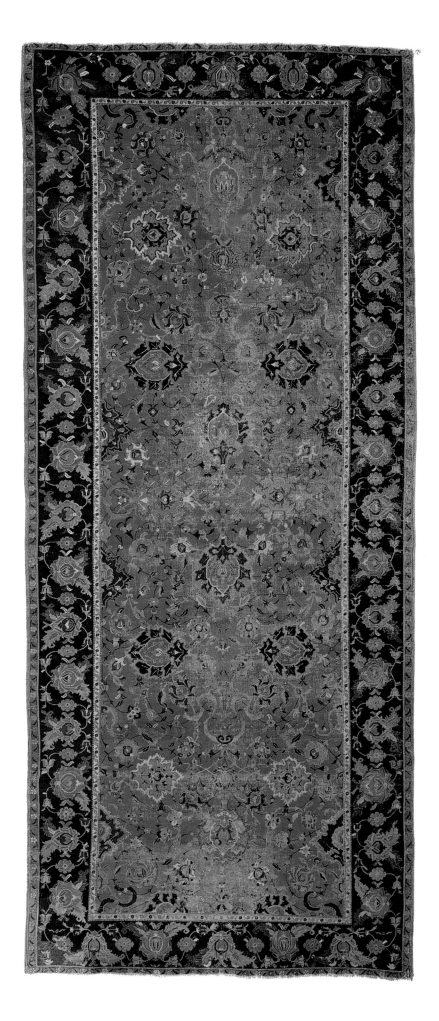

Vase Carpet Fragment
Kerman area, Southern Persia
16th–17th Century
100 x 110 cm

An early vase carpet fragment
with a field design consisting
of a large three-plane leaf lat-
tice containing floral motifs
(see Beattie 1976[1], for a defini-
tion of the vase carpet group
and of its subdivisions). What
sets this fragment further apart
is the unusual backshag wo-
ven to the back of the lower
plane of the warps, thus act-
ing as a sort of inwoven un-
derlay. This rare feature is lim-
ited to vase carpets having this
type of design.
A.L.

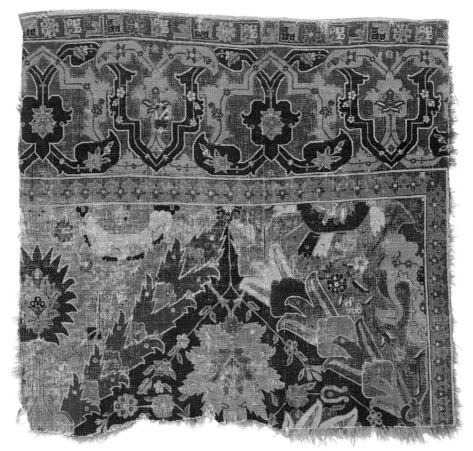

front

back

54
Vase Carpet Fragment
Kerman area, Southern Persia
17th Century
179 x 193 cm

A three-plane lattice design characterises this fragment, this being one of the most frequently encountered lattice patterns. The design consists of overlapping vertical systems of polychrome palmettes and rosettes issuing from a vase (this element being responsible for the name given to this group of carpets), forming large ogival lattices made up of the stems that connect the various floral forms to each other. The rust background is characteristic for the group as is the border, consisting of arabesques scrolling in opposite directions and in contrasting colours against a navy-blue background.
A.L.

55
Vase Carpet Fragment
Kerman area, Southern Persia
17th Century
94 x 167 cm

This vase carpet fragment is decorated by an allover directional pattern of polychrome flowering plants, which contrasts efficiently against the midnight-blue background. The elegant botanical rendering of the design reminds us of the contemporaneous carpets from Mughal India, the iconography of which has clearly inspired a number of the typologies grouped under the vase carpet label.
A.L.

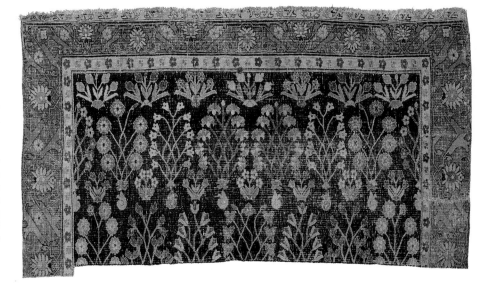

56
Border Fragment
Northwest Persia
17th–18th Century
35 x 123 cm

The motif of this beautiful fragment is seen on the borders of a rare group of medallion carpets (for an example of the group, see Spuhler 1978, no. 45, p. 98) woven in the style of the 16th-century large medallion carpets from Tabriz. It consists of two pairs of split-leaf arabesques issuing alternately from trefoil and quatrefoil palmettes.
A.L.

57
Leaf and Palmette Carpet Fragment
Northwest Persia
18th Century
120 x 135 cm

A very rare and unusual blue-ground fragment decorated with polychrome flaming palmettes from which issue lanceolate and saw-edged leaves. Carpets with similar patterns can be seen in the Islamic Museum in Berlin and in the Victoria and Albert Museum, London (Yetkin 1978, vol. II, pls 170–71, p. 48). They are probably related to the so-called 'transitional' South Caucasian rugs with lancet leaves and cypresses, and to those with multiple medallions (Ellis 1975, pl. 24, p. 79 and pl. 25, p. 80). The reciprocal trefoil border is also a feature of 18th-century Northwest Persian typologies (see Kirchheim 1993, pl. 82, p. 150) and also of certain early South Caucasian rugs (Yetkin 1978, vol. II, pl. 163, p. 42). See technical analysis in *Appendix*.
A.L.

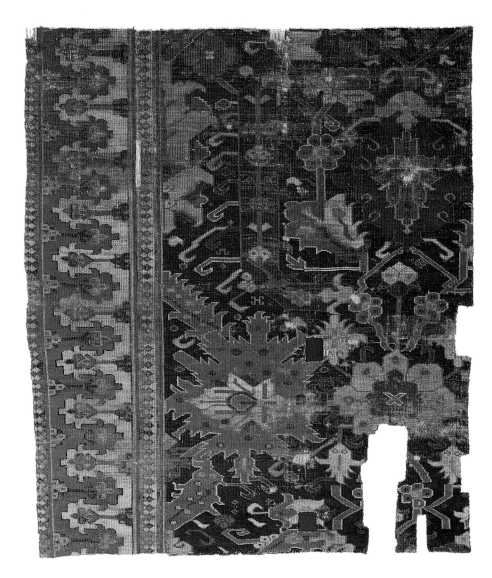

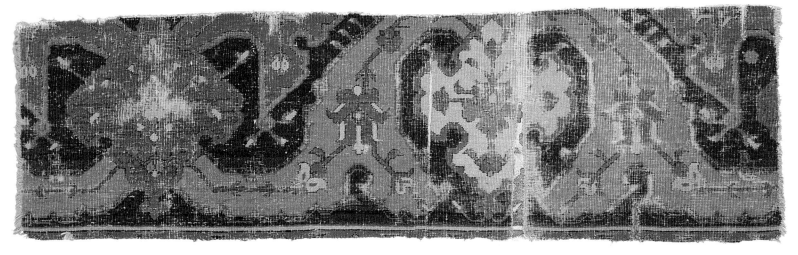

Lattice Carpet Fragment
Khorasan, Northeast Persia
17th Century
192 x 316 cm

This carpet is one of a group of three, the others being formerly in the Schiff Collection (Pope 1938, pl. 1240, attributed to Joshagan) and in the Bernheimer Collection (Bernheimer 1959, pl. 69). All three appear to be related to the von Hirsch lattice carpet (Eskenazi 1981, n. 24, pp. 43–4). The Khorasan attribution of this and its related carpets is still under debate, and hinges essentially on their shared structure consisting of asymmetrical *jufti* knots open to the left, which is typically associated with Khorasan weavings up to the 20th century.

The refined balance between the rectilinear grid composed of parallel lines of star cartouches and the curvilinear floral motifs contained within these cartouches is maintained by virtue of a subtly contrasting colour palette. The multiple borders anticipate the style employed in the 18th and 19th centuries. See technical analysis in *Appendix*.
A.L.

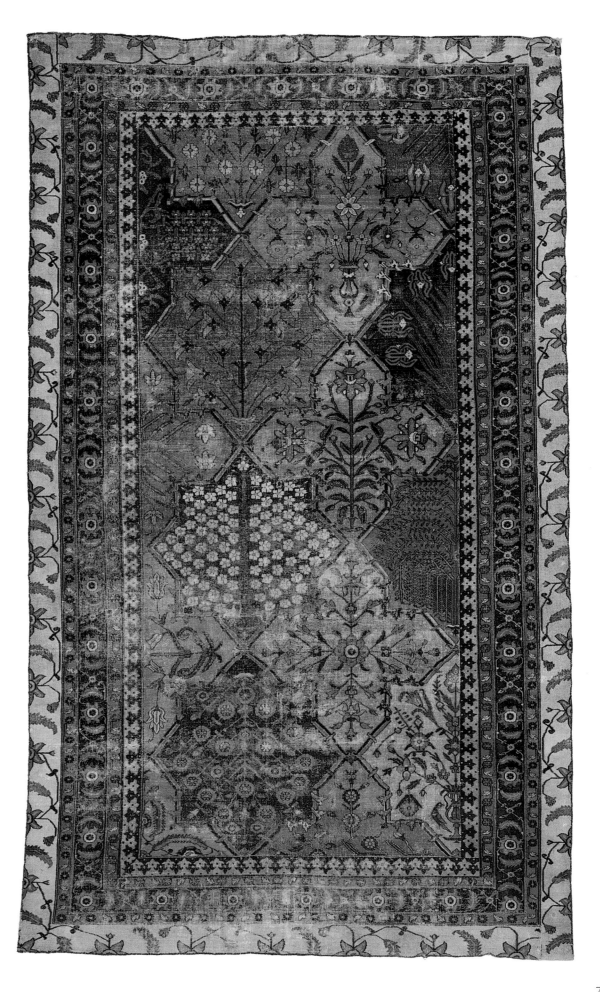

**Durlaeher Tree
and Animal Carpet**
Northwest Persia
17th–18th Century
190 x 390 cm

This wonderful carpet is known to us since 1908, when it was published for the first time by F.R. Martin in his monumental work on carpets before 1800. The Swedish scholar ascribed it to the Southern Caucasus, dating it to around 1680. More recently Ian Bennett included it as part of a rare group of carpets in an article titled 'Animal and Tree Carpets. An Amorphous Group', which appeared a few years ago in *Hali*. Of the nineteen pieces he discussed, our carpet belongs to sub-group C, together with a famous and almost identical piece, once in the McMullan Collection and currently in the Metropolitan Museum of Art, New York, and a third carpet, with its border missing, which appeared on the American art market in 1982. The three pieces are almost identical and depict not only trees and animals but true hunting scenes, representing somehow a highly stylised and naive version of the 16th-century hunting carpet in the Poldi Pezzoli Museum in Milan.

As a matter of fact, all the carpets belonging to this group are characterised by reminiscences of the motifs that were in vogue at the Safavid court towards the end of the 16th century, yet adopting a highly stylised and geometric interpretation of the design. Even the elegant border motif, consisting of circular rosettes alternated to elongated cartouches, is undoubtedly of Persian origin and reminds us of those on 16th-century Tabriz carpets. The symmetrical knot could lead one to assign this group to the Caucasus, although, as noted by Bennett, an attribution to certain Persian Kurdish enclaves or to Northwest Persia in general cannot be ruled out entirely. One should keep in mind that the Caucasus was an integral part of the Persian empire until the beginning of the 19th century; so, all of the so-called 'early Caucasian rugs', with the sole important exception of the dragon and related carpets, de-rive in one way or another from the Safavid court production, adopting the designs and decorative schemes developed within it, such as the *harshang* and *avshan* patterns.

As far as dating is concerned, Bennett is inclined towards a later period with respect to that indicated by Martin, ascribing the carpet to the 18th century. In reality there aren't any obstacles towards an earlier dating, perhaps contemporaneous to the Safavid court examples, as this and the other examples of the group may represent their provincial replicas. See technical analysis in *Appendix*.
A.B.

**Carpet with
Stylised Palmettes**
Kurdish tribes,
Northwest Persia
Circa 1800
135 x 305 cm

A rare and unusual early Kurdish carpet showing an abstract rendition of dramatically large, multicoloured stylised palmettes arranged along two vertical axes, ending with a horizontal row of sawtooth-edged lozenges, the latter being typical of a certain type of protokurdish rug, almost a signature of its 'kurdishness' (for a definition of 'protokurdish' see Levi in *Hali*, no. 70, August-September 1993, pp. 84–93; for a Kurdish rug with the sawtooth-edged lozenge design, see *Hali*, no. 62, April 1992, cover and p. 101).

The border system, consisting of a reciprocal trefoil main stripe flanked by ivory guard stripes with red and blue rosettes, derives from 18th-century garden carpets from Northwest Persia, the latter being of great influence towards the development of a 19th-century Kurdish rug iconography. See technical analysis in *Appendix*.
A.L.

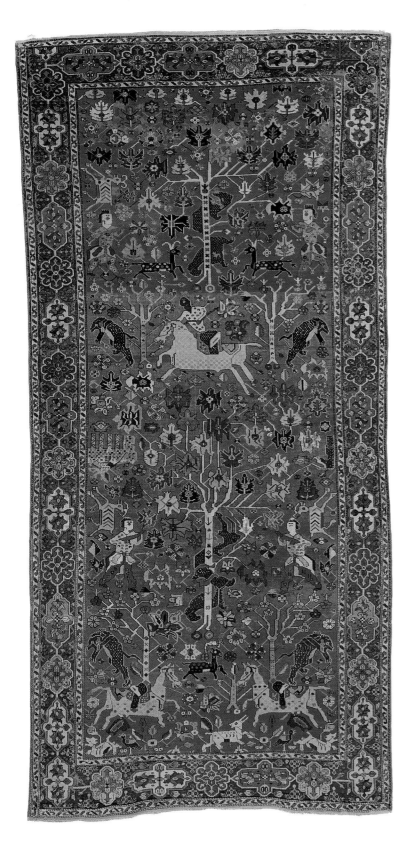
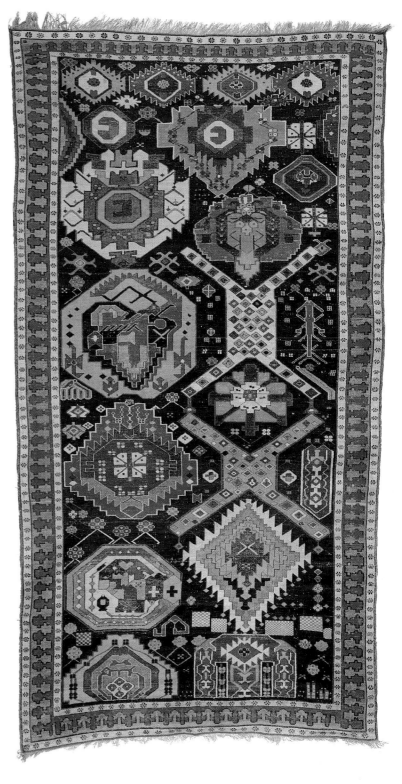

**Protokurdish Rug
with the Harshang Pattern**
Saujbulagh area,
Northwest Persia
Circa 1800
149 x 160 cm

The protokurdish group of car-
pets was defined in a study
that attempted at analysing the
origins of Kurdish rug design
(Levi in *Hali*, no. 70, August-
September 1993, pp. 84–93).
They are characterised by a
symmetrically knotted lustrous
pile on a wool foundation us-
ing two shoots of a tightly
spun rust coloured weft. The
colours are spectacularly sat-
urated and are often highlight-
ed against a dark background.
The designs derive from the
Safavid typologies such as the
vase and garden carpets and
are masterfully interpreted in
a style that has come to be
recognised as characteristically
Kurdish.

In this fragmented example we
see an impeccable rendering
of the *harshang* pattern, ac-
cording to a style that we are
accustomed to seeing in the
long carpets with the *kelleh*
format that are usually indis-
criminately assigned to North-
west Persia, being woven be-
tween the late 18th and the
early part of the 19th century
(for an example of this type,
see Dodds and Eiland 1996, pl.
83, p. 83). Note the presence
of the red outer 'running-dog'
border on a yellow back-
ground, this being typical of
the earlier protokurdish rugs.
See technical analysis in *Ap-
pendix*.
A.L.

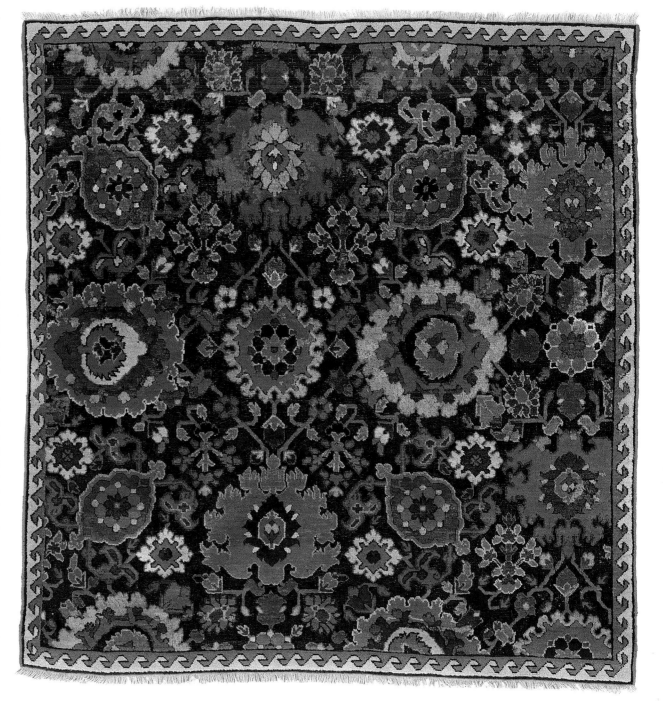

62

**Khorjin Face with
Polychrome Lozenges**
Jaf Kurdish Tribe, West Persia
Circa 1870
58 x 58 cm

The Jaf tribe is known essentially for their *khorjins*, which are double bags for domestic use employed to store utensils of various kind. One finds a fairly large number of them on the market, almost invariably decorated by an allover pattern of hooked devices contained within polychrome lozenges. They are typically separated and usually devoid of their flat-woven back panel and tassels. The present *khorjin* is characteristic of the group, featuring also an extremely lustrous wool pile that best expresses the highly saturated dyes. Note the random yet balanced colour distribution within the lozenges of the field, with the ivory one placed at the centre of the composition, and the use of a different colour background for the top and bottom versus the side borders.
A.L.

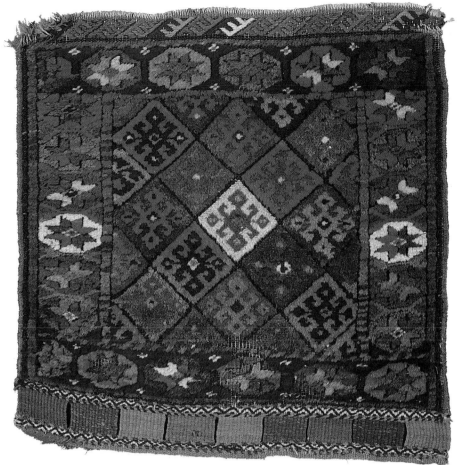

63

**Khorjin Face with
Overlapping Lozenges**
Jaf Kurdish Tribe, West Persia
Circa 1890
39 x 43 cm

On this minuscule example of abstract tribal art we see a latticework composed of an infinite repeat of overlapping lozenges containing a hooked element. This unusual design variant offers a twofold reading possibility, a skilful optical illusion so often encountered on tribal weavings. Note the random, almost pictorial use of ivory, employed to enlighten the dark palette of the entire composition. A similar piece is published in Biggs 1983, pl. 39, p. 86.
A.L.

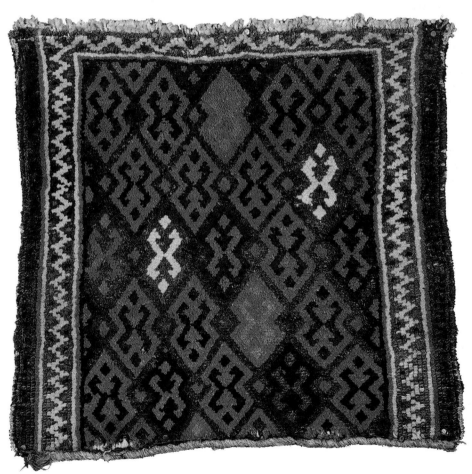

Senneh
West Persia
Circa 1880
134 x 200 cm

A fine and unusual Senneh
town rug, showing a direction-
al design composed of vases
from which sprout leafy stems
of roses with small birds cul-
minating in a sort of nest on
which stands a larger red bird.
Certain finely woven figurative
Persian rugs, and this is a great
example of the type, manage
to achieve an almost surreal
expression, communicating a
meaning that goes far beyond
that of pictorial representation.
A.L.

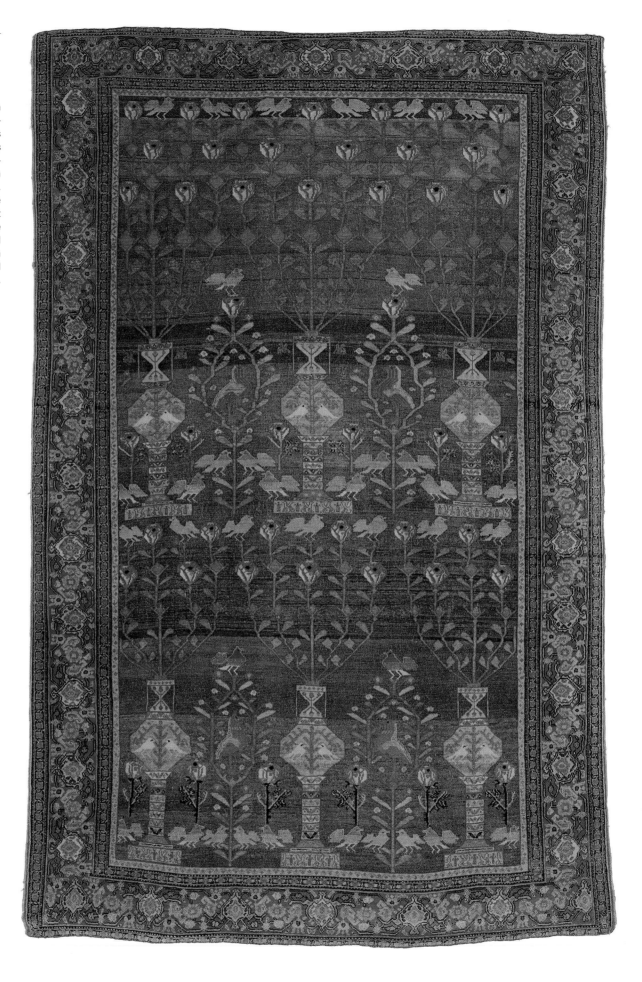

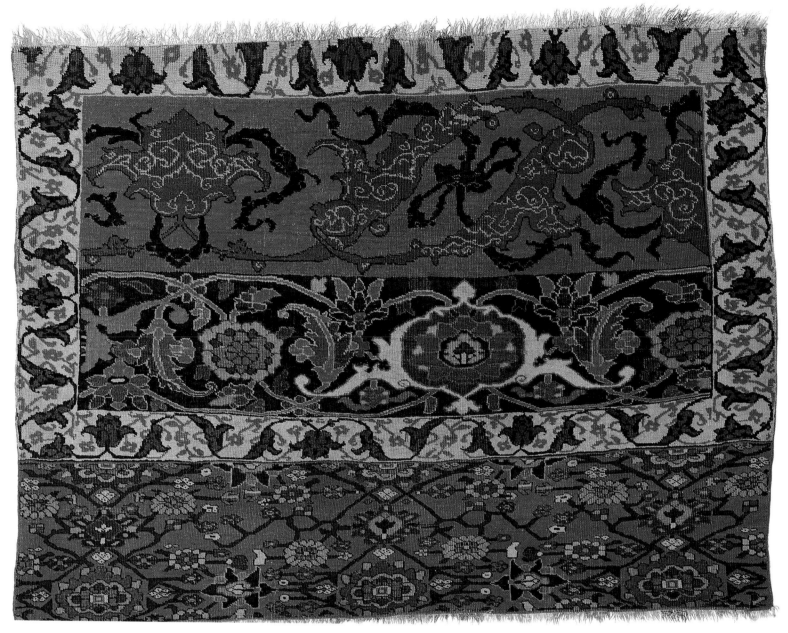

65

Garrus Vaghireh
Bijar area, West Persia
Circa 1870
107 x 143 cm

Known by the term *vaghireh*, such rugs were employed by weavers as samplers of the characteristic patterns for their particular area. The fact that *vaghireh* rugs manage to achieve an overall graphic and chromatic balance makes us forget that we are dealing with a weaving model, with all the approximations that this may entail. Many of these rugs often appear to be much more fascinating than the actual carpet, and can be considered as works of art in their own right. This *vaghireh* is most unusual in that it displays both a format and an arrangement of the design that is typical of the *chuval* storage bags of the Turkmen tribes. Here a field pattern is shown together with a minor border and two types of major border. The lower panel (the *elem*) is decorated by a *mina khani* design variant as it appears on the field of a number of runners and *kelleh* carpets of the Bijar area. The main compartment is divided into two, the upper being ornated with a free flowing large-scale arabesque pattern enriched by ribbon-like cloud-bands in a darker shade of blue, and the lower showing the so-called 'tortoise *herati*' pattern. Both panels are framed by a split-leaf arabesque minor border, which is quite typical of the large Bijar carpets of the earlier type, those woven on a wool foundation, of which this *vaghireh* is an example.
A.L.

Garrus Vaghireh
Bijar area, West Persia
Circa 1880
133 x 245 cm

In this *vaghireh* the design is composed of a field pattern together with three types of border. The central panel shows an infinite sequence of horizontal rows of large-scale leafy arabesques known as the 'Garrus arabesque'. The term arises from the fact that this design typifies a group of carpets with inscriptions which indicate that they were commissioned by certain Kurdish tribal chiefs of the Garrus region, of which Bijar is the capital (Ittig in *Hali*, no. 14, 1981, pp. 124–7).
Both ends show abstract yet creative interpretations of the 'tortoise *herati*' border pattern, while the sides display plant-like motifs that typically frame many of the small *dozar*-size rugs of Bijar.
A.L.

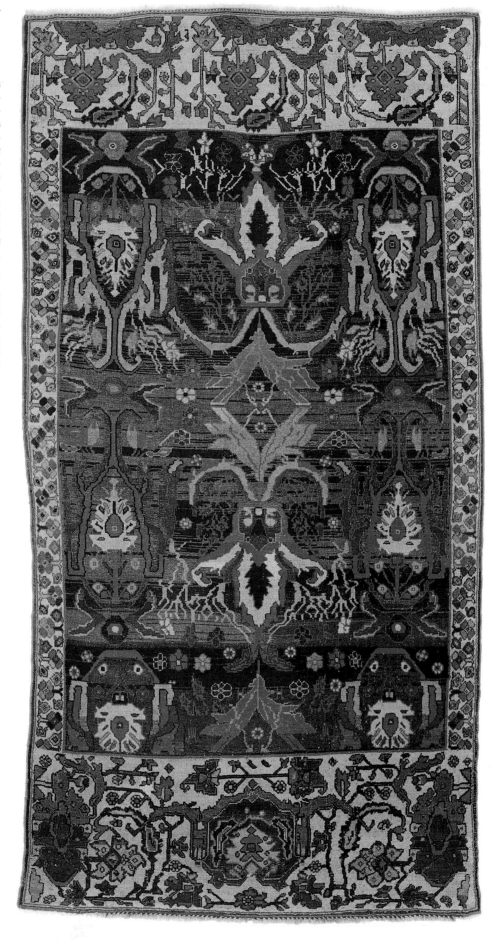

Bijar
West Persia
Circa 1880
229 x 355 cm

A fascinating carpet charac-
terised by an abrashed back-
ground in varying shades of
light blue and by an infinite re-
peat pattern of polylobed
medallions alternating with
smaller hexagonal elements
connected through a stylised
vinery. Published in Eskenazi
1983, pl. 186, p. 265.
A.L.

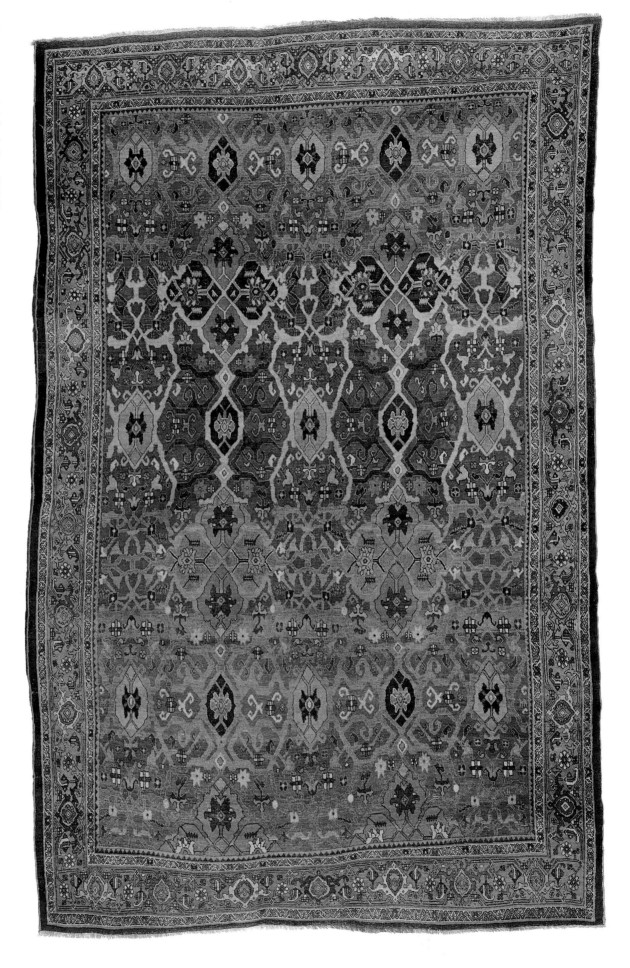

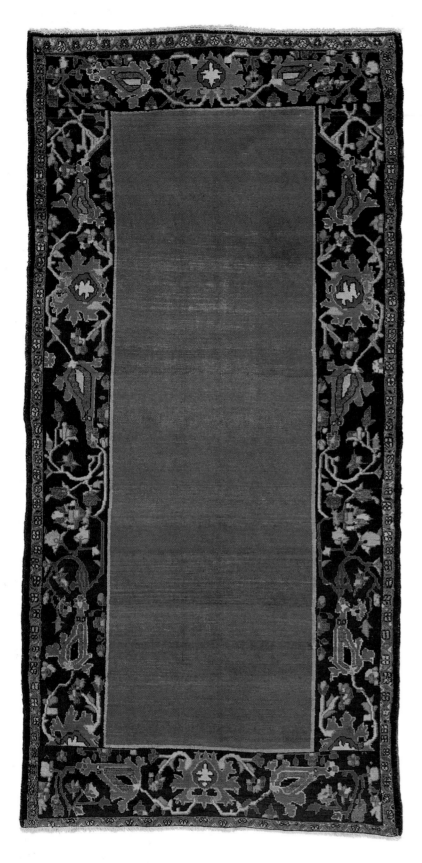

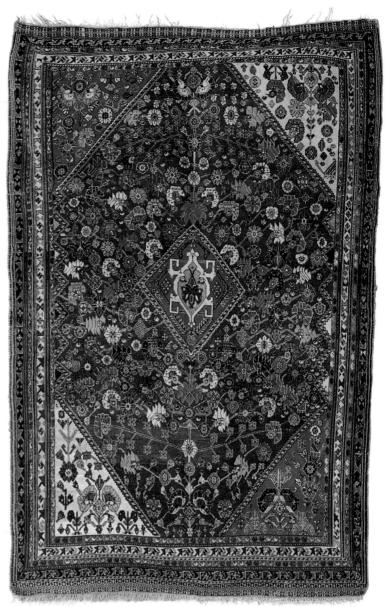

68

Hamadan
West Persia
Circa 1890
140 x 283 cm

The completely open field is quite a rare feature among Persian pile rugs. This carpet belongs to a specific subgroup of weavings from the Hamadan area having field patterns that are strikingly similar to the *gabbeh* rugs of Southern Persia, and are almost invariably framed by borders that are typical of the village and town rugs ascribed to Hamadan.
A.L.

69

Qashqa'i Confederacy
Shishboluki Tribe,
Southern Persia
Circa 1880
140 x 210 cm

An extremely fine silk-wefted Qashqa'i rug characterised by a central lozenge containing a palmette with four arms, the so-called 'Qashqa'i emblem', which recent studies have shown to derive from the stylisation of a pendant form with arabesques present on certain 16th-century medallion carpets from Northwest Persia (Opie 1992, p. 94).
The multitude of polychrome flowers which spring out from the branches connected to the central axis against a light-blue background represent a finely rendered type ascribed to the nomadic subtribe of the Shishboluki, who often employ the four-armed element in their weavings (Opie 1981, p. 30).
A.L.

70

Afshar with Boteh
Southern Persia
Circa 1850
120 x 230 cm

A very finely knotted rug characterised by a pattern of large *botehs* on a dark blue background that defines the so-called 'Hartley-Clark' Afshar subgroup (H. Clark 1922, p. 124). This pattern was typically employed on fine weavings that mimicked the precious and refined Kashmir shawls that at the time were both imported from India and made locally in Kerman, and that represented the most exquisite garments for the tribal chieftains. The subtle palette and the careful rendering of the design are characteristic of the early phase for Afshar rugs.
A.L.

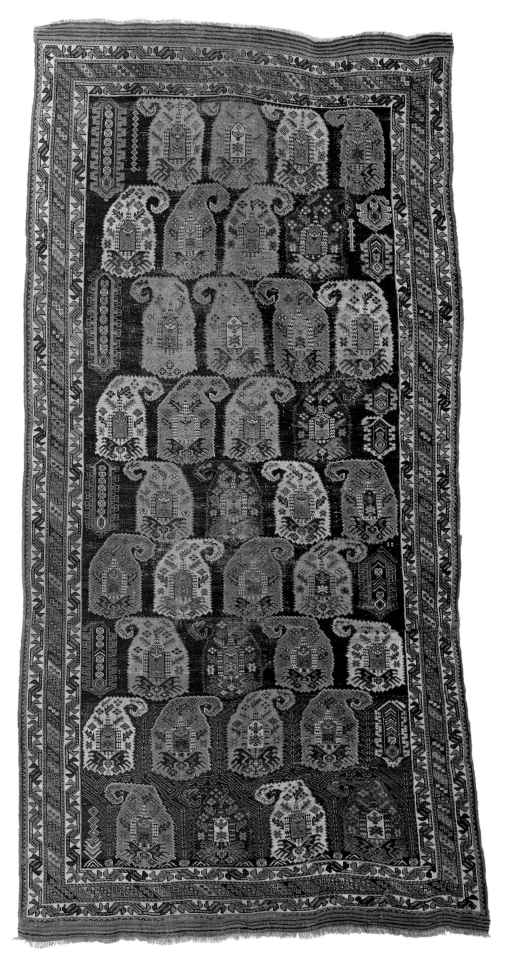

Vase Afshar
Southern Persia
Circa 1880
93 x 114 cm

A jewel-like small rug charac-
terised by a naively executed
design consisting of an over-
size infinite repeat of finely ren-
dered vases, from which issues
a leafy flowering blossom
flanked by a pair of birds. No-
tice how the weaver manages
to convey effectively the ab-
stract, almost surreal qualities
of such a design module, with
the leafy branches belonging
to the sideways vases placed
beyond the limits of the bor-
der, interacting with the
branches in the field, negating
gravity (note the little human
figure floating above the centre
of the ivory field).

This pattern harks to the
Safavid period, and is seen in
the town weavings from the
Ferahan district (often called
the *zil-i-sultan* design) and
from the nearby Kerman area
(described as the *gol-e-bolbol*
pattern), the latter probably be-
ing a source of inspiration for
this rug.
A.L.

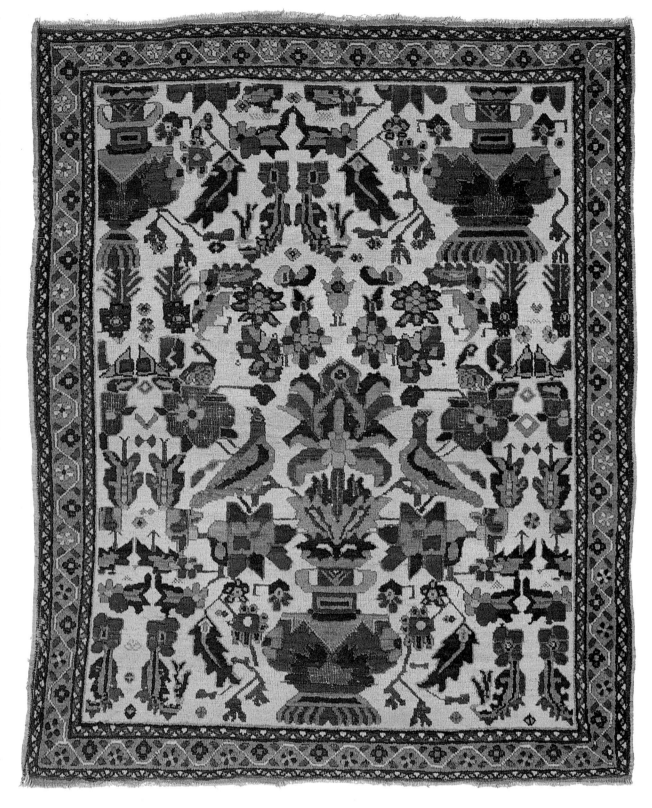

Baluch
Southeast Persia
Circa 1840
162 x 240 cm

Possibly one of the earliest and
most celebrated Baluch rugs
(previously published in Herr-
mann 1981, pl. 78, p. 219;
Thompson 1983, p. 49; Opie
1992, p. 247), it shows an un-
usual variant of the *mina khani*
pattern, with vertical rows of
joined lobed small medallions
connected laterally to eight-
petaled rosettes from which
sprout three ivory daisies that
contrast with the dark blue
background. The wide and dra-
matic border contributes to the
beauty of the piece, fitting per-
fectly with the 'early' feeling of
the composition.
A.L.

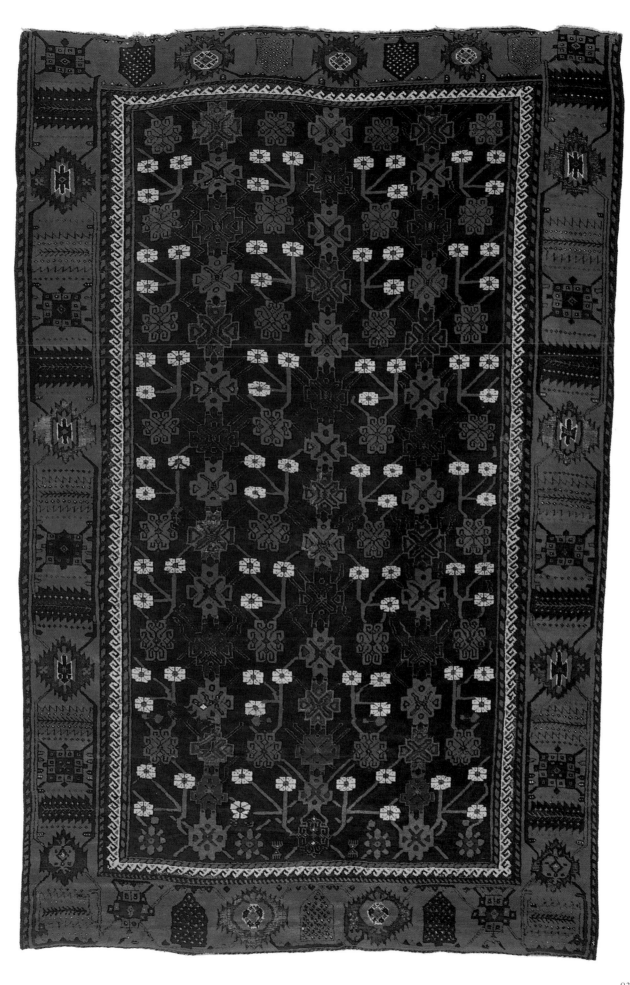

Rugs of the Caucasus

Since the break-up of the Soviet Union, there has been increasing travel to areas that once seemed remote and forbidding. A visit of an Englishman to Zakatala introduced a new label and a new definition for a type we had all seen before, but had called by other names. The visit of an American to the remote kilim weaving area of Tishetia and to the more accessible Bordjalou also allowed us to place the Caucasian rug into a clearer perspective.[1] The Wright and Wertime[2] publication in 1995 provided the first scholarly discussion of Caucasian flatweaves and introduced substantial background information from the Russian literature that had not previously been known in the West. Reports from archaeological excavations of a group of caves in remote Georgian parts of the Caucasus have also provided fresh perspectives.[3] These caves were apparently inhabited as areas of refuge during periods of Mongol and Turk depredations in the lowlands. Finds, including coins and pottery shards of known type, date the time of habitation around the 13th and 14th centuries, and not surprisingly carpet fragments, both pile and flatweave, have been found. So the Georgians must be added to the other Caucasian peoples as weavers of carpets, unless one were to postulate that the impoverished refugees living in these mountains could afford to import carpets as luxury goods. Part of the good news is that there are many other unexcavated cave complexes in Georgia, and more carpet fragments are likely to be found.

Another topic needing an update is the long-standing debate as to the source of the Caucasian dragon carpets, with suggestions ranging from East Turkey to the Caucasus and to Persian Azerbaijan. Although they have been attributed to Kuba, the Armenians, and the peoples of East Turkey, where many of them have been found, there was a suggestion made several decades ago that they were woven someplace in the Karabakh region in the general area where most of their 19th-century descendants were found. Shusha, as probably the largest population centre in the region was, without any direct evidence, cited as the likely source.

In the meantime Wright and Wertime argued for an origin in the Tabriz area, pointing out that Shusha was not founded until 1752, sometime after many of the dragon rugs must have been made.[4] Like a tennis ball in motion, however, the issue keeps moving from place to place. Now an early history of the Karabakh provides information that again opens the possibility of a Shusha source.[5] The account was written by a local gentleman from one of the aristocratic families, who made his career as scribe to several local rulers. As he was writing shortly after the events in question, he would seem credible when he points out that it was in 1754 that the fortress of Shusha was built on land previously used as pasturage by villagers from the nearby town of 'Shushi'. Subsequently it was residents of this town that moved into the completed fortress. Obviously the town had been there for some time and was simply being upgraded to a fortified stronghold in the mid 18th century.

As for Caucasian village rugs of the 18th and 19th centuries, collectors during the last several decades have become more adept at differentiating the traditional, indigenous products from the late commercial rugs, even though the same basic designs continued to be used. In some areas it is a matter of higher knot counts in the early rug, but this is not always the case, particularly with rugs from the Kazak area, in which even the earliest appearing rugs are no finer than late commercial production. The distinction is thus real but at times subtle, as even turn-of-the-century rugs may show natural colours.

[1] M. Eiland, III, visited the Bordjalou area in the summers of 1997 and 1998, and he and another speaker provided information about it during the 1999 ICOC in Milan and Florence.
[2] R.T. Wright and J.T. Wertime, *Caucasian Carpets and Covers: the Weaving Culture*, London 1995.
[3] M. Eiland, III, 'Archaeological Evidence of Early Carpets in Georgia', in *Hali*, no. 99, July 1998, pp. 57–9.
[4] Wright and Wertime, *op. cit.*, p. 26.
[5] G.A. Bournoutian, *A History of Qarabagh: An Annotated Translation of Mirza Jamal Javabshir Karabaghi's Tarikh-e Qarabagh*, Costa Mesa 1994, pp. 71–2.

Dragon Carpet Fragment
Karabakh area,
Southern Caucasus
17th–18th Century
86 x 93 cm

This corner fragment is part of a large Caucasian so-called 'dragon carpet', which carpet scholars agree in ascribing to an Armenian workshop in the Karabakh area, perhaps in the city of Shusha. According to C.G. Ellis' classification of such carpets (Ellis 1975), this piece belongs to the earlier group, probably still dateable to the 16th century, in which we can still recognise the dragons as well as a number of other more or less stylised mythical or real animals. On the fragment reproduced here we can clearly see the depiction of a stylised green bird on a red background, that Ellis calls 'pheasant', which, together with another, unfortunately missing analogous figure, was framing the large palmette on a dark brown background. The complete examples belonging to this specific subgroup of carpets are very few, the most similar to our example being, because of its black background, the carpet once belonging to Bardini, now in a private collection in Genoa (Yetkin 1978, vol. II, fig. 122, p. 13).

The drawing of the 'pheasants' is almost identical for both this fragment and the complete example, although the palmettes are quite different, the one on the Bardini carpet resembling a sort of pineapple. The borders are decidedly different, ours being much more angular and geometric, identical to that of another large fragment belonging to the so-called 'transitional period' between the dragon and the floral carpets, now in the Museum of Turkish and Islamic Art in Istanbul, dated to the 18th century (Yetkin 1978, vol. I, no. 31, inv. no. 944, from the Ali Pasha Mosque in Tokat).
A.B.

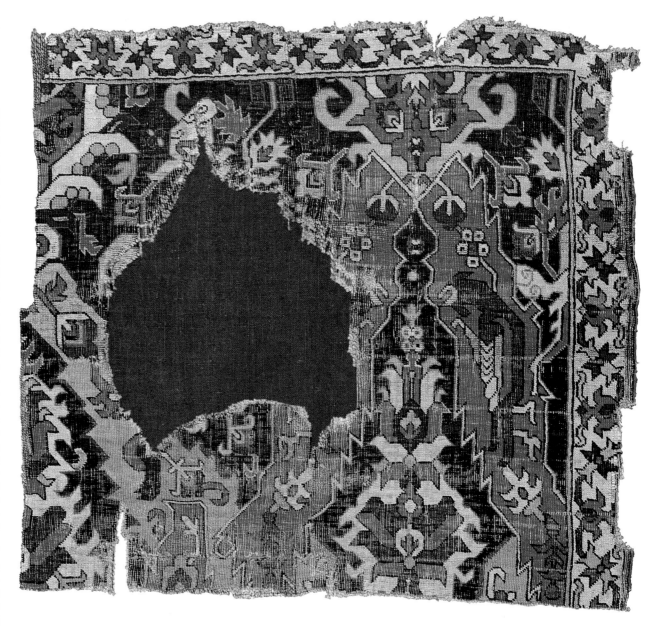

**Flower and Palmette
Carpet Fragment**
Karabakh area,
Southern Caucasus
18th Century
130 x 162 cm

Together with carpets bearing
dragon motifs, the earliest Cau-
casian rugs consist of examples
woven with floral patterns, al-
so known as 'blossom carpets'.
These are characterised by a
design scheme that is similar
to that of the dragon carpets,
yet it is made up of palmettes
of various size and type instead
of stylised animals.

Some are closer in style to the
dragon pieces, and for this rea-
son are called 'transitional'. The
corner fragment illustrated here
belongs to the latter group,
where we can recognise the typ-
ical hooked contour of the large
palmettes which decorate the
field. Another very similar frag-
mentary example is in the Mu-
seum of Turkish and Islamic Art
in Istanbul, showing a border
analogous to that of our piece,
flanked by more complex guard
stripes (Yetkin 1978, vol. I, no.
36, inv. no. 28, from the Yeni
Cami of Sivas). A complete ex-
ample of the same type but with
a decidedly different border is
in the Textile Museum in Wash-
ington, D.C. (Ellis 1975, no. 16,
pp. 62–3).
A.B.

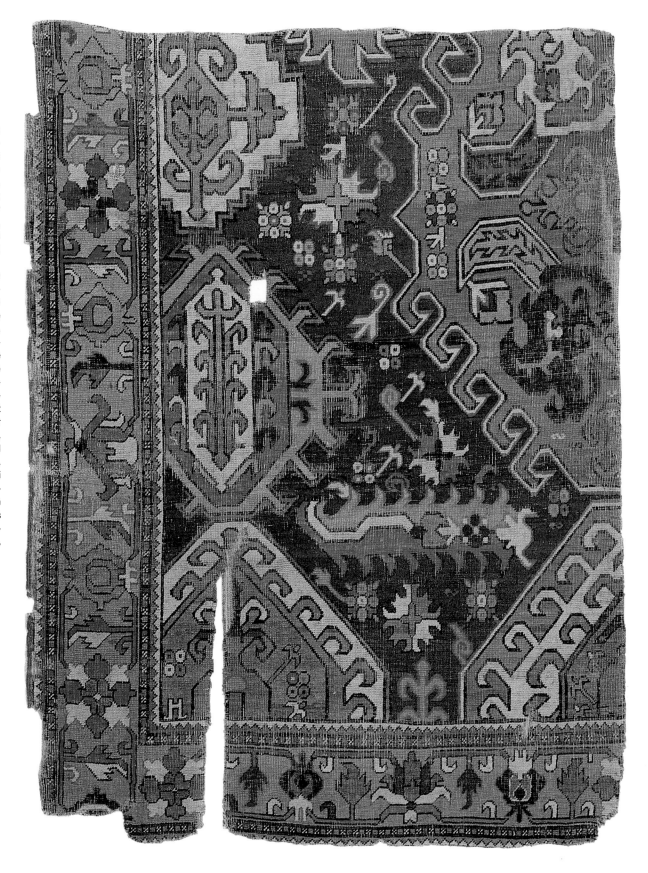

75
Silk Embroidery Fragment
Azerbaijan
17th Century
38 x 40 cm

The textile art of the Caucasus is not only renown for its marvelous pile carpets, kilims and *sumakhs*, but also for a number of extremely refined silk embroideries which still deserve to be studied more fully. The *kaitag* embroideries from Dagestan have recently received considerable attention, although the art of the embroidery must have been popular throughout the Caucasus and, analogously to carpets, had the grandiose Persian textile art tradition of the Safavid period as its prime source of inspiration. The small fragment illustrated here shows, in fact, motifs and animal figures that we can easily encounter on certain Safavid court carpets, but also on brocades, velvets and especially on the precious silk kilims generally attributed to Kashan.

The simplification of the design and the more rustic and provincial style with respect to the Persian court prototype, leads us to ascribe it with a degree of certainty to the Caucasus, it belonging to the very rare group of figurative embroideries (an example similar in design, technique and colour, but without animals, is published in Kirchheim 1993, no. 45, p. 72). The style of this embroidery does not differ much from that of early Caucasian rugs, and is clear evidence of the origin of the dragon carpets from Persian court prototypes.

The border motif is particularly similar to that on some of the most renown dragon carpets, such as the famous Graf piece in the Islamic Museum in Berlin, destroyed during the Second World War (Erdmann 1970, fig. 161, p. 132).

A.L.

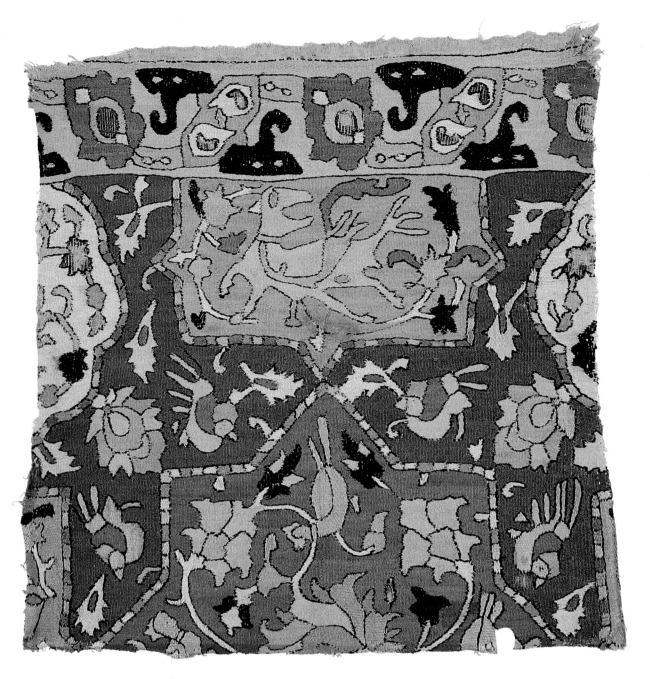

76
Silk Embroidery
Azerbaijan
17th–18th Century
89 x 94 cm

Aside from *kaitags*, the most common group of early Caucasian embroideries is represented by this example. They typically consist of square fabrics each side of approximately 90 cm, embroidered in silk by means of a very precise diagonal stitch, having a predominantly soft palette consisting of yellow, beige, light and dark blue. It is probably because of this specific polychromy that Schürmann assigns this type of embroideries to the Baku area, calling them Chila or Surahani (Schürmann 1974 pp. 354–5 and 358–9). The minute geometric ornaments with cartouches, lobed stars and stylised leaves recall those on early Caucasian rugs and on certain early 19th-century Kazak and Karabakh rugs, such as the so-called 'star Kazaks' that, according to Kirchheim, have many features in common with these embroideries (Kirchheim 1993, nos 46–8, pp. 73–4).
Among the published examples, one of the most similar to ours, although differing in certain ornaments, is in a private collection in Tel Aviv (Hasson 1985, no. 74, pp. 168–9).
A.B.

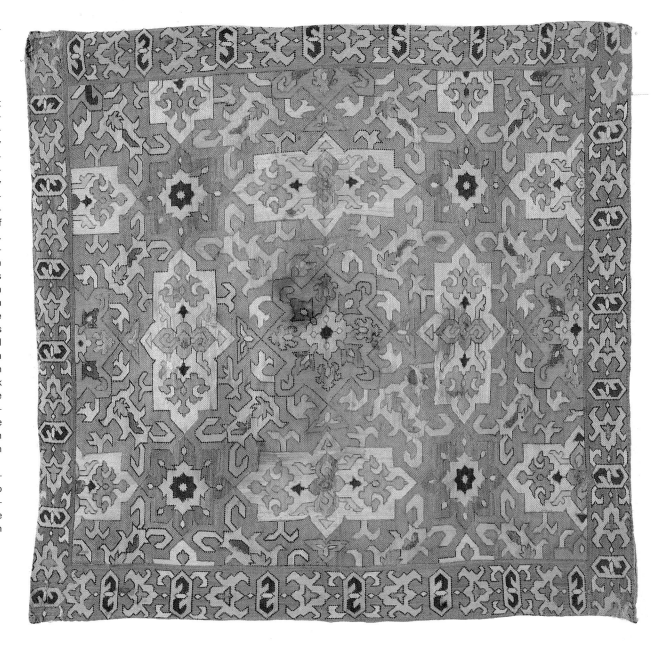

Armenian Door Carpet (?)
Southwest Caucasus
17th Century
95 x 158 cm

Although incomplete, this rare example is of great interest and presents a number of difficulties towards attribution. On the one hand, the coupled-column design is reminiscent of similar prayer rugs woven in West Anatolia in Ghiordes or Kula in the 18th and 19th centuries, as well as of the earliest types, probably from the Ushak area, known as 'Transylvanian' or, erroneously, as 'Column Ladiks'. On the other hand, however, there are structural as well as iconographic elements that connect it to the Caucasian tradition: in the spandrels above the *mihrab* the ram's horn motifs recall certain details present on early dragon carpets as well as on 19th century Perepedil rugs, while the border consisting of stylised flowers and vine branches appears virtually identical on certain early Caucasian rugs from the 17th and 18th centuries. The guard stripes show a reciprocal motif that is seen both on Caucasian and 'Transylvanian' rugs.

This rug has to be regarded as a transitional piece, placing it along a border that separates different cultures. It belongs to a very rare, if not unique typology. We only know of three comparable pieces: the first one, published on the cover of the famous book by Albert Achdijan, *Le Tapis - The Rug* (Paris 1949), has a double-niche design and is probably later than our example, although the author dates it to the late 15th–early 16th century and ascribes it to Konya. A second example appeared in an auction in London in 1993 (Christie's, London, October 21, 1993, lot 412. See also *Hali*, no. 72, December 1993–January 1994, p. 123), and is now in an Italian private collection. The third one, though disappeared since many years, has been known to scholars since 1895 (Riegl 1895), bearing an early Armenian inscription which has been variously translated and interpreted, and a date that could correspond to 1202 (see *Hali*, vol. 5, no. 3, 1983, p. 386; see also Gantzhorn 1991, pl. 680, p. 484). According to Riegl, the in-scription should be translated as 'Curtain for the door of the Holy Sacred [of the] Temple of Saint Hripsimo in the year 651, Me Gorzi, artist [did or gave]'. Since the Armenian calendar begins with the year 551, then the date would correspond to 1202. Gantzhorn translates the inscription in a similar way, but interprets the date as 1051 (A.D. 1602). According to another scholar, Lemyel Amirian (see *Hali*, vol. 6, no. 1, 1983, pp. 107–8) the inscription should be read differently, without any reference to the use of the rug as a curtain, and the date should really read 1202, although it may have been copied from an earlier rug. The same opinion is expressed in Der Manuelian and Eiland 1984, fig. 23, p. 56, although truthfully it belongs to the first half of the 17th century. However one interprets the inscription, it is certainly an Armenian rug, and therefore despite the design, one can rule out its Islamic ritual function as a prayer rug. The hypothesis that it may have served as a door rug still remains valid, such as a hanging in use in some Armenian churches in Southwest Caucasus (Karabakh or Armenia). A similar use has been documented for a group of carpets bearing a similar column design with Hebrew inscriptions, employed as a *parokhet*, a curtain for the cabinet containing the Torah Scrolls. This is in use in certain synagogues of the Middle East and even in Italy, like the famous Mamluk rug from Padua (A. Boralevi in *Critica d'Arte*, no. 2, July–September 1984, pp. 34–47). After all, even the Islamic world does not ignore the use of a door carpet, such as, for example, the Turkmen *ensis*.

A.B.

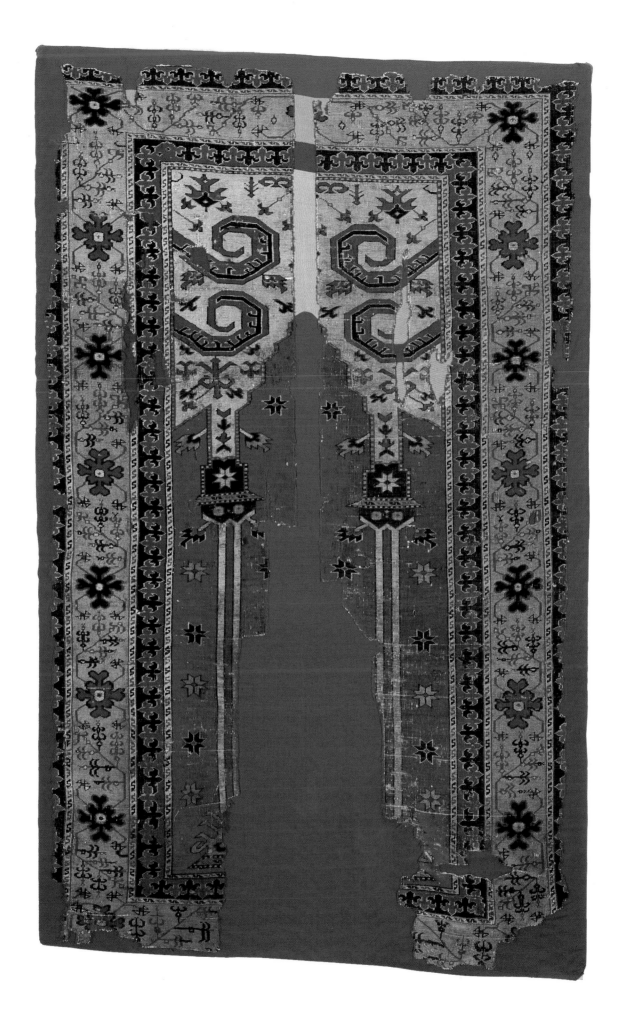

**Carpet Fragment
in the Harshang Design**
Southern Caucasus
18th Century
162 x 169 cm

This fragment is from a very large carpet of which we know other pieces, the largest one in a private collection in Genoa. It is decorated in the *harshang* (crab) design, one of Persian derivation, employed in the Caucasus since the 17th century and, by means of successive simplifications and stylisations, throughout the 19th century. The so-called Karagashli rugs are an example, where only one element of the design, the diagonally arranged palmette with its pair of forked leaves (the latter resembling crab claws) becomes the main focus of the composition. The complete pattern, which is summarised in this fragment, includes other types of palmettes as well, arranged either horizontally or vertically with respect to the warps, the most characteristic being the so-called 'flaming palmette' that we see here in yellow and light blue.

Large carpets with a similar framework were also woven in Persian Kurdistan until the 18th century, but differ in structure from the Caucasian ones, like our example, in that the latter type shows a structure similar to that of the dragon carpets. Typically Caucasian is also the reciprocal *medachyl* border in yellow and light blue, often employed to frame the carpets decorated in the related *avshan* motif with circular rosettes, such as the fragmentary example in the Bardini Museum in Florence (inv. no. 860/489) (Boralevi 1999, no. 46).

Three other carpets with the *avshan* design but only one with the *harshang* pattern, all having identical borders, are in the Museum of Turkish and Islamic Art in Istanbul (Yetkin 1978, vol. I, nos 63–5, 85).
A.B.

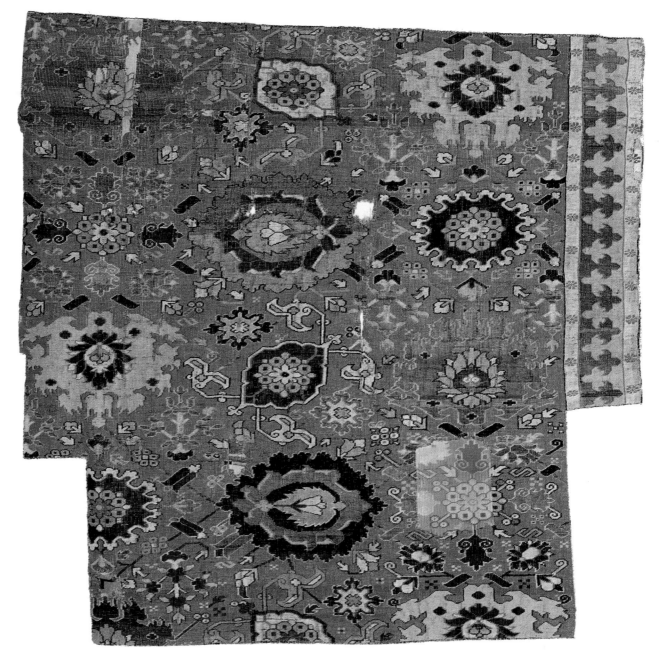

**Flower and Palmette
Carpet Fragment**
Southern Caucasus
Late 18th Century
141 x 178 cm

It is known that the motifs on
early Caucasian rugs are often
derived from late Safavid court
production, and are based up-
on a reinterpretation of those
workshop-derived patterns.
While the Durlaeher Tree and
Animal Carpet (see cat. no. 59)
reminds us of the great Safavid
hunting carpet tradition, like the
famous piece in the Poldi Pez-
zoli Museum in Milan, this frag-
ment (which amounts to slight-
ly over a third of the original)
shows a Caucasian, more
stylised and naive rendering of
the pattern seen on the palmette
and cloudband carpets from Es-
fahan, woven in large numbers
in Persian court workshops be-
tween the late 16th and the ear-
ly 18th centuries.
Similar examples, although
with different designs, have
been identified by Ellis (1975,
no. 19, pp. 37, 68 and 104) both
in the Karabakh and in the Shir-
van regions, the latter probably
being the place of origin of our
piece. The fragment reproduced
here shows highly saturated
dyes, but most importantly it
has a low sheared pile on a cot-
ton foundation. A very similar
example belongs to the Muse-
um für Angewandte Kunst in
Vienna (inv. no. OR 320) and is
dated by E. Gans-Ruedin to the
17th century (Gans-Ruedin
1986, pp. 40–1).
A.B.

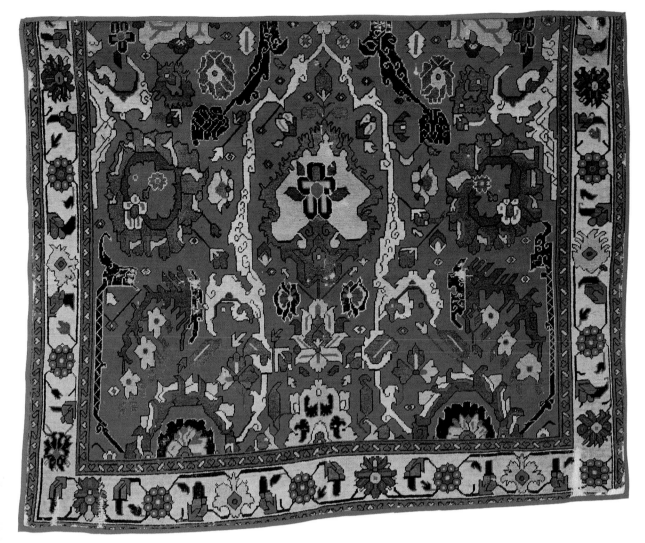

Shahsavan Confederacy
Southwest Caucasus
19th Century
95 x 125 cm

The border set against a white
ground reiterates — albeit in a
simpler fashion — an archaic
stylistic trait common to Ana-
tolian carpets, and frames the
singular, heraldic-looking field
pattern arranged in staggered
rows that create a visual diag-
onal, forming a running pattern
of lively polychromy. The latter
allows for a Shahsavan attri-
bution, while the designs inside
the 'shield' elements are tenu-
ously linked to stylised bird pat-
terns, generally facing or, as in
this case, addorsed, having here
a slightly floral appearance.
Such designs are rooted in prim-
itive cults and beliefs (on this
subject, see the lengthy dis-
cussion by R. Pinner in Pinner
and Franses 1980, p. 204 ff.).
Published in *Hali*, no. 65, p. 29.
E.C.

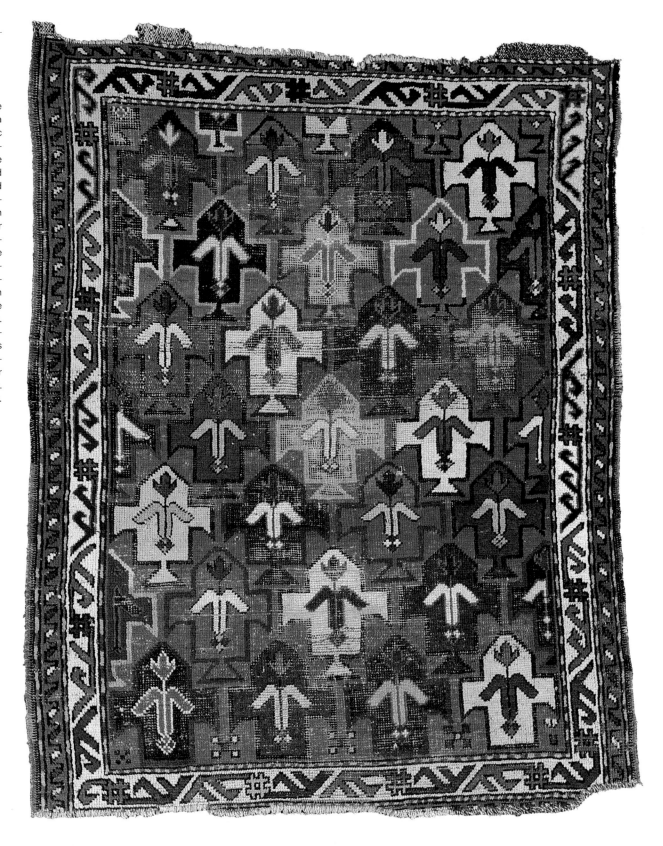

Shahsavan Confederacy
Southern Caucasus
Circa 1860
135 x 305 cm

The Shahsavan Confederacy is
better known for their various
trappings woven in the *sumakh*
technique. Their rare pile rugs
have been the subject of a study
(see Tanavoli in *Hali*, June 1989,
no. 45, pp. 30–7), and are typi-
cally ascribed to the Shahsavan
by virtue of the similarity in de-
sign and colour to their *sumakh*-
woven counterparts.
The design of this long rug is
inspired by a certain class of
early Caucasian rugs, labelled
as 'transitional' (see Yetkin 1978,
vol. II, p. 41), the pattern con-
sisting of parallel rows of di-
rectionally arranged 'egg pal-
mettes' (see Ellis 1975, p. 60)
propelled by a flaming element
typical of certain rugs from the
Caucasian region of Shirvan.
The unusually coloured back-
ground is punctuated by vari-
ous filler motifs that remind us
of those present on many flat-
woven pieces of the Shahsa-
van. Published in *Hali*, no. 45,
1989, pl. 5, p. 33. See technical
analysis in *Appendix*.
A.L.

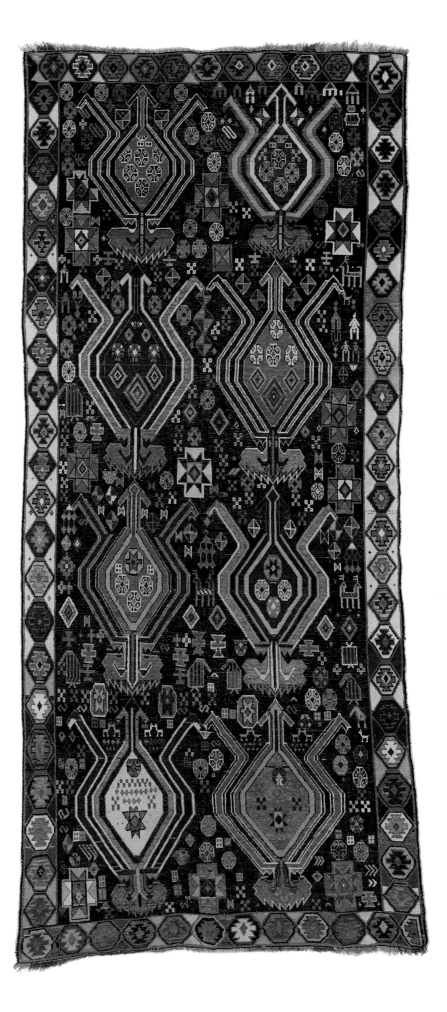

82

Shemakha District

Northeast Caucasus
Circa 1870
145 x 167 cm

The source for the design of this rare and beautiful pile rug is clearly that of the *jajim* flat-weaves, often decorated by colourful vertical bands usually containing a series of hooked motifs alternated to human and zoomorphic forms.

In a recently published book on Caucasian rugs (Wright and Wertime 1995) is illustrated a silk *jajim*, a so-called 'anchor' piece, attributed to the She-makha district in Northeast Caucasus, which shows the characteristic vertical stripe design that we normally ascribe to the Shahsavan Confederacy. Given the fact that the structure of the present rug is similar to that of the pile rugs from the Shir-van region (short pile with no warp depression), it would be reasonable to assign this small group of rugs to the Azeri population of Shemakha.
A.L.

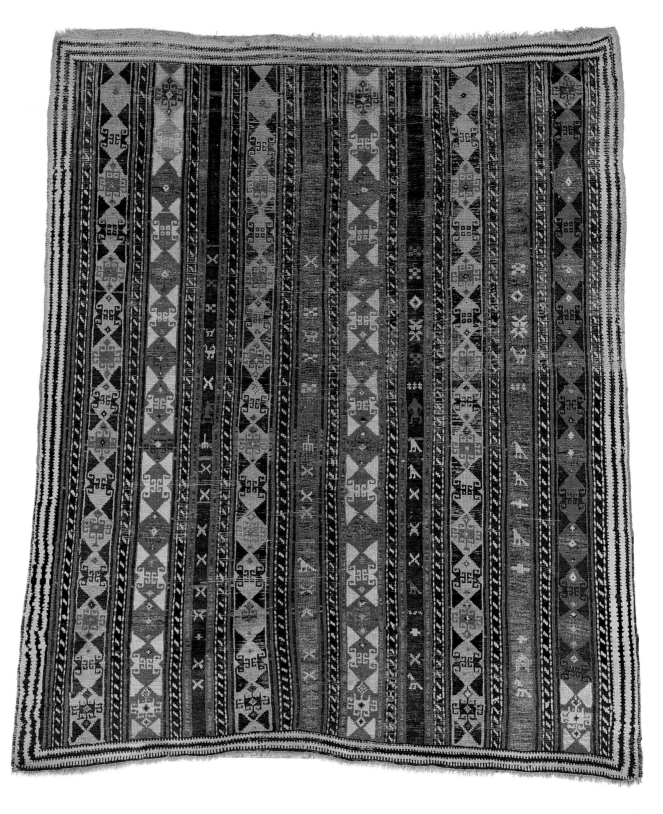

83
Seikhur Gollu Chi-Chi
Northeast Caucasus
19th Century
145 x 215 cm

An important group of carpets from the Kuba area has been ascribed to the village of Seikhur. This group comprises a plethora of designs and is characterised by peculiar chromatic features as well as by minor ornaments and borders that enable these weavings to be easily recognised.

Among the most typical designs of the group, the one illustrated here is usually known as the 'St. Andrew's Cross', although Kerimov calls these carpets *gollu chi-chi*. Those on an ivory background are undoubtedly the oldest and most beautiful. Others, on a blue background, almost invariably have a long format with four or five 'crosses' aligned along the central axis.

This pattern probably derives from the iconography of dragon carpets, and consists essentially of lozenges from whose vertexes extend two pairs of arms ending with typical fan-shaped palmettes. The lozenges aligned along the central axis alternate with similar half lozenges, arranged along the sides and connected to each other by means of diagonal arms, the latter fitting perfectly inside the fan-shaped palmettes. The refined pattern thus generated creates a substrate design consisting of columned ellipses, this being a styleme that we see on certain 'Lotto' carpets as well as on other early Turkish rugs, but which is extremely unusual for Caucasian village rugs.

The main border shows another fairly typical pattern for Seikhur: the rose and carnation design, rendered in a very 'European' style as seen on certain Persian rugs with the *gol farangh* design as well as on Karabakh rugs with allover patterns of roses. The main border is contoured by a double Greek fret border in ivory and light blue, also known as the Georgian border, which is almost always present on Seikhur rugs, irrespective of their field design.
A.B.

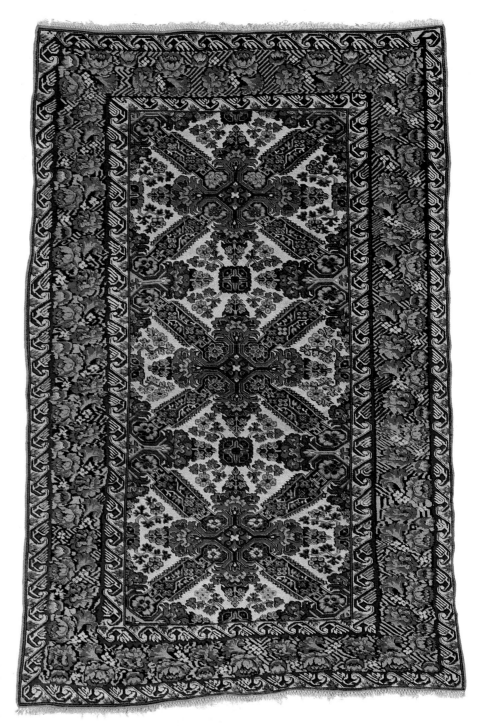

'Crivelli' Sumakh
Northeast Caucasus
Second half 19th Century
132 x 186 cm

The design on this small *sumakh* rug is composed of three large octagons aligned along the central axis, each containing the characteristic sixteen-pointed star known as the 'Crivelli star'. This name is derived from a famous painting by the Venetian Carlo Crivelli (active between 1457 and 1493) now in the National Gallery in London: *The Annunciation with Saint Emidius* (Mills 1983, pls 14–5, p. 53). We see this motif on certain early Turkish rugs from the 15th century onwards, and it is revisited, with all due stylisations like in this case, in the 19th-century Caucasian rug production. It appears as being employed solely for carpets woven in the *sumakh* technique, and it is fairly commonly employed as a secondary ornament within the large lozenge medallions that typically ornate *sumakh* carpets.

The example shown here has a bright palette and a wonderful yellow ground border, decorated with polychrome stars contained within octagons. In the lower red octagonal medallion appears what could either be an inscription or a date, unfortunately not being sufficiently clear for us to interpret.
A.B.

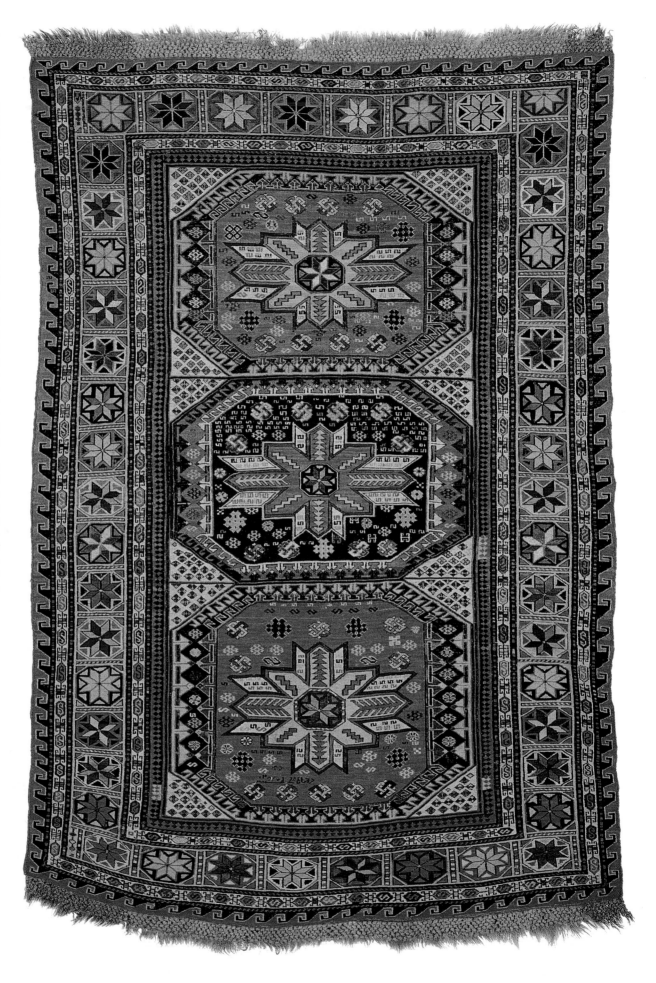

85
Avar Rug with a Lesghi Star Design
Dagestan
Late 19th Century
88 x 118 cm

The so-called 'Lesghi star' design, which appears on this small rug, consists of eight-pointed stars with typical stepped and jagged outlines. This motif has been thought of being representative of the Lesghi tribe, although this is highly unlikely since, contrary to what has been written in some old carpet books, there isn't a region called Lesghistan to which one could ascribe all the rugs bearing this pattern. In fact we see this design on East Caucasian rugs, on Southwest Caucasian rugs (Kazak) and on certain *sumakhs*. Our carpet belongs instead to a recently studied group of weavings from Dagestan, specifically of the Avar tribe from Davaghin (Wilber and Milberg in *Hali*, no. 29, 1986, pp. 40–4), essentially known for their long kilims and small pile rugs. Typical of this group of rugs are the geometric simplicity of the designs as well as the use of a limited palette, employing always red and light blue. In our example we see a highly geometric and stylised meander border in blue with red contours on a light blue background, this being almost a signature of Avar weavings.
A.B.

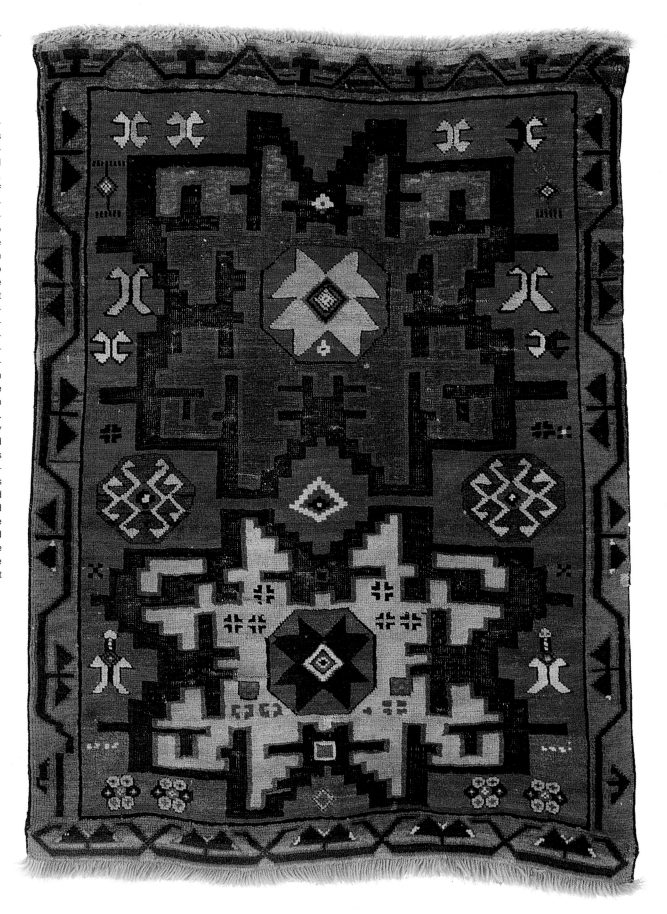

Kazak Gendje
Southern Caucasus
Circa 1850
130 x 295 cm

This unusual coral-rose long rug is characterised by three large star medallions similar to those on Fachralo Kazaks, the difference being in the more rounded horizontal outlines of the stars. These stellar motifs have a very archaic appearance, reminding us of some rare examples ascribed to the 18th century, such as the piece from the Orient Stars Collection, which also shows a field colour very similar to that of our rug (Kirchheim 1993, p. 40, no. 5). The wide border, instead, consisting of a green open field contoured by red triangles, has been sometimes interpreted as a depiction of a brook, and is typical of a specific group of Gendje rugs, usually decorated by tree or garden designs.
A.B.

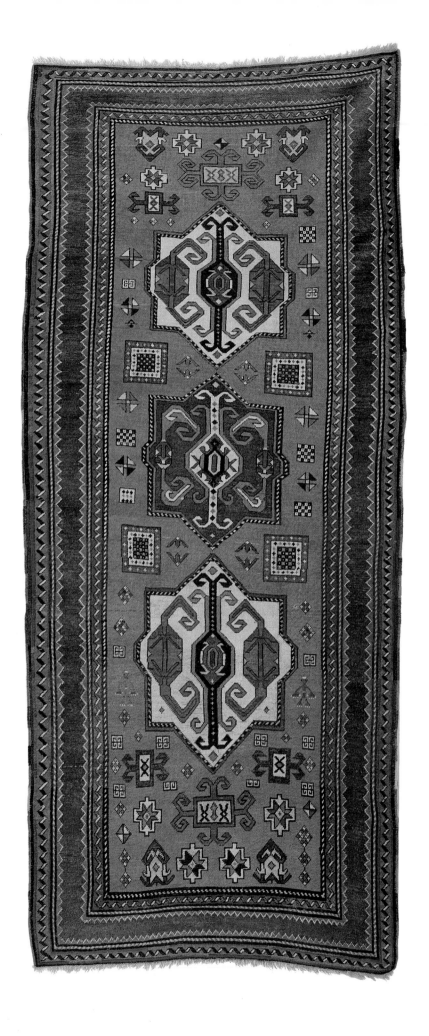

Kazak Bordjalou
Southwest Caucasus
Mid 19th Century
162 x 202 cm

The Kazak rugs assigned to the
village of Bordjalou consist es-
sentially of two types, which are
completely different from one
another: the first type has a nar-
row field and a very wide bor-
der, the latter being made up of
a characteristic meander motif
of hooked lozenges, while the
second normally shows a field
decorated by an elongated oc-
tagonal cartouche containing a
stylised tree element, and is
framed by a double (and some-
times triple) border consisting
of reciprocal arrowheads.

The rug illustrated here is a great
example of the first type, and
is very effective both graphi-
cally and chromatically. The am-
ple border, contoured by a typ-
ical red and blue reciprocal mo-
tif, seems to act more as a back-
ground rather than a frame for
the narrow field, composed of
three rectangles of different
colours containing octagonal
stars, small lozenges divided in-
to four parts and tribal 'horn'
motifs (*kotchak*).
A.B.

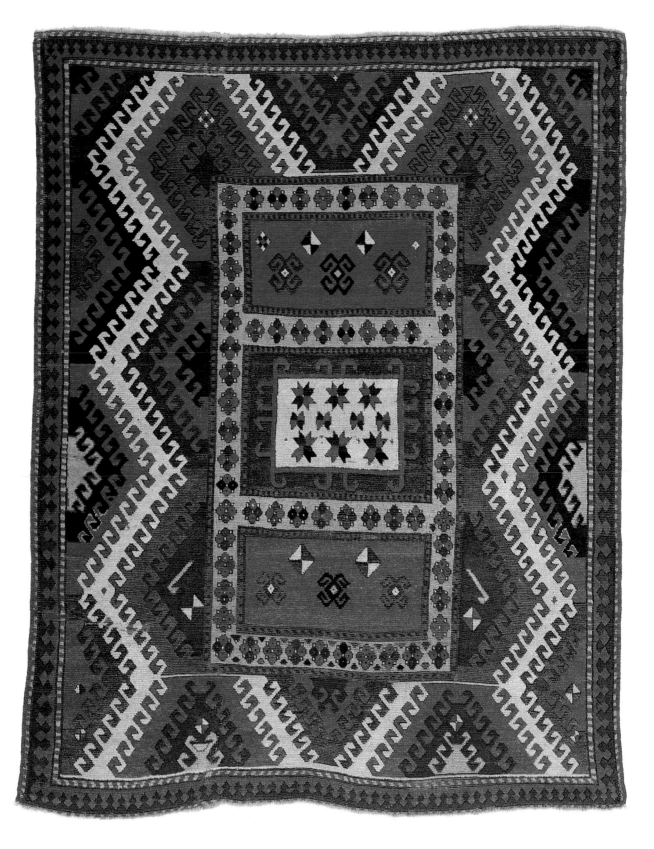

The Kilims

During the last three decades the various types of flatwoven rugs have received many times more attention than in all the preceding years of rug study combined, and they are at last coming to be understood both in terms of their structure and the evolution of their designs. Marla Mallett[1] has recently contributed what is certainly the best account of the structures of flatweaves, explaining with concise diagrams and clear prose the various types of brocade, weft float patterning, *sumakh*, twining, and other structures. With this book one should be able to identify and come to understand even the most complex handmade fabrics. As for the kilims themselves, more truly early pieces have become available, particularly from Turkey, and a more secure connoisseurship has developed with increasingly higher standards. Among the survivors that have recently come to light are a disproportionate number of early *safs*, some of which are seen in this catalogue. This probably relates to the inappropriateness of the design for household use, where the average lifespan of a kilim is probably low. It is difficult to imagine *safs* being used outside of a mosque, where they would ordinarily be expected to receive less intensive wear.

The great variety of Turkish designs that have emerged has also been surprising and has allowed for increasingly more precise identification of sources. Not too many years ago the task of sorting out the weavers of various types of kilims seemed next to impossible, as there were a number of common designs among recent kilims that seemed to have wide distribution throughout the country. It has been up to such scholars as Belkis Balpinar, Josephine Powell,[2] Harald Böhmer,[3] and Serife Atlihan[4] to provide more specific information through intensive field-work. Their material is at times startlingly precise as to where a given type of kilim was woven and by whom, and this often concerns fabrics that could not have been localised within several hundred miles twenty years ago.

Kilim study in Iran carries with it a slightly different focus, as those fabrics of interest to collectors are generally associated with peoples who are nomadic or have been nomadic in the recent past. Nevertheless, many varied flatweaves are still woven by Persian villagers, although the number is probably declining. Tanavoli[5] has given special attention to this village work, while Western collectors are more interested in kilims and trappings from the pastoralists of the Fars province, particularly the Qashqa'i. These people weave bags, covers, and kilims in perhaps a dozen structures, and recently there has been a resurgence in the use of natural dyes. Since the designs have changed little over the last century, many late products are good replicas of what might have been produced during the 19th century.

Otherwise the Shahsavan, mostly in Azerbaijan, the Afshar west of Kerman, and the Baluch along Iran's eastern border still produce various types of flatweaves. It appears as though production of the appealing Lori-Bakhtiari type from the Zagros has declined.

Among Persian kilims is a small group from the environs of Senneh (modern Sanandaj), many of which are some of the most finely rendered fabrics of their type made in the Near East. These fabrics are essentially sophisticated city products rather than folk art. There is no modern equivalent in Turkey, although a small number of beautiful kilims survive from the early Ottoman court.

In the recent past the Avar or Davaghin kilims of Dagestan were virtually unknown, but their bold designs have now made them popular among connoisseurs. Several other Caucasian types are sought by collectors, particularly the one with large stylised dragon figures in horizontal rows.

[1] M. Mallett, *Woven Structures: a Guide to Oriental Rug and Textile Analysis*, Atlanta 1998.
[2] J. Powell, 'A Survey of a Group of Recent Anatolian Nomad Weavings', in *Oriental Carpet & Textile Studies V*, Danville 1999, pp. 172–8.
[3] H. Böhmer, 'Turkish Knotted Carpets and Flatweaves with Similar Designs', in *Oriental Carpet & Textile Studies IV*, Berkeley 1993, pp. 57–66.
[4] S. Atlihan, 'Traditional Weavings in One Village of Settled Nomads in Northwest Anatolia', in *Oriental Carpet & Textile Studies IV*, Berkeley 1993, pp. 77–88.
[5] P. Tanavoli, 'Palas Culture', in *Oriental Carpet & Textile Studies V*, Danville 1999, pp. 128–30.

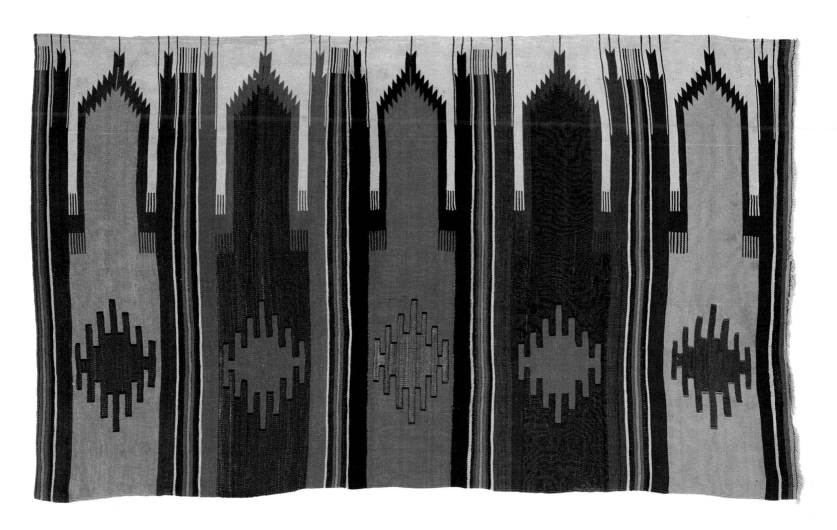

88

**Multiple-Niche
Kilim Fragment**
Central Anatolia
Before 1850
84 x 146 cm

This impressive fragment
shows five of the original thir-
teen halved double-niches. The
stripes connecting the two
weaving edges at the long sides
of the kilim indicate the origi-
nal beginning or end of the
piece. The portion, published in
Cootner 1990, pl. 9, stems orig-
inally from the same weaving
and shows a complete panel
that is, half of the original kilim.
J.R.

89

Three-Niche Kilim
Central Anatolia
19th Century
145 x 315 cm

A so-called *saf* kilim with three
niches on a rare ivory back-
ground. This distinct group of
saf kilims has been described
in detail by Balpinar in Mellaart,
Hirsch and Balpinar 1989.
J.R.

90

Multiple-Niche Kilim
Central Anatolia
19th Century
178 x 376 cm

A quite exceptional, intense in-
terpretation of the *saf* design
in a Central Anatolian kilim,
whose most outstanding fea-
ture is its refined and elegant
palette.
A.L.

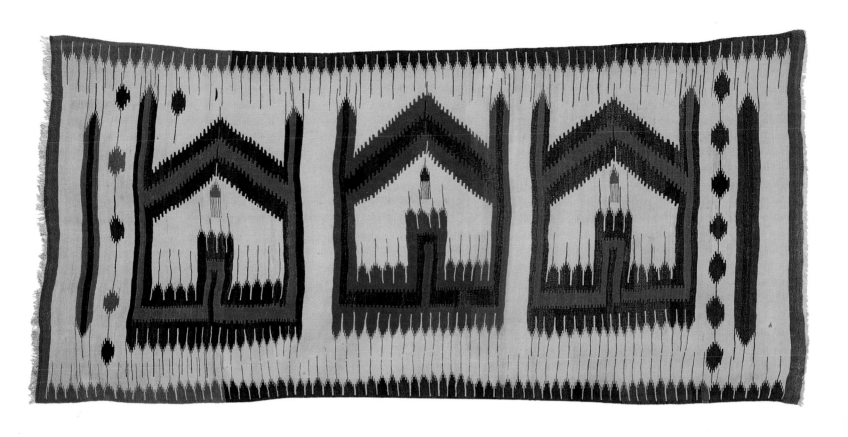

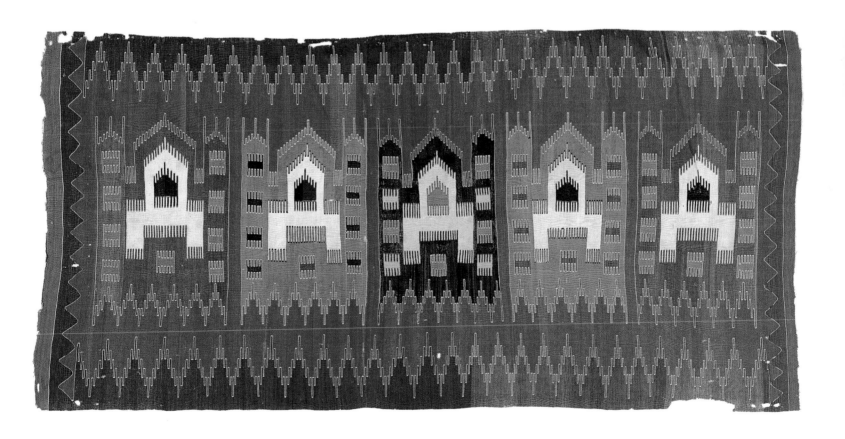

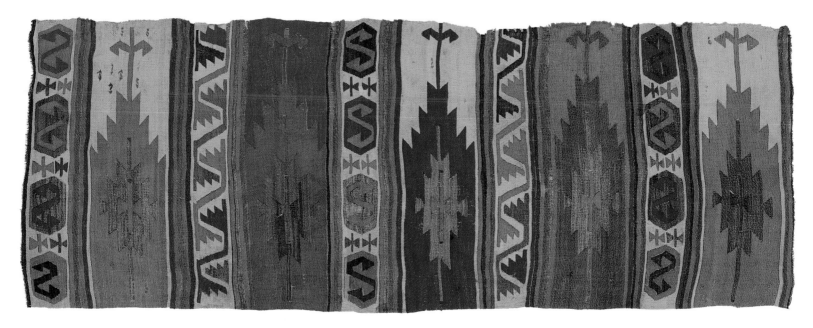

91

**Multiple-Niche
Kilim Fragment**
Central Anatolia
Before 1850
82 x 225 cm

A rare fragment of half a kilim,
characterised by a subdued
palette as well as by an archa-
ic design of polychrome nich-
es. The stripes separating each

niche show an unusual pattern
consisting of octagons con-
taining S- or Z-shaped forms.
A.L.

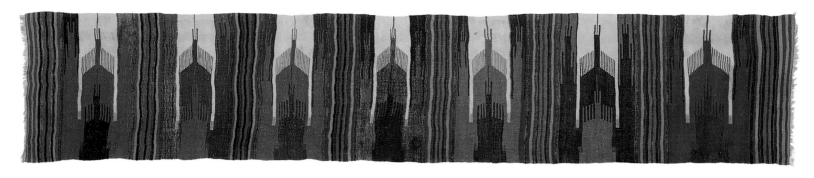

92

Multiple-Niche Kilim
Central Anatolia
Before 1850
66 x 355 cm

A double-niche kilim of the same
type is in the Caroline and H.
McCoy Jones Collection in San
Francisco. This multiple-niche
kilim shows the glowing colours
that set this group of flatweaves
apart from most others. The
comparison piece is complete
and has a somewhat softer
palette.
J.R.

93

Multiple-Niche Kilim
Central Anatolia
19th Century
144 x 430 cm

A nearly identical, but probably older piece is in the Caroline and H. McCoy Jones Collection in San Francisco. Both pieces are decorated by a sequence of cartouches alternated to five double niches. The double niches show a colour symmetry with respect to the central axis by following the direction of the weft (in the sequence red, light blue, yellow, light blue, red). The kilim illustrated here has additional narrow white ground skirts at its ends.
J.R.

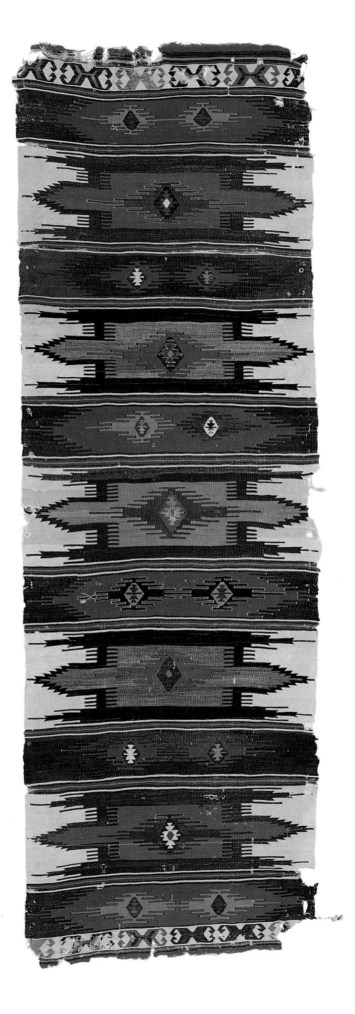

Open-Field Kilim
Central Anatolia
19th Century
173 x 415 cm

The majestic aubergine open field is framed by a remarkably elaborate border pattern consisting of a white zigzag line with closely adjacent spirals on both sides. Such a border is found on a similar red-ground open-field kilim in the Vok Collection, but with spirals only on one side of a dark-brown zigzag line laid over an ivory background, and without the additional skirts along the short sides.
J.R.

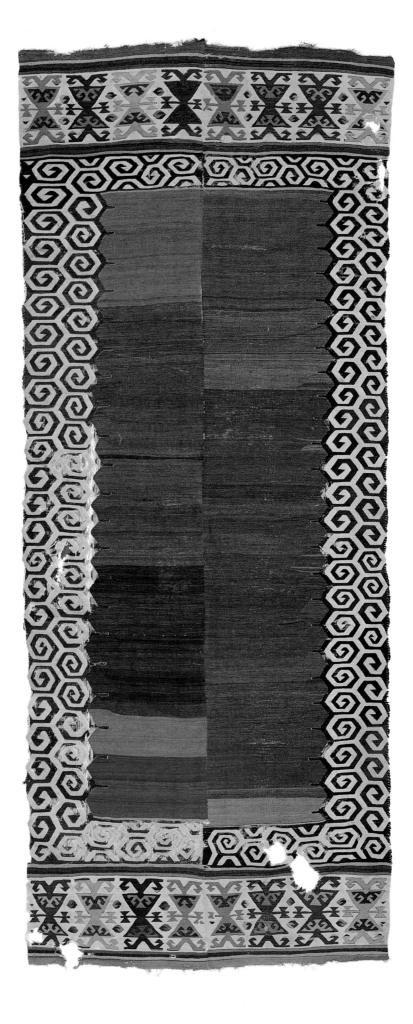

Polychrome-Stripe Kilim
Central Anatolia
18th–19th Century
55 x 356 cm

A fragment of the other half of
this kilim is published in
Frauenknecht 1984, pl. 18, and
is now in the Fine Arts Muse-
um in San Francisco (inv. no.
1984.61). A rare and early Ana-
tolian kilim characterised by a
pattern of polychrome stripes
containing an unusual hooked
motif of obscure significance.
J.R.

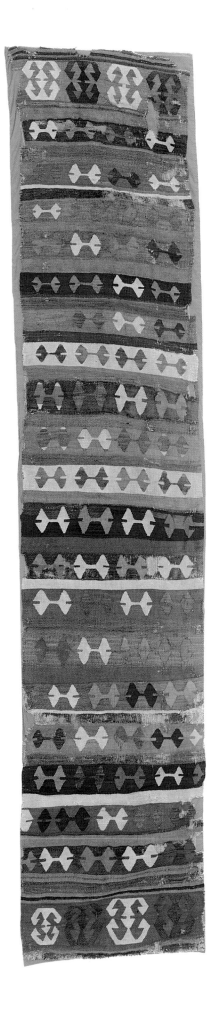

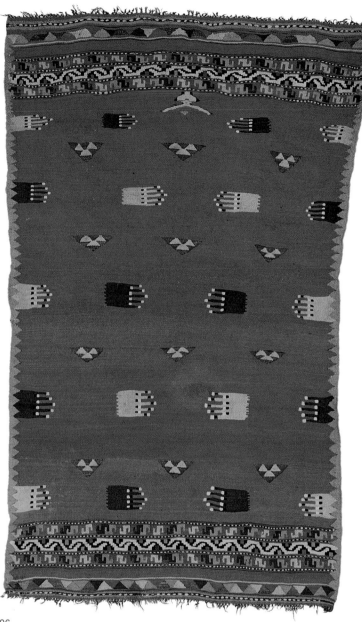

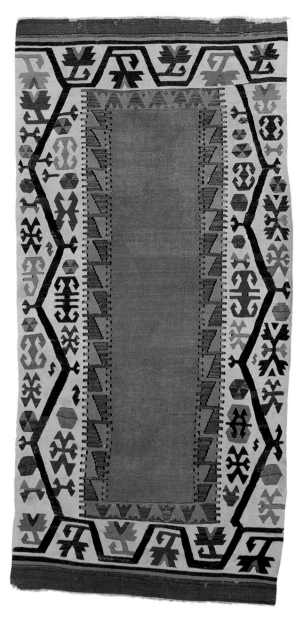

96

Manastir Kilim
West Anatolia
Second half 19th Century
94 x 154 cm

The small niche-like form placed
at the top of the red field of this
unusual piece indicate that this
is a rather rare Manastir prayer
kilim.
J.R.

97

Konya Kilim
Central Anatolia
Before 1850
70 x 140 cm

This particularly attractive kil-
im is characterised by a pecu-
liar motif separating the red
open field from the dynamic
borders. Kilims of this type have
often been attributed to the
Gaziantep region. Published in
Eskenazi and Valcarenghi 1985,
pl. 50, p. 73.
J.R.

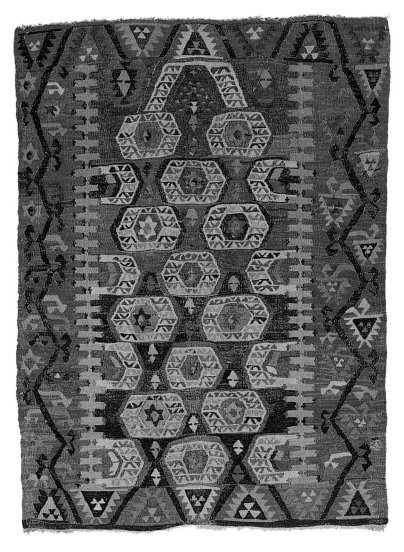

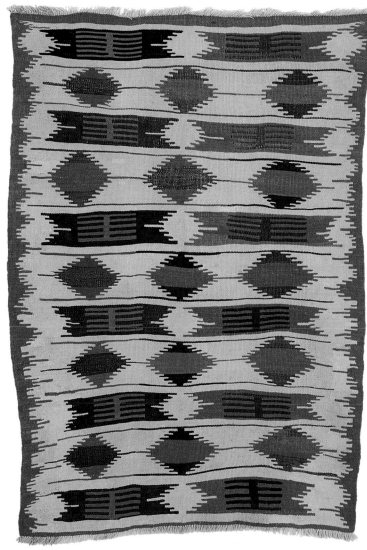

98

Prayer Kilim
Nigde (?), Central Anatolia
19th Century
103 x 136 cm

Although a fair amount of research has been carried on into what prompted the use of the octagon motif, as well as its meaning and message, little study has been made of the hexagon. The deeply rooted partiality for these forms in Asiatic cultures needs more definitive research data, in order to shed light on the underlying intentions of the subjects they contain.

As is often the case with Anatolian kilims, especially those from the south-central areas (see cat. no. 101), the hexagon becomes the principal element of composition which carries a niche that is both modest in size and notably humble in its religious sense, giving rise to an unpretentious masterpiece of pastoral expression. Published in Petsopoulos 1979, pl. 79.
E.C.

99

Karapinar Kilim
Central Anatolia
19th Century
100 x 135 cm

An unusual small-size Karapinar kilim with a design originating from the repertoire of related *saf* kilims from the same area. Published in Eskenazi and Valcarenghi 1985, p. 69, pl. 44.
J.R.

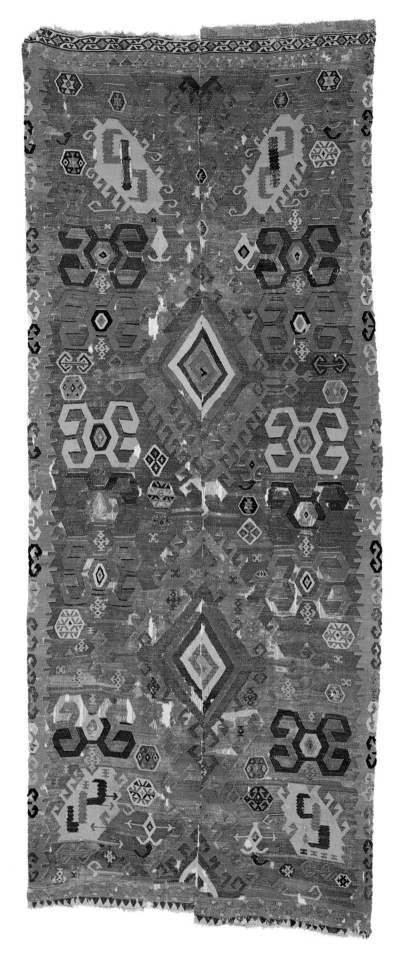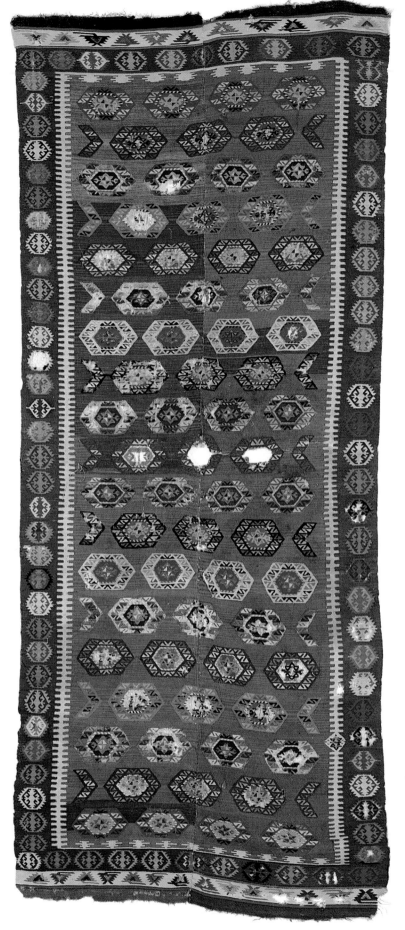

112

100
Kilim
East Anatolia
Before 1850
Circa 150 x 360 cm

This kilim bears an interesting combination of design elements seen on the flatweaves originating from Anatolia, the Caucasus and Southern Persia. However, both the colour palette and the type of motifs employed in the design seem to suggest an Anatolian attribution.
J.R.

101
Green-Ground Kilim
Southeast Anatolia
19th Century
147 x 358 cm

Green-ground kilims are very rarely encountered, particularly in Anatolia. Both the design elements and the use of metal-thread brocading point towards Southeast Anatolia.
J.R.

102
Avar Dragon Kilim
Dagestan, Northeast Caucasus
19th Century
92 x 388 cm

Decorated by an allover pattern of stylised dragons, this particular subgroup of Avar kilims has been recently the subject of an article by Paul Ramsey which appeared in *Hali* (no. 89, 1996, p. 78 ff.).
J.R.

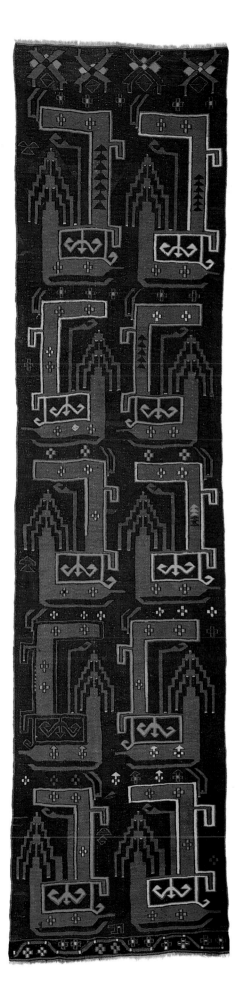

Silk Kilim
Northwest Persia
or Southeast Caucasus
19th Century
106 x 126 cm

Possibly the work of the Shah-savan tribe, known more for its wide array of flatwoven textiles rather than for its knotted pile rugs, this silk kilim draws on one of the most elementary and primitive compositions to create a highly sophisticated cover with a thoughtful juxtaposition of colour, giving rise to a piece that is a pleasure for both eye and touch.

The best source of information about the Shahsavan and their textiles remains the exhaustive study by P. Tanavoli (1985), complete with generous illustrations.

E.C.

Ru-Korsi
Southwest Persia
19th Century
117 x 121 cm

An old tradition, occasionally practised even today, involves gathering up cinders left over from a fire for further use: though they have largely exhausted their oxygen, the cinders remain hot for a long time; it is enough to put them in an appropriate container (*korsi*) and cover them (*ru*, meaning 'above/over' in Persian) with a piece of fabric that is a *ru-korsi* (Tanavoli 1985, fig. 166).

The tribal confederations of Southwest Persia were active in the production of this particular type of flatweave, generally almost square in shape, and with a stiff, heavy handle. These were mainly executed in toned-down, dull colours, more in accord with the cinders they covered than with the embers they were to keep aglow. In the rare cases where the situation is inverted, the leap in quality is considerable: such is the case with the example illustrated here, in which once again one notices that the simplest of means can lead to an intense, solid expressive outcome. This *ru-korsi* involves a process of abstraction, evincing an impeccable rapport between form and colour. Both ends are brocaded with motifs commonly employed by the Bakhtiari, the Qashqa'i, the Lori, and even the Afshar tribes, and consequently it is difficult to establish a precise tribal origin for this piece. We are in need of more specific field research that could provide us with new data about tribal rug designs and techniques.
E.C.

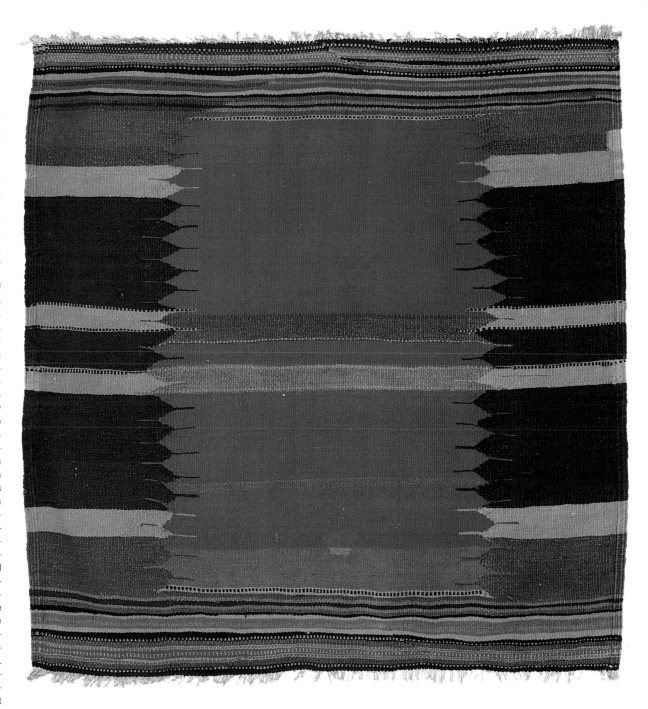

Rugs of the Turkmen and Other Peoples of Central Asia

The most dramatic recent development in the scholarship of Turkmen rugs has been the work with radiocarbon dating, which has given credence to the notion that some of the Turkmen rugs we have traditionally clustered together in the 19th century may, indeed, be anywhere from a century to three centuries older.[1] This concept is based on the notion that the designs went through a period of several centuries with essentially no change, although there is also the suggestion that minor structural features can be used to differentiate the older rugs from the new examples they closely resemble.

It will be interesting to follow the development of this thesis through time and the inevitable challenges that will come. This area of study seems even more important now that there is information that Shah Abbas established a workshop in Astarabad. This is based upon the mention of Astarabad, and other Persian cities, by the Polish Jesuit Father Krusinski, who lived in Persia from 1704 to 1729.[2] It seems ironic that just as a discussion of the significance (or believability) of this workshop was about to appear in print from this author and Robert Pinner,[3] a carpet with an Astarabad inscription and a 1660 date was brought forward. As had been anticipated, the carpet seems to bear some relationship to the so-called Eagle groups of carpets, both in design and structure. Considering also that the so-called 'eagles' look most like rectilinear renditions of Persian 'flaming' palmettes, one could hardly be blamed for wondering how much of the Northeast Persian Yomud production is adapted from urban design traditions — perhaps from the Astarabad workshop — and how much remains from the Yomud's earlier life as pastoral nomads. The question also arises as to whether there is a logical inconsistency in labelling tent bags in typical Yomud designs as belonging to an Eagle gul group rather than a particular tribal group. Another area of study that has so far only been touched upon concerns the relationships — as reflected in carpets — between the Turkic groups who migrated into Anatolia beginning in the 10th century and those who remained behind in what is now Turkmenistan and Uzbekistan. Particularly since the last several decades have uncovered many times more Turkish rugs that probably predate 1500, or even 1400, than were available several decades ago, we would seem to have a better opportunity to construct design relationships within the Turkic nation that at one time extended from the Syr Darya to the Aegean. The period of Seljuk hegemony did not last long, but it may represent the last time during which we could expect to find some semblance of a unified Turkic design *continuum*.

The other area which beckons more research at the present time concerns the Beshir type rug from a group of villages east of the Amu Darya in modern Uzbekistan. Beshir rugs have always been categorised with Turkmen rugs, although the relationship of these fabrics to those of the Ersari has been poorly defined. Moshkova,[4] however, suggested among the people inhabiting the villages weaving these rugs a group called the Olams and another group of Salor Turkmen. The former people are not Turkmen at all, but originally Indo-European, and the name is alleged to be a corruption of the word 'Alan', a people associated with the Sarmatians. Some Alans remained in Turkestan even after the Hunnic invasions, but others migrated to the Northern Caucasus, where they are now called Ossetes. Yet another group migrated into Western Europe as far as France and Spain.

Interestingly, Moshkova also gives a reference from a Tang Chinese source suggesting that the areas around Kerki and Beshir were among the places exporting rugs as early as the 5th to 7th centuries A.D.[5] So it is little wonder Beshir rugs are not so readily categorised as Turkmen products.

The part Salors may have played in the carpet production of this area is even more intriguing, but has so far not been researched. Anyone looking for a promising location for fieldwork might consider this region.

[1] The Basel Rug Society's symposium on radiocarbon dating is described by H. Neumann in *Hali*, no.104, May–June 1999, pp.82–5.

[2] T. Mankowski, 'Some Documents from Polish Sources Relating to Carpet Making in the Time of Shah Abbas I', in *A Survey of Persian Art*, edited by A. U. Pope and P. Ackerman, pp. 2431–2. Here is discussed the account of Tadeusz Krusinski, who indicated that Shah Abbas had factories established in the provinces of Shirvan, Karabakh, Gilan, Kashan, Mashad, Astarabad, and Esfahan. Carpets and other fabrics were to be made, with each place weaving in its own manner.

[3] Mention of the Krusinski reference will appear in a catalogue by R. Pinner and M. Eiland, Jr., of the Wiedersperg Collection of Turkmen Rugs to be published by the DeYoung Museum in San Francisco.

[4] V.G. Moshkova, *Carpets of the Peoples of Central Asia*, edited and translated by G. O'Bannon and O.K. Amanova-Olsen, Tucson 1996, pp. 269–70.

[5] *Ivi*, pp. 8–9.

Hali
Salor Tribe
West Turkestan
18th–19th Century
270 x 480 cm

Apart from the fact that the magnificent and elegant carpets of this type were woven by the Salor, we know surprisingly little else. It is still not clear how old they are and whether they were woven in tents by nomads for their own use or that of tribal chiefs; or whether they were produced for sale by settled Turkmen in workshops.
R.P.

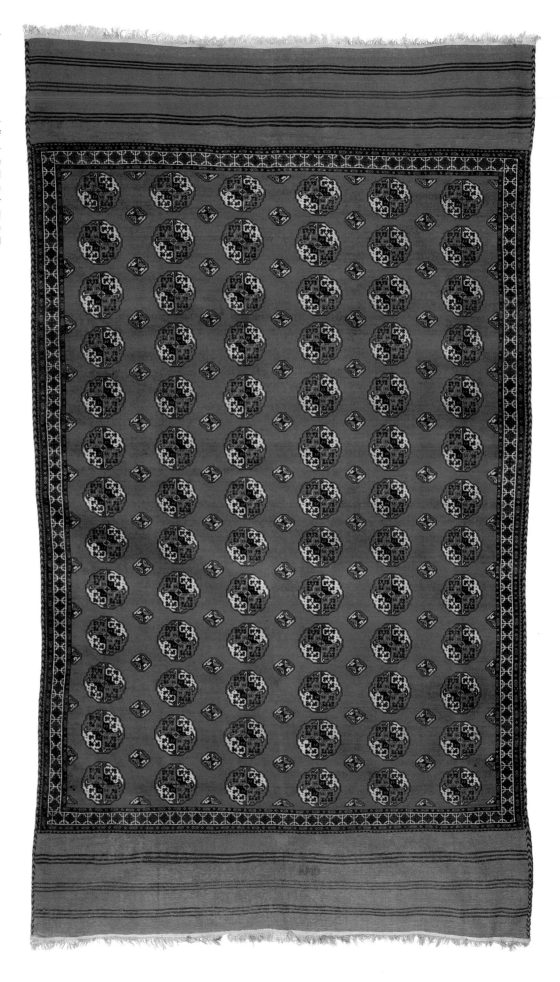

Camel Trapping
Salor Tribe
West Turkestan
18th Century
70 x 212 cm

Salor trappings woven in the *kejebe* (the litter on the bridal camel in the wedding caravan) design are drawn with between one and three of the large hexagonal *darvaza guls*. The length of the last type often exceeds two metres, and raises the question of how the trapping was used on the camel.

The outermost, diamond-filled border is taken around the sides to form a 'shoulder' piece. Originally, this would have been decorated with fringes which would move to and fro with the gait of the camel.
R.P.

Hali Fragment
Salor Tribe
West Turkestan
18th–19th Century
68 x 102 cm

This fragment illustrates the weavers' strict adherence to the traditional designs of Salor main carpets. All but one of the known examples have the same secondary ornament. Published in Mackie and Thompson 1980, pl. 5.
R.P.

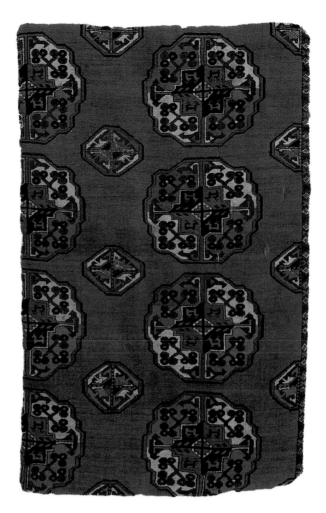

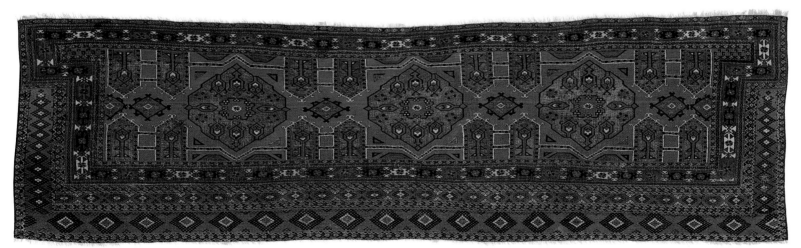

Hali
Yomud Tribe
West Turkestan
16th–17th Century
191 x 310 cm

V.G. Moshkova's belief that Yomud carpets with the *chuval gul* were among the oldest of Turkmen main carpets, received some support when a fragment of an almost identical *chuval-gul* carpet which had been radio-carbon dated to 1488–1656 A.D. was shown at a symposium in Basel in February 1999. This extraordinarily beautiful carpet has survived almost intact and, apart from the fragment mentioned, is similar to two others which now form a small group of four with the same almost naturalistically drawn floral *elem* and the same field and border designs. Another member of the group was illustrated in a book on Turkmen carpets published in Moscow in 1927 by F.G. Gogel, while the best known example is at the Textile Museum in Washington, D.C., where it was shown in the 'Turkmen' exhibition during the Washington ICOC in 1980 (Mackie and Thompson 1980, pl. 67). See technical analysis in *Appendix*.
R.P.

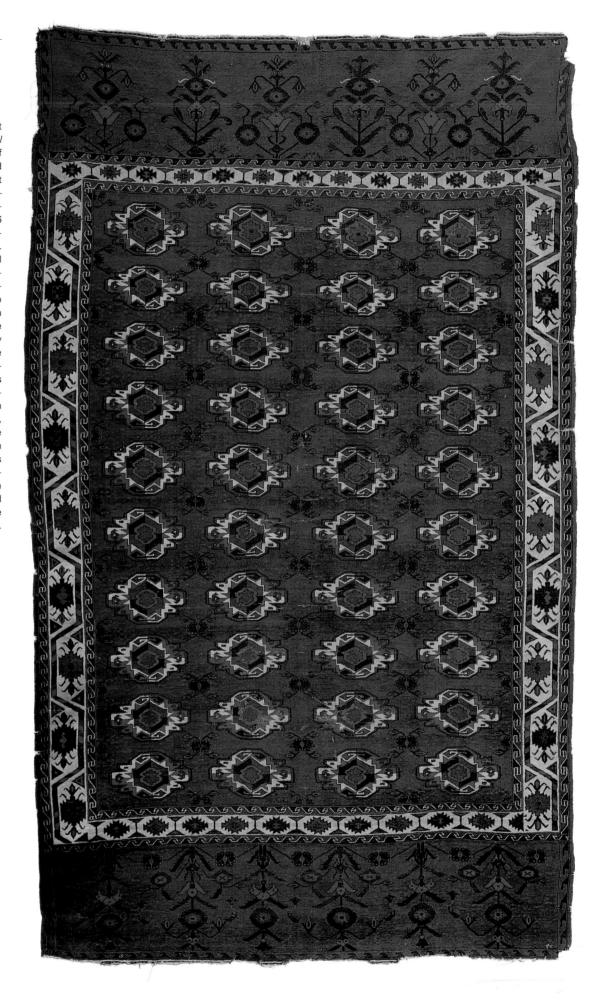

Hali
Yomud Tribe
West Turkestan
First half 19th Century
175 x 322 cm

An early *kepse-gul* carpet with
glowing colours and an inter-
esting *elem* with a rare, almost
three-dimensional design.
R.P.

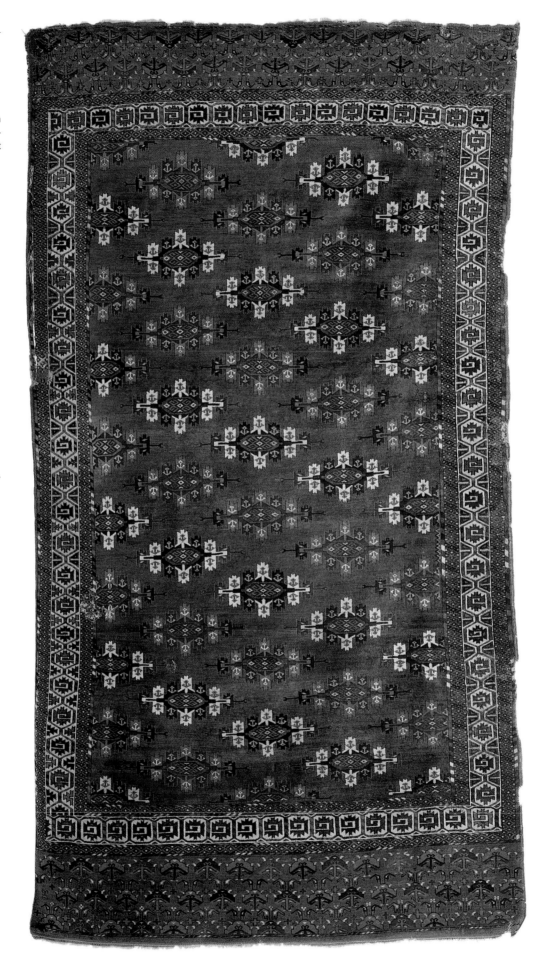

110
Tufek Bash
Yomud Tribe
West Turkestan
Second half 19th Century
15 x 120 cm

The design on this rare Turkmen gun cover, which is woven with dense and soft wool, is that of a border commonly used on Yomud tent bags. Another *tufek bash* has been published by S. Azadi (1975, pl. 48). R.P.

111
Namazlyk
Yomud Tribe
West Turkestan
18th–19th Century
97 x 118 cm

For most connoisseurs of Turkmen rugs, since its appearance in a German auction house in 1994, this little rug has ranked as one of the two most beautiful Turkmen prayer rugs known (the other being the famous Ersari prayer rug from the Dudin Collection in the Museum of Ethnography in St. Petersburg; Tsareva 1984, pl. 98). Even a good colour photograph cannot do it justice. The camel ground contrasts with the bright cherry red, navy blue, and the deep lustrous green of the *mihrab*.

Some of the unusual designs, such as the pentagonal white-ground shield above the prayer niche, the pairs of small *botehs* filling the ground at the top, the small white-ground panel at the bottom of the central arch, with a gable carrying a *kotchak* at the centre; these are all present on an otherwise very different Yomud prayer rug illustrated in Felkerzam 1914, pp. 117–53; also Tsareva 1984, pl. 102. Published in Rippon Boswell, Wiesbaden (auction catalogue), November 12, 1994, lot 93. See technical analysis in *Appendix*. R.P.

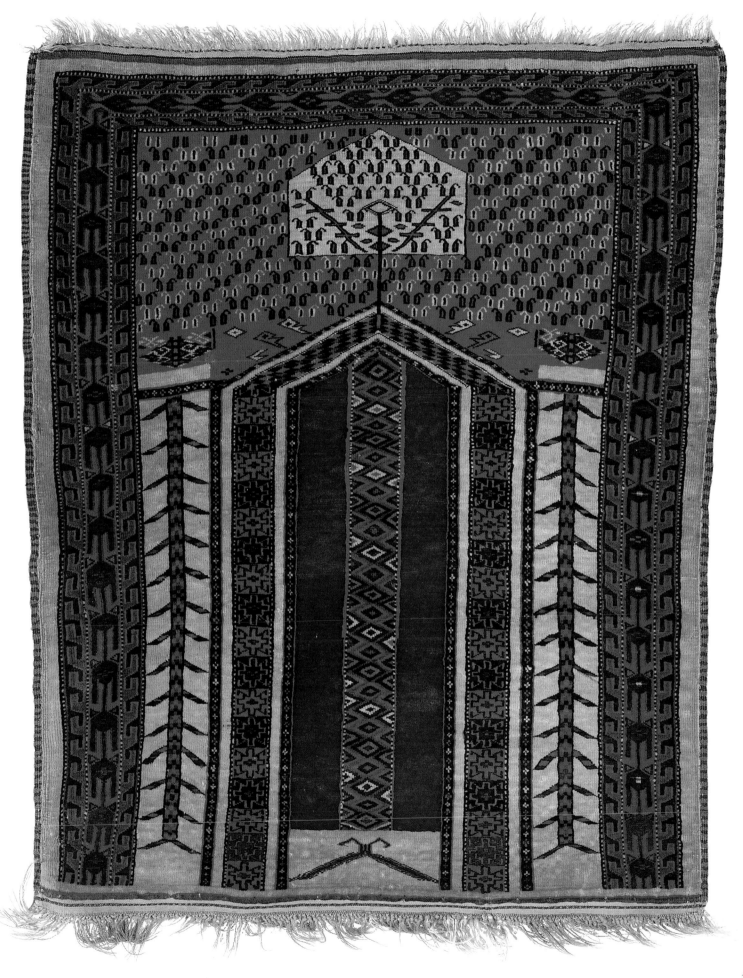

Eagle Gul Group II Hali
Turkmen Tribe
West Turkestan
18th–19th Century
180 x 270 cm

General A.A. Bogolyubov, Governor of Transcaspia at the turn of the 19th century, assigned these rare carpets to the Ogurjali tribe, now counted as a Yomud group. Apart from their close similarities in designs but significant differences in structure (asymmetrical knots open on the right; Z2 pile yarn; and weft shoots of mixed wool and cotton), compared with Eagle Gul Group II rugs, we have learned little more about these carpets. The eight examples of this group published by Rautenstengel and Azadi (1990) have since been joined by three others, of which this is the most distinguished one; it belonged to the Fabergé family in the last century. Its remarkable state of preservation and particularly of colours that look as fresh as if the carpet was new, suggests that it was kept out of the light during most of its life. Published in *Hali*, no. 89, 1996, p. 55. See technical analysis in *Appendix*. R.P.

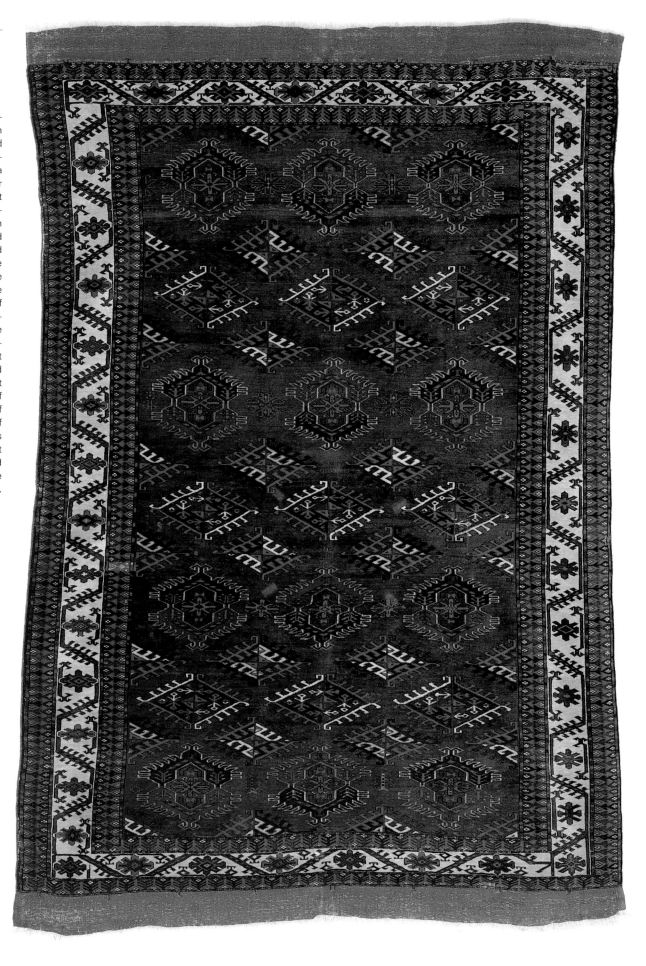

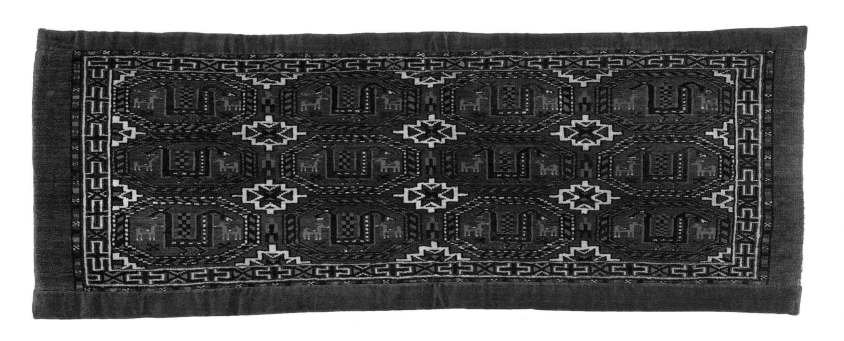

113

Eagle Gul Group I Torba
Turkmen Tribe
West Turkestan
18th–19th Century
35 x 98 cm

The design in this *torba*, octagons with a large bird and opposing quadrupeds, first came to the attention of Turkmen rug connoisseurs in a drawing taken from a *khalyk* in the Fine Arts Museum in Ashkhabad by V.G. Moshkova (Moshkova 1946, pp. 145–62; Engl. transl. in Pinner and Franses 1980, pl. 31, p. 23). Since then it has become clear that this design belongs to a number of small weavings of the Eagle Gul Group I type which has been tentatively attributed to the Goklen tribe by S. Azadi. The ground colour of the members of this group is often a rather dark brown obtained from madder; the structural features, which were published in Rautenstengel and Azadi 1990, in-

clude asymmetrical knots open to the left, Z3 and Z4 pile yarn, and wefts in which wool yarn alternates with a yarn made up of one strand of wool and one of silk.
A similar *torba* with different secondary motifs and in which the quadrupeds are replaced by geometric symbols was exhibited in Washington, D.C., in 1980 and published by Mackie and Thompson (1980, pl. 57).
R.P.

Hali
Tekke Tribe
West Turkestan
Late 18th–early 19th Century
205 x 300 cm

This rather large Tekke main car-
pet is woven in fine lustrous
wool dyed with the four stan-
dard colours: red (ground), oran-
ge, dark blue, green, as well as
natural brown and white. Its 4
x 10 Tekke and *chemche guls*
decorate a dark madder ground.
The simple frame shows an early
form of border octagons and in-
termediate ornaments, lacking
minor borders.
R.P.

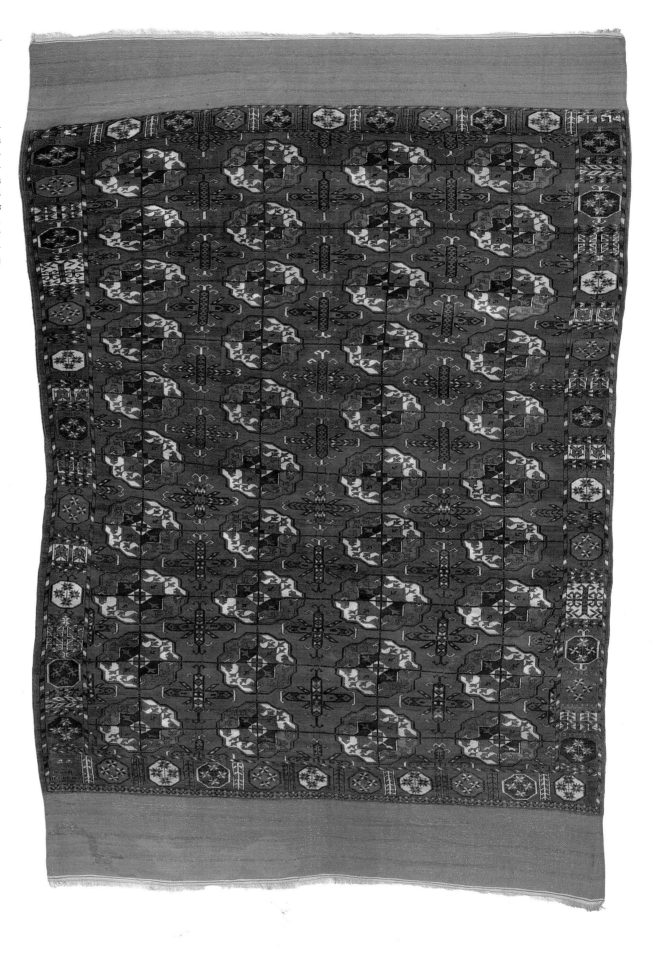

115

Chuval

Tekke Tribe
West Turkestan
Late 18th–early 19th Century
80 x 110 cm

An early Tekke *chuval* with 4 x
4 well-spaced *chuval guls* and
chemche minor *guls*, a stylised
floral compartment border, and
boldly drawn 'trees' with saw-
tooth branches in different
colours. Of the surviving Tekke
chuvals, most are from a later
era and have a larger number
of small *guls*.
R.P.

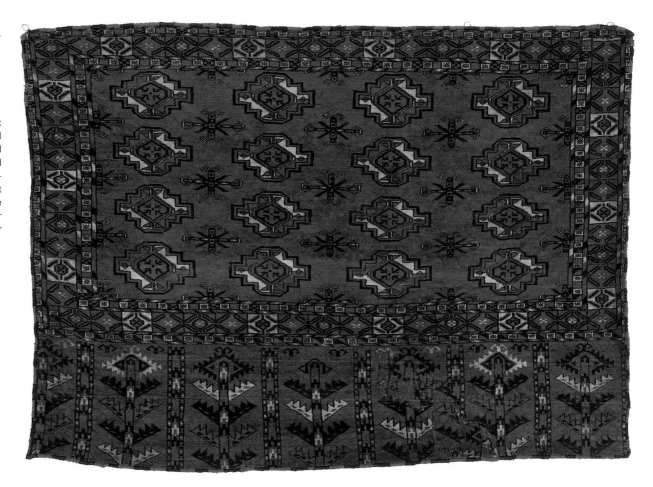

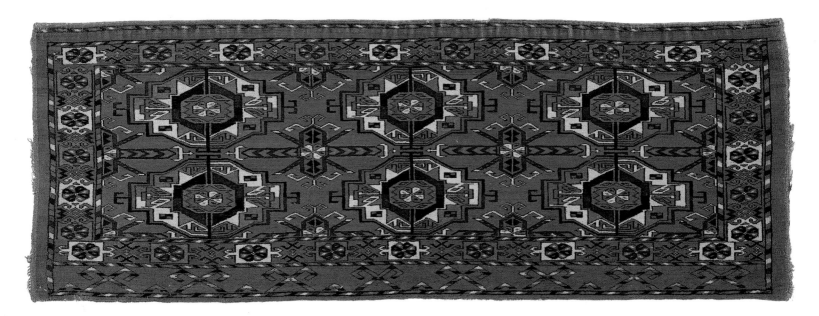

116

Torba

Tekke Tribe
West Turkestan
Late 18th–early 19th Century
41 x 116 cm

Tekke *torbas* of this design-
group are regarded as among
the most beautiful Turkmen tent
bags, which may also have been
used as trappings on the Tekke
wedding caravan. Characteris-
tic features are rosettes in the
centres of the primary and sec-
ondary (*chemche*) *guls*; T-
shapes at both ends of the ma-
jor *guls* and 'bow and arrow'
forms at the ends of the minor
guls; and either a *kochanak* or
a specific form of a compart-
ment main border.
R.P.

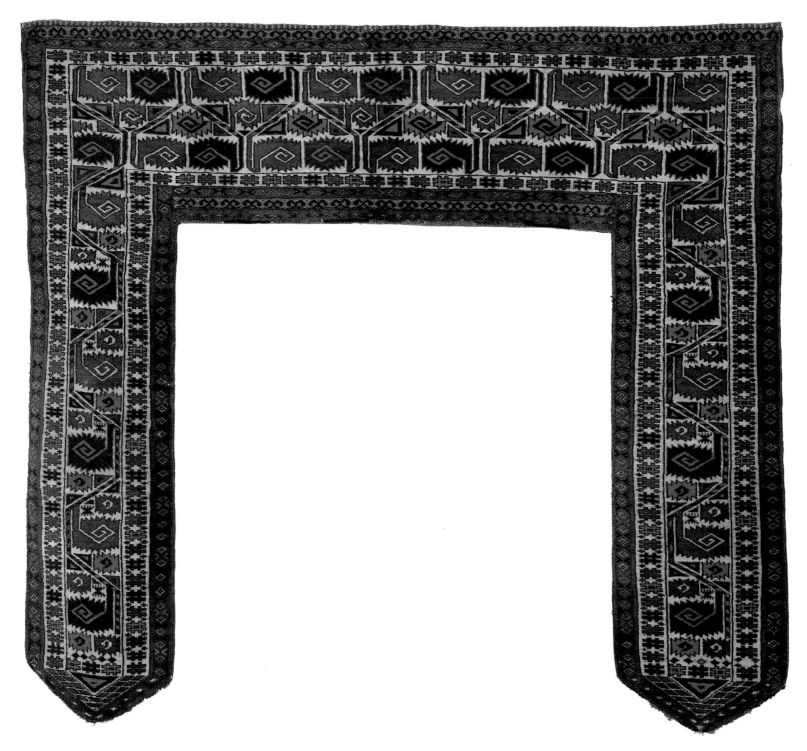

117

Kapunuk
Tekke Tribe
West Turkestan
Mid 19th Century
63 x 100 cm

The 'curled leaf' design is shared by the *kapunuks* (door surrounds) of most Turkmen tribes. Its unfolding leaves symbolise fertility. At the top, two large and one small 'curled leaf' occupy reciprocally arranged half-hexagons that form a lattice which continues into the 'arms' of the *kapunuk*.
R.P.

118
Beshir Rug
West Turkestan
Mid 19th Century
180 x 247 cm

After weaving the first half me-
tre of a carpet with a complex
pattern, reminiscent of that on
a rug in an American private
collection (Mackie and Thomp-
son 1980, pl. 86), the weaver
changed tack and completed it
in a simple and attractive pro-
gression of rows of large and
small diamonds filled with *gul*-
like designs in red, green and
white.
R.P.

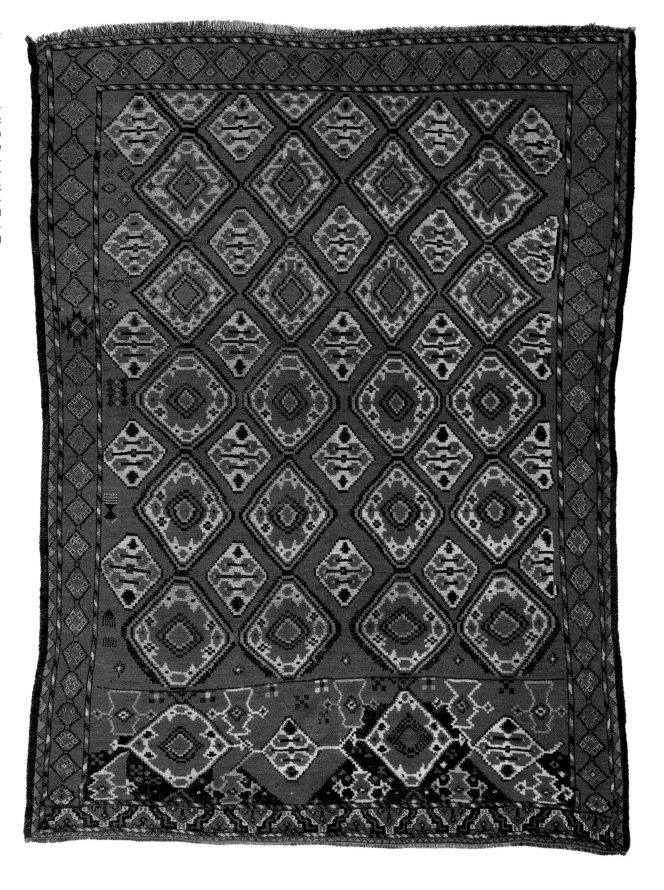

Turkmen Rug
West Turkestan
19th Century
142 x 220 cm

We have been able to contribute
little more than question marks
to this attractive rug with its yel-
low ground, straight rows of
regular octagons, and pairs of
H motifs in the places where
pairs of two-headed animals
stand in the *gul* quarters of the
tauk nuska gul.
R.P.

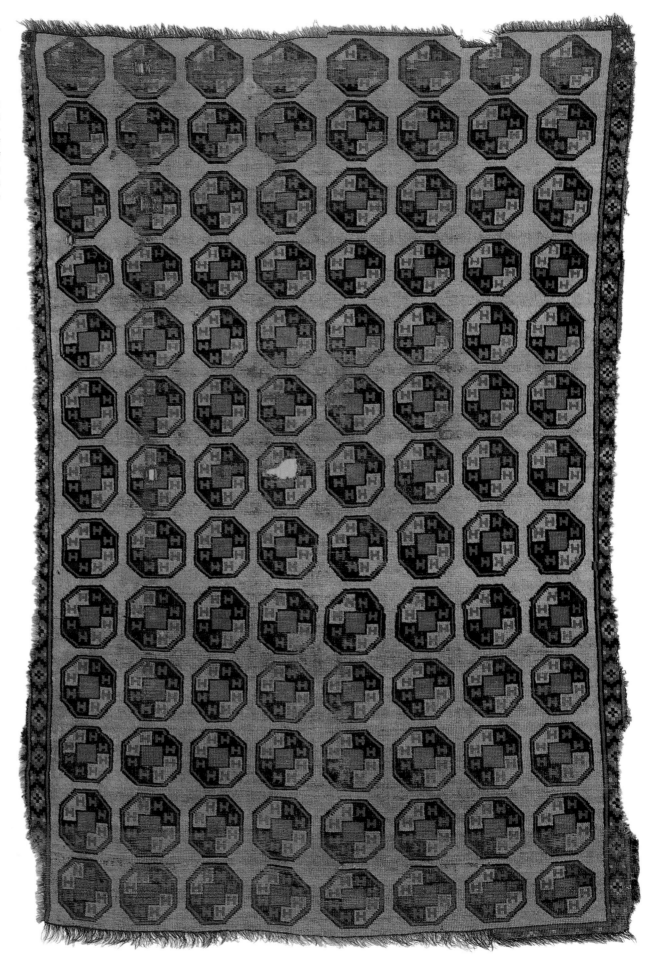

Beshir Rug
West Turkestan
Second half 19th Century
104 x 180 cm

The design of this carpet is apparently derived from an older form in which the compartments contain a directional figure, with a hexagonal cartouche at its centre, which some weavers drew as vases with stylised blossoms and curved leaves (Lefevre, London, November 1976, lot 53) while others clearly saw a scorpion or 'tarantula' (Schürmann 1969, pl. 43).

This rug also demonstrates that development is by no means synonymous with degeneration. The brightly contrasting colours (red, black and white in the field and yellow in the narrow border) and perfect proportions lend this rug a cheerful elegance lacking in some of the older examples. Published by König in Mackie and Thompson 1980, pl. 64, p. 201.
R.P.

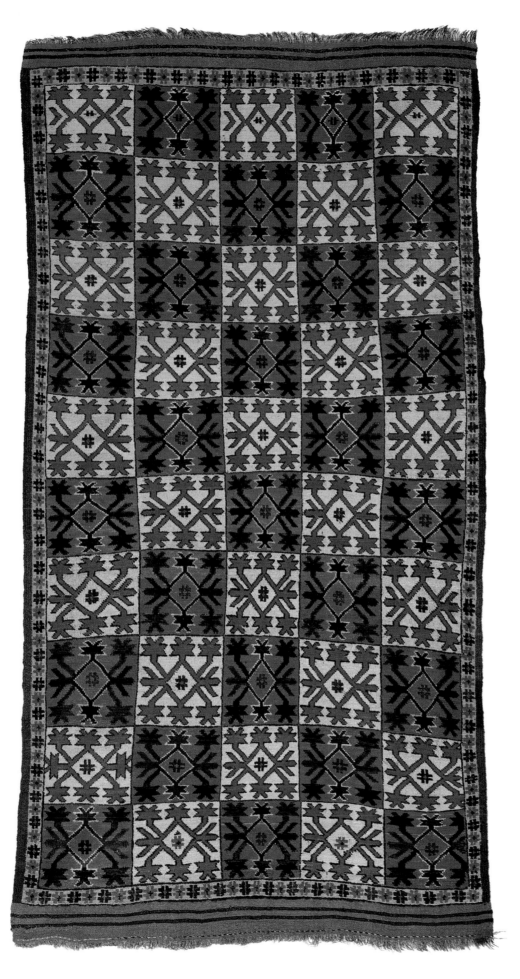

121

Ensi

Ersari Tribe
West Turkestan
Second half 19th Century
156 x 208 cm

Ersari *ensis* (door hangings) are among the largest of such artefacts woven by the different Turkmen tribes and, as most *ensis* of the Ersari, Yomud, and Salor, it lacks the *mihrabs* responsible for the earlier misconception that *ensis* were prayer rugs. Other features characteristic for Ersari *ensis* are the large criss-cross field ornaments, the innermost border with its leafy vine and the *elem* with its trees arising from boxed elements.
R.P.

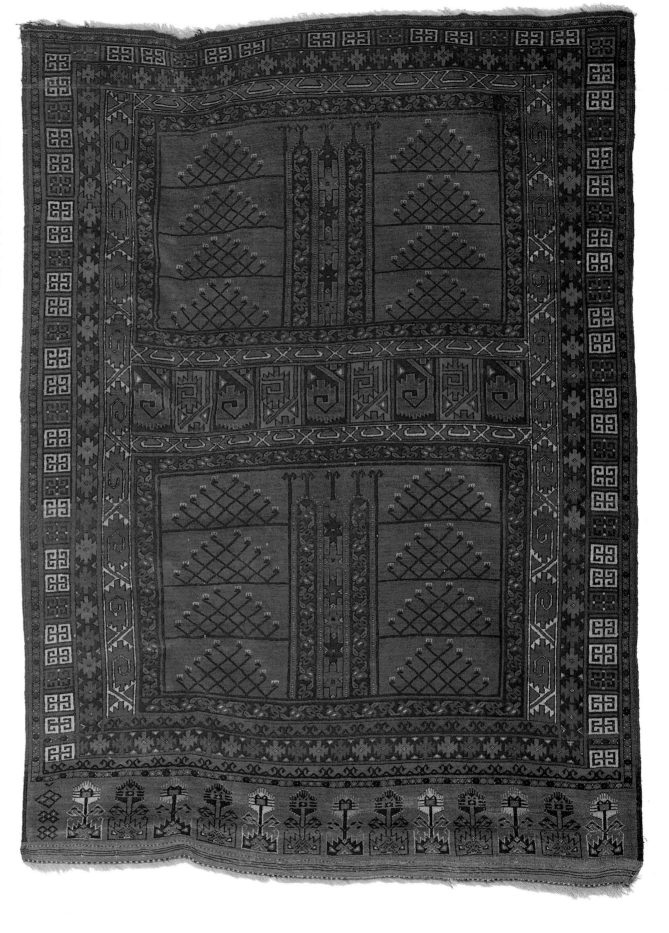

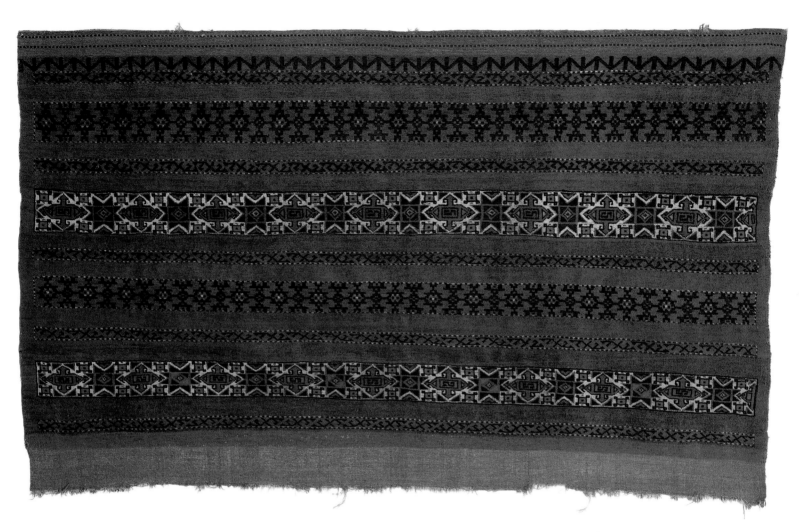

122

Chuval

Ersari Tribe (?)
West Turkestan
Mid 19th Century
106 x 207 cm

The question mark against the Ersari attribution is fully justified since we have little data on this very rare pilewoven rug. A piece of comparable dimensions and with almost identical stripes has been attributed to the Kirghiz (Tsareva 1984, pl. 141).

However, *chuvals* of similar size, woven on a red ground and with undecorated red *elems*, have been made by the Ersari in large number in brocaded flatweaves and are so similar in design that it seems probable that the rare pilewoven examples were made by the same tribe.

In their proportion of flatweave to pileweave these pieces can be compared with the smaller *kizil chuvals* of the Yomud who, as well as weaving rugs with similar designs as brocaded flatweaves, and a very few pileweaves, have also produced a somewhat larger proportion in flatweaves with pileweave stripes (analogous to the Tekke *ak chuvals*). In addition, full-pile *kizil chuvals* in similar sizes to the corresponding Yomud *chuvals* are known from both Eagle Gul Group I (A. and V. Rautenstengel and Azadi 1990, fig. 30) and Eagle Gul Group II (E. Tsareva in *Oriental Rugs from Atlantic Collections*, 1996, pl. 127).

The illustrated piece is not only rare, but it is also very beautiful, not least because of its vivid colours. Like the smaller corresponding pieces from other tribes (except for the Eagle Gul Group I *chuvals*) the larger *kizil chuvals* from the more eastern regions have no borders.
R.P.

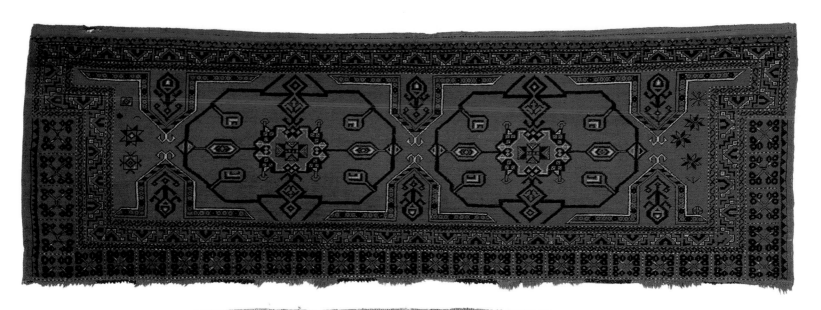

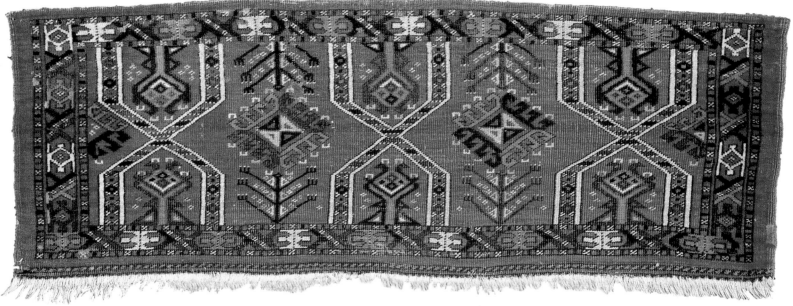

123	124
Trapping	**Trapping**
Ersari Tribe	Ersari Tribe
West Turkestan	West Turkestan
Mid 19th Century	Mid 19th Century
70 x 247 cm	43 x 127 cm

This trapping is of similar size and format to the Salor trapping on cat. no. 106, but the *kejebe* design of the Ersari version is on a larger scale, clumsy in the mutual proportions of its designs, and less precise in drawing. Compared with the Salor piece it is a country cousin and it possesses charm rather than beauty. Published by König in Mackie and Thompson 1980, pl. 57, p. 193. See technical analysis in *Appendix*.
R.P.

A smaller trapping clearly of a different Ersari group, in which the *darvaza gul* is replaced by a version of the *dyrnak gul*.
R.P.

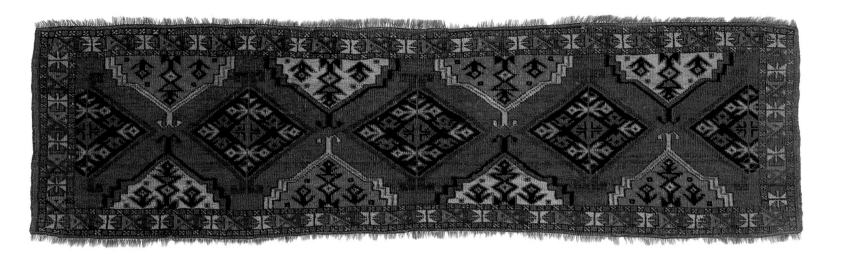

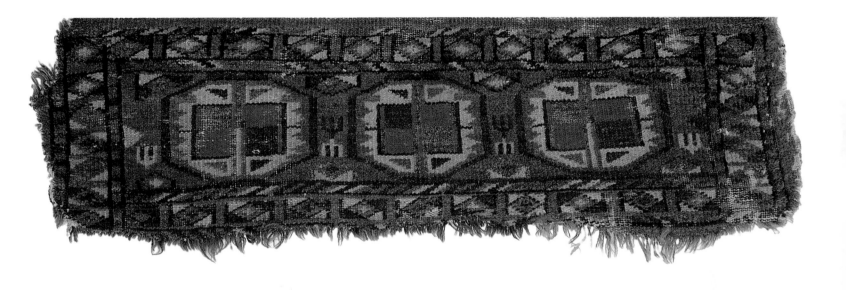

125

Trapping

Ersari Tribe (?)
West Turkestan
Second half 19th Century
40 x 145 cm

Another Ersari trapping has a design of half-*ertmen guls* in a composition similar to that of the *kejebe* design. Here the place of the *darvaza gul* is taken by a diamond with the interior drawing of a dyrnak gul but without hooks. The design clearly borrows from the Kizil Ayak repertoire and from that of the Chodor, but the structure is that of Ersari rugs.
R.P.

126

Torba

Turkmen Tribe
West Turkestan
19th Century
32 x 110 cm

In this *torba* — with its hesitant lines and unusual tones, woven with asymmetrical knots open on the left on a cotton foundation without offset warps — certain features bear witness to the acquisition of weaving methods in workshops in the outlying areas of centres occupied by the Turkmen, namely the iteration of the *sekme gul* in the border, and that of the simplified *aina gul* in the field. This should discourage attempts at a precise attribution, though this does not lessen the delight of this small and unusual object, which is complete of its back, woven using thick cotton threads.
E.C.

Suzani
Uzbekistan
19th Century
95 x 125 cm

With the collapse of the Soviet
Union, many types of textiles
began to make their way
through to the West. *Suzani* (lit-
erally 'with the needle') em-
broideries are certainly among
them, although only a small
fraction appears to be of col-
lector's quality. Indeed, the mar-
ket has been swamped with late
examples marred with aniline
dyes. The rare 19th-century
suzanis were intended as dowry
objects, exquisitely embroi-
dered in silk on a cotton foun-
dation, and employed to deco-
rate the nuptial household. They
are ascribed to specific areas
(such as Bukhara, Samarkand,
or Tashkent) on the basis of cer-
tain designs, colour combina-
tions as well as type of stitch.
The Nurata *nim-suzani* illus-
trated here was made as a pil-
low cover. Its characteristic pat-
tern of radially arranged floral
bouquets is made particular
both by the type of star medal-
lion placed at the centre and by
the peculiar stitch employed.
The composition is aptly framed
by a refined, free-flowing bor-
der. The largest and most ex-
tensively studied collection of
suzani embroideries can be
found in Vok 1995.
E.C.

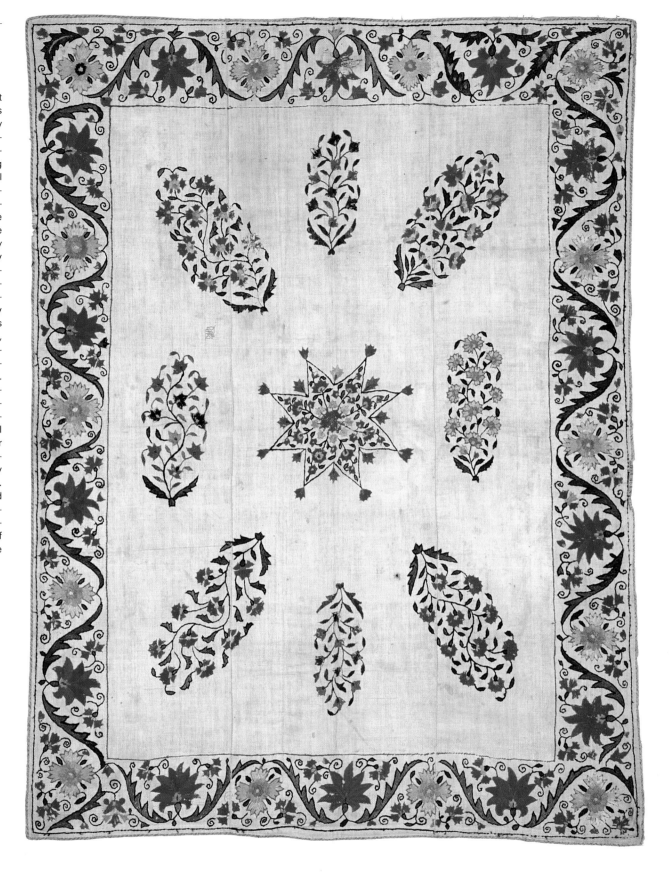

Ikat
Uzbekistan
First half 19th Century
149 x 233 cm

Careful forethought and planning for a design that involves separate dyeing batches of warp threads constituting the visible part of the weave: this is in short the technique that lies behind the *ikat*, a textile common in Insulindia and among the peoples of Turkic stock, principally the Uzbeks; the brief but inevitable phase of dyeing, which comes to light as the threads are pulled taut, is not only the distinguishing trait but underlies the sudden flamed appearance of these textiles. Such a blazing chromatic effect is also seen on silk velvets, where the colour saturation achieves levels of breathtaking resonance. These precious textiles were primarily intended as a kind of haute couture for the Uzbek upper class, although they were employed also as wall hangings, such as the piece illustrated here, decorated by large unusual bi-directional elements flanked by small pairs of *botehs* against a strong-red background.

For further reading on *ikats*, an exhaustive inquiry can be found in Fitz Gibbon and Hale 1997.
E.C.

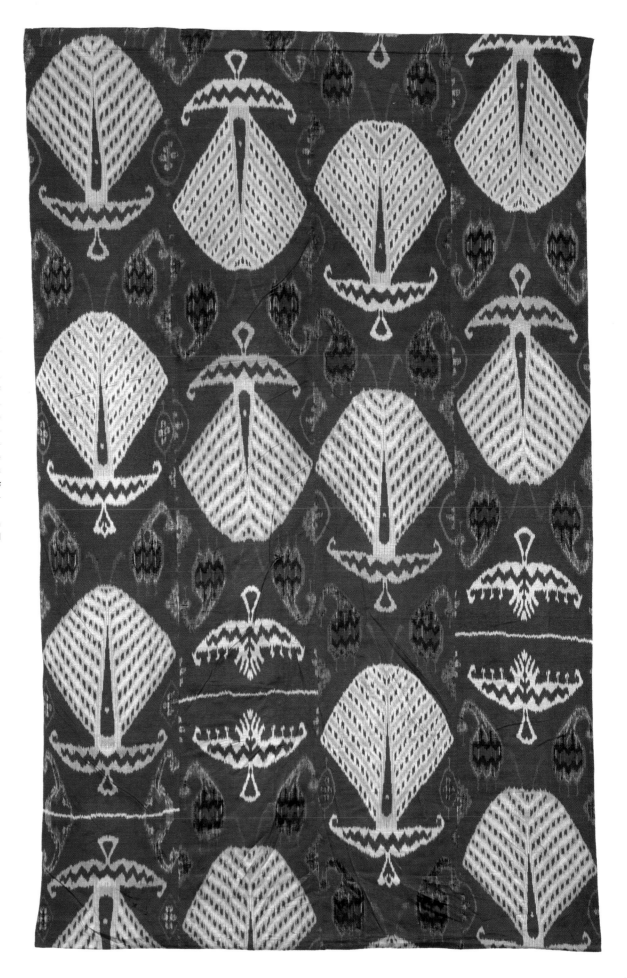

Khorjin
Uzbekistan
Probably 19th Century
38 x 54 cm

This little double bag called
khorjin was and still is used to
transport one's belongings on
the back of a donkey. Many of
these small weavings were
made with particularly loving
care. It is done in weft float bro-
cading and depicts a floral pat-
tern: the field of both flaps de-
picts stylised flowers in three
colour combinations arranged
in diagonal rows. The borders
as well as the middle band al-
so show a diagonal design with
a geometric pattern which may
also have a floral origin.
H.K.

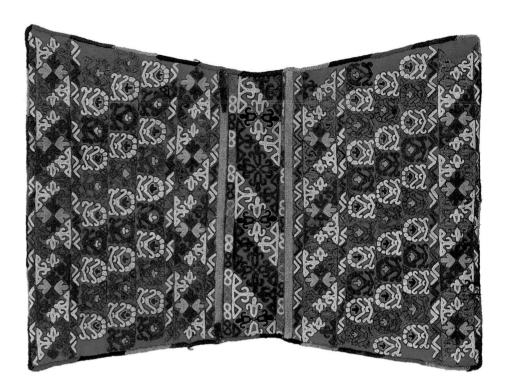

130
Silk Embroidery
Uzbekistan
19th Century
41 x 42 cm

This little silk square shows ar-
chetypal motifs which can be
found from Tibet and Mongo-
lia to Kirghizstan and Turk-
menistan. In fact, it is rather
reminiscent of the Tibetan rep-
resentation of the Dorje. Colours
are sparingly used: the ground
is dark blue while the plain bor-
der is red as is the design of the
field which is outlined in white.
Similar patterns occur on felt
rugs of various Central Asian
peoples.
H.K.

131
Silk Embroidery Vaghireh
Uzbekistan
19th century
44 x 46 cm

The early 19th century witnessed the revival of the textile arts in Central Asia, beginning with Bukhara and Samarkand, gradually involving smaller out-lying towns, influencing their production. This unusual silk embroidery *vaghireh* is an ex-ample of such revival, even though it could be of rural ori-gin and is in many respects sim-ilar to certain weavings of the Lakai Uzbek tribe. For further readings about the connection with the Lakai, it would be use-ful to consult the article by K. Fitz Gibbon and A. Hale which appeared in *Hali*, no. 75, 1994, p. 69 ff., entitled 'Lakai'.
The considerable quantity of designs, minutely concentrat-ed and developed with such astonishing profusion of daz-zling colours, freely juxtaposed for demonstrative need, makes this small weaving an incan-descent treasure.
E.C.

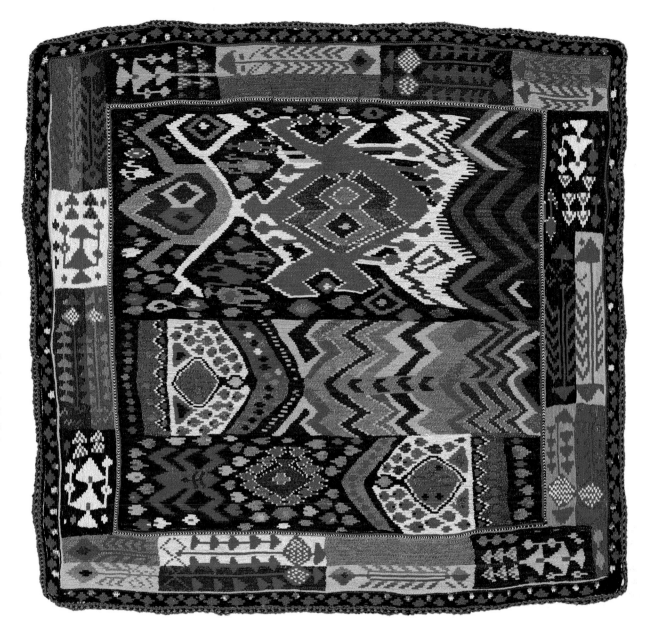

The Rugs of East Turkestan

In 1995 this author made a trip to the oasis cities of East Turkestan in an attempt to verify the standard information of the oriental rug field. At that time it seemed possible to have a clear understanding of the subject, as Kashgar was traditionally associated with a particular kind of silk rug with metal brocade; Khotan was, in the literature, characterised as a place that produced rugs with three dark wool wefts, while Yarkand was associated with light blue wefts and occasionally silk pile. This made for an orderly world in which most rugs could conveniently be assigned a name. Unfortunately the picture once I arrived became somewhat clouded. Starting in Kashgar, I found several carpet factories producing no rugs that were even remotely identifiable as either Chinese or from East Turkestan. No traditional designs were used, and no one seemed to know anything about older rugs. There were many small mosques without rugs, but the enormous Id-Kah Mosque was covered with hundreds of *safs* in the same designs — but with synthetic colours — as those associated in the Western literature with the 1870s, when there was a Moslem/Uighur attempt to become independent from China. Such *safs* for the most part have dark wool wefts in the manner associated with Khotan, and, not surprisingly, I found one inscribed with the name Khotan, presumably as its source. Later I learnt that the rugs were woven in Khotan.

There is a row of rug shops outside the mosque, and yet most of the stock was Kirghiz material, including many pile tent bands, unusual animal trappings, and small pieces of the kind of single-wefted Kirghiz work associated with the area of Andijan. The bazaar shops had few rugs — with none for which a local origin was claimed — and even the Sunday market had only a small number of Khotan type rugs.

Yarkand proved even more barren. While there are a number of towns on the periphery of the Takla Makan still weaving rugs for a government agency, this was no longer the case in Yarkand, where one could find scarcely a trace of a rug.

It was in Khotan that the answers began to emerge. Here was not just a city, but an extensive oasis with over a million and a half people and cultivated land extending over an area about 40 × 40 miles. There is a city of Khotan, but there are dozens of towns and villages scattered throughout the area, and what proved interesting is that different structures were to be found in different parts of the oasis. Dark blue-field rugs with the pomegranate design were found with light blue wefts in one area. Ten miles away in the same oasis there were rugs in traditional Khotan designs being woven with undyed thick cotton wefts. When I asked why dark wool is no longer used, the answer given was that it had been a low-grade wool — thus requiring three shoots — and the two cotton wefts constitute an upgrade.

There was a part of the bazaar with a number of rug shops, which had many pieces they considered old, but which probably did not predate 1900. There the dealers were amused by the Yarkand label, indicating that in times past a number of Khotan dealers had commissioned rugs to be made there, but this was no longer the case. Not a single one of their older stock, including pieces with light blue cotton wefts, was labelled by them as a Yarkand rug. It also became clear that there is a large silk crop in the Khotan oasis, and silk rugs are still being woven there.

As for the silk rugs with metal brocading, not a trace of the older pieces was found, but upon returning to Urumchi I found that very fine versions of this type are currently being woven there in Persian designs. They are sold in the small rug shop in the Urumchi Museum, and they are woven by young women who work mostly in their homes. It seems unlikely, but not altogether impossible, that this production is related to earlier rugs usually labelled as Kashgar.

It seems highly probable that almost all rugs made in Sinkiang come from the Khotan oasis, and this also probably applies to 19th-century rugs we have traditionally called Yarkand. This notion is so ingrained in the rug field, however, that the old labelling is likely to continue, and — whether or not it is correct — there is a general awareness of what is meant when one calls a rug by the Yarkand name.

Yarkand

East Turkestan
Late 18th Century
183 x 375 cm

Three somewhat squarish blue
disc medallions dominate the
plain red field. The small tra-
ditional swastika meander bor-
der remains close to the field,
both in colour and spirit, while
the main border provokes an
explosion with its crenellated
reciprocal design in red and
greenish-yellow.

This is a very satisfactory ren-
dition of one of the aestheti-
cally most pleasing patterns in
East Turkestan. While this de-
sign with its reciprocal border
will usually belong to Yarkand,
there are at least two known
pieces of Khotan origin. Com-
pared to their cousins from
Khotan, carpets from Yarkand
have a rather more solid tex-
ture and strongly depressed
warps. Very often a light blue
weft is used, more rarely the
weft may be yellow. Published
in Eskenazi 1983, pl. 293; Viale
1952, no. 60, pl. 276. See also
Schürmann 1969, pl. 79; Bid-
der 1964, pl. V; Spuhler, König
and Volkmann 1978, pl. 103.
H.K.

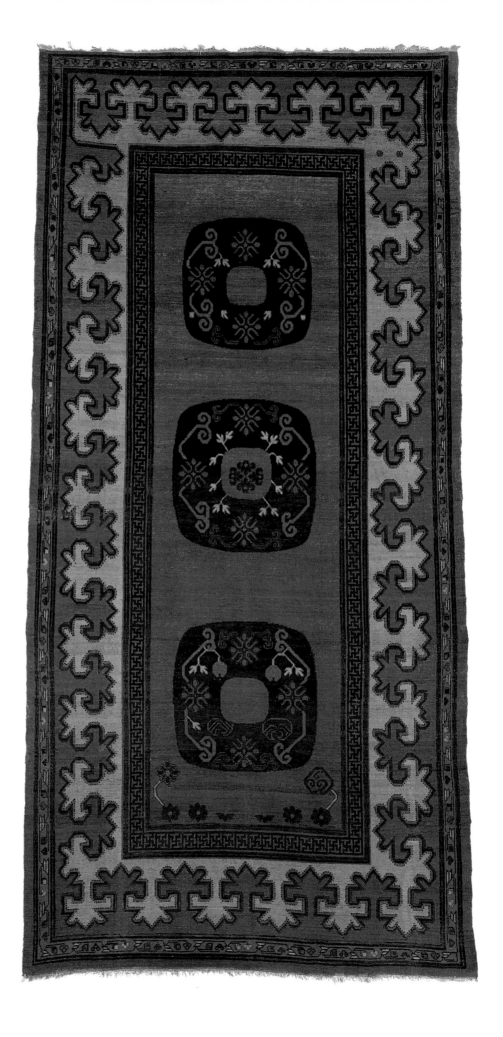

133
Khotan
East Turkestan
First half 19th Century
185 x 370 cm

Though rejected by Constantinople at the Council of Ephesus, A.D. 431, in Asia, and particularly in the Sinkiang region, the heretic doctrine of Nestorius was so successful that some fifteen centuries later it still pervades local memory through its symbols, interspersed with those of the Buddhist faith. The cross figure, around which the entire composition revolves, is the cross of Christ, which emerges in even greater relief in an unusual carpet discussed by J. Eskenazi (1983, pl. 294).
The main border is decorated by a motif representing the primeval mount rising from the elements. In the field, meanwhile, we witness a foretaste — here still graceful — of the oncoming *horror vacui* which, in our own century, would engender spurious compilations of bundled space-fillers.
E.C.

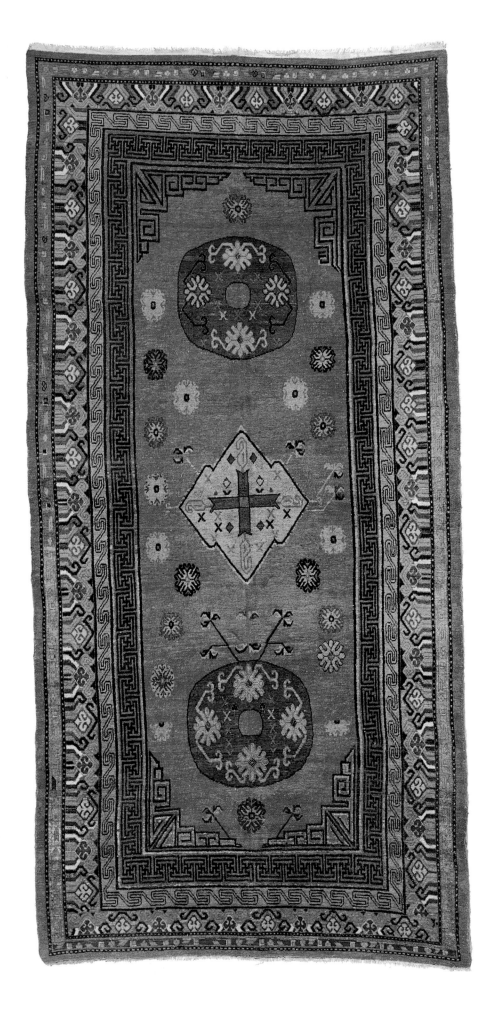

Khotan

East Turkestan
19th Century
115 x 240 cm

The Uygur, a Turkic people in-
habiting the Tarim basin, were
the main carpet weavers of the
oases west of the Takla Makan
desert. These carpets are read-
ily distinguished in homoge-
neous sub-groups via their
technical and stylistic charac-
teristics. Even today, it is com-
mon practice to attribute this
type to one of the three towns
crossed by the southern
branch of the Silk Road. There
is a substantial lack of evi-
dence, however, which at this
point is perhaps beyond re-
trieval (see the account of the
recent visit made by M.L. Ei-
land, Jr., in the introduction to
this chapter), and often the at-
tributions appear to be merely
arbitrary. There may be little
sense in pursuing the matter,
given the continuous branch-
ing out of smaller townships
where undoubtedly weavers
were hard at work. Further-
more, the time-worn labels are
now virtually indelible, and it
would be pointless trying to
hazard systematic distinctions
between the three groups.
The floral forms inserted in the
squares that form the main
border of our rug are given a
different rhythm and are not
free of the framing, as seen on
cat. no. 135 as well as in others
in the same category, whose
provenance has been assigned
to Yarkand. The handsome
blue ground of the three round
medallions stands out against
the red field. This design fea-
ture, together with the rug's
pliable handle, denotes its like-
ly provenance as Khotan.
E.C.

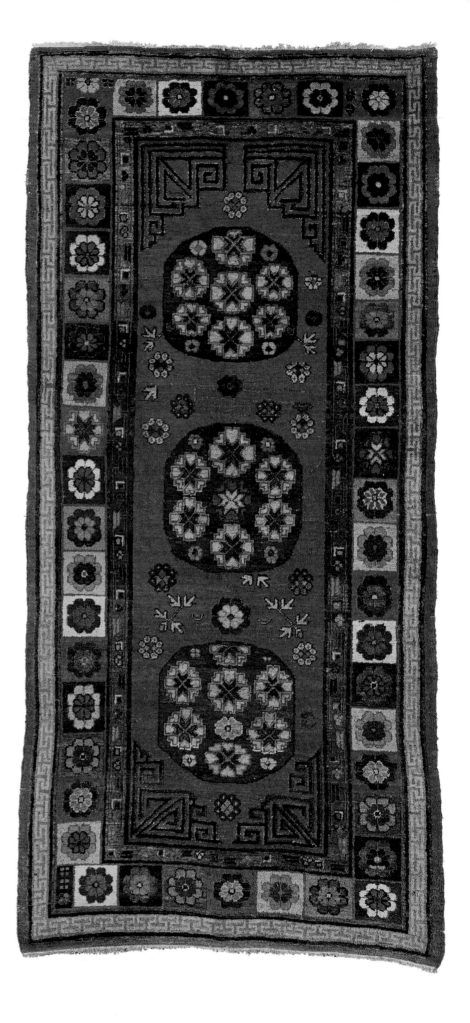

135
Silk Yarkand
East Turkestan
First half 19th Century
210 x 420 cm

Pomegranate trees grow out
of pairs of vases at both ends
of the field and meet in the
middle. The green boughs and
leaves and the red fruit con-
trast harmoniously with the
light blue field. The pomegran-
ate is, in most cultures, con-
sidered a symbol of fertility
and often linked to the orna-
mental objects surrounding the
wedding. In East Turkestan it
is represented so as to show
its interior with numerous pips,
signifying progeny.

Most of the silk Yarkand of this
design and size have the same
colour combination. However,
one piece in the Thyssen-
Bornemisza Collection has a
yellow ground. There are wool
carpets of this size — roughly 2
x 4 metres — with mostly a
dark blue, occasionally yellow,
ground. The wool version is
likely to be older than its silk
counterpart.

There are quite a few smaller
carpets or rugs from Khotan
showing the same design, of-
ten with only one or two vases
on white, yellow or turquoise
ground. The fact that there is a
majority of Yarkand rugs illus-
trated in this book may lead to
a wrong conclusion: most of
the surviving old carpets from
East Turkestan have a Khotan
origin. See Dimand and Mai-
ley 1973, fig. 306; Bidder 1964,
pl. I; Spuhler, König and Volk-
mann 1978, pl. 105.
H.K.

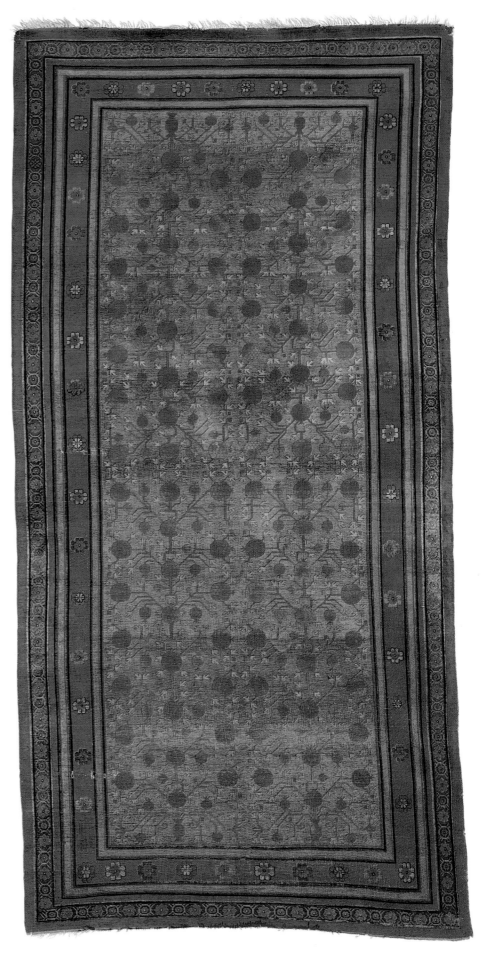

Khotan
East Turkestan
circa 1800
102 x 175 cm

Admiration for the carpets of
the Uygur weavers has always
been universal. These rugs,
with their immediacy and high
legibility yet sophisticated in
their voluptuous elegance, have
found special favour in Europe
especially among enlightened
collectors. Testifying to this ten-
dency is the splendid example
shown here, bearer of ancient
Sino-Tibetan paradigms, atten-
uated by a warm, embracing
palette, that elicits a sense of
refined, mutual intimacy.
E.C.

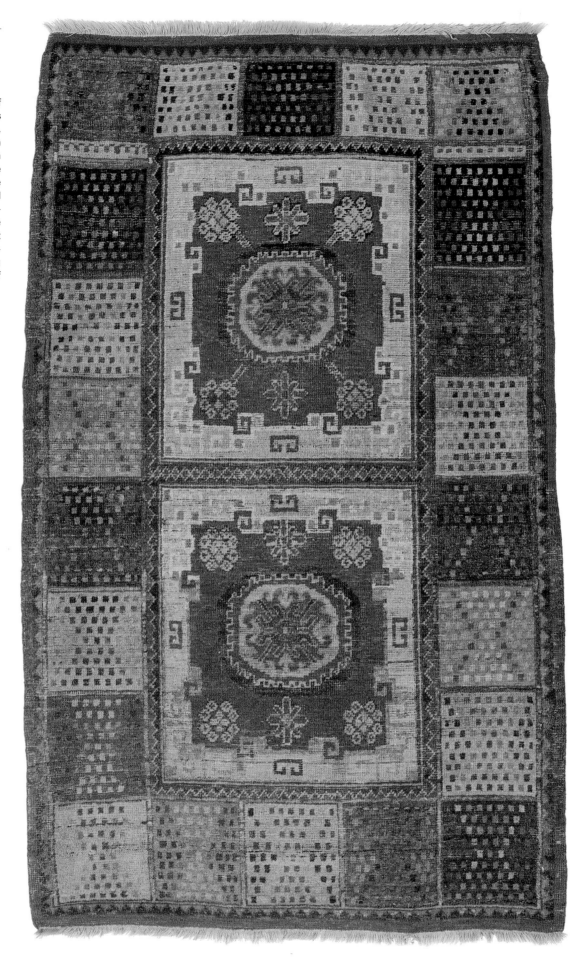

137
Silk Kashgar
East Turkestan
18th Century
51 x 66 cm

This was intended for the back
of an armchair and probably
made for Chinese clients, since
armchairs with backs were not
customary among the local
population in the Tarim basin.
Similar rugs for the same pur-
pose were made in Ningxia, al-
though most of those are of
19th-century origin.
The angular floral scrolls are
characteristic of a whole group
of Kashgar rugs. It might be as-
sumed that the provincial
weavers in the far west of Chi-
nese Turkestan were unable to
reproduce the elegant curvilin-
ear design of Chinese brocades
or embroidery. However, other
fairly early rugs from this part of
the world show flowing graceful
patterns which tend to prove
that the angularity is intended
and probably corresponded to
the taste of either the weaver or
the client. Published in Thomp-
son 1988, pl. 47. See also Schür-
mann 1969, pl. 69.
H.K.

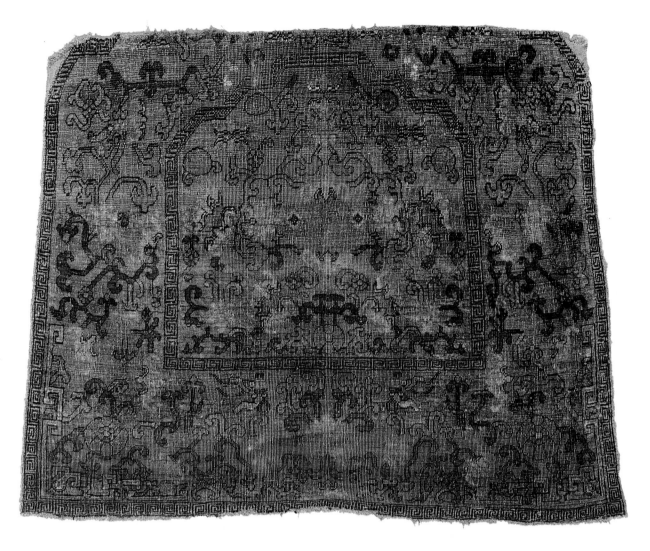

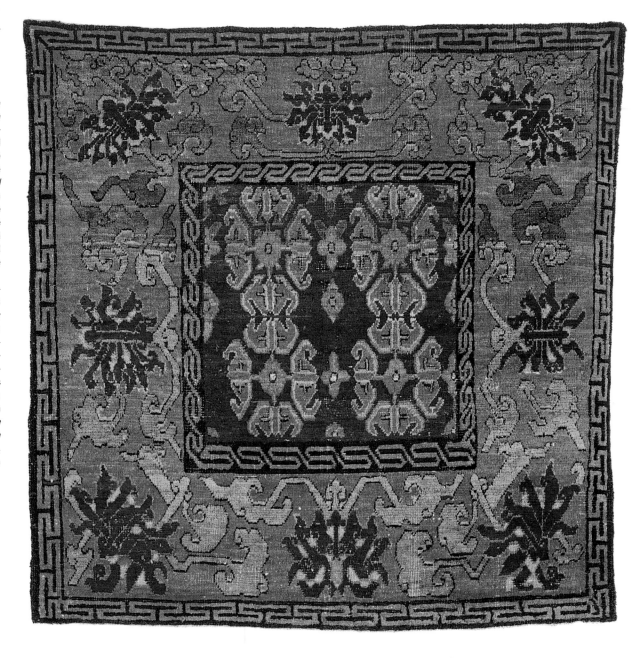

138

Yarkand
East Turkestan
1700 or earlier
99 x 109 cm

This is a well-known rug, one of a pair, that for a long time was in the Bernheimer Collection in Munich. The floral forms in the field remind the viewer of the interior of the rosettes of the coffered *gul* type. However, as Schürmann notes, the charm of this little piece mainly resides in its wide border which radiates joy and strength; both the design and the colour combination create a jewel-like effect.

At present there is not yet unanimity as to the purpose such squares served. Were they used for tables, as cushion covers or seat mats? The pattern of the squares is often influenced by Chinese textile design, much as Chinese textiles and porcelain hit European fashion in the 17th and 18th centuries. Illustrated in *The Bernheimer Family Collection of Carpets*, Christie's, London, February 14, 1996; Schürmann 1969, pl. 78.
H.K.

Khotan Saddle Rug
East Turkestan
First half 19th Century
93 x 184 cm

For the peoples of Northern
Asia, horses were always a pre-
cious resource. Among the to-
kens of affection they accord-
ed their steeds was a spongy
piece of material under the sad-
dle, an accessory that benefit-
ted the animal and was mean-
while an aesthetic addition.
Sometimes, the use of these
protective fabrics was limited
enough to allow for their con-
servation and subsequent
transmission to posterity.
In our rug the mirrored gradu-
ality of the elements individu-
ally arranged interplays with tra-
ditional Chinese dragon figures,
rendered geometrically to com-
pose a spherical anchor — not
just visually — whose centrality
is endorsed by the two individ-
ual elements on either side that,
according to H. Bidder, origi-
nate in the *yun-chien* symbol,
through a 'multicoloured disin-
tegration of Indian influence'
(Bidder 1964, p. 67).
E.C.

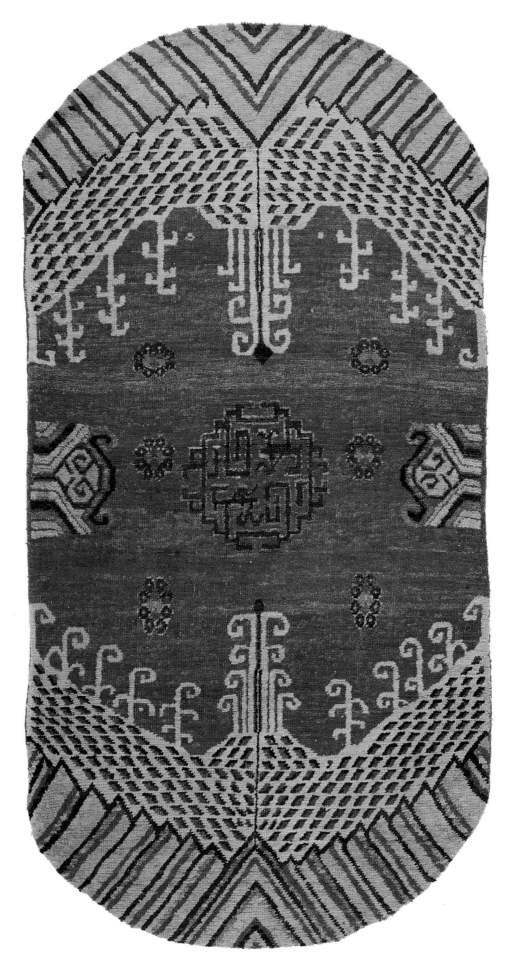

The Tibetan Rug

The Tibetan rug was long such an unknown entity in the West that one of the standard introductory guide books of 1970s assured readers that from Tibet, '... examples of knotted carpet production are lacking'.[1] It was probably not after 1959, when an abortive revolt against Chinese rule sent thousands of Tibetans fleeing the country — mostly for refuge in India and Nepal — that the indigenous Tibetan rug began to appear in the West. Surprisingly, it was found to be constructed in a different manner than any other type of rug still being woven, although the slit-loop technique employed there resembled fragments that had been found by archaeologists at such western Asian sites as Dura-Europos and Palmyra and from several sites in Egypt.[2] The technique seems more complex than it is, as the yarn is brought from the loom toward the weaver and looped over a gauge rod, and these loops are subsequently cut with a knife. It seems an efficient manner of creating pile, however, and a single weaver can weave a rug of about 0.8 × 1.6 metres in about seven days of work. Although the density is low, a curvilinear effect can be created by slight variations in the weave which make the points of colour transition more graceful. One unusual type of Tibetan rug involves the pile yarns being attached only to an upper shed of warp, making the design virtually invisible from the back of the rug. The earliest Tibetan rugs usually have wool warps and wefts, but later pieces may have cotton warps. Rarely one finds a Tibetan piece with silk pile.

In design the rugs owe a great deal to China, as older examples range from direct copying of Chinese design to modifications both in colour and form. Those pieces that appear most Chinese may have a blue and white colour scheme, with slightly stiffer versions of Chinese floral forms, such as peonies and lotus blossoms. At times there will be simplified renditions of Chinese silk fabrics, usually in only two shades of the same colour. These pieces are less likely to have borders.

Carpets ranging farthest from the Chinese model may show dragons — usually in longitudinal profile rather than the full frontal form found on recent Chinese rugs — which may be vividly coloured and somewhat more playful in tone than the more formal dragons of Chinese

rugs. Instead of fo-dogs, the Tibetan rug is more likely to show an animal described locally as a snow lion. The tiger is also a favoured theme, in renditions from the fully drawn beast prowling the jungle to the spread pelt. At times there is no effort to depict the animal, but to suggest the tiger by his stripes only.

There is some hint of a more mobile past among the Tibetans in their occasional use of rugs as tent trappings in the manner of pastoral nomads. One occasionally finds a Tibetan door rug, usually with a quartered field as in a Turkmen *ensi*. Decorative animal trappings are common, particularly horse blankets. Many blanket pairs have survived, and there are two basic types. Some are shaped in the Chinese style, except that the larger lower piece has squared rather than rounded ends, which are more common on the Chinese examples. Another type has a butterfly shaped lower piece.

Rugs made for use in Buddhist temples and monasteries are also common. Many of these are small, squarish pieces described as 'meditation mats', and at times they can be found joined together in long strips as they would have been when the monks sat in rows for meditation. There are also a few rugs meant to be draped around temple columns, and these usually do not have side borders so that the design becomes continuous when the rug is fastened around the column.

After the exodus from Tibet in 1959 the refugees who settled in such places as Nepal began to support themselves with Tibetan handicrafts. Much of this centred around rugs, which soon earned a niche in the Western market. Revivals of natural dyeing began around Kathmandu in Nepal as early as the late 1970s, and many of these rugs showed a meticulous respect for indigenous designs. But most of the production gradually came to take on a more commercial flavour, and by the late 1980s a number of new, western-oriented designs began to appear.

As much as the traditional Tibetan carpet owes to Chinese sources, it still maintains a distinctly separate aesthetic that reflects the manner in which the Tibetan people are temperamentally different from the Chinese. It is the gradual disappearance of this quality that one regrets.

[1] R.G. Hubel, *The Book of Carpets*, New York 1970, p. 283.
[2] Fragments of rugs woven in this technique have also more recently been found at the At Tar Caves, a 2nd to 4th century A.D. site in Iraq. Refer to H. Fujii and K. Sakamoto, 'The Marked Characteristics of the Textiles Unearthed from the At-Tar Caves, Iraq', in *Oriental Carpet & Textile Studies IV*, Berkeley 1993, pp. 35–46.

140

Dove Carpet
Tibet
19th Century
427 x 523 cm

There are no extant specimens of Tibetan carpets predating the 19th century, but the dry climate of the country's highlands (nothing is worse for textile fibres than a high degree of constant humidity), and the innate sense of care and conservation of the Tibetans has meant the survival (despite the repeated, destructive assaults made on this staid and meditative community) of a number of early pile rugs (not only commissioned by the monasteries from neighbouring areas of production, but also imported from more distant regions, such as Anatolia: in fact, it was here in Tibet that the animal rugs of the Seljuk era were rediscovered), knotted works that testify to centuries of appreciation that engendered independent forms of production, realised with special techniques (the so-called Tibetan knot, which entails a series of loops protected along the row by a small rod, which is removed once the weave is ready and the loops have been cut), and sometimes made of yak wool.

Although the design is framed by details borrowed from the Sinkiang area, this outsize carpet, undeniably of Tibetan origin given the techniques employed, is remarkable for the utter originality of its distinguishing single subject, namely doves, suspended, motionless, rendered with composed realism in a neat oval, almost a modern Western form of imagery. It is possible that this unique carpet was made for a specific purchaser or to celebrate an important occasion.

The light blue background, together with the flock of birds express with serene, smooth unicity the decorative adaptability of this exceptional carpet.

E.C.

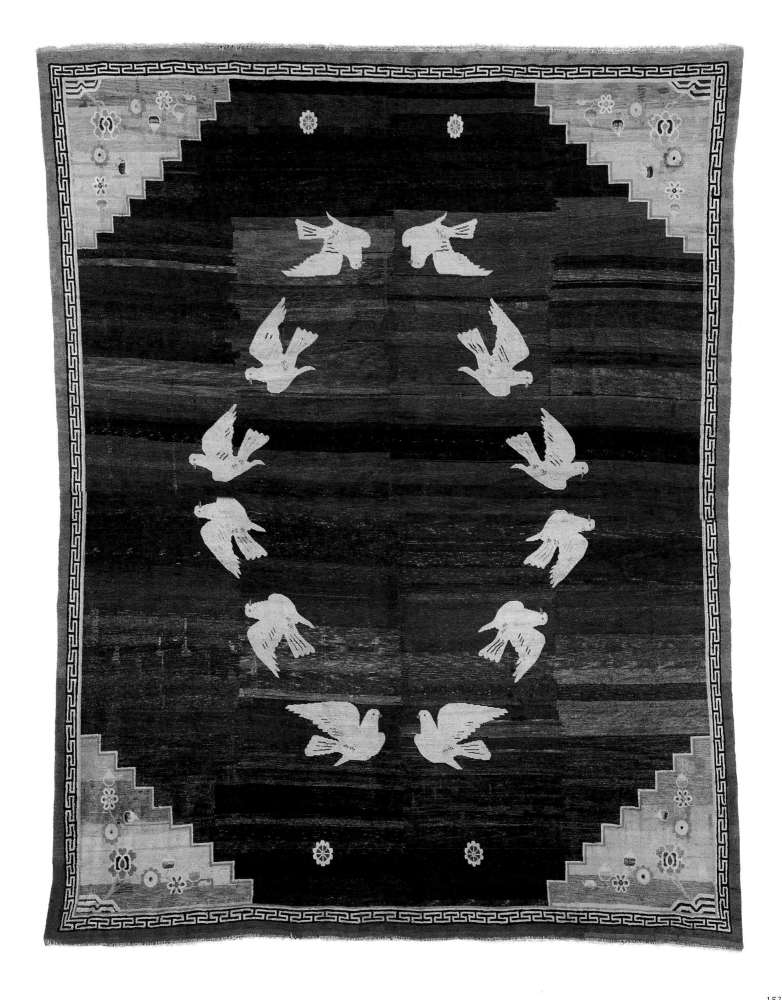

153

Khaden
Tibet
19th Century
93 x 163 cm

This is a Tibetan *khaden* rug whose length is roughly twice its width. On a white ground tree-like forms descend from both ends towards the middle of the rug, four at one end and three at the other. The simple and stark effect is increased by the sparing use of colours which favourably compares with the rather garish chromatic combinations of some of the later Tibetan rugs. The tree-like forms can probably be linked to the symbol of the tree of life, an archaic motif which transcends into the art of all religions in Asia. Seen from a distance, this rug is somehow reminiscent of a felt rug.
H.K.

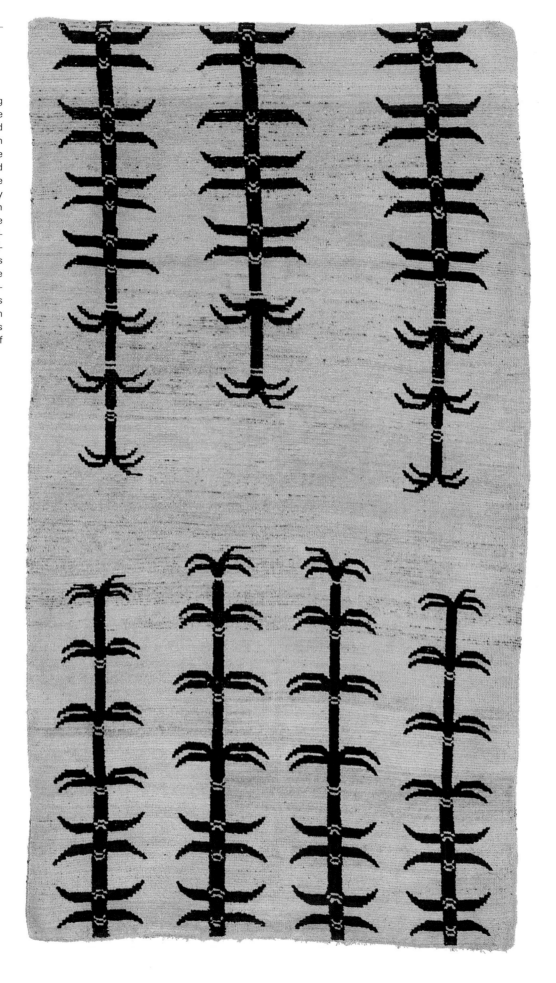

142

Pillar Rug
Tibet
19th Century
70 x 150 cm

This Tibetan *khaden* has an un-
usual and attractive design. The
upper end is marked by a key
fret border and underlined by
a light blue stripe. From this
horizontal arrangement, dark
blue and green floral clusters
are suspended over less than
one quarter of the field. The rest
of the field is a plain but lively
red, except for the lower end
which is likewise monochro-
matic but in off-white.
The *khadens* were normally
used as seat mats or bed cov-
ers. This piece may have cov-
ered a rectangular pillar since
there are clear traces of wear
along two straight vertical lines.
H.K.

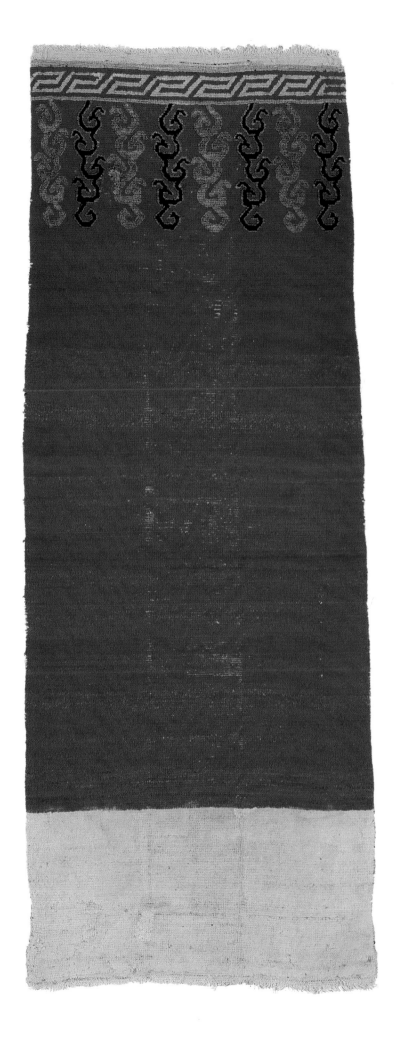

Chinese Carpets

[1] While I heard such comments from Ellis a number of times, I have not, as yet, found any place where he committed them to print.
[2] The Gion Matsuri rugs are described by N. Kajitani and K. Yoshida, *Gionmatsuri 'Yama' 'Hoko' Kensohin Chosa Hokokusho: Torai Senshokuhin no Bu*, Kyoto 1992, Gion Festival Committee. I discussed the matter with Ellis on his return from Japan, and he was convinced that nothing there predated 1800.
[3] Those rugs often described as probably Ming are often as coarsely knotted as about 12 knots per square inch and seldom exceed 30. The wefting is somewhat variable, and there are often two rows of knots between the passage of wefts. The colours include less use of blue than is common on other types, little if any of the eroded brown seen on the traditional Ningxia type, and one or two greens, which are uncommon on other Chinese rugs. The field is often a pale rosy brown dyed with brazilwood.
[4] M.L. Eiland, Jr., 'The Earliest Chinese Rugs', in *Papers, Presentations, 7th International Conference on Oriental Carpets,* Düsseldorf 1996, pp. 115–28.
[5] J.B. Du Halde, *Description géographique, historique, chronologique, politique, et physique de l'Empire de Chine,* Paris 1735, IV, p. 468.
[6] Id., *The General History of China,* 3rd edition, London 1741, IV, p. 224.

Chinese carpets have always been problematic to Oriental carpet collectors, and scholarship on the subject has been a relatively recent phenomenon. The late American scholar Charles Grant Ellis often made statements[1] to the effect that none of the surviving Chinese rugs predate 1800, and even a group of rugs in Japan listed in 17th-century inventories was thought by him to include only 19th-century pieces.[2] Such views were not uncommon several decades ago, but in the meantime a group has been identified that is now often being described as Ming work.[3] Somewhat more plausibly this same group is being increasingly linked with the Chinese Imperial household, and several rugs of this distinctly identifiable type are currently found covering platforms of the great reception halls of the Forbidden City.

But rug scholarship is seldom so simple, and in this case history provides some difficult hurdles for the idea that these rugs were both used in the Forbidden City and had continued in use there during various vicissitudes of fortune. These include the burning and looting of the Summer Palace complex in 1860 at the climax of the last Opium War, the complete looting by European armies of the Imperial Palace after the Boxer Rebellion was crushed in 1900, and the Japanese occupation of Beijing in 1937, prior to which everything movable was shipped to Taiwan, where it is now part of the Imperial Palace Museum in Taipei.[4]

Just how Ming carpets would have survived in place during these upheavals challenges even the creativity of carpet scholarship, but it is clear that there is much we do not know about Chinese rugs.

This begins with their places of manufacture and thus the labels applied to them. Our best early documentation comes from a group of French Jesuits attached to the court of the Emperor K'ang Hsi.

One of them, Father Gerbillon, made a journey into Gansu with the Emperor K'ang Hsi in 1697. At Ningxia, he noted, 'they also presented to his majesty several floor rugs, somewhat resembling our floor rugs of Turkey, only more coarse. They are made here, and the Emperor was curious to see them worked in

his presence...'[5] Currently early Chinese rugs not part of the group described above are almost universally described by the label, 'Ning Xia'.

Yet another Jesuit, Father Du Halde mentioned that in Taiyuan, capital of Shanxi, 'besides the silks which are wrought here, as elsewhere, they make fine carpets. Such as Turkey ones, of all sizes'.[6] Certainly this is adequate reason to believe that rugs were woven in Taiyuan, but the label is essentially never applied to an early rug, despite the fact that there are a number of distinct groupings within the larger category of pieces described as Ningxia. Considering that the rugs mentioned above as associated with the Imperial Palace are clearly not Ningxia products, this suggests yet another unknown place of manufacture.

It thus again points out that our understanding of early Chinese rugs is limited and may remain so. There has been progress, however, in that we no longer feel any reluctance to identify a Chinese rug as dating from the 17th or 18th century, although we must develop clear criteria for making such assertions.

143

Silk Rug with Inscription
China
Before 1700
90 x 178 cm

While this carpet has been summarily ascribed to China, a better definition would be the 'area of Chinese cultural influence', though this expression's meaning and implications have somewhat faded. The characteristics of this silk pile rug offer enough evidence to exclude Tibet as one of the possible sources of manufacture. Similarly, the oases around the Takla Makan desert (from Kashgar and Kansu to Khotan and Kucha) must be excluded, likewise Mongolia, and the Chinese 'continent'. It is worth noting that the rug is complete with both side and end finishes. It has slightly depressed warps and the asymmetrical knotting is tighter than usually found in the Chinese cultural area. To venture an interpretation of the figure (an ideogram, perhaps?) that emerges in strong chromatic relief would perhaps be stretching a point. The (sole) intention to interfere with the resolute monochromatic scheme is achieved by diminishing the yellow along rows of equidistant small circles. The possibilities are myriad, and while the design may be dictated by some practical need or particular use, it is nice to read into it some kind of symbology (such as the pearl, a favourite in Chinese imagery), or metaphorical statement (i.e., the *chintamani*, which seems to originate in this part of the world), or maybe distant echoes of Byzantium (Gantzhorn 1991, p. 119), or reminiscences of primitive imagery, or, not least, a mere product of the weaver's whim.

What we said earlier in the case of the carpet with empty field (see cat. no. 44) applies to the present rug as well, notwithstanding the absence of a border, the type of material employed, and the colour scheme: the border frames an entity, identifying it as something self-sufficient, as a particle of infinity applied to represent infinity, while its 'absence' forces the observer to recognise and isolate that same essence, committing him individually. Wool tends to absorb light more read-

ily than silk, which instead induces colours to vibrate with metallic iridescence, like moonshine, arousing discontinuous, alternating, deconcentrated sensations. The yellow represents the authority of a millennial empire, and that of a culture which overtook half the world; the yellow, combined with the silk support, transmits a sense of withheld emotivity, luxurious discretion, and relaxed aloofness.
E.C.

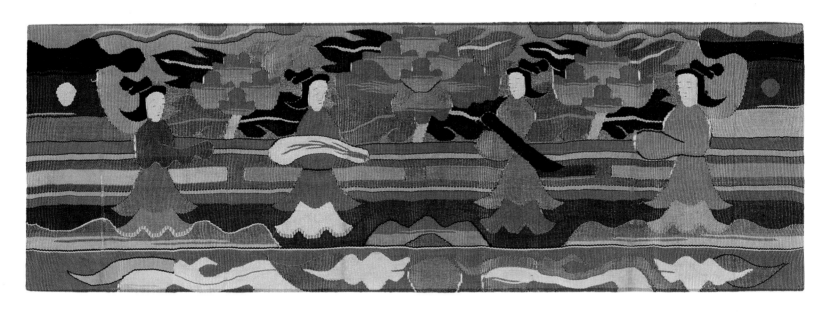

144
Silk Kesi
China
16th Century or earlier
13 x 40 cm

This little fragment is a part of
a *kesi*, a piece made in tapes-
try technique. It tells us a sto-
ry: for a special occasion, at-
tendants or courtiers arrive in
a procession from the left and
the right carrying gifts on their
outstretched arms. The other
part of the background shows
stylised lotus flowers while, at
the bottom, there are two ab-
stract dragons with a ball or a
pearl between them. The *kesi*
is in perfect concordance with
the standards of tapestry weav-
ing during the Ming period,
however its design, with four
persons acting a part, its com-
position and its colour scheme
lend it a special charm.
H.K.

145

Ningxia
Northwest China
Circa 1600 or earlier
112 x 130 cm

Although only a fragment, this is a piece of great importance for the history of the Chinese carpet. It is a cut-off section of an elegant curvilinear design on a light tan ground. The size of the individual design units gives an idea of the vast dimensions this carpet must have had. The leaves or flowers are depicted in green, dark blue, gold-brown, dark brown and yellow.

This piece is very similar to a somewhat larger fragment in the Frankfurt Museum für Kunsthandwerk. The concept and the spirit, as well as the colour scheme are the same, although the two fragments definitely belong to different carpets.

Several fragments of this type of carpet are in existence. They are slightly different in style and feeling from most of the other carpets that have survived from the Ming period. P.W. Meister, the then director of the Frankfurt Museum, very convincingly attributed this fragment to the second half of the 16th century. Cf. Lorentz 1973, pl. 20. See technical analysis in *Appendix*.
H.K.

Clouds and Cranes Carpet
Ningxia, Northwest China
Circa 1700 or earlier
190 x 365 cm

An attractive early carpet be-
longing to a group distinguished
by the cloud pattern on a dark
blue ground. Although the
cranes appear naturalistic, they
are in effect highly stylised,
arranged in a way that follows
the order established by the hor-
izontal rows of cloud forms. The
border is a classical swastika
meander. The outer guard stripe
is kept in the more or less cor-
roded brown-grey of the ma-
jority of old Chinese carpets.
It has been possible to trace 21
examples of this particular
group: ten of them have cranes
while eleven show the cloud
pattern only, sometimes in vary-
ing colour combinations, but al-
most always on a blue ground.
The best-known and possibly
one of the oldest examples of
the cloud pattern with cranes is
the carpet in the Textile Muse-
um, Washington, D.C., on which
the clouds of the field design
alternate with bats. See Ellis in
Textile Museum Journal, vol. 2,
no. 3, pls 40 and 42, left side.
H.K.

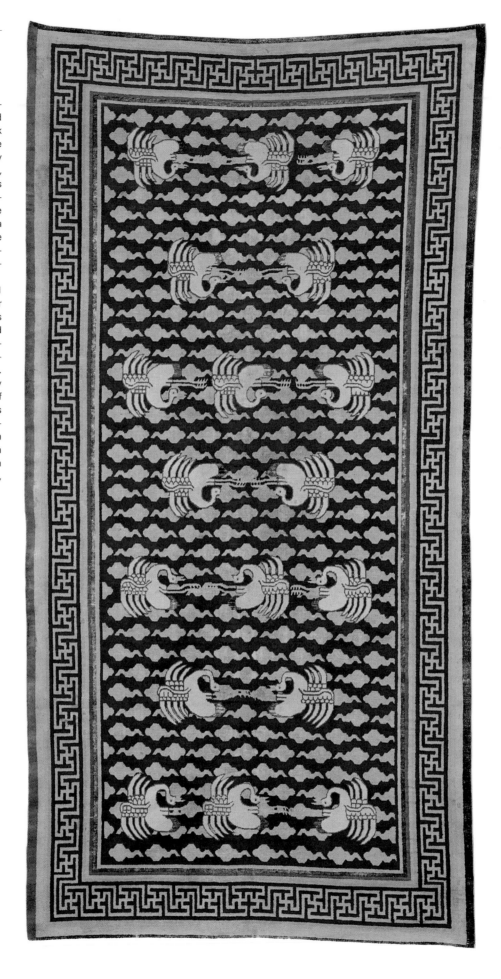

147

Lotus Flower Carpet
Ningxia, Northwest China
First half 18th Century
165 x 258 cm

Scrolling vines linked to flowers, buds and leaves cover the reddish-tan ground of this carpet. This floral pattern at first gives the impression of an overall design. However, it is actually very well structured. The centre is marked by a large blue flower and the spandrels are occupied by four outward-looking flowers, while the rest of the field is clearly and symmetrically subdivided by other flowers.

This border type occurs in a number of carpets that are usually attributed to the Yong Zheng period (1722–35). Our carpet's border is unusual in that there are depictions of masks or grotesque heads resembling the Tao Tie designs on classical bronzes that are 2,000 years older. See Ellis in *Textile Museum Journal*, vol. 2, no. 3, p. 36 (T.M.R. 5126) and p. 49.
H.K.

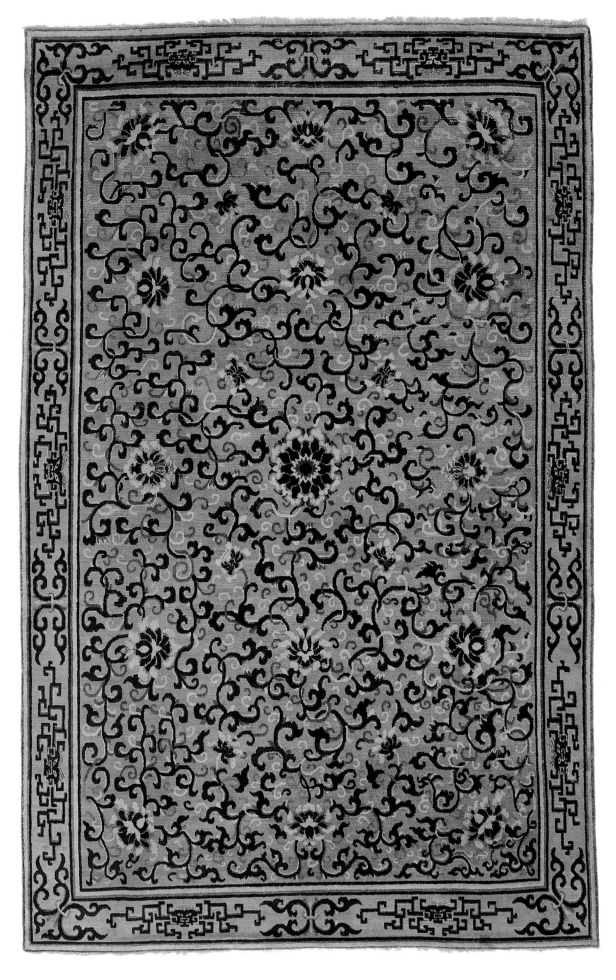

Octagon Rosette Carpet
Ningxia, Northwest China
Early 18th Century
180 x 319 cm

The ground of this distinguished
carpet is completely covered by
a repeat pattern: octagons filled
with rosettes that alternate with
squares in staggered rows. This
pattern occurs on Chinese car-
pets of all sizes up to the second
half of the 19th century. In its ef-
fect it often resembles tiles cov-
ering a wall or a floor.

It will be noted that the inner
border is formed by halved oc-
tagon rosettes in a colour com-
bination different from the field.
These split octagons in anoth-
er colour create an illusion of
depth and of a third dimension.
The other border is the tradi-
tional swastika fret with a
change of direction half way
along the sides of the carpet,
while the usual brown-grey out-
er stripe is separated by light
blue and yellow bands.
H.K.

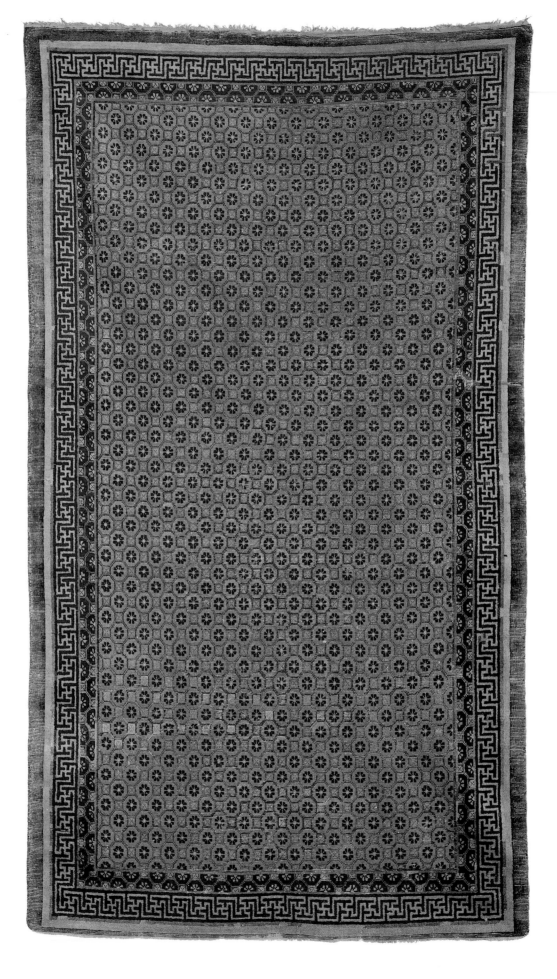

Dragon Carpet
Ningxia, Northwest China
18th Century
153 x 312 cm

The central medallion is formed by two blue foliate dragons; it is inscribed in a square composed of a design echoing the inner border and carrying in its corners a triangular fretwork which is probably also derived from stylised dragons. Two pairs of spotted khilin appear to frolic joyfully in the two lower halves of the field.

The ground colour is a very light pinkish-beige which would correspond to the — erroneous — idea that old Chinese carpets should be blue and white like the best known variety of Chinese porcelain.

Although the design is geometrical or stylised, the carpet has a delicate and dainty, almost 'feminine', appearance. See Tiffany Studios 1976, pl. III.
H.K.

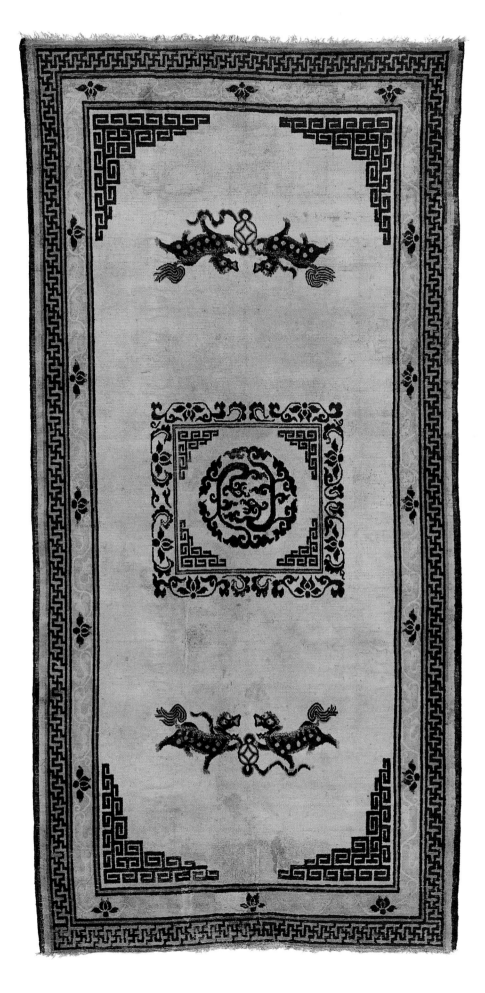

**Carpet with
Longevity Pattern**
Ningxia, Northwest China
circa 1700
180 x 267 cm

The cloud lattice, also called 'longevity pattern', is probably a very old archetypal design found in Central and Eastern Asian cultures. It was known and used beyond the borders of China proper, e.g. it is frequently found on East Turkestan carpets, as well as on Kirghiz rugs; there also is a definite link to the design of certain Mughal Indian carpets.

Bats and smaller stars are inscribed in the quatrefoils in alternating rows. The repeat pattern of quatrefoils and stars conveys a powerful and noble impression. In this carpet the somewhat severe lattice is unexpectedly opposed to a sophisticated and elegant border.

Both lattice and border design are not confined to pile carpets; they also occur in classical Chinese furniture and architectural ornaments. See Lorentz 1973, pl. 31; Herrmann 1991, pl. 77; Ellis in *Textile Museum Journal*, vol. 2, no. 3, p. 44, top, no. 5; Larsson 1988, pl. 6; Tiffany Studios 1976, pl. VIII; Schürmann 1969, pl. 96.
H.K.

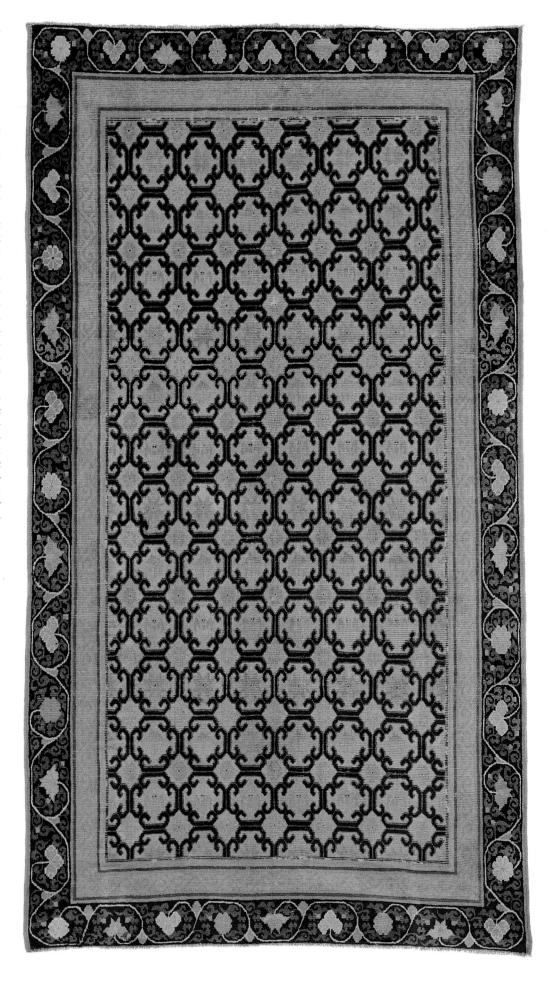

151

Medallion Carpet
Ningxia, Northwest China
First half 18th Century
175 x 253 cm

Here again the field is covered by the octagon rosette and square pattern (the squares themselves are subdivided by swastikas). However, its subdued colour scheme makes it an appropriate backfoil for the strong medallion. This medallion is composed of two elaborate foliate dragons forming a circle; eight smaller foliate elements are arranged around it, the whole creating a polygonal medallion which, in this form, is typically Chinese. The same type of medallion on East Turkestan carpets is more geometrical and angular (see Schürmann 1969, pl. 87, Victoria and Albert Museum). The inner key fret border separates the field from the enchanting main border with its scrolls of lotus flowers and winged leaves on a dark blue ground (see also border on cat. no. 150). See Tiffany Studios 1976, pl. IV; Herrmann 1991, pl. 75.
H.K.

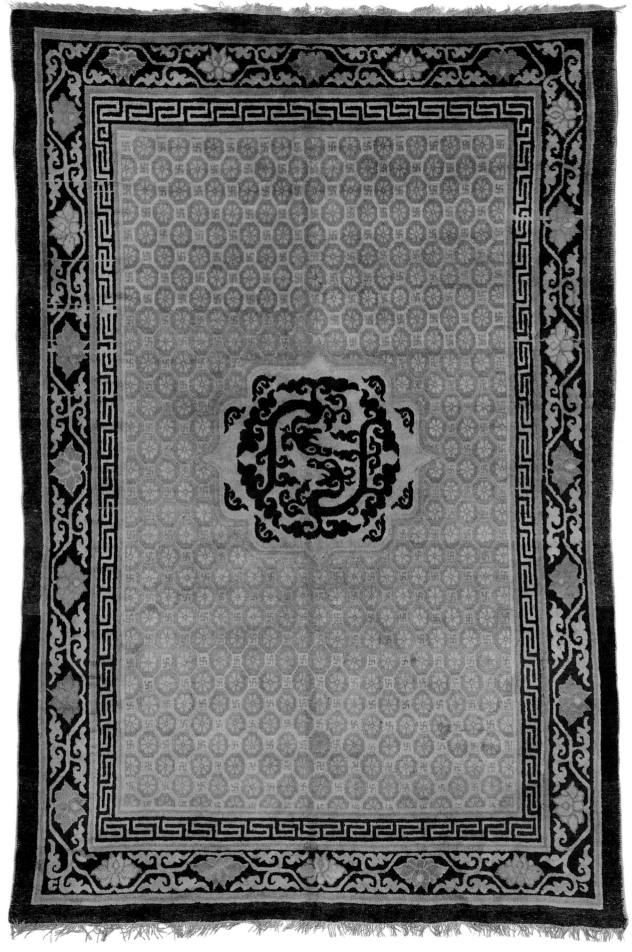

152
Peony Carpet
Sinkiang (?)
17th–18th Century
136 x 243 cm

In their presentation of a cushion cover of identical colouring and design in the Metropolitan Museum, New York (a second one, in a private collection, is similar but with blue figures on a red background), M.S. Dimand and J. Mailey (1973, fig. 280) date it to the 17th century, ascribing it to China. The curvilinear floral elegance of the lotus-peony emblem, known also as 'The Precious Image Flower', endorses the origin of the piece; but further to the stylistic issues, the technique involved would suggest for this recomposed carpet (originally it must have been far larger) a source closer to East Turkestan. Consequently, the dating given to the piece may be too early. One could postulate the existence of an urban workshop situated in the fertile outskirts of the Takla Makan desert, active in the 18th century.

What remains is the refined, tempered elegance of this rare type, and the confirmation that the chromatic moderation of the palette adds to a well-articulated design a quiet feeling of consummate knowledge. See technical analysis in *Appendix*.
E.C.

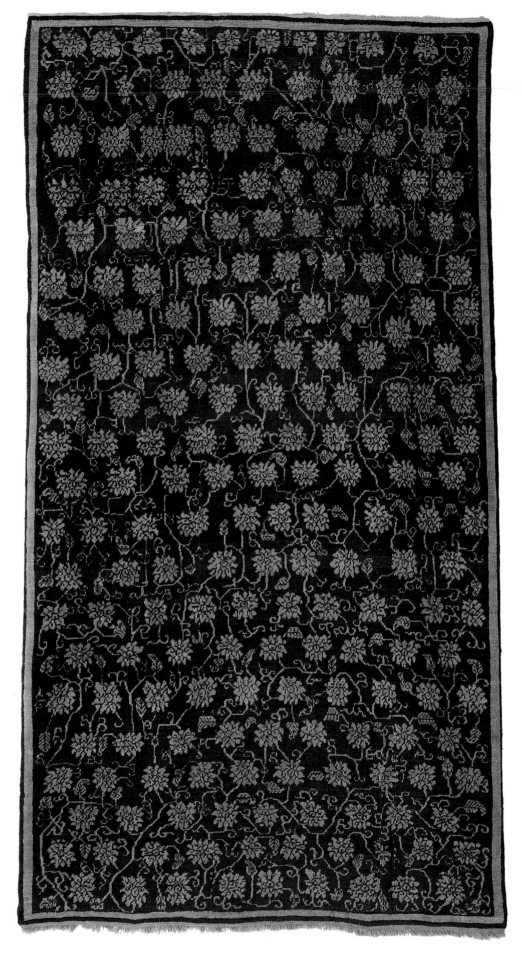

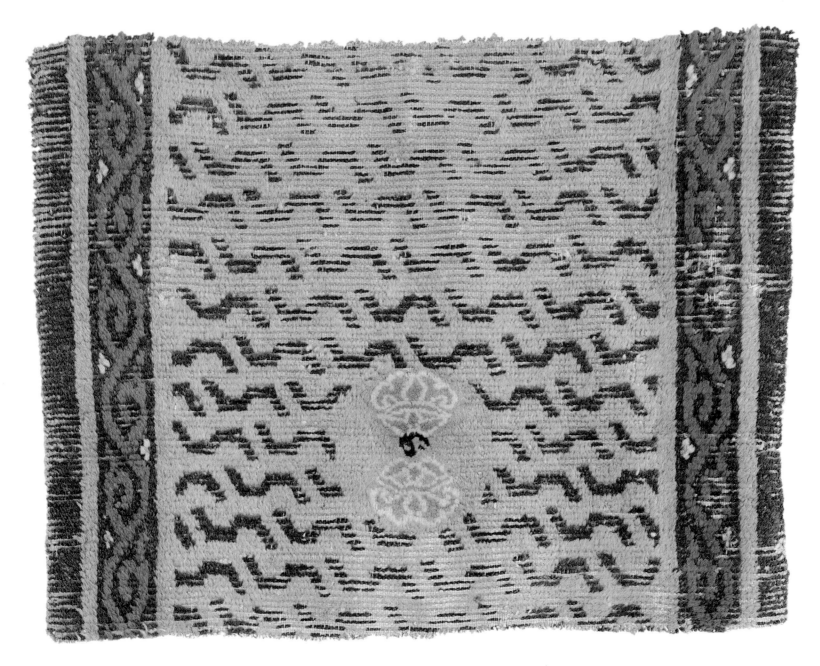

153

Tiger Pelt Carpet Fragment
Ningxia, Northwest China
18th Century
60 x 81 cm

This is a fragment of a long carpet; it would be tempting to regard it as another part of the longer fragment illustrated by Herrmann. However, neither the measurement (81 cm wide compared to 90 cm for Herrmann's piece) nor the medallion-like ornaments distributed along the middle axis fit together.

The dark brown linear shapes on the yellow tan ground create a simple but striking pattern. While the main colours, brown and yellow, are evocative of a tiger pelt, we feel that it is not another variant of the tiger stripe design. The blue border on a dark brown ground belongs to the standard repertory of classical Chinese carpets. See Herrmann 1991, pl. 76; Herrmann 1988, pl. 125.
H.K.

154

Saddle Rug
Ningxia, Northwest China
Circa 1700
90 x 138 cm

It has been customary to call
these weavings 'saddle rugs' al-
though, strictly speaking, they
were placed beneath the saddle
and did not cover it. Such 'true'
saddle covers were occasional-
ly, but rarely, made (Herrmann
1990).
Joseph V. McMullan, the great
American collector, did not have
any Chinese rugs in his famous
collection except for 18 saddle
rugs which he called Mongol.
We prefer to attribute them to
the Ningxia area. This rug is very
likely supposed to represent a
tiger skin. The border design,
which is very rare, enhances the
tiger impression. Published in
Eskenazi 1983, pl. 332. See also
McMullan 1965, pl. 140.
H.K.

155

Saddle Rug
Ningxia, Northwest China
Circa 1600 or earlier
58 x 127 cm

This may be the oldest of the
surviving Chinese saddle rugs.
Its form is the same as that of
cat. no. 154, as opposed to an-
other type of saddle rug which
is not rounded but has an in-
dented rectangular shape. A lat-
tice of blue and white peonies
covers the tan field which makes
for a very discreet colouring.
Two stripes function as inner
borders. Contrary to what is
normally the case, the field pat-
tern goes beyond the dark
brown-black inner border. This
little rug has an unusually fine
weave.
Amateurs of Chinese art know
that such saddle rugs frequently
appear on paintings from the
Song to the Ching dynasty. Pub-
lished in McMullan 1965, pl. 135.
H.K.

The Carpets of Mughal India

[1] S.J. Cohen, 'A Fearful Symmetry: the Mughal Red-Ground Grotesque Carpets', in *Silk and Stone: the Art of Asia*, London 1996, pp. 104–35.

[2] F. Sindermann, 'A Group of Indian Carpet Fragments with Animal Grotesque Design on a Red Ground', in *Oriental Rug Review*, vol. 15, no. 5, June–July 1995, pp. 21–7.

[3] D. Walker, *Flowers Underfoot: Indian Carpets of the Mughal Era*, New York 1998.

[4] A. Fazl, *Ain-i-Akbari*, translated by H. Blochman, Calcutta 1873, p. 55. In searching for this frequently cited reference, the author first came across the earlier Gladwin translation, which, inexplicably, omits the information that carpets were still imported from Persia. Subsequently the Blochman edition of the original manuscript has revealed that the material is, indeed, there. Perhaps Gladwin thought it was unimportant.

[5] All the rugs discussed in this and the next paragraph are illustrated in E. Gans-Ruedin, *Indian Carpets*, New York 1984. They are, in the order noted above, on pp. 136, 135, 120, 104, 123, and 84.

[6] M.L. Eiland, Jr., 'Some Unresolved Technical Issues', in *Oriental Rug Review*, vol. III, no. 8, November 1983, pp. 312–17.

The carpets of Mughal India have received increasing attention during the last several decades. The long-term puzzlement about the red field animal grotesque carpets has been worked out and resolved by both Cohen[1] and Sindermann,[2] and the Metropolitan Museum in New York has mounted a lavish display of some of the most dramatic surviving Mughal carpets.[3] Moreover, Indian carpets have finally reached the respectable price levels in the international auction scene, with some impressive prices both for the 'millefleurs' prayer rugs and for the finely woven larger carpets. This attention is surely gratifying to those who have long felt a special interest in the Indian carpet, but before we lapse too soon into a congratulatory sense that we have solved the problems presented by these carpets, it may be useful to focus upon many questions that are still unresolved and aspects that are still puzzling. First we know from the *Ain-i-Akbari*, a chronicle written by Abul Fazl, the emperor's minister and friend, that 'Akbar caused carpets to be made of wonderful varieties and charming textures; he appointed experienced workmen who have produced many masterpieces. The carpets of Iran and Turan are no more thought of, although merchants still import carpets from Goshkan [Joshagan?], Khuzistan, Kerman, and Sabsawar. All kinds of carpet weavers are settled here, and drive a flourishing trade'.[4] The question arises as to what has happened to these carpets. They appear in the illuminated manuscripts of Akbar's time — some of which are larger and more detailed than the contemporary Near Eastern miniature paintings — and they show carpets and the kind of designs associated with carpets. They do not, however, show designs that are anything like what we find on the carpets seen in Daniel Walker's catalogue of the Metropolitan exhibit, and it would seem as though no rugs of the sort depicted in the art of Akbar's time (he died in 1605) or from the entire 16th century have survived. This seems surprising when so much Indian art of the period, including the paintings, has survived, and one would expect a carpet attributed to the late 16th century, for example, to show designs suggestive of those found among the paintings surviving from Akbar's time. Another apparent discrepancy concerns the silk rugs

associated with the Mughal court of Akbar or his successors, Shah Jahan and Jahangir. These include a fragment in the Victoria and Albert Museum,[5] along with another piece presumed to be from the same carpet in the Kunstmuseum, Düsseldorf, which are clearly in the style introduced by Jahangir in which individual flowering plants and shrubs are repeated across a red field, at times with a field divided by a lattice. These pieces are extremely fine and gracefully drawn. Another silk fragment in the Keir Collection shows an elaborate quatrefoil lattice with meticulously drawn flowering plants. Perhaps the most interesting Mughal piece of this genre is one first published by Hendley and still to be found in the City Palace Museum in Jaipur today. This shows a silk foundation combined with a wool pile of extraordinary softness. The well-known Frick carpet also comes into this category, and a particularly fine silk pile rug is to be found in the Musée Historique des Tissus, Lyon, with a knot count exceeding 900 per inch. The apparent discrepancy here is that these rugs are usually dated to the 17th century, as are the relatively coarse animal carpets with which they share essentially no design elements. Could the silk rugs and animal and hunting carpets date from the same decades? Another issue first described in print by this author twenty years ago[6] concerns the issue of whether the warps on some of these rugs — attributed almost universally to the early 17th century — are handspun or spun by the kind of machinery that was not developed until the late 18th century. In other parts of the rug weaving world, particularly regarding Chinese rugs, there has been a rule of thumb that cotton warps of more than 5 or 6 strands are likely to be machine spun and therefore late. No explanation has yet been offered for why the warps in most Indian carpets generally labelled as 17th-century work range from 8 to 12 strands, when this would appear to suggest that they were not handspun. So even though there has been great progress in understanding the rugs of Mughal India, important questions remain.

Mughal

North India
Last quarter 16th–
first half 17th Century
70 x 185 cm

This is a known, but previous-
ly unillustrated fragment from
an enormous carpet (or possi-
bly even a pair of carpets) once
owned by the Hindu Rajput
rulers of Amber-Jaipur in North
India. While some fragments
are reputed to be in the now in-
accessible Jaipur carpet store-
rooms, others left that collec-
tion earlier this century and are
now owned by the Calico Mu-
seum in Ahmedabad; The Tex-
tile Museum, Washington, D.C.;
Brooklyn Museum; Howard
Hodgkin Collection, London;
Wher Collection and other pri-
vate collections. Typical in its
construction (thick multi-strand-
ed cotton warps Z8, 10 and 11S),
colouring (rich red ground and
much use of ton-sur-ton), and
design (many wisteria-like
racemes) of other early North
Indian knotted-pile carpets. De-
spite its condition, this fragment
remains an important artefact
because of its date and relative
rarity. Other fragments from the
same carpet are published in
Walker 1997, pp. 47–8, 50–1, figs
41–4, cat. nos 7a–7c. The latter
is the best description of this
carpet's structure, history and
its original design. See techni-
cal analysis in *Appendix*.
S.C.

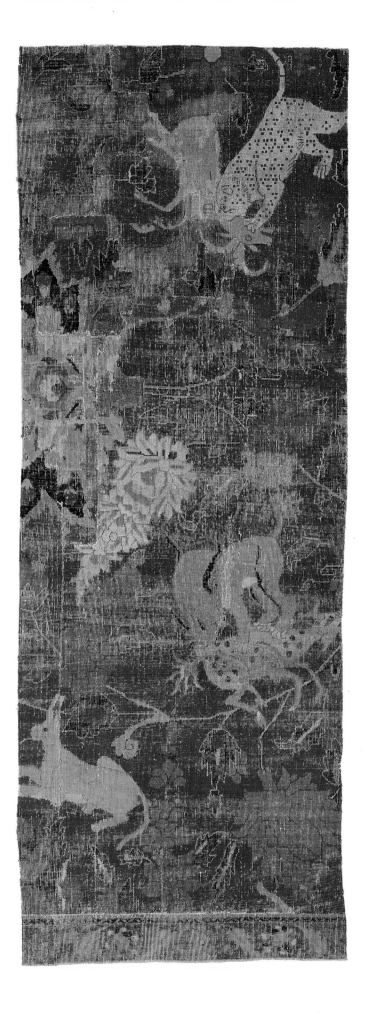

Mughal
North India
Late 16th–first half 17th
Century
62 x 74 cm

This is a late 16th- or early 17th-century Mughal knotted-pile carpet with a central field design displaying many varieties of four-legged animals and winged birds cavorting among huge fantastic flowering plants. One normally insists on physically examining such fragments prior to speculating about their probable dates and origins because there is always the possibility, however remote, that they could be late 19th-century copies of earlier carpets. No. T 674-1890 in the Victoria and Albert Museum, London, is a good example of just such a 19th-century copy.

Relative to the two other Mughal animal carpets described here in cat. nos 156 and 158, the animals appearing on this fragment are the simplest and least sophisticated and they most closely resemble the naive style of animal representation typical of most 16th- and 17th-century Persian carpets. Those were the models which most strongly influenced the design of early Mughal carpets. Stylistically, the treatment of the animals on this fragment immediately recalls the famous Sackville carpet from Knole, now in the Metropolitan Museum of Art, New York (inv. no. 17.190. 858). The design of the Sackville carpet differs primarily because of the addition of stiff trees to its central ground, but in terms of animal depictions, both that complete carpet and this small fragment share the same child-like level of naive draughtsmanship and may even have been produced contemporaneously.
S.C.

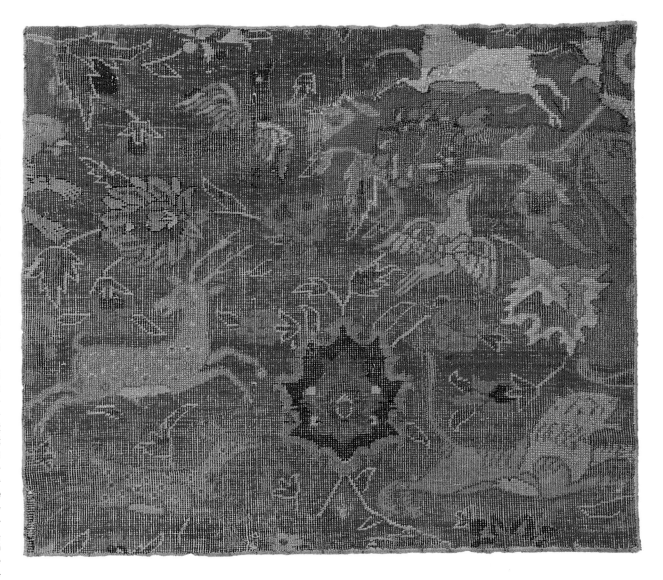

Mughal

North India

Late 16th–first half 17th
Century

147 x 234 cm

Mughal carpets with ground designs featuring animals placed within semi-naturalistic settings were woven in a wide range of qualities during the first half of the 17th century (if not slightly earlier) and this fragment is an example of a more sophisticated drawing and composition than the previous cat. no. 156. However, in terms of its structure and recent history, it is still closely related to no. 156 since it, too, probably came out of the same Jaipur royal collection and is also an incomplete patchwork of long narrow border and field fragments. Sadly, in its present reduced state, it is impossible to fully appreciate the beauty of the original design. However, an almost complete pair to this carpet was offered for sale by the Hungarian dealer Imre Schwaiger in the 1920's and was eventually purchased by George Hewitt Myers. It is now in the Textile Museum, Washington, D.C. (inv. no. R.63.00.1). Schwaiger had particularly good connections with Jaipur and his best carpets, velvets and other textiles came from that source, often still bearing official Jaipur inventory and stock taking labels. Other fragments from the pair of carpets are in the London collection of Howard Hodgkin (59 x 143.8 cm) and another (86 x 86 cm) was sold at Sotheby's, New York, December 3, 1988, lot 4.

S.C.

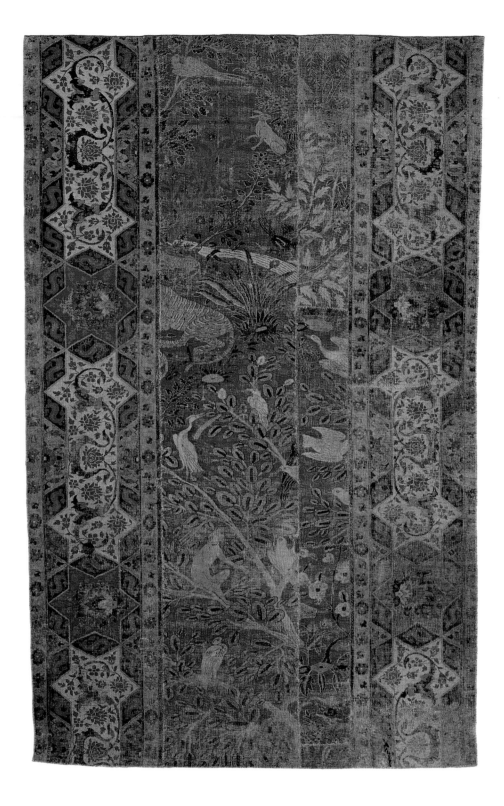

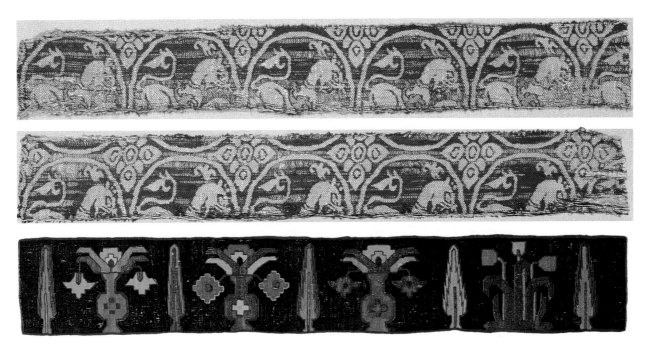

159

Silk Samite Fragments

Northeast India
13th–15th Century
Two fragments, each approx.
7 x 49 cm (mounted
dimensions: 26 x 60 cm)

These two silk fragments were woven on a drawloom in a distinctive structure known as samite. In this particular example, it is a weft-faced 2 and 1S compound twill with the pattern carried entirely by the continuous coloured wefts which are manipulated by two distinct sets of warps, main and binding, performing two different functions. Until recently this complex technique was not associated with India; rather, it was considered primarily to be the cultural and technological property of the classical world of late antiquity i.e., the Roman, Byzantine, and Persian Empires. Eventually, knowledge of samite spread to their successors which arose in Europe, the Middle East, Iran, Central Asia and even China and Japan. But for some reason, India was never considered to have participated in that transfer of technology. The recent discoveries in Tibet of previously unknown textiles has changed that perception since many appear to have been designed by Indian artists, for domestic use in India. For that reason as well as factors such as the use of particular dyes and varieties of silk, it is now generally recognised

that many samite-woven silks, including these fragmentary examples, were probably produced in India prior to the Mughal conquest which began in 1526. Other examples woven with the same pattern are published in Dodds and Eiland 1996, no. 322; Cohen in *Hali*, no. 91, March 1997, pp. 100–1; Jeremy Pine advertisement in *Hali*, no. 63, June 1992, p. 14. Also see Riboud 1998.
S.C.

160

Border Fragment

North India
Second half 17th–
first half 18th Century
36 x 230 cm

This is a bound fragment of a side border from a curious Indian flatwoven carpet. In terms of its structure and material content, it would be considered a kilim in Turkey, the Middle East, and Central Asia but in India the closest descriptive title would be a *dhurrie* or even a *drugget*. Its warps consist of thick multi-stranded white cotton (Z10-11S) but unlike most Indian *dhurries*, all of its wefts are wool rather than cotton.

Others have compared the floral designs, the quality of wool, and especially the colours of this fragment to the famous 'shaped' knotted-pile floral carpets which were first used at Jaipur during the second half of the 17th century. To some, those similarities suggest a common origin and date, but none of the Jaipur floral carpets contain figures of animals whereas four very large, extremely silly-looking tigers are significant design features of the central field from which this border fragment has been detached.

From the point of view of general Indian art history, the tigers do not resemble tigers found on any other 17th-century Mughal artefacts but rather, they are drawn in a typical 18th-

century provincial style and that is most probably the date of this fragment. Unpublished, but other fragments from this, and others in the same set, are published by Cohen 1982, p. 19, fig. 13; *Hali*, vol. 4, n. 3, 1982, p. 241, fig. 5; 'Calico Museum of Textiles', inv. no. 1423; Jayakar 1980, pp. 60–1, fig. 1; Jon Thompson's 1985 unpublished manuscript of carpets in 'Calico Museum of Textiles', inv. nos 258, 259, 349, 1423, 1426.
S.C.

Rugs of the Mediterranean Countries

It is often assumed that the handmade pile carpet is a product of the East, and its appearance in the Mediterranean basin is imitative and represents an attempt to make locally what would otherwise be available only as a costly import. There is no solid basis for this assumption, as the pile carpet in Egypt, for example, extends into Greek and Roman times, and there is good reason to believe that carpets were a significant part of Byzantine decor, particularly during the time of Justinian.[1] The classic period Egyptian carpets — a number of which survive — are associated to a large extent with Coptic Christianity, and they were primarily woven with the single warp knot. Later this structure came to be linked to rug making in Spain, where it may have spread, perhaps when the Umayyads established themselves there. Spain and Portugal, however, may well have learnt rug weaving even earlier from the Moorish invaders, who arrived in the 7th century and were not completely expelled from Spain until 1492. Prior to their departure carpet weaving seems to have been an almost exclusive Moslem occupation practiced in relatively few towns. Ibn Sa'id, as-Saqundi, and al-Idrisi, all 12th- or 13th-century writers, attested to the existence of a strong carpet industry in parts of Moslem Spain. The reference by al-Idrisi[2] is most explicit, as he identifies the town of Chinchilla in the Province of Murcia, as making wool carpets. By the 1255 wedding of Eleanor of Aquitaine and Edward I of England, a large display of Spanish rugs in the procession and in the Queen's apartments attracted considerable attention in London. The Spanish carpet industry must, at that time, have been capable of a sustained output, and it was probably the most prolific one. Spanish carpets, not the work of Persia, Anatolia, or Egypt had become established as probably the premier hand-knotted fabric of the 13th century. Not surprisingly, the designs on the earliest surviving Spanish carpets reflected Islamic art in their use of the dense geometric decor found on such buildings as the Alhambra. Several designs, most notably the Lotto, are found on both Anatolian and Spanish rugs, and there is usually an assumption that they arose among the Ottomans, although this is open to serious question.

While carpet-making continued after the Moslems were expelled, the flavour of the designs changed, becoming more 'European'. The opposite occurred in Egypt, where the Graeco-Roman style of the Coptic rugs gave way to a geometric style after the Islamic conquest. Few early examples survive prior to the group of rugs described as Mamluk, most of which are generally thought to have been made in Cairo. At some point, however, the Cairene looms began weaving rugs for the Ottoman court, and these may be distinguished from Anatolian work by their S-spun yarns more reliably than from their lavishly floral designs. Whether both types were woven at the same time, or the Ottoman court style followed the Mamluk style has not been conclusively demonstrated. Spanish rugs are virtually all made with the single warp knot, but there are a few pieces — possibly all late — in the symmetrical knot, and there is an unusual technique used for rugs from the Alpujarra region. The surprising feature of these rugs, woven in an area between Granada and the Mediterranean, is that they show a slit loop pile, identical to examples found at Dura Europos and at the At Tar Caves, and similar in some respects to the technique used in Tibetan rugs. While only several rug fragments survive that may arguably be assigned to the parts of North Africa comprising present-day Morocco and Algeria, it is likely that rugs were woven from an early period here as well. The wide array of structures used there — including the symmetrical and asymmetrical knots, the single warp knot, and a 'Berber' knot tied around multiple warps — suggests that there may have been multiple sources of the tradition. During the 19th century, workshops were established in such cities as Rabat in Morocco and Kairouan in Tunisia, but much of this production seems to be based on Turkish rugs of the period rather than on indigenous design. Trade in carpets within the Mediterranean area appears to have been brisk by the 14th century if not before. A number of terms referring to carpets are used in the surviving trade records, but even apparently specific references to such cities as Cairo and Damascus often leave some doubt as to exactly which carpets are being described.

[1] J. Ebersolt, *Les Arts somptuaires de Byzance*, Paris 1923, pp. 11, 14, 46.
[2] A.M. Edrisi, *Description de l'Afrique et d'Espagne*, translated and edited by R.P.A. Dozy and M.J. de Goeje, 1866, reprinted Amsterdam 1969, p. 237.

Saf Fragment
Probably Damascus region
16th Century
60 x 69 cm

This little fragment is from the only known prayer carpet which, by virtue of its technique, can be associated with the group of carpets centered on the so-called compartment or chessboard structure. These have Mamluk elements in their designs, and are also asymmetrically knotted but now with Z rather than S-spun wool. Their place of origin was long ago proposed as Damascus or the Adana plain, previously the northernmost limit of the Mamluk domains, and this still seems most likely even though no certain proof has been found. The centre, wherever it was, was producing rugs already in the 15th century (the 'para-Mamluks'), and the compartment and other-design rugs from the 16th century until well into the 17th. Another piece of this carpet is said to be in the Museum of Turkish and Islamic Art in Istanbul. Published (image reversed) in Various Authors 1989, pp. 46–7. See technical analysis in *Appendix*.
J.M.

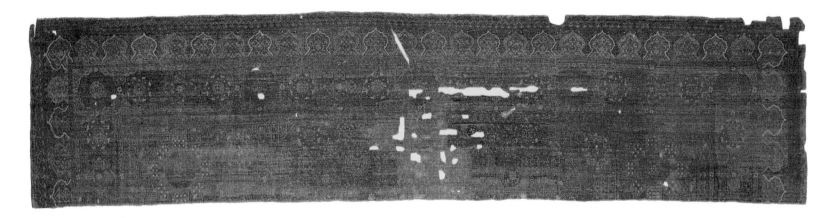

162

Mamluk Carpet Fragment
Egypt
First half 16th Century
90 x 406 cm

This fragment consists of one end of what must have been one of the largest Mamluk carpets. In width it is equal to the 'Medici Mamluk' in the Pitti Palace, which is 409 x 1088 cm (Boralevi 1986; King and Sylvester 1983, p. 61, no. 21), and somewhat wider than the example in the Scuola di San Rocco, Venice which is 375 x 970 cm (Curatola 1986, no. 1). The first of these is from the mid 16th century, the second before 1541. The apparently even wider Bardini Mamluk (450 x 920 cm) is now known to have been woven in two halves (Boralevi in *Hali*, no. 103, 1999, p. 79). The present piece is unusual in having a border apparently unique among known Mamluk rugs. The prototype is a Persian reciprocal border but the two halves of the reciprocal are now no longer of equal size. It is not possible to reconstruct the field design, which presumably included large octagons or squares. In addition to the customary red, green and light blue colours there are also small amounts of ivory and yellow.

Acquired in Italy (Ferrara) many years ago (along with a second piece, now in a private collection), such a large carpet must, like the Medici piece, have originally been in ducal or princely possession and most likely ordered from Egypt. It most probably dates from the second or third quarter of the 16th century. See technical analysis in *Appendix*.
J.M.

181

163
Cairene Ottoman Carpet
Egypt
Late 16th Century
136 x 205 cm

It was once believed that following the Ottoman conquest of Mamluk Egypt in 1517, the Mamluk carpet designs were rapidly supplanted by the Ottoman floral style, as exemplified by this rug. In fact we now know that the two styles coexisted over several decades, and the later one may have made only small inroads before the mid 16th century. Mamluk carpets can be recognised in a number of Italian paintings (mainly Venetian: Leandro Bassano, Tintoretto, Palma il Giovane) of the second half of the 16th century, but Cairene Ottoman carpets are conspicuously absent.

These rugs share the colours and other technical characteristics of the earlier Mamluk rugs and their origin in Cairo seems now generally accepted, rather than a production (in whole or in part) in Istanbul or Bursa as once proposed. They continued to be made well into the 17th century, as evidenced by their appearance in Dutch paintings of that time as well as the 1623 date of acquisition of the Pitti Palace carpet (Boralevi 1986; King and Sylvester 1983). Published in American Art Association, *Works of Art, Collection of the Estate of the Late Judge Elbert H. Gary*, New York (auction catalogue), April 19–20, 1928, lot 291.
J.M.

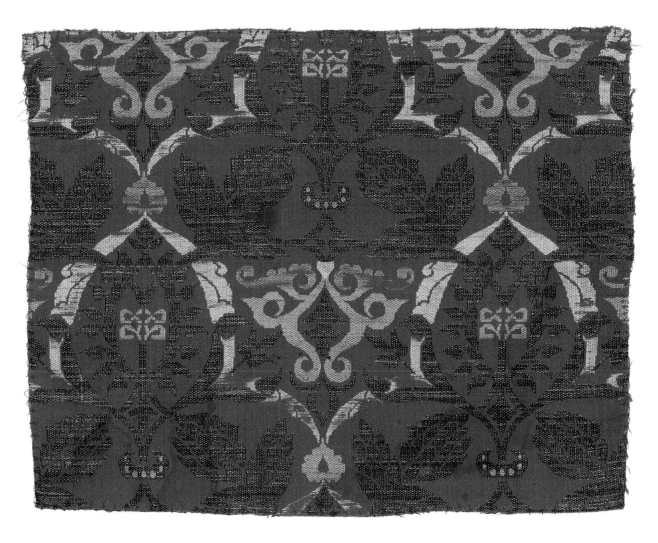

164

Silk Lampas
Probably Granada, Spain
15th Century
20 x 25 cm

Green palmettes, enclosing a knot form in yellow, are the joining points of a bold and forceful lattice along which grow triads of green hop blossoms. The semi-naturalistic grid in turn emerges against a further ornamentation of yellow arabesques and white airy arcs that enliven the chromatic contrast between the crimson of the field and the green lattice itself. This fragment, a good example of 15th-century Nasrid silk weaving, belongs to a group of textiles which are characterised by more imaginative patterns as compared to the standard production of the period, which generally followed a few set styles, showing less innovation than in earlier weaves (see May 1957, pp. 171–248, and in particular pp. 188–91. Another portion of the same silk from which this fragment comes is in the collection of the Hispanic Society of America, New York).

The wars of the Reconquest had by then reduced Nasrid rule (1237–1492) to a small kingdom, whose capital, Granada, was still the main centre for quality silks which were in great demand from the increasingly powerful Christian kings and churches. The silks produced in this period are usually known as *mudejar*, that means, made by Muslim weavers for Christian patrons who ruled the geographical areas where these craftsmen lived. However, as pointed out by S. Carboni, this term should be considered incorrect 'since the production in Granada was still under the control of the Nasrids and probably regarded as a business transaction' (Suriano and Carboni 1999, cat. no. 21).

The western appreciation of these products, in a time of Muslim political and military decadence, naturally caused an adaptation of the Islamic patterns to conform to the tastes of the new patrons. The present silk is a case in point, as it mingles fleshy arabesques and white split-leaf motifs, of a kind similar to those shown in a silk in the Bargello Museum, Florence (Museo Nazionale del Bargello, inv. no. 2372), with green blossoms more akin to western taste.

C.M.S.

165
**Rug Fragment
with Textile Design**
Spain
Late 15th Century
104 x 108 cm

There is written evidence for the production of carpets in Spain from the 12th century, but putative survivals consist only of small fragments (Kühnel and Bellinger 1953). In the 15th century production was centered in long since re-christianised Murcia, in what is now the province of Albacete, and carpets of three different design types were current. The so-called 'Armorial' or 'Admiral' carpets followed a pattern of a lattice of small motifs already known from the previous century, now often with superimposed heraldic blazons; the second followed more or less contemporary Turkish designs; and the third was based on silk textile designs often with a lattice forming ogival or hexagonal compartments as in the present example.

By the 16th century the main weaving, collection and marketing centre was Alcaraz, and this has given the generic name to the carpets of the region, although these were often ordered or supplied from many other centres, particularly Letur and Liétor, where they were made in both workshops and cottages. In the 15th century, when part of the Encomienda of Socovos, these were the places principally mentioned in inventories as sources of rugs including some clearly of the 'Admiral' type, which may most plausibly be considered to originate there. Alcaraz itself only started to recover from a long period of economic decadence after the middle of the century when simultaneously, the Socovos towns suffered the loss of their Moorish populations (circa 1454; replaced by Christians) and major disasters consequent upon their being on the wrong side in a civil war (Sánchez Ferrer 1986).

This fragment comes apparently from a large carpet of which the main part is now in the Textile Museum, Washington, D.C. (Kühnel and Bellinger 1953, p. 11, pl. IX). Of exceptional interest, this was originally started as an 'Admiral' car-

pet and then continued in this totally different design. Obviously both parts stem from the same place and an origin in Letur or Liétor seems therefore more likely than Alcaraz, though Ellis has argued that the 'Admiral' designs may have continued in use in Alcaraz (Ellis 1988). Coming at the end of their currency, and having the poorer colours (no good red) of many later carpets, a late 15th century date seems probable, or possibly earlier when dyeing skills had been lost with the Moors and not yet recovered. The design has mostly survived in rugs with better and brighter colours but there is a very archaic-looking fragmentary rug like the present one in the Musée Historique des Tissus (Bateman Faraday 1990, pl. V, p. 39). For further discussion on the subject see Ferrandis Torres 1933, Mackie (in *Textile Museum Journal*, vol. 4, no. 4, 1977, pp. 15–32), May 1977 and Sherrill 1996. Published in *The Bernheimer Family Collection of Carpets* (auction catalogue), Christie's, London, February 14, 1996, lot 75.

J.M.

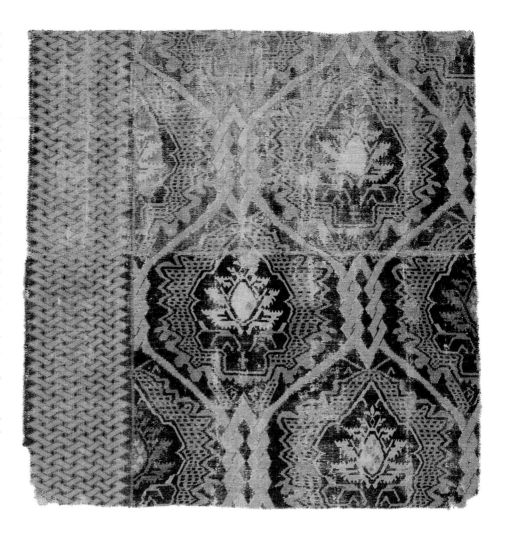

166
Hispano-Moresque Carpet Fragment
Spain
Late 14th–early 15th Century
75 x 250 cm

This fragment, together with two others, must have formed part of a large court carpet. Before the Second World War they were in the possession of Count Welczeck and are said by Lefevre to have been exhibited in Berlin. The design consists almost entirely of two systems of interlacing: one forms a framework yielding octagonal spaces; the second forms endless knots largely filling these. At their centres, and at the junctions of the framework are placed diamond-shaped yellow rosettes. The whole is somewhat evocative of a coffered ceiling.

Alexander suggests a very early dating (9th–11th century) for this piece largely on supposed distinctions between knotted and interlaced designs which are hard to follow. Here it must suffice to say the following: while the inner endless knot motif occurs also on a later Mudejar rug with the 'Large-Pattern Holbein' format (Kühnel and Bellinger 1953, pl. XIII, p. 13), the present carpet shows no signs of Christian Spanish influences (nor indeed of Turkish ones) and it is reasonable to think it was made within the Muslim domains, most likely in the Nasrid Kingdom of Granada. Interlace designs occur on artefacts of every type, as well as on decorative architectural features from much earlier, but are still frequent on Nasrid textiles of the 14th–15th centuries (examples in May 1957, Spuhler 1978 and Dodds 1992). The carpet could well have been made during this period, possibly to furnish one of the palaces of the Alhambra. It is unique, so the dating can hardly be settled, unless perhaps by carbon 14 testing, for which this seems an ideal case. Published still joined to a second piece by a strip of re-weaving, in Bennett 1978, p. 6. This second piece (Alexander 1993, p. 114) was earlier published by Lefevre, sale June 18, 1982, lot 24. A third fragment is in the Frankfurt Museum für Kunsthandwerk and was published in their catalogue *Neuerwerbungen*, 1956–74, pl. 53, and in Hubel 1970, pl. 154, p. 295. Alexander is mistaken in stating that this was the piece once joined to his. See technical analysis in *Appendix*.
J.M.

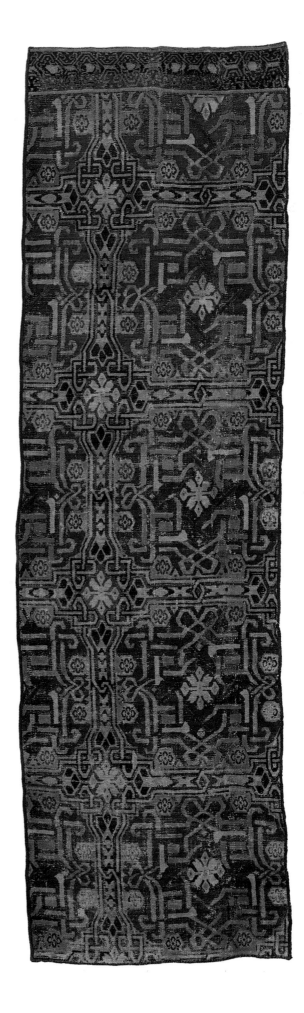

'Large-Pattern Holbein'
Mudejar Carpet Fragment
Spain
Mid 15th Century
142 x 242 cm

Carpets of this type follow closely the 15th-century Turkish pattern of octagons within rectangles formed by dividing bands. The octagon fillings, here with an outer ring of 'stars and bars' and eight palmettes pointing inward towards an eight-pointed star, also duplicate Turkish originals. A good number of these carpets survive, sometimes complete and with as many as two columns of six compartments or even (though with smaller compartments) three columns of six in the Cleveland Art Museum example (Sánchez Ferrer 1986, pl. XXXI, p. 342). On the assumption that the Turkish prototypes can hardly have been available before the mid 15th century, the Spanish examples are usually dated to the second half. They commonly have extra end panels, sometimes with the trees and animals to be seen on the 'Admiral' carpets. Thus they could have been made in the same places (Letur or Liétor) though they are more usually assigned to Alcaraz. Sánchez Ferrer has suggested Alcaraz or Hellín (another town known to have produced carpets), though his reasons are not made clear.
J.M.

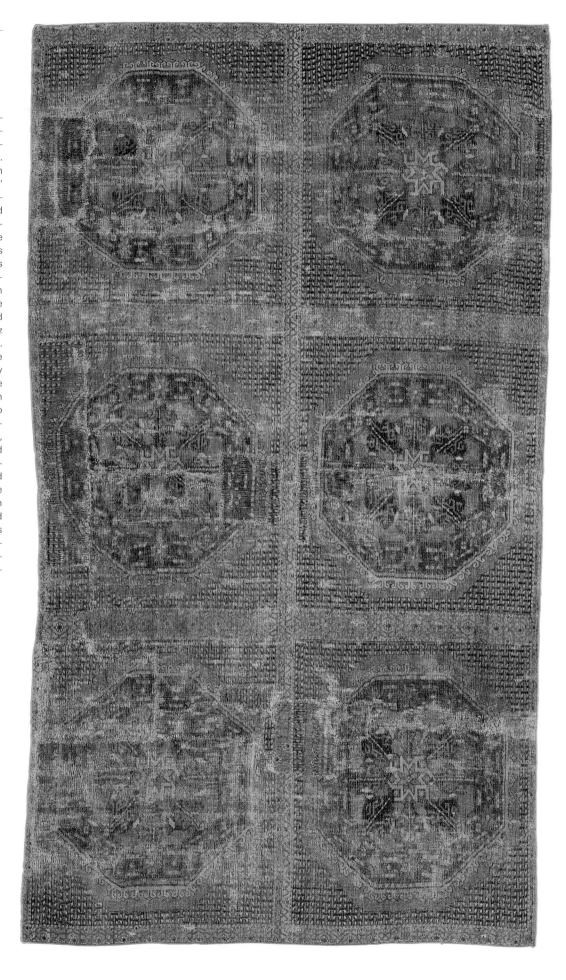

168
Alcaraz
Southern Spain
16th Century
232 x 385 cm

Collectors from the French mainland — for a question either of taste or of geographical proximity — have always kept a watchful eye on Spanish carpet production. The fragment illustrated here comes from the Catan Collection in Paris, where for good reason this type was denominated *ferronnerie* (from the French for 'ironworks') owing to its design's similarities to wrought iron. C.G. Ellis (1988, p. 256 ff.) has commented on similar, contemporary pieces in the Victoria and Albert Museum, London, and in the Hispanic Society of America (New York). We are in the 16th century, the Moors have been driven out of the Iberian mainland, and the workshops in Southern Spain evince a gradual shift towards more 'civilised' and European tastes, in which the 'barbaric' elements are played down together with the rigorous interlinked geometrical figures, ceding to a more naturalistic mood in tune with the incipient spirit of the Renaissance. The specimen illustrated here is a mature testament of its kind, possessing a sedate calligraphy describing vases (in reverse movement they reappear three centuries later in Morocco; see cat. no. 172) in a curvilinear lattice, and endowed with a temperate, innocuous colour scheme that limns in an ashen yellow, liquid green and well-considered blue. E.C.

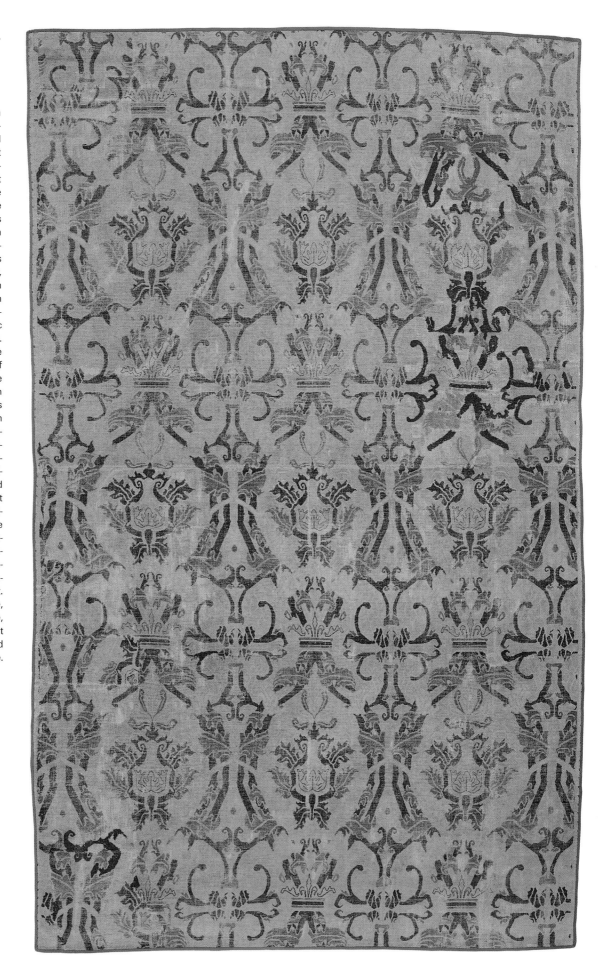

Weft-Loop Pile Rug
Alpujarra region,
Southern Spain
18th–19th Century
180 x 239 cm

The Alpujarras comprise the
south-facing slopes of the Sier-
ra Nevada and valleys below. It
was here that the Moors were
allowed to settle after the fall of
Granada in 1492 until their fi-
nal expulsion from Spain after
1609. Seemingly no loop pile
rugs from this early period sur-
vive, but it is generally supposed
that such must have existed and
been the precursors of the
known pieces, made by the
Moors' Christian successors,
from the 18th and 19th cen-
turies. These are woven on nar-
row looms and the strips, usu-
ally three as here, sewn to-
gether. The common occur-
rence of inscriptions with sig-
natures, dates and coats of arms
often allows dating. These are
lacking here but a rug owned
by the Hispanic Society of Amer-
ica has an almost identical field
design and the same central
motif and is signed and dated
1766 (Weeks and Treganowan
1969, p. 29). A carefully planned
and executed leafy vine border
is an attractive feature of the
present rug. Published in Bate-
man Faraday 1990, pl. XII, p. 51.
J.M.

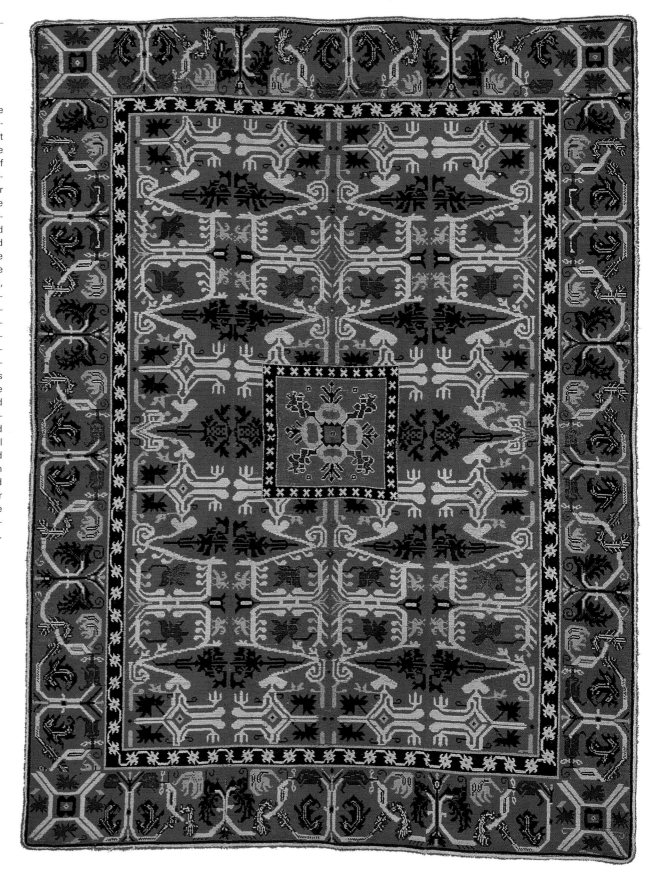

**Portuguese Needlework
Carpet Fragment
in Mamluk Design**
Probably Arraiolos,
Portugal
17th century
93 x 270 cm

The early history of carpets in
Portugal is obscure but docu-
ments exist appointing royal
carpet weavers (*tapiceiros*),
both Moors and Christians, be-
tween 1434 and 1677 (Baptista
de Oliveira 1983, pp. 16–7). What
technique they were using is
not clear nor is it known exact-
ly when the production of
needlework carpets in the small
town of Arraiolos (some 20 km
north of Evora) commenced,
but the cited author suggests
that it might have been with the
settling there of the Moors ex-
pelled from Lisbon by Manuel
I in 1496. They are made with
forms of cross-stitch on a can-
vas base, originally of linen but
later also of other materials such
as jute and hemp.

The earliest surviving Arraiolos
carpets are not thought to pre-
date the 17th century though
they are commonly copies of
earlier Turkish and Persian de-
signs. This example closely fol-
lows an Egyptian Mamluk car-
pet design of the 16th century
and the colours too might once
have been closer to the origi-
nal since the darker straw-colour
was probably once red. The
same colour changes seem to
have occurred with Portuguese
as with many Spanish carpets.
These copies may have been
made to make available cheap-
er versions of expensive im-
ported carpets or possibly to
perpetuate much loved old car-
pets which were wearing out
and could not otherwise be re-
placed.
J.M.

**Needlework Carpet
in 'Lotto' Design**
Arraiolos, Portugal
18th century
140 x 228 cm

Although almost no early Turk-
ish carpets survive in Portugal
today, they must have existed
there since copies such as this
one were made. Turkish origi-
nals with this rosette border are
relatively uncommon and at-
tributable to the late 16th–17th
century. Another Arraiolos 'kil-
im-style Lotto' rug like this, of
similar size, is in the Museu de
Arte Antiga, Lisbon (Baptista de
Oliveira 1983, fig. 76, p. 160).
The two tones of yellow used
here in the field and design must
once have been more easily dis-
tinguishable and one was pre-
sumably red, as Oliveira says
also of the ground of the Lis-
bon rug.
J.M.

Rabat
Morocco
19th Century
185 x 305 cm

In the last decade, through conferences and specialist publications, the carpet production of Morocco has been deservedly examined and re-evaluated. The textile traditions of North Africa go back deep into the past, and even today the Berber tribes continue in a candid expression of their characteristic age-old isolation through unusual weavings that come close to the modern sensibility.

Without delving into the archaeological pile fragments dating to the age of the Pharaohs (many plausible links require tracing, and one hopes finding), we will consider the knotted carpet as a feature of Islamic culture, which made its way to the southern and western shores of the Mediterranean in its early phase of expansion.

In the case of Moroccan carpet production, the distinction between workshop output and products made on rural domestic looms is keener than elsewhere. The first type is a prerogative of the Atlantic coast (Casablanca, Mediouna, Rabat), and resumes exotic stylistic traits (at first Anatolian, then Persian, and even Spanish; witness the flowering vases adorning one of the multiple frames of the present carpet); the second, fairly widespread in the country, is the work of the Berber and Arab tribes, and draws on distant traditions. It goes without saying that, given the natural sensibilities of the North African people, a measure of osmosis took place between the two types of production, which had certain features in common, including the quality of materials as well as the type of workmanship which in the case of the nomadic weavers involved knotting techniques exclusive to them.

In this carpet, the central medallion stands out from the entire framework in a Mediterranean sky blue, enclosed by the same lilies that J. Housego correlates to certain architectural ornaments of the 14th century (in *Oriental Carpet & Textile Studies II*, 1986, p. 221 ff., fig. 15), and rounded off lengthways by patterned panels with stylised elements found also on Mamluk carpets (Kühnel and Bellinger 1957, pls 7–8), which attests to a cultural continuum of sorts throughout North Africa. Another feature worth noting is the repeated presence in the border of a pinwheel element, which was employed in Anatolia as the main motif on a certain group of carpets (Batari 1994, pl. 23).
E.C.

Rabat
Morocco
19th Century
135 x 274 cm

The fact that, unlike Spain, Morocco has not yielded any knotted carpets dating to before the 18th century, does not signify that none were made. Actually, one might infer that these carpets were endowed with considerable formal values, but the conditions for their conservation were lacking, such as donations to institutions where they would be conserved. It was not until the colonial era that large quantities of Moroccan carpets arrived in Europe, where occasional ones have survived to testify to the powerful colour schemes, of African savour, applied for the elementary straight figures, disconnected from each other, as in the carpet presented here. Though made in an urban workshop, the piece evinces a marked tribal influence, such that U. Schürmann dated it to circa 1700 (Schürmann 1974, p. 31). Similar dates have been ascribed to other surviving examples (Various Authors 1989, pp. 175–7): it seems feasible, though not likely. Published in Schürmann 1974, p. 31.
E.C.

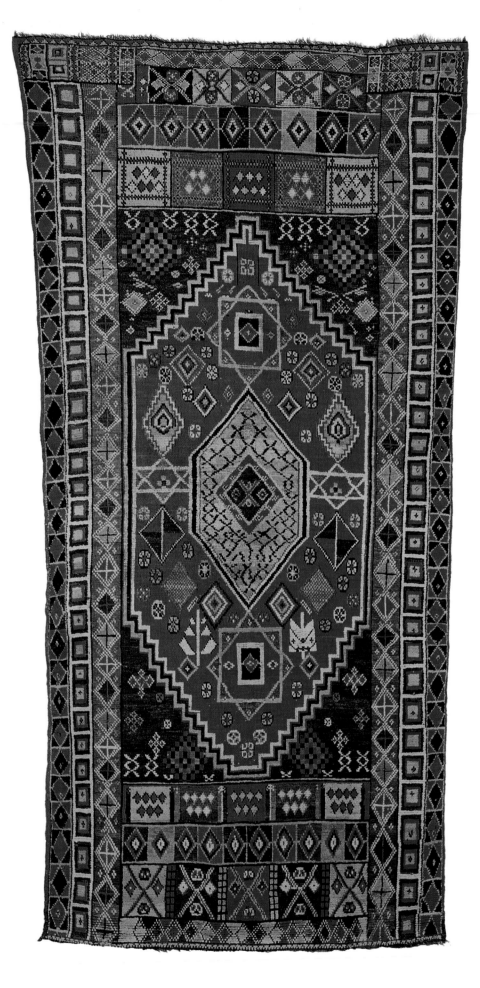

The Turkmen Wedding
Carpets from the Collections of the
State Russian Museum of St. Petersburg

The Turkmen Wedding

Irina Boguslavskaya
Elena Tsareva

The following section of the book, 'The Turkmen Wedding', is a selection of 32 unique Turkmen rugs and carpets from the collections of the State Russian Museum in St. Petersburg, specifically gathered for the exhibition 'Sovrani Tappeti', organised during the 9th International Conference on Oriental Carpets in Milan; none of the exhibits have ever been shown abroad before.

Compiled around 100 years ago, the collection has survived some dramatic moments in Russian history, and for at least the past 75 years has been practically inaccessible to the public.

We show here the stars of the collection, dated mostly to the 17th–19th centuries. In making our selection we have had several ideas in mind. First, we wanted to demonstrate the tribal peculiarities of Turkmen carpet production, together with the great variety of types of nomadic weavings. Another aim was to show the exceptionally high level of technical achievement that characterises the best examples of Turkmen carpet weaving. As a result, every piece is notable for its individuality and beauty, and at the same time is typical of its group.

This combination of outstanding features makes it possible to call this chapter 'Masterpieces of Turkmen Weaving', as every item shows that degree of care, skill and creative individuality which produces genuinely unique artifacts. It could also have been called 'Turkmen Antiquities', as both the artistic image and the manner of knotting of Turkmen carpets has preserved and carried to our times the spirit and visual 'footprints' of the creative genius and philosophy of the now vanished civilizations of the Great Steppes. However, we have chosen to call our selection 'The Turkmen Wedding', as most nomadic rugs and carpets were made for the dowry, and played important roles in the marriage ceremonial. Thus, although we were at first surprised, it is in fact quite logical that wedding caravan camel trappings have turned out to be the numerically largest part of the Russian Museum collection. Before describing the collection, we want to relate something of its formation and subsequent history during the 20th century.

The State Russian Museum in St. Petersburg was founded in 1895 as a Department of Fine Arts of the Russian Museum of Alexander III. Today it preserves and shows to the public more than 450,000 Russian paintings, drawings, sculptures and items of applied art. Some of the collections came to the museum as indivisible funds, and contained objects of folk art of diverse origin, including Oriental carpets.

The Russian Museum carpet collection numbers 280 items, the largest and most important part of which — over 100 objects — is Turkmen. In addition to piled weavings it contains 13 felts and two flatweaves. This collection has never been properly studied, published or exhibited: this is therefore the first time that we have had the opportunity to recount its history and attempt to analyse its content.

Turkmen rugs and carpets came to the Russian Museum in 1937–38 as part of the collections of the former St. Petersburg Handicrafts Museum. This fund formed the basis of the holdings of the Department of Folk Arts Handicrafts, which since 1950 has been the Department of Folk Arts of the Russian Museum.

Like many others, the Handicrafts Museum was founded in response to a broad public movement which developed in Russia in the second half of the 19th century, and aimed to support the country's vanishing handicrafts industry. In 1872 the Russian government established a Study Commission on the Handicrafts' Industry, which investigated the prevailing situation in the field in different regions of the country, and also founded a Handicrafts Museum in St. Petersburg in 1876. It took rather a long time to gather the necessary collections, so the Museum was not opened to the public until 1892, by which time it had over 5,000 works from 40 provinces. These were either purchased directly from the producers, or with the help of handicrafts agents, who were responsible for specific regions and types of folk crafts.

The carpet collection was assembled mostly in the 1900s. Archival records show that in the summer of 1900 D.A. Timiryazev (1837–1903), a well-known handicrafts industry agent, 'collected during his business trip to Turkestan and to the Caucasus samples of local carpets for 312 roubles'.[1]

In 1903 the Ministry of Agriculture and State Property gave 1,000 roubles to the court councilor Nikolay F. Bur-

[1] RGIA, fond 395, opis' 1, edinitsa khraneniya 1239, list 70 - oborot (Russian State Historical Archives, fund 395, inventory 1, item of curation 1239, sheet 70 - the back).

[2] N. Burdukov, *Kovrovoye proizvod-stvo Zakaspiiskoi oblasti* (Carpet manufacture of the Transcaspian Province), SP-b. 1903; *Kovrovoye proizvodstvo Zakaspiiskogo kraya i Kavkaza i zavisimost' yego ot rastitel'nyh krasok privoznyh iz Persii* (Carpet industry of the Transcaspian Province and the Caucasus and its dependence on natural dyestuffs imported from Persia), SP-b. 1903; *Kovry Turkestana. Kollektsiya N. Burdukova* (Turkestan carpets. Collection of N. Burdukov), SP-b. 1904; *Ukazatel po kovram, vystavlennym na Istoricheskoi vystavke v Muzee Uchilitscha barona Schtiglitsa* (Guide to carpets, displayed at the Historical Exhibition in the Museum of Baron Stieglitz), St.-Peterburg 1904.

[3] Among the most prominent Russian scholars and collectors of Central Asian carpets there were such high ranking officials and officers as A.K. Kaufmann, A.A. Bogolyubov, A.V. Veretschagin, and also art historians as S.M. Dudin and A. Felkerzam.

[4] N. Burdukov, *Kovry Turkestana…* cit., pp. 1–2.

[5] N. Burdukov, *Kovrovoye proizvodstvo Zakaspiiskoi oblasti*, cit., p. 7.

[6] N. Burdukov, *Kovrovoye proizvodstvo Zakaspiiskogo kraya…* cit.

[7] RGIA, fond 395, opis' 1, edinitsa khraneniya 1239, pp. 4–5, 44, 48, 49, 52–53, 94, 142–144.

[8] RGIA, fond 395, opis' 1, edinitsa khraneniya 2336, pp. 93, 206–211, *Ibid.*, edinitsa khraneniya 2624, pp. 90–91.

[9] See also: Ir.Ya. Boguslavskaya, *Iz istorii kollektsii narodnogo iskusstva Russkogo Muzeya. Iz istorii sobiraniya i izucheniya proizvedenii narodnogo iskusstva. Sbornik nauchnyh trudov* (On the history of the collection of folk art of the Russian Museum. Studies on the history of collecting and study of the works of folk art), L. 1991, pp. 4–13; *Kollektsiya Shkoly narodnogo iskusstva. Iz istorii formirovaniya etnograficheskih kollektsii v muzeyah Rossii (19–20 vv.)* (Collection of the School of folk art. On the history of formation of ethnographic collections of museum of Russia (19–20th century), SP-b. 1992, pp. 160–72.

[10] Arkhiv Otdela narodnogo iskusstva Russkogo Muzeya (Archives of the Department of Russian Art of the Russian Museum). Delo (case) no. 8, 1923, pp. 7–9.

[11] *Ibid.*, Delo no. 10, p. 8.

dukov to collect carpets in the Transcaspian Province for the St. Petersburg Handicrafts Museum. After his trip Burdukov published a series of articles on the state of the craft in the regions, and also organised a carpet display at the Museum of the School of Technical Drawing of Baron A.L. Stieglitz.[2]

Burdukov was one of a brilliant pleiad of Russian statesmen of the late 19th and early 20th centuries, who did not just think in practical categories, but tried to understand the essence and spirit of folk art, and greatly appreciated Oriental carpet weaving.[3] He wrote: 'In this industry, in which techniques have survived practically unchanged since their invention until the present time, we find collected, as in a sacred vessel, the precious drops of the artistic creations of the peoples of epochs and civilizations which succeeded one another in the vast arena of the Orient.

In the artistic field of this industry, as in a mirror, there is reflected in all times both the peoples' fantasy, and artistic creativity, and their mood, and all experienced by them peripeteia'.[4]

Burdukov proved to the handicrafts agents the necessity of supporting the Transcaspian carpet industry, which provided a livelihood to hundred of thousands of people.[5] He also tried to draw attention to the importance of the preservation of traditional natural dyestuffs in Central Asian carpet weaving, as much more durable than commercial alternatives, and determining to a great extent artistic image and individuality of Turkmen carpets.[6]

On the 29th of October 1903, the St. Petersburg Handicrafts Museum sent the Ministry of State Property a list of 52 objects from the collection of N. Burdukov, and reported that they were registered in the museum inventories.[7] Unfortunately those inventory numbers were lost during the long life of the objects in the museum. However, the brief descriptions which we find in the list make it possible to identify some items of Burdukov's collection. In 1911–12 Adrian Prakhov, a well-known art and culture agent of the time, purchased for the museum Caucasian works of folk art, including carpets.[8] No recorded remarks have survived, so this part of the former Handicrafts Museum collection, as with those pieces collected by Timiryazev, cannot now be identified.

After 1917 the collections of the Handicrafts Museum were given to the Museum of the School of Folk Arts, founded in 1911 by the Dowager Empress Alexandra Feodorovna. Later the collections were reformed and consigned to different places for storage[9] several times, while the School itself was changed into the Petrograd Handicrafts' Training College. Some of its museum exhibits were given away; some were used in 1923 to fuel the heating system of the college. Nearly 60 pieces were sold.[10]

These events caused a protest by museum workers and curators. A special commission, headed by A.A. Miller, a prominent ethnographer of that time, compiled a list of 91 objects which he thought to be of 'a high museum value'.[11] As a result further sale of the carpets was stopped. Miller listed many of the carpets now in the stores of the Russian Museum. Twenty-eight of them are included in this exhibition, among them nine from Burdukov's collection.

The book includes products of all most important 17th–19th century Turkmen carpet weaving tribes: twelve Tekke, five Yomud, five Saryk, three Salor, three Ersari (or as we now prefer to call them 'Middle Amu Darya group'), two Arabachi and one Chodor. The tribal origin of four pieces cannot be identified precisely, so they are simply described as 'Turkmen'.

As to the types of objects, we have included one main carpet (*hali*), a prayer rug (*namazlyk*), a door hanging (*ensi*), a small door surround (*khalyk*) and two threshold strips (*germech*). The latter are rather rare — at least they are the only ones in all the St. Petersburg carpet collections. Of particular charm are two tent bands (*yolam*), with their typical frieze arrangement of ornaments and their specific graphic outlook.

The largest number of objects are different format tent bags: six *chuvals* and four *torbas* for storing clothes; four small bags (*mafrash* or *kap*) for keeping food while travelling, and an envelope-shaped *bukcha*.

However, an important role is played by the four wedding camel trappings, or *asmalyks*. Manufactured with special care as exceptionally important objects for the wedding ritual, these trappings are strikingly beautiful and bear patterns which can be traced back to the immemorial past.

Every famous carpet collection has its stars and superstars. So too does the Russian Museum, with priority given to the rare 18th-century pieces of tribal character. Most illuminating from this point of view are the main carpets with field designs of so-called *gul* medallions. Accepted as specific tribal emblems, the *guls* of each Turkmen group should not, in theory, change over the course of centuries. But comparing the ornaments of the two Tekke main carpets in the collection (cat. nos. 202 and 183), we can see that they are quite different, both in the outlines and many of the details of the main medallions and intermediate so-called *chemche* figures. As to the set of borders, they have no common motifs. Cat. no. 202 has rather a common pattern, which consists of a row of octagons containing eight-pointed stars, while cat. no. 183 uses a quite rare intricate meander, with double-headed camels on a white ground. Both main carpets have complex structures and diverse colour schemes. Cat. no. 202 uses a rare rich tint, often called 'purple'.

Of similar interest is the comparison of a pair of Saryk *ensis* (cat. nos. 179 and 178). Knotted *ensis*, as well as main carpets, did not belong to the objects of everyday use, and

were put out only on festive occasions. Their functions were more ritual and decorative than utilitarian, and thanks to this *ensis* could survive for 200–300 years or longer. The genesis of *ensi* ornamentation is complex and poorly interpreted until now. Practically every element of its decor, similar to the composition itself, poses many questions, and there are few answers. Most evident are the patterns/amulets, aiming to protect the entrance to the *yurt* against unfavourable factors of different kinds.

Other elements are much more difficult to understand. Let us look first of all at the composition as a whole. The area is clearly divided into three parts: the bottom, middle and the top. The lower panel, named *zamin* (the earth), probably corresponds to the level of the ground, and bears figures of plants/human beings. The upper level, decorated with a row of horizontal arches, supposedly marks the heavens. In between we find the symbols of the world of steppes: sheep, goats, dogs, dragons-lightnings, birds, and so on. *Ensi* ornaments also portray important nomad mythological and shamanistic images, such as a meander, which connects the earth and the sky, and symbolises an everlasting continuity of life; representations of ancestors on the outer border, named *sainak* and, sometimes, *yaileh* (from Arabic *a'ila* — family), etc. At the same time the central part of the *ensi* has a cross-shaped structure usual for wooden doors, thus adding stability and completeness to the picture.

When we study extremely complicated and overloaded composition in detail there appears a strong feeling that the *ensi* design was developed by professional artists, possibly priests, who filled it with symbols of different levels of knowledge, including mystical and magical concepts. It is also important that both the *ensis* are made in a most refined technique, with rare and specific methods such as offset knotting and warp sharing. This applies particularly to cat. no. 178, as it is woven in irregular knots throughout, a technique which helped the weaver to create really picturesque floral images, and also made the textile strong and flexible.

Besides all the usual Turkmen objects there were some which were specific to different tribes. One of them is the *khalyk*, a small lambrequin, known mostly for the Tekke.[12] The piece on display (cat. no. 188) possesses technical and ornamental features typical for this group, such as a high knot density and a highly accurate weaving; special field patterns, and a white ground main border. *Khalyks* have always been of great interest to students of Turkmen carpet weaving, not only because they are rare but also because of the mystery of their usage. Most plausible of all the various suggestions is that their main purpose was to frame the entrance to the small litter, on the camel on which the bride rode to her husband's *yurt* or house. After arriving, the item was placed, together with a *kapunuk*, over the *ensi*, with its back facing outside.

Another rare type of door equipment is the *germech*, threshold rug. The design of the traditional *germech* follows that of the lower (sometimes central) panel of an *ensi*, and it has a specific finish at the lower end. One of the two exhibited examples has this typical design and finish (cat. no. 193). It is woven with great care, and has many original details of execution. Besides the usual brown and red wefts, there are some light blue ones. The pile is of wool, silk, cotton and camel hair. The weaver used methods which are otherwise rare for asymmetric knotting such as offset knotting, warp sharing, knots tied over three warps, and 'missing warps'.

The colour scheme of this *germech* is also strikingly diverse, with its 17 soft shades. The finish of the lower part of the right side, which looks as a woollen lace, is a surprise. As a whole this piece can be accepted as a real masterpiece of pile-weaving and as one of the brightest stars of this rich collection.

The fifth item included in the group of door ornaments is open to question as to its usage (cat. no. 194). Its traditional attribution: a 'tent bag' — cannot be accepted, since the piece does not ever seem to have had a back. According to some characteristics, it can be either a *germech*, or, more probably, a wedding litter decoration of the *khalyk* type. This idea is supported by such important factors as its size — too 'high' for a threshold rug — the method of finish, and, the most important feature, a field design which is typical for Tekke *khalyks*.

The largest number among the rugs illustrated are tent bags of different forms and measurements. This is natural, as tent bags were the most numerous piled objects of Turkmen *yurt* furnishings. The show includes six *chuvals*, five *torbas*, three *mafrashes*, and a *bukcha*.

The *chuvals* were the largest of the tent bags, and were used for keeping and transporting clothes. Similar to other types of tent bags, they were made in pairs, although they usually entered collections as singles. The designs of the *chuvals* are of different main types, with the *gul*-system being the dominating one. Every tribe had its favourites as to the kind of *guls* and their arrangement over the field. The only Salor *chuval* in the collection has nine *guls* (cat. no. 174) and is very beautiful and expertly woven. According to the manner of knotting, richness of colour (18 shades), and ornamental characteristics, it can be attributed to a group of Salor *chuvals* from which early examples have been radiocarbon dated to the 15th–16th centuries[13], and which continued practically unchanged in designs and colouring.

The Saryk part of the collection is much richer than the Salor. Of the four Saryk *chuvals* two are included in the exhibition. One of these (cat. no. 180) belongs to a very rare type of multi-*gul chuvals*, with a cherry-purple ground in the field. The bag is entirely woven using the same intricate techniques as the *ensi* in cat. no. 178 (above), and

[12] Several others known are Yomud, Eagle gul I and some unattributed.

[13] Carbon dating of several Turkmen carpets, bags, trappings and tent bands, made recently by Jürg Rageth and Georges Bonani in the Swiss Federal Institute of Technology, shows that many of the tested items can be attributed to the 16th–17th centuries, and one Salor *chuval* fragment was dated to the 15th–16th century. The results were announced during the Basel symposium in February 1999.

as is usual for this group, has an early date.

Another Saryk *chuval* (cat. no. 181) represents the classical design with 3 by 4 *guls* and demonstrates the best qualities of Saryk pile-woven products, which made them the most artistic of Turkmen weavings. Its decoration reached a fine balance between the static outlined *guls* of the field, and the graceful floral motifs in the *elem*. The cold red-and-blue colour scheme of the *chuval* is brought to life with a suffusion of white cotton and glossy of crimson and sky-blue silk.

The Tekke pieces in the collection are the most numerous and consist of 28 items, although there are only six *chuvals* of which two form a pair. One of these shown in the exhibition is decorated with the *Marv-gul* (cat. no. 186). The high knot density of this *chuval* allowed the weaver to create a fine picture, resembling a *erre* with a short pile, giving a texture resembling velvet.

The second of the Tekke *chuvals* on display (cat. no. 185) is notable for its deep, bright shades, and an unusual combination of *aina-khamtoz* motifs in the field with *erre* pattern in the *elem*. The design of this *chuval* is described by Burdukov as: '… *aina-gul* with a herring-bone pattern, which we find in Yomuds; Marv manufacture'. Since Burdukov visited Marv during his trip to Turkmenia, we can accept this note as authentic information.

The *kyzyl-chuval* (cat. no. 207) belongs to a rare group of Turkmen piled products, which has been studied insufficiently to allow a clear attribution. According to some technical characteristics it can be identified as Tekke, though some experts do not accept such an assumption. One of the most impressive exhibits of the show is a Tekke *torba* with 12 *guls* (cat. no. 187). It has rather large and tightly sitting *guls*, with a camel caravan decorating the top *elem*. The *torba* has an unusually dark purple-brown ground, which makes a bright contrast to the orange and white filling of the *guls*. Another unusual feature is the technical fulfillment of the piece, as it has a multitude of irregularities in the structure, being rows of symmetrical knot-sharings the most unusual of them. To do that the weaver had to be highly experienced, and know peculiarities and possibilities of knotting methods. In our understanding, they also had to have a great talent and strove for perfection. Though special methods of knotting are quite common for early Turkmens, the creators of real masterpieces had to have put personal features into their works (see the main carpet, cat. no. 202, *ensi*, cat. no. 178, *torbas*, cat. nos. 187 and 182, and *bukcha*, cat. no. 201). The structure referred to as 'missing warps' — are they the result of precise calculation or of a sense of humour, which helped the weaver to make a kind of joke in her hard work? This structural feature which is extremely rare in Turkmen carpets was identified in the Russian Museum collection in two weavings of refined beauty and technical fulfillments: the *germech* in cat. no. 193, and *chuval*, cat. no. 207.

Side by side with these perfect items the Salor *torba* with the *shemle* ornament looks like a pupil's work (cat. no. 175). The fault is not in the manner of weaving — it is excellent, and not in the colouring — it is vivid and extremely attractive, but in the character of pattern, which is reproduced with numerous mistakes and looks simplified. This is more than strange, especially if we remember that Salors are well known for the special regularity of their patterns. Examining this particular *torba* we had the impression that it was produced by a method which differed from the usual, by which Turkmen weavers recreated a design by the use of their visual and mechanical memory, or copying. It seems that in this case she followed an unfamiliar pattern, which she had seen but which she had not been trained to reproduce. A similar impression is given by the upper end finish: it is close to a method traditional for the Salor, but not quite identical, giving the impression of an imitation.

The Russian Museum collection is famous for its *mafrashes*, the smallest of the horizontal tent bags. The exhibition includes four of these: three knotted of Tekke origin, and one flatwoven, probably also woven by a Tekke. According to different sources, *mafrashes* were used in different ways, but their main function was to serve as containers for carrying food which people brought for festive occasions. This explains their fineness of weave and design, as well as the many grease spots, which are often visible even after careful cleaning.

One of the *mafrashes* reproduced here (cat. no. 191) is of special importance, as it has given its name — 'Leningrad's pattern' — to a whole group of designs. This came about in 1975, when a small group consisting of Anatoly Ivanov from the Hermitage, Robert Pinner, Michael Franses and Elena Tsareva were the first to see this collection which had not been studied for at least half a century. Among the rugs we examined, we saw this bag with an unusual and so far unknown white-ground ornament. Later, when Pinner and Franses published the piece, they named it 'Leningrad pattern', a term which is still used. *Mafrashes* of this type are not unique any more — we know several others with this design but they are quite rare, and the pattern still defies interpretation.

The second *mafrash*, with three white-ground *kelleh* (head, flower) panels, represents a well-known design for these bags (cat. no. 190). Every element of the design has a floral/zoomorphic character, and is reproduced in a manner which must have been preceded by a long, highly developed tradition.

While the Russian Museum white-ground *mafrashes* were woven in a marked Tekke manner, they have some specific artistic peculiarities, which makes it possible to suggest an origin different from Tekke. One of the possibilities is that they were produced by special Turkmen groups, commonly named *ovlad*, and were traditionally derived

from the most worshipped Muslim saints. The white ground of most *mafrashes* can serve as an indirect confirmation of this theory, as white in Turkmen tradition is a colour symbolising respect, also used in decoration of prayer and burial rugs.

Comparing the two *mafrashes* discussed above with another quite different piece (cat. no. 189) characteristic of Tekke design and ornaments, we notice a common feature: as in the white-ground *mafrash*, both the checked field and the main border of the bag are decorated with amulets, indicating a sacred character for its ornamentation. Apart from this, the piece is notable for a rich variety of red, blue and green shades, with a total of 16 colours. The only flatweave on display is another *mafrash*, woven in a brocade *oidume* (Iranian *zerbaf* — brocade) technique (cat. no. 192). Tiny even for this group of small bags, the piece is a real work of art not only for its ornamentation but also for its weaving technique and colouring. Its dominant shades are a slightly blueish carmine, crimson and purple-brown. The colours serve as a background for the 'mosaic' contours of the dark-blue *gochak* (ram's horns) motifs, inserted into the diagonal blue diamond lattice of the central panel. Quite a contrast to this dark, cold field are the small twinkling 'stars' of white and ivory. As to technique, Turkmen themselves say that *oidume* is the most complicated method of weaving they know, and it was used to manufacture the most festive items of *yurt* furnishings.

Another rare item associated with a festive occasion, which is on display, is an envelope-shaped bag, *bukcha*, or *bukhcha* (cat. no. 201). As far as we can conclude on the base of rather poor sources, bags of such type were used by Turkmen women for keeping their own most valuable belongings, mostly jewellery. According to our own information, *bukchas* also served as containers for the Koran.[14] The several *bukchas* I have seen are similar in size, as well as in pattern and system of weaving, including the use of offset knotting and warp sharing throughout. This suggests that they originate from a common primary source, once developed — or perceived — by a group of Turkmen, most probably Yomuds.

All Turkmen, irrespective of tribe, and commonly with other Central Asian nomads, decorated their wedding *yurt* with a so-called *yolam* or tent band. Traditionally, *yolams* were made in a combined technique, with a flatwoven white ground, and multicoloured pile patterns. From the point of composition, *yolam* designs resemble a frieze, consisting of panels with different motifs. As to their function, the largest bands surround the *yurt* inside on the level of the otherwise inaccurate conjunction of the lattice walls and the roof poles.

Among the objects illustrated are two tent bands, which differ in length, ornamentation, and, most probably, tribal origin. The smaller one — Burdukov names it *tuni-chipi*

— is notable for its delicate colouring and design (cat. no. 195). Some irregularities in the execution of the motifs add special charm and gracefulness to the design. Bands of small dimensions are quite rare, and have functions different from 'belting'.

The second band (cat. no. 196) has a typical length and width (14.56 m × 36 cm), but this is its only standard feature. The *yolam* (according to Burdukov) is striking one with its sense of luxurious, beautifully coloured and interpreted motifs. One can enjoy the piece and study its patterns again and again, each time finding new interesting details. One such detail is two pairs of boys and girls in the corners of one of the panels.

Carpets, bags, bands, and threshold rugs were an obligatory part of the Turkmen brides' dowry. All of them were used — in one way or another — to decorate the wedding caravan. Its main destiny was, however, to furnish a *yurt*. The only Turkmen weavings which were made and used exclusively as attributes of the wedding ceremony, were camel trappings. Similar to the tent bags, camel trappings were made in pairs, and could be of pentagonal, heptagonal or rectangular shape. The modern literature names the first two types *asmalyk*, although at the beginning of the century Russian scholars, including Burdukov, used this term also for rectangular panels.

The basic difference of the *asmalyk* in comparison to other trappings is not in its shape, but in its design. Common to many Yomud *asmalyks*, irrespective of their size or ground colour, is a 5-stem composition. The exhibition includes four *asmalyks* of this type: one on a red ground, two on white, and another with the ground colour alternating between dark blue and red.

Most widespread is the last type, with alternating colours (cat. no. 200). The Russian literature[15] attributes these to the Cheleken island, inhabited in the 19th century by the Ogurjalis, one of the most ancient Turkmen tribes, affiliated to the Yomud. As many other antique rugs of this group, the *asmalyk* was woven using offset knotting and warp sharing methods.

All these *asmalyks* have only a few common features: the 5-stem composition, the use of the symmetrical knot, and complex weaving techniques. Even the white-ground trappings (cat. nos. 198 and 199) have quite a different interpretation of the stems and borders, as well as colour range and weaving techniques. All three *asmalyks* on display were purchased in the period 1904–5. Quite possibly cat. no. 200 and cat. no. 199 are from the same source.

The most magnificent item of the group, a red-ground 5-stem *asmalyk* (cat. no. 197) takes an intermediate place: from the point of knotting it is close to cat. no. 200, while in ornamentation, including the borders, it is related to cat. no. 199. The red-ground *asmalyk* belonged to the collection of Nikolay Burdukov, who attributed it to the Yomud.

[14] Different from most of other kinds of Turkmen bags, *bukchas* were known under the same name for another Central Asian people, though of different size and material (usually silk in quilt technique). As to Turkmen, they made also felt envelopes, decorated either with applique work, or embroidery (the most beautiful of the last type belongs to the Askhabad Museum of Fine Arts).

[15] See, for example, A.A. Bogolyubov, *Carpets of Central Asia*, London 1973, pl. 19.

It is interesting to note that the 5-stem composition can also be identified on several embroidered Turkmen *asmalyks* of different origin. Identical shapes, designs and finish for these pentagonal trappings, irrespective of their technique, lead us to an ancient local tradition, represented in a knotted variant related to the Yomud Turkmen which inhabited the Caspian Sea coast in the 19th century.

The wedding trappings displayed demonstrate another specific type of design which is used by several different Turkmen tribes. These are long rectangular panels with two rows of *kejebe* (wedding litter) motif, each arch of which contains a vertical standing figure, usually interpreted as a 'Tree-of-Life'. Rather similar to the *kejebe* is a *darvaza* (gate) composition, notable for large central rosettes. The most complicated type of *darvaza* design was possessed by the Salor; among the other tribes that used it, we find the Ersari, though their variant is much simpler as to details and colouring (cat. no. 205). According to historical sources, the Ersari were nearest to the Salor; both were active members of the Salor Confederation of tribes. They were the last to leave Mangyshlak in the 17th–early 18th centuries, and settled near each other along the Middle Amu Darya. Ersari men were also the only non-Salor who were able to marry Salor women. Intermarriage and proximity of territory explains the formation of common sets of designs for both tribes, one of which was the *darvaza* composition.

More questions arise when we find rather similar arrangement of motifs in the camel trappings from tribes other than the Salor and Ersari, such as the Arabachi and Chodor. Both are among the most ancient Turkmen groups, the Chodor also being known to lead the Chodor Confederation of tribes. It is important to add that in the late 18th century both these Turkmen tribes were settled along the Middle Amu Darya, although the actual date of their arrival to this region is unclear.

The Arabachi are known for a specific technique and appearance of their pilewoven products. The trapping (cat. no. 204) demonstrates the best features of this tribe's carpet weaving, such as a combination of rich colours, clear and complete patterns, and an original interpretation of motifs common to all Turkmen. Another feature of this trapping is its lustrous, soft and silky wool, which adds greatly to its beauty.

The *kejebe* design is represented here by another Arabachi piece (cat. no. 203). This trapping is rather unusual. On the one hand, it is notable for its great variety of colours (17 shades), and the use of packing knots in the structure. On the other hand, the pattern contains several mistakes and looks rather clumsy, giving the impression that the weaver copied an unfamiliar pattern.

Another representative of this family of designs is a Chodor trapping of breathtaking beauty (inv. no. KOV-224). The trapping is decorated with three pairs of half-*ertmen guls*, and central contour-drawn stepped rosettes. The shape and arrangement of the main element, together with the 'tree-of-Life' and pairs of birds filling of *ertmens,* leave no doubt as to their relationship to the *darvaza* and *kejebe* designs.

Thus the selection proposed presents four 5-stem *asmalyks* characteristic for the west of Turkmenistan, and four trappings with arched composition, typical for the eastern, Middle Amu Darya Turkmen territories. While very different, they contain one common element: the representation of a vertical 'tree', an obligatory attribute of wedding rituals of many Central Asian peoples of the past.

As for the two Salor pieces, which are ascribed as trappings, their decor has a transitional character, and can also be seen on *chuvals* and *torbas*. The first trapping bears 6 by 3 rows of small octagons typical for the Salor (cat. no. 177), while the second is decorated with a compartment lattice and *aina-khamtoz* motifs (cat. no. 176). The main reason why these pieces are not thought to be tent bags is because of the type of finish, which is practically identical for all types of camel trappings.

Both trappings are bewitchingly attractive, and surprise us with the brightness of their cold red shades. This strong visual colour effect is probably the only common feature of the pieces, as in other respects the trappings are quite different. The smaller (cat. no. 177) has a regular, slightly static pattern: its small *guls* and cross-shaped intermediate elements are accurately inserted into the vast carmine-red ground of the field. The larger trapping is decorated with large and bright rectangular motifs, and has a distinctive diagonal colouring (cat. no. 176).

This difference in appearance between objects which are similar in use can have several explanations. Firstly, for a number of reasons, the Salor tended to lose carpet weaving traditions since at least the early 19th century. As a result they stopped making some items necessary for nomadic life, and former tent bags gradually turned into purely ritual objects. Secondly, the trappings could be made by various tribal clans, and in different territories. Burdukov's note: '*aina-gul*. Salor Turkmen living in Serahks', concerning cat. no. 176, names one of the traditional Salor locations.

As to the differences in shape for the trappings — pentagonal and rectangular — it is possible that this was related in the past to the need to adapt to different breeds of camels: Arabian and Bactrian. Until now this is speculation and to be sure one has to study the use by Turkmen of different kinds of camels in different times.

As already stated, the Russian Museum has only a few non-tribal, Turkmen pieces made for commerce, although these are represented in other museum collections in St. Petersburg in larger numbers. As far as we can judge, the Turkmen were very quick to start making carpets for sale.

Nevertheless, up to the 1860s, when Russians and other Europeans came to Transcaspia, only the population along the middle of the Amu Darya was actively involved in this industry. In the 18th and 19th centuries this territory was inhabited by a large number of people from different tribes, different origins and different times of arrival to the river. Among them lived the descendants of ancient local Iranian, Arabic and Turkic-speaking groups, as well as Turkmen who were comparatively later migrants. All of them seem to be experienced weavers, and worked for sale, mostly for the markets of Bukhara, Samarkand, Khiva and other Central Asian and Khorasan markets. Amu Darya carpets were famous for their large variety of patterns, the bright and often rather light colours, and the superb quality of their local wool and goat hair. A classical sample of the best Amu Darya production is the white-ground *namazlyk* (prayer rug) with *kelle* (head, flower) ornaments (cat. no. 208).

Another representative of this large family of weavings is a wide carpet with the *minahani* pattern (cat. no. 206). The rather simple allover floral motifs of this carpet demonstrate a degree of perfection, which can only result from a long developed tradition, spread since earlier periods over Khorasan and adjacent territories. Middle Amu Darya weavers used these patterns to decorate different objects: besides carpets we can often find the same design on *chuvals* and *torbas*, and even on *ensis* and *namazlyks*.

There is one common feature, which joins all Amu Darya pieces with the *minahani* design: they are made in a very specific manner of knotting, which makes it possible to identify them as a specific group of pileweaves, notable for excellent technique, rich colouring, and well-balanced and highly developed design.

Abbreviations

Sy: symmetric knot
As: asymmetric knot

174

Chuval

Salor Tribe
18th Century
KOV-202
81 x 124 cm

Warps: goat hair (?), ivory, Z2S; depressed.

Wefts: 2 shoots; wool, brown, Z2S; fine.

Pile: wool, silk, 3 mm high.

Knot: As, open left, pile looks up.

Knot count: 48 x 70 = 3,360 per sq. dm (1:1.5).

Colours (18): cherry-red (2 shades), orange, yellow, chestnut, violet-brown, dark blue, sky-blue, black-blue, turquoise, green (3 shades), ivory Z2S, carmine Z3S; pink-red, crimson (silk) Z2S and Z4S, bright red Z5S.

Sides: red wool plaiting on 2 pairs of warps.

Ends: (upper) red and ivory plain weave folded over to the back and sewn down; pink plaited tape sewn on to the front; dark blue slanting stitching along the edge; (lower) cherry-red plain weave, cut.

175

Torba

Turkmen Tribe
(Salor copy?)
19th Century
KOV-201
40.5 x 99 cm

Warps: wool, ivory, Z2S; depressed.

Wefts: 2 shoots; wool, red, Z1.

Pile: wool, silk, 3 mm high.

Knot: As, open right.

Knot count: 75 x 46 = 3,450 per sq. dm (1:1.6).

Colours (11): crimson (silk), pink (silk), red, orange, yellow, purple-brown, brown, dark blue, green-blue, ivory Z2S-Z4S, carmine Z2S-Z3S.

Sides: red wool wrapped around side warps.

Ends: (upper) ivory plain weave folded over to the front; coarse woolen brown tape sewn on over the fold; lower part finished with pink silk stitching; (lower) ivory plain weave, folded over to the back and sewn down. Remains of dark blue fringe on 4 warps.

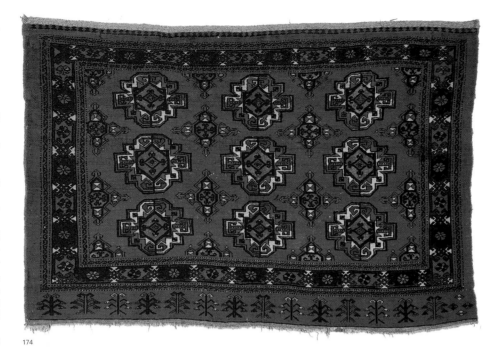

174

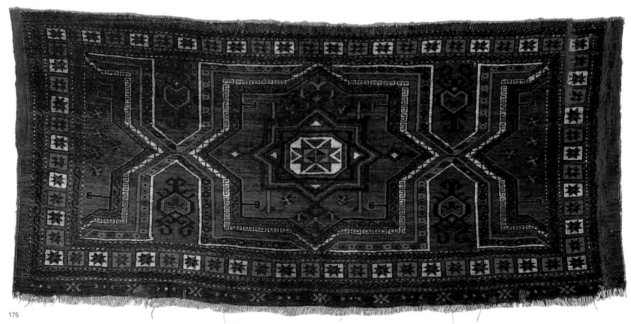

175

Camel Trapping

Salor Tribe
Late 18th–early 19th Century
KOV-215, purchased by
N.F. Burdukov in 1903
Original description:
'Torba aina-gul, with silk,
manufactured by Salor Turk-
men, living in Serakhs (?)'
43 x 125 cm

Warps: wool, ivory, Z2S; de-
pressed.
Wefts: 2 shoots; wool, brown,
Z2S, fine.
Pile: wool, silk, 3 mm high.
Knot: As, open left, pile looks up.
Knot count: 54 x 66 = 3,564 per
sq. dm (1:1.2).
Colours (15): pink (silk), crim-
son (silk), light yellow, khaki, vi-
olet-brown of 2 shades, black-
brown, dark blue, light green-
blue, green-blue, ivory Z2S,
cherry-red, carmine (2 shades)
Z2S- Z3S, lilac-pink (silk) Z3S.
Sides: original finish missing.
Ends: (upper) missing; (lower)
ivory plain weave folded over
to the back and sewn down.
Green-blue fringe, 12 cm long,
on 4 warps.

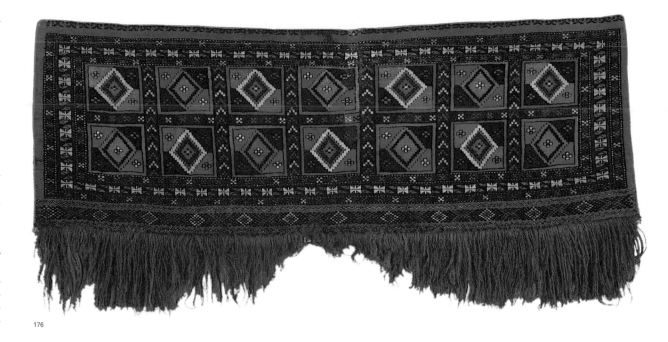

176

Camel Trapping

Salor Tribe (?)
Late 18th–early 19th Century
KOV-206
53 x 114 cm

Warps: goat hair (?), white, Z2S,
deeply depressed.
Wefts: 2 shoots; wool, brown,
Z2.
Pile: wool, silk, 3 mm high.
Knot: As, open left, pile looks
up.
Knot count: 32 x 64 = 3,048 per
sq. dm (1:2).
Colours (13): cherry-red, pink
(silk), orange, chestnut, violet-
brown, sky-blue, black-blue,
black-green, ivory Z2S, bright
cherry-red Z2S-Z3S, pink-or-
ange, orange-red Z3S-Z4S, ter-
racotta Z3S.
Sides: 4 side warps wrapped
around with dark-blue wool.
Ends: (upper) red and white
plain weave, folded over to the
back and sewn down; (lower)
ivory plain weave, folded over
to the back and sewn down.
Black-blue fringe, 30 cm long,
on 4 warps.

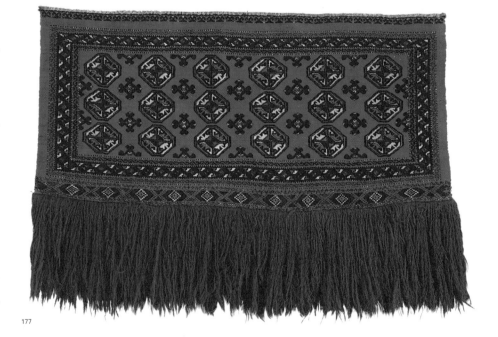

177

178

Ensi

Saryk Tribe
Late 18th Century
KOV-160
146 x 172 cm

Warps: goat hair mixed with wool (?), white, Z2S, depressed.
Wefts: 2 shoots; wool, brown, Z2S, fine.
Pile: wool, cotton, silk, 3 mm high (worn).
Knot: Sy, with multitude of offset, sharing and on 3 warps.
Knot count: 36 x 68 = 2,448 per sq. dm (1:2).
Colours (16): orange-red, orange, yellow, olive-brown, dark brown, dark blue, blue, black-blue, dark green-blue Z2S, carmine, crimson (silk) Z4S, *abrash* carmine, crimson Z3S, pink-orange Z2S-Z3S, turquoise Z1, white (cotton) Z2S-Z4S.
Sides: brown wool plaiting on 4 pairs of warps.
Ends: (upper) white plain weave folded over on front, covered on front with dark brown plaited tape; (lower) 8 cm of live-brown plain weave, with 2 motley plaits. Warp ends in fringe 8 cm long.

179

Ensi

Saryk Tribe
Late 18th–early 19th Century
KOV-158, purchased
by N.F. Burdukov in 1903
Original description:
'Ensi, manufacture of Saryk Turkmen of the Pendeh district'
112.5 x 163 cm

Warps: goat hair (?), white, Z2S, fine, depressed.
Wefts: 2 shoots; wool, light brown and orange-red (*elem*), Z2S, fine.
Pile: wool, cotton, 2 mm high (worn).
Knot: Sy, with offset and sharing.
Knot count: 38 x 68 = 2,584 per sq. dm (1:1.8).
Colours (11): carmine, pink-orange, orange, terracotta, dark blue, black green-blue Z2S, yellow, ivory (cotton) Z2S-Z4S, pink-orange (cotton) Z4S, corroded pink (2 orange plied together with carmine), light yellow (cotton) Z3S.
Finish: original finish missing.

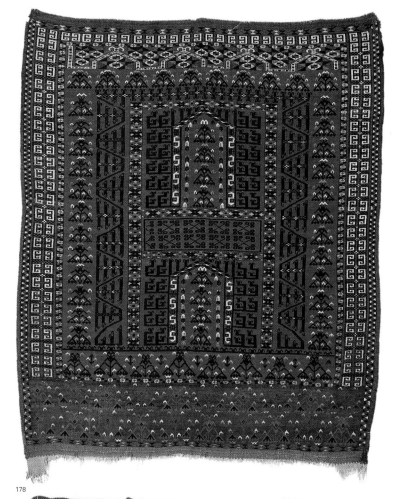

178

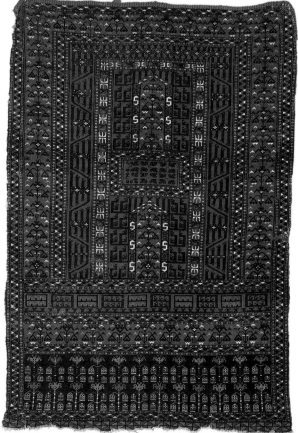

179

Chuval

Saryk Tribe
Late 17th–early18th Century
KOV-220
98 x 140 cm

Warps: goat hair (?), ivory, Z2S; slight depression.

Wefts: 2 shoots; wool, light-brown mixed with ivory and gray, Z2S.

Pile: wool, silk, cotton, 3 mm high.

Knot: Sy, with offset and warp-sharing knots, and packing knots (rows and singles); pile looks up.

Knot count: 41 x 88 = 3,608 per sq. dm.

Colours (11): cherry-red, orange, khaki, brown, dark blue, dark green-blue, white (cotton) Z2S, lighter shade of cherry-red, carmine Z2S-Z4S, crimson (silk) Z3S, ivory (silk) Z1.

Sides: 2 side warps wrapped around with cherry-red wool.

Ends: (upper) red and ivory plain weave folded over to the back and sewn down; (lower) cut.

181

Chuval

Saryk Tribe
First half 19th Century
or earlier
KOV-183
91 x 141 cm

Warps: goat hair (?), ivory, Z2S, fine; some depression.

Wefts: 2 shoots; wool of mixed colours, Z2S, fine.

Pile: wool, silk, cotton.

Knot: Sy, with offset knots and warp sharing, some packing knots and knots over 3 warps.

Knot count: 50 x 80 = 4,000 per sq. dm (1:1.6).

Colours (10): cherry-red, crimson (silk), brown, dark blue, sky-blue (silk), green-blue, white (cotton) Z2S; carmine Z4S, purple-red (2 shades) Z3S.

Sides: cut.

Ends: (upper) red and ivory plain weave folded over to the back and sewn down; (lower) red plain weave, cut.

182

Torba

Saryk Tribe
18th Century
KOV-193, purchased
by N.F. Burdukov in 1903
Original description:
'Torba, with silk, manufactured by Saryk Turkmen of the Pendeh district'
42 x 120 cm

Warps: wool, ivory, Z2S.

Wefts: 2 shoots; wool, brown, Z2S, fine.

Pile: wool, silk, cotton, 3 mm high.

Knot: Sy, with multitude offset and warp sharing knots, some on one warp.

Knot count: 40 x 80 - 74 - 50 (elem) = 3,200 - 2,960 - 2,000 per sq. dm.

Colours (10): cherry-red (2 shades), crimson (silk), orange, olive-brown, dark blue, green-blue of 2 shades, ivory (2 shades) (wool and cotton).

Sides: wool wrapped around 4 warps.

Ends: (upper) red and ivory plain weave, folded over to the back and sewn down; (lower) cut. Remains of dark blue fringe over 2 warps.

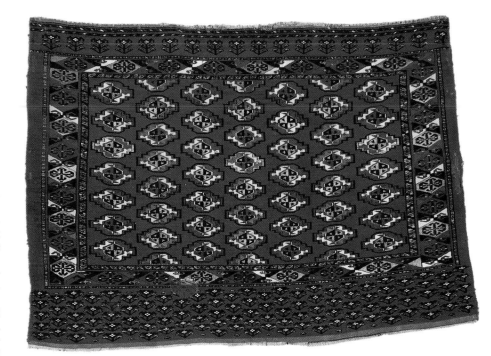

180

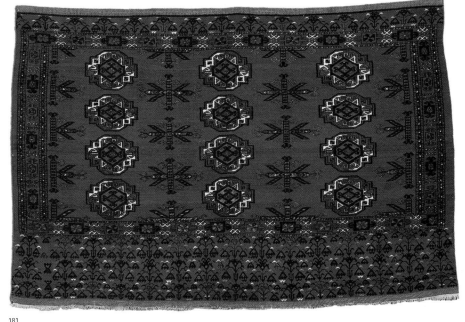

181

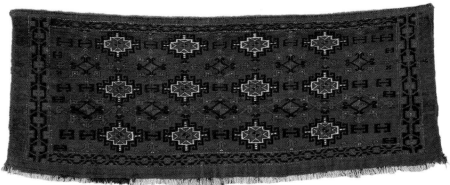

182

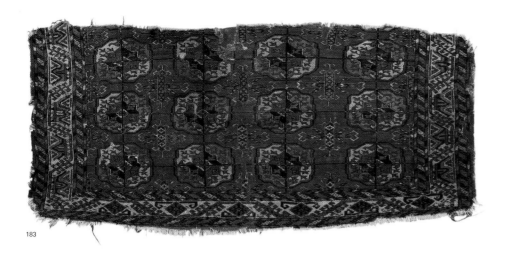

183

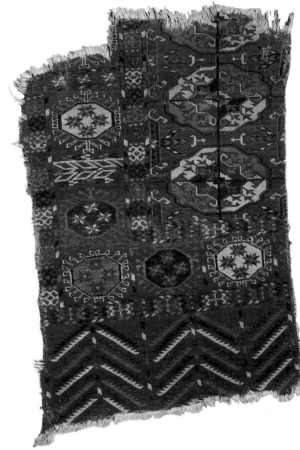

184

183
Hali Fragment
Tekke Tribe
18th Century
KOV-176, purchased by
N.F. Burdukov in 1903
Original description: 'Sample –
a piece of a carpet. Tekke-gul'
167 x 175 cm

Warps: wool, ivory, slightly rust-
colored, Z2S.
Wefts: 2 shoots; wool of light
shades, Z1, alternating with red,
Z2S.
Pile: wool, cotton, 3 mm high
(worn).
Knot: As, open right, multitude
offset and warp sharing knots,
over 3 warps, rows of packing
and 'disappearing' knots; 4 (right)
and 3 (left) rows of Sy knots on
both sides.
Knot count: 42 x 66 = 2,772 per
sq. dm (1:1.6).
Colours (11): purple-red, cher-
ry-red, orange-red, pink-orange,
camel, brown, dark blue, green-
blue (2 shades), ivory, white (cot-
ton) Z2S-Z4S.
Sides: dark blue wool wrapped
around 2 side warps.
Ends: missing.

184
Hali Fragment
Tekke Tribe
Late 17th–early 18th Century
KOV-204
69 x 99.5 cm

Warps: wool, ivory, Z2S.
Wefts: 2 shoots; wool, pink, al-
ternates with ivory mixed with
brown, Z2S, fine.
Pile: wool, 2 mm high (worn).
Knot: As, open right, some pack-
ing knots, and 'inserted' rows in
the border; 3 rows of Sy on the
right side (left side missing).
Knot count: 36 x 65 = 2,340 per
sq. dm (1:1.8).
Colours (11): cherry-red, purple,
pink-orange, orange-red, yellow,
dark brown, dark blue, sky-blue,
turquoise, green-blue, ivory Z2S-
Z4S.
Sides: dark blue wool wrapped
around 4 side warps.
Ends: missing.

Chuval
Tekke Tribe
First half 19th Century
KOV-228, purchased
by N.F. Burdukov in 1903
Original description: 'Chuval,
aina-gul, with a herring-bone
pattern, which we find in
Yomuds; manufactured
by Merv Turkmen'
71 x 112 cm

Warps: wool, ivory, Z2S, de-
pressed.
Wefts: 2 shoots; wool, brown
mixed with gray and ivory, Z1.
Pile: wool and silk, 2.5 mm high.
Knot: As, open right; 2 rows of
Sy on the right side.
Knot count: 57 x 100 - 110 - 90
(*elem*) = 5,700 - 6,270 - 5,130 per
sq. dm (1: 1.8 - 1: 2 - 1: 1.6).
Colours (12): dark cherry-red,
dark violet-red, crimson (silk),
pink (silk), carmine, orange, yel-
low, dark brown, dark blue, sky-
blue, green, white Z2S.
Sides: dark cherry-red wool
wrapped around side warps.
Ends: (upper) red plain weave,
folded over to the back and sewn
down; dark blue cord sewn on
to the edge; cotton printed cloth
(*chit*) stripe sewn on inside; (low-
er) ivory plain weave used for
the back.

186
Chuval
Tekke Tribe
Mid 19th Century
KOV-217
73.5 x 125.5 cm

Warps: wool, ivory, Z2S.
Wefts: 2 shoots; wool, brown,
Z2S, fine.
Pile: wool, silk, 3 mm high.
Knot: As, open right; pile looks
up.
Knot count: 60 x 110 - 70 (*elem*) =
6,600 - 4,200 per sq. dm (1: 1.9-
1.1).
Colours (12): cherry-red (2
shades), carmine, purple-red,
crimson (silk), pink, dark brown,
dark blue, blue, sky-blue, dark
green-blue, ivory Z2S.
Sides: cherry-red wool plaiting
on side warps.
Ends: (upper) ivory and red plain
weave, folded over to the back
and sewn down, dark blue plait-
ed tape sewn on to the front
edge; (lower) ivory plain weave,
cut.

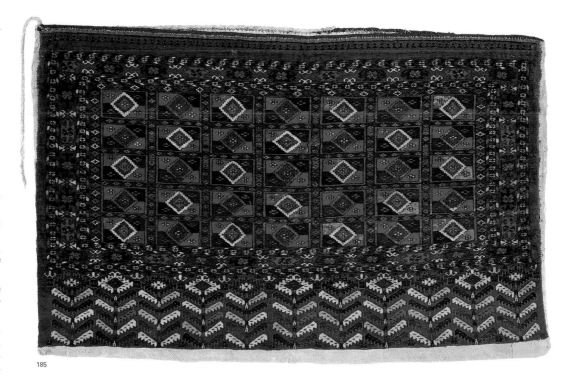

185

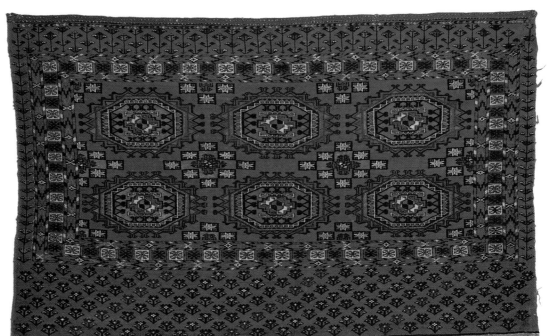

186

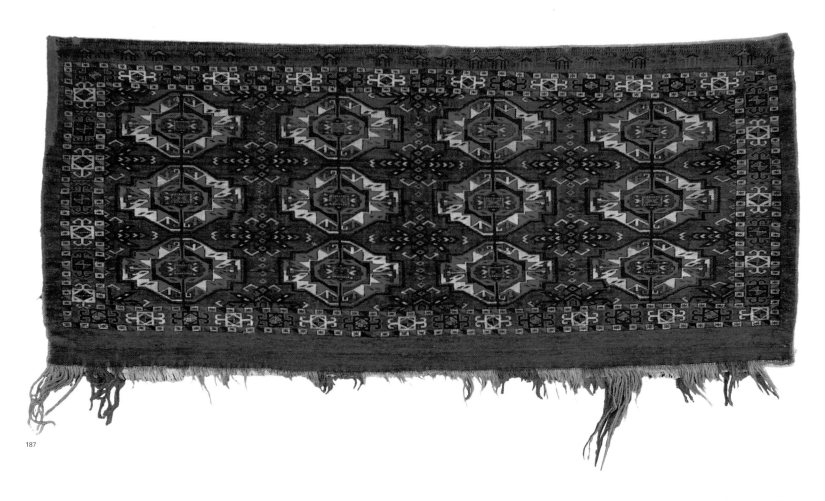

187

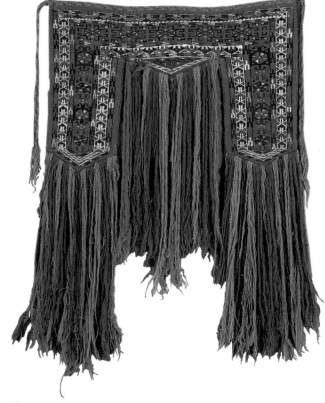

188

187	188
Torba	**Khalyk**
Tekke Tribe	Tekke Tribe
18th Century	19th Century
KOV-190	KOV-177
57 x 135 cm	44.5 x 70 cm

Warps: wool, gray plied together with ivory and brown, Z2S, fine.

Wefts: 1 and 2 (*elem*) shoots; wool, brown, Z2S, fine.

Pile: wool, 2.5 mm high.

Knot: As, open right, with warp-sharing, offset knotting and knots over 3 warps; 10 Sy offset on both sides, all offset; 2 rows of sharing Sy knots, 17 cm and 10 cm long, in the upper part.

Knot count: 53 x 85 - 90 - 65 (*elem*) = 4,505 - 4,770 - 3,445 per sq. dm (1:1.4 - 1.7 - 1.2).

Colours (8): orange-red (2 shades), purple-red, brown, dark blue, green-blue, green, ivory Z2S.

Sides: purple-red plaiting on side warps.

Ends: (upper) orange and ivory plain weave, folded over to the back and sewn down; (lower) cut. Remains of multicoloured fringe on 4 warps.

Warps: wool, white, Z2S.

Wefts: 1 shoot; wool, white, Z1.

Pile: wool, 2 mm high.

Knot: As, open right; 1 row of Sy on the left side, and 5 on the right. pile looks up.

Knot count: 49 x 100 = 4,900 per sq. dm (1:2).

Colours (9): cherry-red, bright red, orange-red, yellow, dark green, dark blue, sky-blue, dark brown, ivory Z2S.

Sides: dark blue wool wrapped around 2 side warps.

Ends: (upper) ivory plain weave, folded over to the back and sewn down; green-and-red plait sewn over the front; (lower) ivory plain weave, folded over to the back and sewn down. Multicoloured fringe, 70 cm long, on 6 warps.

189

Mafrash
Tekke Tribe
First half 19th Century
KOV-211
29 x 61 cm

Warps: wool, ivory, Z2S.
Wefts: 1 shoot; shades of brown, plied together with ivory, Z2S, fine.
Pile: wool, silk, 2 mm high.
Knot: As, open right; pile looks up.
Knot count: 45 x 92 - 60 (*elem*) = 4,140 - 2,700 per sq. dm (1:2 - 1:1.3).
Colours (16): cherry-red, red (silk), carmine, pink (silk), pink-orange, orange, yellow, violet-brown, brown, dark brown, dark blue, sky-blue, turquoise, dark green-blue, green, ivory Z2S.
Sides: original finish missing.
Ends: (upper) red and ivory plain weave, folded over to the back and sewn down; (lower) cut.

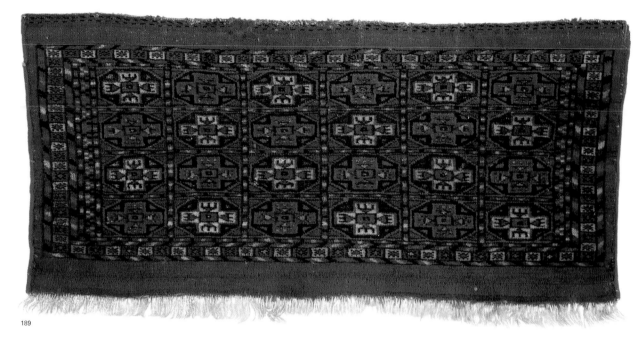

189

190

Mafrash
Tekke Tribe
19th Century
KOV-161
36.5 x 75 cm

Warps: wool, ivory, Z2S.
Wefts: 2 shoots; wool, brown, Z2S, fine.
Pile: wool, silk, 2 mm high.
Knot: As, open right, 4 rows of Sy knots on right and 2 rows on the left.
Knot count: 47 x 80 = 3,760 per sq. dm (1:1.7).
Colours (10): cherry-red, crimson (silk), orange, yellow, brown, dark blue, green-blue, green, turquoise, ivory Z2S.
Sides: 2 side warps wrapped around with red wool, sewn together with the back, the stitch is covered with sewn on red-and-blue plait.
Ends: (upper) red and ivory plain weave folded over to the back and sewn down; (lower) ivory plain weave makes the back. Remains of multicoloured fringe on 4 warps.

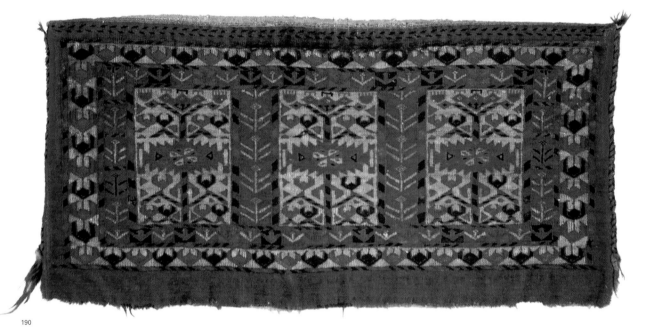

190

Mafrash
Tekke Tribe
19th Century
KOV-208
34 x 79 cm

Warps: wool, ivory, Z2S, fine.
Wefts: 2 shoots; light brown,
ivory and light pink plied to-
gether, Z2S.
Pile: wool, 2 mm high.
Knot: As, open right.
Knot count: 42 x 84 = 3,538 per
sq. dm (1:2).
Colours (8): cherry-red, orange-
red, yellow, brown, dark blue,
blue, green-blue, ivory Z2S.
Sides: 2 side warps wrapped
around with red wool.
Ends: (upper) green-blue and
ivory plain weave folded over
to the back and sewn down;
(lower) cut. Remains of original
fringe on 4 warps.

192

Mafrash
Tekke Tribe (?)
19th Century
KOV-152, purchased
by N.F. Burdukov in 1903
Original description:
'Flatwoven torba, Yomud
manufacture'
37 x 72.5 cm

Warps: wool, ivory, Z2S.
Main wefts: carmine and vio-
let-red, Z2.
Pattern-weft: wool, silk, cotton,
Z2S. *Oidume* brocade techni-
que.
Colours (13): carmine, claret,
crimson (silk), orange-red, light
yellow (silk), dark blue, sky-blue,
green-blue, green, violet-
brown, 2 shades; brown, white
(cotton).
Sides: no additional finish; 10
cm of green-and-crimson (silk)
plaiting in *elem* part.
Ends: (upper) ivory plain wea-
ve, folded over to the back and
sewn down; (lower) ivory plain
weave, makes the back. Multi-
coloured fringe, 13 cm long,
worn out.

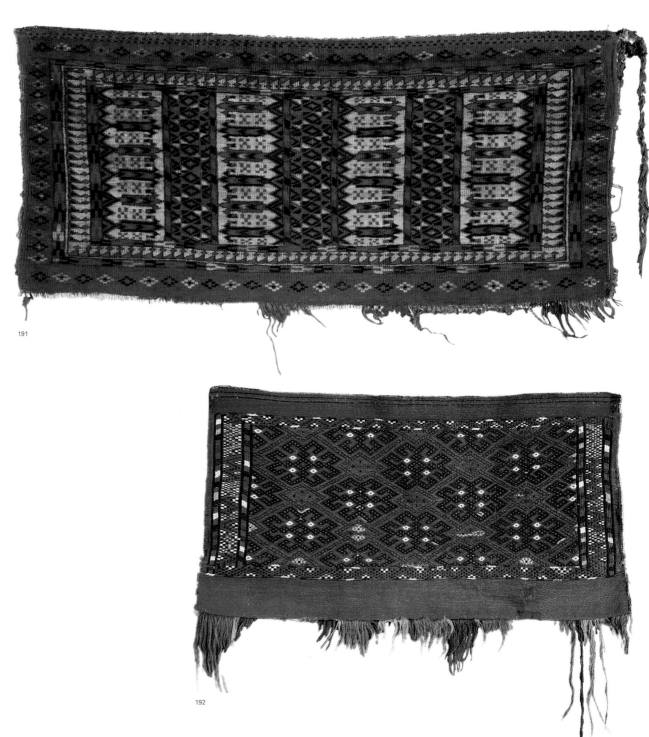

191

192

193

Germech

Tekke Tribe

First half 19th Century
or earlier

KOV-180, purchased
by N.F. Burdukov

Original description:
'Akhal torba, with ensi's
end design'

26 x 76,5 cm

Warps: wool, ivory, mixed with
camel hair (?), Z2S, fine.

Wefts: 2 shoots; wool, dark
brown, alternates with red and
blue, Z1 (?).

Pile: wool, camel hair, cotton,
silk, 2 mm high.

Knot: As, open right, with off-
set knots and warp sharing, over
3 warps, and 'empty' warps.

Knot count: 44 x 88 = 3,872 per
sq. dm (1:2).

Colours (17): cherry-red (2
shades), pink (silk), crimson
(silk), orange-red, yellow, camel,
chestnut, dark brown, dark blue
(2 shades), sky-blue, turquoise,
dark green, non-bleached cot-
ton, ivory, white (cotton) Z2S.

Sides: dark blue wool wrapped
around side warps; right side
lower part – loose wrapping
around, and a kind of lace plait-
ing.

Ends: ivory plain weave turned
around to the back, sewn down,
dark brown diagonal stitching
at the edge; (lower) 3.5 cm of
ivory plain weave, with 2 plain
red stripes, and a stripe of bro-
cade with triangular pattern.
Warp ends knotted into a fringe,
5 cm long.

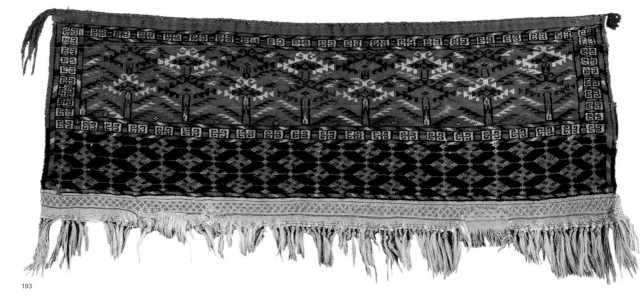

193

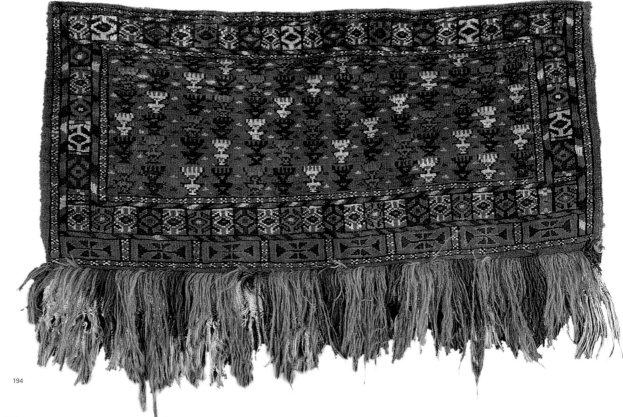

194

194

Germech

Tekke Tribe

19th Century

KOV-241

34 x 75 cm

Warps: wool, ivory, Z2S, fine.

Wefts: 2 shoots; wool, brown,
Z1.

Pile: wool, 3 mm high.

Knot: As, open right, 3 rows of
Sy knots on the left side, and
one on the right; pile looks up.

Knot count: 38 x 70 = 2,660 per
sq. dm (1:1.6).

Colours (9): cherry-red, terra-
cotta, orange, yellow, brown,
dark blue, sky blue, green-blue,
ivory Z2S.

Sides: 2 side warps wrapped
around with dark blue wool.

Ends: (upper) red and ivory plain
weave folded over to the back
and sewn down; (lower) 5 cm
of ivory plain weave. Warp ends
knotted into fringe 22 cm long.

195

Yolam

Turkmen Tribe
18th Century
KOV-171, purchased
by N.F. Burdukov in 1903
Original description:
'Tjuni-chipi, Merv manufacture'
16 x 276.5 cm

Warps: wool, ivory and red, Z2S,
fine.
Wefts: bleached cotton and non-
bleached silk, Z2S, fine.
Pile: wool, silk, cotton, 2 mm high.
Knot: Sy, single-level knotting over
3 and 5 warps.
Knot count: 45 x 70 = 3,150 per sq.
dm (1:1.6).
Colours (15): orange-red, terracot-
ta, dark pink, lilac (silk), purple-
brown, yellow, ivory (silk), dark blue,
blue, sky-blue, dark green, green,
white Z2S, crimson (silk) Z1, white
(cotton) Z1-Z3S.
Sides: no additional finish.
Ends: blue-and-red plait at the edge.
Warp ends wrapped around with
wool of different colours, 35–40 cm
long.

196

Yolam

Turkmen Tribe
18th–19th Century
KOV-159, purchased
by N.F. Burdukov in 1903
Original description:
'Ip - tent band,
of Askhabad manufacture'
30–36 x 1,456 cm

Warps: wool, ivory, brown, red and
terracotta, Z2S, fine.
Wefts: bleached silk, cotton and
wool, Z2S, fine.
Pile: wool, silk, cotton, 3 mm high.
Knot: Sy, single level knotting, over
3 and 5 warps.
Plain weave: 220 warps x 90 wefts
per sq. dm.
Colours (21): red, cherry-red, ter-
racotta, chestnut, orange, yellow,
violet-brown, dark blue, sky-blue,
turquoise, dark green-blue (2
shades), green (2 shades) Z2S, scar-
let, orange-pink, crimson (silk), light
blue, white (cotton) Z1; bright red,
Z1-Z2S; orange-red Z2S-Z3S.
Sides: red wool wrapped around
2 side warps.
Ends: 77 cm of ivory plain weave,
with 7 brocade and 3 piled orna-
mented stripes. Red fine plait and
blue-and-red 2 cm wide plait at the
edge. Warp ends plaited into cords,
80 cm long.

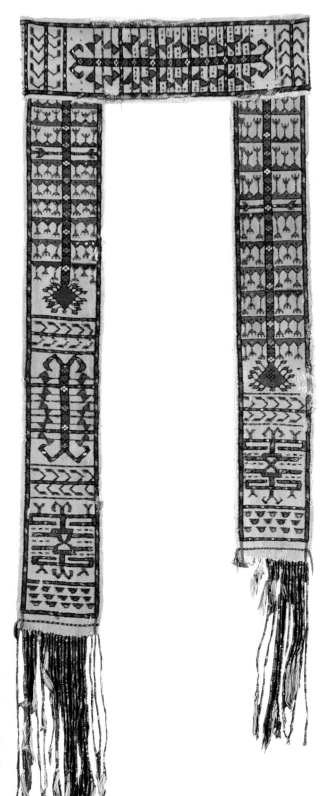

195

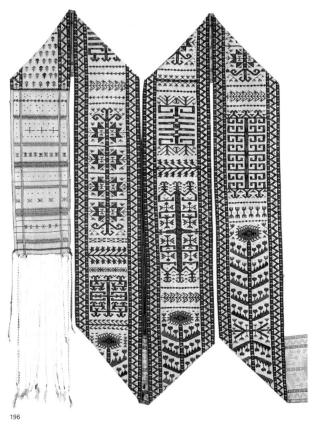

196

211

197

Asmalyk

Yomud Tribe
18th Century
KOV-207, purchased
by N.F. Burdukov in 1903
Original description:
'Khamykh for decorating
a camel, of Yomud
manufacture'
92.5 x 143.5 cm

Warps: wool, ivory plied to-
gether with brown-gray, Z2S.
Wefts: 2 shoots; wool, mixed
brown, ivory, gray, Z2S.
Pile: wool, 3 mm high.
Knot: Sy, some As open left and
right; some warp sharing, some
knots over 3 warps, and pack-
ing knots.
Knot count: 47 x 76 = 3,572 per
sq. dm (1: 1.6).
Colours (7): red, violet, dark
green, blue-green, dark blue,
dark brown, ivory Z2S, some Z1
in packing knots.
Sides: no additional finish.
Ends: (upper) red plain weave,
folded over to the back and sewn
down; remains of striped tape
sewn on in the middle; and
green-and-red cords at the ends;
(lower) red plain weave folded
over to the back and sewn down.
3.5 cm wide *gadjari* flatwoven
tape, with 19 cm long dark blue
fringe, sewn on to the sides and
the bottom.

198

Asmalyk

Yomud Tribe
Mid 19th Century
KOV-191, purchased in 1905
81 x 138 cm

Warps: goat hair (?), ivory, Z2S.
Wefts: 2 shoots; white wool and
cotton plied together, Z2S.
Pile: wool, 5 mm high.
Knot: Sy, with sharing and off-
setting.
Knot count: 38 x 66 = 2,508 per
sq. dm (1: 1.7).
Colours (5): orange-red, violet-
brown, dark brown, dark green-
blue, ivory Z2S.
Sides: no additional finish.
Ends: (upper) red plain weave
folded over at the back and sewn
down; (lower) ivory plain
weave, folded over to the back
and sewn down. Plain weave
tape sewn on to the bottom end
and 1/2 of the sides.

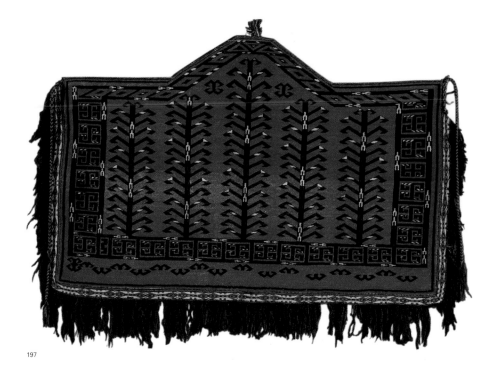

197

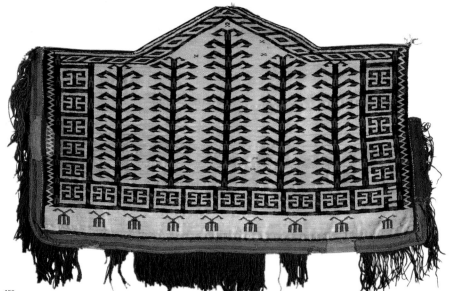

198

212

199

Asmalyk
Yomud Tribe
19th Century
KOV-167, purchased in 1904
84.5 x 135 cm

Warps: wool, ivory, Z2S.
Wefts: 2 shoots; bleached cotton plied with camel hair, Z2S; fine.
Pile: wool, camel hair, cotton, 4 mm high.
Knot: Sy, with offset knots and warp sharing.
Knot count: 90 - 105 - 96 (*elem*) = 3,600 - 4,200 - 3,840 per sq. dm (1:2.2 - 1:2.6 - 1:2.4).
Colours (14): terracotta-red, purple, brown-red, orange, camel, green, dark green-blue, dark blue, blue, dark brown, ivory, white (cotton) Z2S, pink-red, pink-orange Z2S-Z3S.
Sides: no additional finish.
Ends: (upper) dark blue and ivory plain weave folded over to the back and sewn down; (lower) ivory plain weave, folded over to the back and sewn down. Sides and bottom are trimmed with a blue-and-purple tape, decorated with 5-level multicoloured tassels, 30–35 cm long.

200

Asmalyk
Yomud Tribe
19th Century
KOV-166, purchased in 1904
89 x 142 cm

Warps: wool, white mixed with gray, Z2S.
Wefts: 2 shoots; wool, dark brown and white mixed with gray, Z2S.
Pile: wool, 3 mm high.
Knot: Sy, with offset, warp sharing knots, and some knots over 3 warps.
Knot count: 40 x 80 - 110 - 90 (*elem*) = 3,200 - 4,400 - 3,600 per sq. dm (1:2 - 1:2.8 - 1:2.2).
Colours (8): red, orange, violet-brown, dark blue, blue, green, brown-black, white Z2S.
Sides: green wool wrapped around side warps; 3-level tassels attached to the edge.
Ends: (upper) violet-red and red plain weave folded over to the back and sewn down; red-and-blue plaiting on the front; green slanting stitching in between the plait and pile; green-and-red cord sewn on in the centre; (lower) as upper end; 3-level tassels attached to the edge stitching.

201

Bukcha
Yomud Tribe
Late18th–early 19th Century
KOV-240
83.5 x 86 cm

Warps: wool of light tints and camel hair, Z2S.
Wefts: 2 shoots; white cotton plied together with unbleached silk, Z2S; fine.
Pile: wool, camel hair, 3 mm high.
Knot: Sy, the whole panel is made in the offset method, with much warp sharing, over 3 and 1 warp and packing knots.
Knot count: 80 x 80 = 6,400 per sq. dm (1:1).
Colours (15): orange, orange plied together with camel hair, cherry-red, carmine, violet-red, violet-red plied together with pink, violet-brown of 2 shades; dark brown, camel hair, dark green-blue, dark blue, blue, ivory Z2S-Z4S, corroded crimson/pink Z3S.
Sides: orange wool wrapped around side warps.
Ends: orange plain weave, folded over to the back, and sewn down. The sewn together edges of the envelope are connected by a blue-and-red plait. The opening flap is finished with long slanting blue and red wool stitches.
Back (remains): orange and ivory plain weave, with a geometric pattern (long narrow triangles).

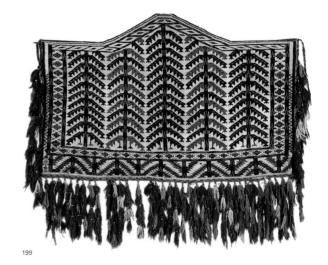

199

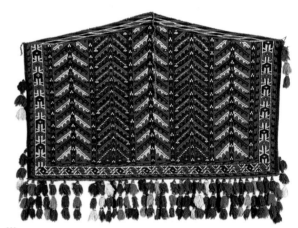

200

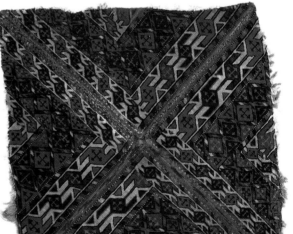

201

213

Camel Trapping
Chodor Tribe
Middle Amu Darya
19th Century (?)
KOV-204, purchased
by N.F. Burdukov in 1903
Original description:
'Torba, made by the
Chodor tribe (Charjui)'
48.5 x 135 cm

Warps: goat hair, gray, ZS, de-pressed.
Wefts: 2 shoots; white cotton plied together with camel hair, Z2S.
Pile: wool, silk, 4 mm high.
Knot: As, open left; pile looks up.
Knot count: 38 x 60 = 2,280 per sq. dm (1:1.4).
Colours (11): orange-red, yellow, violet-brown, dark brown, dark blue-green, sky-blue, blue, dark blue, ivory Z2S, carmine Z6S, crimson (silk) Z4S-Z6S.
Sides: some warps wrapped round with cherry-red wool.
Ends: (upper) cherry-red, blue-green, ivory plain weave, folded over to the back and sewn down; blue-and-red plait along the edge; (lower) cut.

Camel Trapping
Arabachi Tribe
Middle Amu Darya
19th Century
KOV-187
59.5 x 144 cm

Warps: wool, ivory, plied to-gether with brown-gray, Z2S.
Wefts: 2 shoots; white cotton plied with camel hair, Z2S.
Pile: wool, silk, 6 mm high.
Knot: As, open left, some pack-ing knots on one warp.
Knot count: 34 x 60 = 2,040 per sq. dm (1: 1.8).
Colours (17): red, violet-red, pink (silk), pink-orange, orange, yellow, light green, green, green-blue, sky-blue, blue, dark blue, light chestnut (silk), dark brown, camel, white Z2S, carmine Z3S-Z4S.
Sides: 2 side warps wrapped around with violet-red wool.
Ends: (upper) red and ivory plain weave folded over to the back and sewn down; green-blue and pink-orange stitching at the edge; (lower) red and ivory plain weave, cut. Remains of multi-coloured fringe on 6 warps.

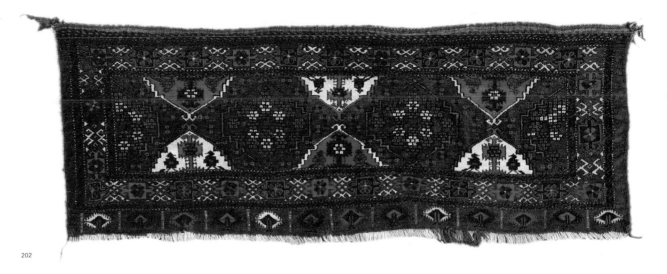

202

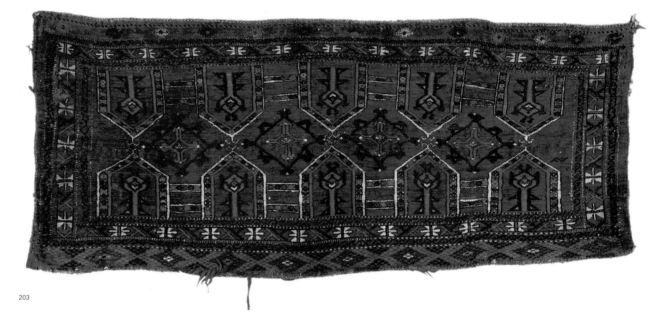

203

204

Camel Trapping
Arabachi Tribe
19th Century
KOV-203
61 x 137 cm

Warps: goat hair mixed with wool of different shades, Z2S, depressed.
Wefts: 2 shoots; camel hair plied with white cotton, Z2S.
Pile: wool, 4 mm high.
Knot: As, open left.
Knot count: 36 x 54 = 1,944 per sq. dm (1: 1.5).
Colours (8): orange-red, chestnut, dark brown, purple-brown, dark blue, blue, green, ivory Z2S.
Sides: brown goat hair wrapped round 4 side warps.
Ends: (upper) violet-brown plain weave, with blue and red stripes on the front, ivory/camel hair folded over to the back and sewn down; (lower) cut. Remains of multicoloured fringe on 6 warps.

205

Camel Trapping
Ersari Tribe (?)
Middle Amu Darya
Second half 19th Century
KOV-205
64 x 168 cm

Warps: wool, ivory, Z2S.
Wefts: 2 shoots; wool, gray and brown of different shades including purple-brown, Z2S.
Pile: wool, 4 mm high.
Knot: As, open right, some over 3 and 4 warps at the sides; pile looks up.
Knot count: 38 x 45 = 1,720 per sq. dm (1:1.2).
Colours (9): cherry-red, orange, yellow Z2S-Z4S, brown, blue, dark blue, green-blue, turquoise, ivory Z2S.
Sides: plaiting in red wool on 2 pairs of warps; plaited red-and-blue tape sewn on to the edge.
Ends: (upper) 2 cm of red plain weave, with a row of turquoise diamonds, 1 cm of ivory plain weave folded over to the back and sewn down; (lower) red and ivory plain weave, folded over to the back and sewn down. Remains of dark blue fringe on 4 warps.

206

Hali
Middle Amu Darya
19th Century
KOV-261
214 x 402 cm

Warps: goat hair of light shades, Z2S.
Wefts: 2 shoots; wool of mixed shades, Z2S.
Pile: wool, 5 mm high.
Knot: As, open left.
Knot count: 30 x 43 = 1,290 per sq. dm (1:1.4).
Colours (18): red, carmine, orange-red, orange, yellow (2 shades), terracotta, brown, violet-brown, blue (2 shades), sky-blue, turquoise, dark green-blue, green, white, plied shades of red, plied shades of green Z2S.
Sides: brown wool plaiting on 3 pairs of warps.
Ends: 16 cm of striped kilim, blue on red ground.

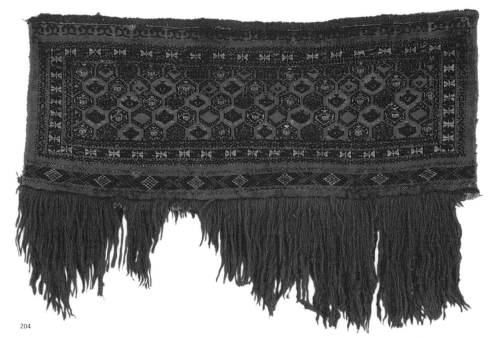

204

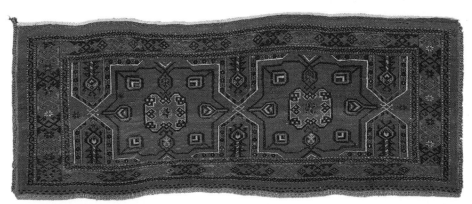

205

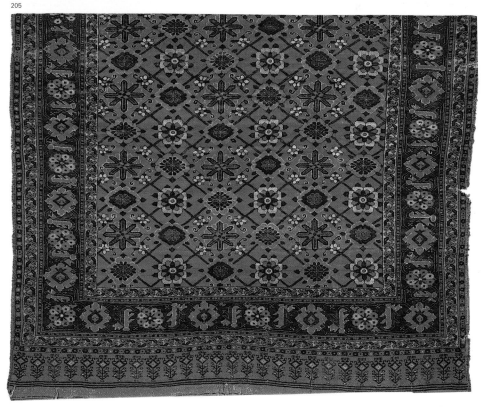

206

207

207

Chuval

Turkmen Tribe
First half 19th Century
KOV-237, purchased
by N.F. Burdukov in 1903
Original description:
'Kyzil-chuval, manufactured
in Askhabad'
82 x 121.5 cm

Warps: wool ivory, Z2S.
Wefts: 1 and 2 (undecorated areas) shoots; wool, light brown, Z2S, fine.
Pile: wool, 3 mm high.
Knot: As, open right, with many irregular knots, including knots over 3 warps, packing knots and missing warps; 2 rows of Sy on the right side.
Knot count: 44 x 150 - 110 - 100 (undecorated areas) = 7,000 - 4,840 - 4,400 per sq. dm (1:3.3 - 1:2.5 - 1:2.3).
Colours (11): cherry-red (2 shades) Z2S-Z4S, carmine, orange, orange plied together with red, brown, dark blue, green-blue, green, ivory Z2S, turquoise Z2S-Z4S.
Sides: cherry-red wool plaiting on 2 warps; red-and-blue cord sewn on to the *elem* part.
Ends: (upper) green, red and orange plain weave, folded over to the back and sewn down; a cord sewn on to the edge; (lower) ivory plain weave, makes the back.

208

Namazlyk

Middle Amu Darya
19th Century
KOV-257
104.5 x 186.5 cm

Warps: goat hair of mixed shades, Z2S.
Wefts: 2 shoots; brown-gray, ivory, light pink, Z2S.
Pile: wool, 3 mm high.
Knot: As, open right.
Knot count: 29 x 40 = 1,160 per sq. dm (1: 1.3).
Colours (8): red, light yellow, brown (different shades), dark blue, blue, light blue, sky-blue, ivory. At the bottom all colours change to off-shades, Z2S.
Sides: dark brown wool plaiting on side warps.
Ends: striped kilim, late (?)

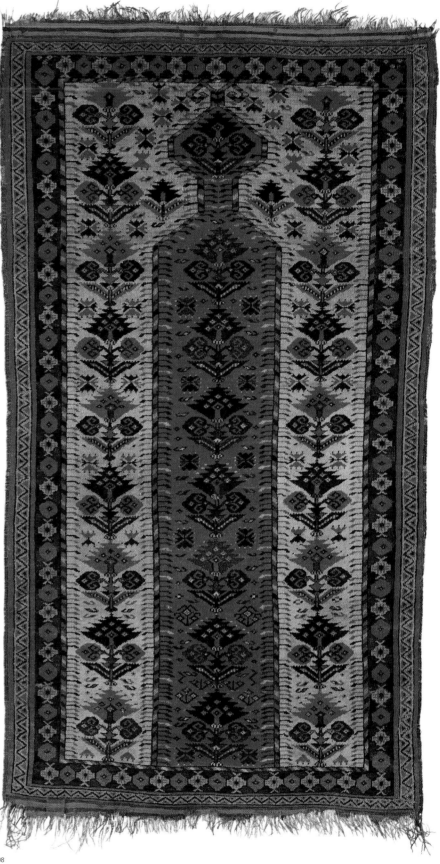

208

Appendix

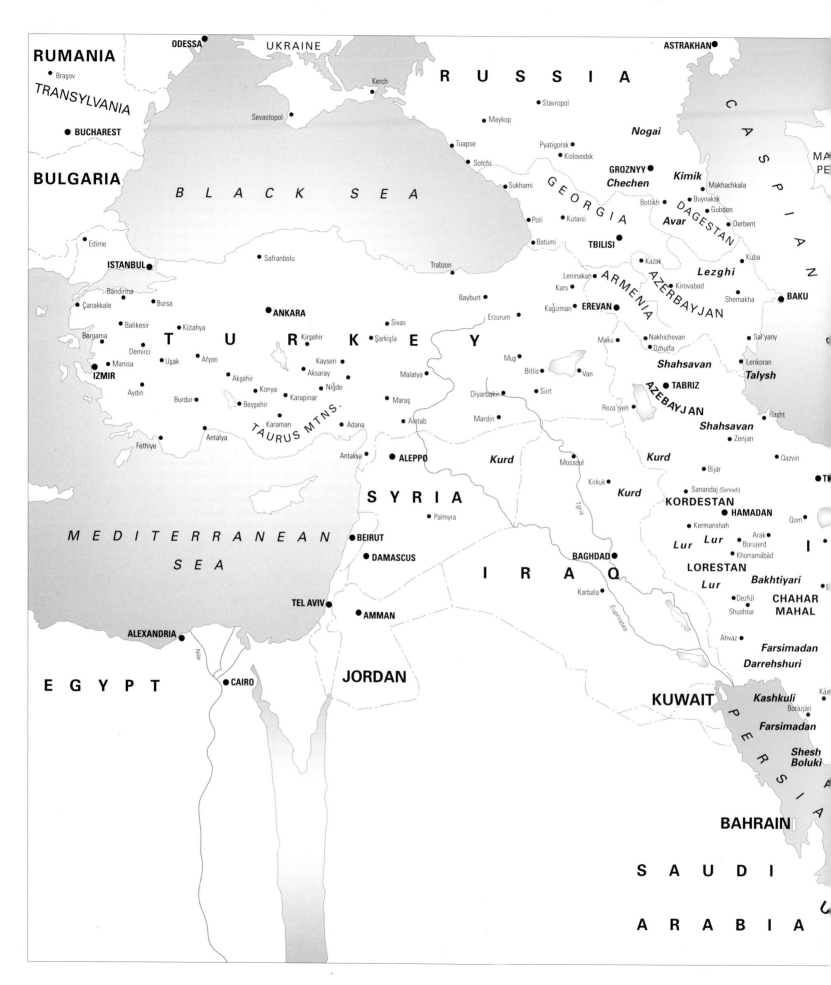

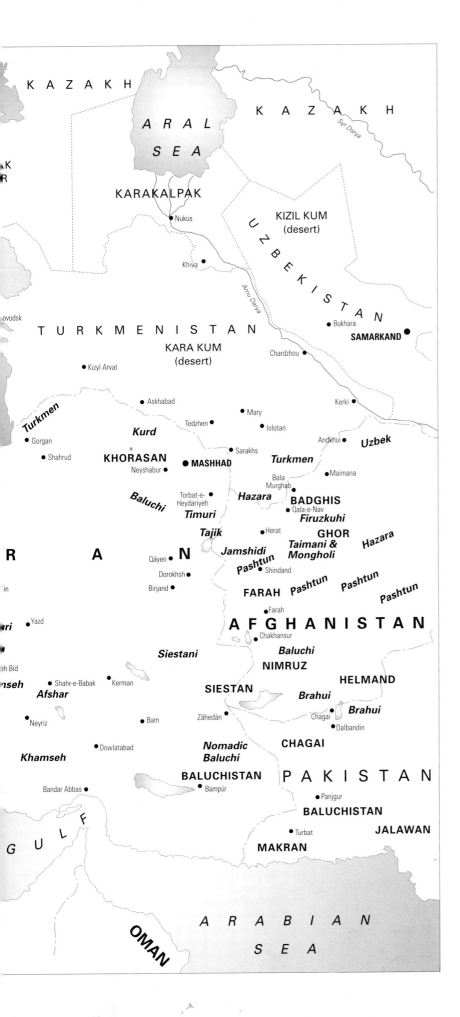

*Map of Western Asia.
The distribution of carpet
weaving nomadic and tribal
groups, together with the main
centres of urban and rural carpet
production.*

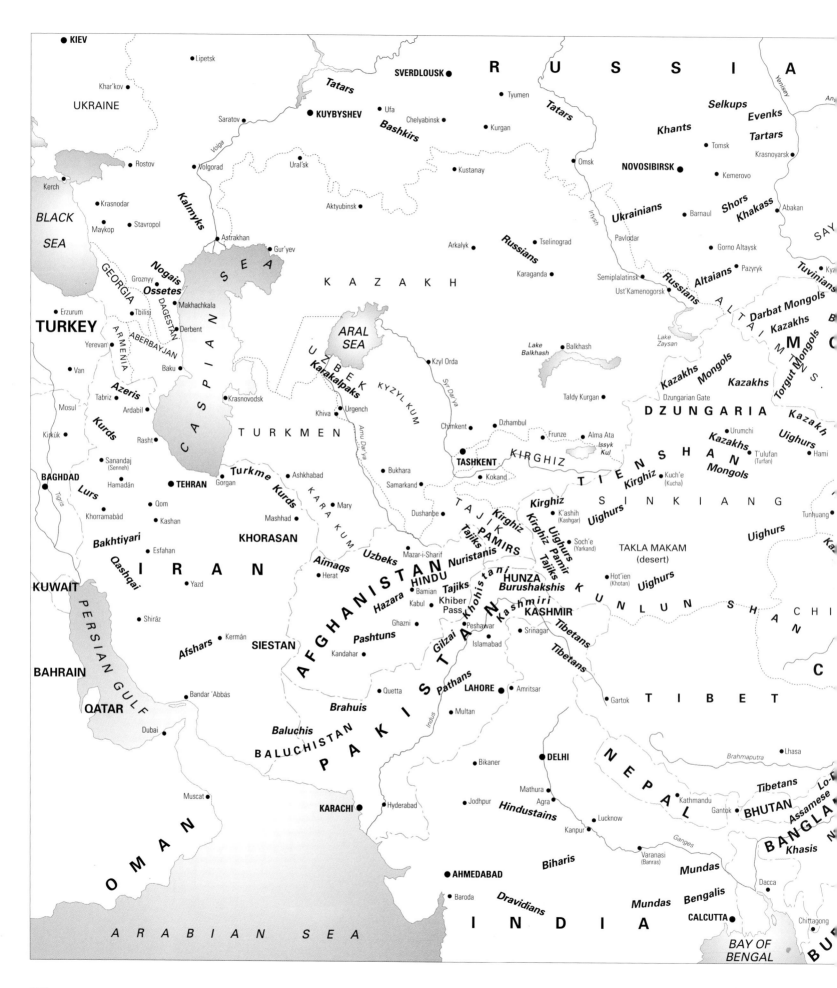

KIEV

Lipetsk

Khar'kov

UKRAINE

SVERDLOUSK

RUSSIA

Tatars

Saratov

KUYBYSHEV

Ufa

Chelyabinsk

Tyumen

Tatars

Selkups

Evenks

Khants

Tartars

Bashkirs

Kurgan

Tomsk

Krasnoyarsk

NOVOSIBIRSK

Kemerovo

Rostov

Volgorad

Ural'sk

Kustanay

Omsk

Ukrainians

Shors

Khakass

Kerch

Krasnodar

Aktyubinsk

Barnaul

Abakan

BLACK
SEA

Maykop

Stavropol

Astrakhan

Gur'yev

Arkalyk

Tselinograd

Pavlodar

Gorno Altaysk

SAY

Kalmyks

KAZAKH

Russians

Russians

Altaians

Pazyryk

Tuvinians

Kya

Nogais

Groznyy

Karaganda

Semiplalatinsk

ALTAI

M

Ossetes

Makhachkala

Ust'Kamenogorsk

Darbat Mongols

Erzurum

GEORGIA

DAGESTAN

Derbent

ARAL
SEA

Kazakhs

Dzungarian Gate

DZUNGARIA

Kazakhs

Torgut Mongols

Tbilisi

Lake
Balkhash

Balkhash

TURKEY

ARMENIA

Mongols

Kazakhs

Kazakh

Yerevan

ABERBAYJAN

Baku

Kzyl Orda

Lake
Zaysan

Van

UZBEK

Karakalpaks

Taldy Kurgan

Azeris

Tabriz

Krasnovodsk

KYZYL KUM

Urumchi

Kazakhs

Uighurs

Mosul

Ardabil

Khiva

Urgench

Syr Dar'ya

Chimkent

Dzhambul

T'ulufan
(Turfan)

Hami

Kirkük

Kurds

Rasht

TURKMEN

Bukhara

Frunze

Alma Ata

TIEN SHAN

BAGHDAD

Sanandaj
(Senneh)

Turkme

Ashkhabad

TASHKENT

Samarkand

Issyk
Kul

SINKIANG

Uighurs

Lurs

Hamadān

Gorgan

TEHRAN

Kurds

Kokand

KIRGHIZ

Kirghiz

Kuch'e
(Kucha)

Tigris

Amu Dar'ya

Dushanbe

Kirghiz

Mongols

Khorramabād

Qom

Kashan

KARA KUM

Mary

TAJIK

Kirghiz

Kirghiz
Pamir

K'ashih
(Kashgar)

Uighurs

Bakhtiyari

Esfahan

Mashhad

KHORASAN

Uzbeks

Mazar-i-Sharif

PAMIRS

Tajiks

Soch'e
(Yarkand)

TAKLA MAKAM
(desert)

Uighurs

Aimaqs

Tajiks

Nuristanis

Qashqai

IRAN

Yazd

Herat

HINDU

HUNZA

Hot'ien
(Khotan)

Uighurs

KUWAIT

Hazara

Kabul

Tajiks

Burushakshis

CHI

Afshars

Kermān

SIESTAN

Bamian

Khiber
Pass

Ghazni

Kashmiri

KASHMIR

KUN LUN SHAN

Shiráz

AFGHANISTAN

Pashtuns

Peshawar

Islamabad

Srinagar

Tibetans

Kohistani

BAHRAIN

PERSIAN GULF

Kandahar

Gilzai

Tibetans

Gartok

TIBET

Bandar 'Abbās

Quetta

Pathans

LAHORE

Amritsar

C

QATAR

Brahuis

PAKISTAN

Multan

Dubai

Baluchis

Bikaner

DELHI

NEPAL

Brahmaputra

Lhasa

Muscat

BALUCHISTAN

Jodhpur

Mathura

Tibetans

Lo-

Hyderabad

Hindustains

Agra

Kathmandu

Gantok

BHUTAN

Assamese

KARACHI

Kanpur

Lucknow

BANGLA

Khasis

Biharis

Ganges

Varanasi
(Banras)

Mundas

AHMEDABAD

Dacca

Baroda

Dravidians

Mundas

Bengalis

N

OMAN

INDIA

CALCUTTA

Chittagong

ARABIAN SEA

BAY OF
BENGAL

BU

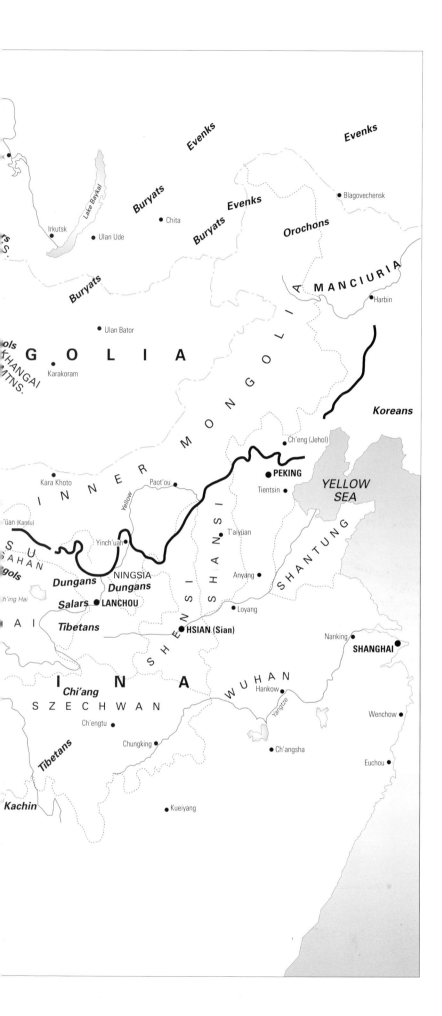

Map of Eurasia and Southern Siberia. The historical areas of interaction between Northern nomadic populations and the Southern settled civilisations.

Bibliography

General Reference Books

Achdijan, A., *Le Tapis - The Rug*. Paris, 1949.

Alexander, C., *A Foreshadowing of 21st Century Art. The Color and Geometry of Very Early Turkish Carpets.* New York and Oxford, 1993.

Antique Oriental Carpets from Austrian Collections, vol. II. Vienna, 1986.

Aurel Stein, M., *Serindia. Detailed Report of Explorations in Central Asia and Westernmost China.* Oxford, 1921.

Batari, F., *Ancient Oriental Rugs*. Budapest, 1986.

Bateman Faraday, C., *European and American Carpets and Rugs.* 1990.

Bausback, P., *Antike Orientteppiche*. Braunschweig, 1978.

Bausback, P., *Old and Antique Oriental Art of Weaving*. London, 1983.

Beattie, M.H., *The Thyssen-Bornemisza Collection of Oriental Rugs.* Castagnola and Lugano, 1972.

Benardout, R., *Antique Rugs*. London, 1983.

Bennett, I., *Book of Oriental Carpets and Rugs*. London, 1973.

Bennett, I., *Rugs and Carpets of the World.* London, 1978.

Bernheimer, O., *Alte Teppiche des 16.-18. Jahrhunderts der Firma Bernheimer.* Munich, 1959.

Bernheimer: Oriental Carpets & Textiles. London, 1987.

Black, D., *The Macmillan Atlas of Rugs and Carpets.* New York, 1985.

Black, B., and C. Loveless, *Embroidered Flowers from Thrace to Tartary.* London, 1981.

Bode, von, W., *Anciens Tapis d'Orient.* Paris, 1911.

Bode, von, W., and E. Kühnel, *Antique Rugs from the Near East*, transl. C. Grant Ellis. New York, 1984.

Boralevi, A., *Oriental Geometries. Stefano Bardini and the Antique Carpet.* Florence, 1999.

Brancati, L.E., *Questioni sul Tappeto.* Turin, 1998.

Burnham, D.K., *Warp and Weft. A Dictionary of Textile Terms.* New York, 1980.

Campana, M., *Oriental Carpets.* London, 1969.

Cannon, J. and M., *Dye Plants and Dyeing.* London, 1994.

Collingwood, P., *The Techniques of Rug Weaving.* New York, 1968.

Denny, W., and D. Walker, *The Markarian Album.* Cincinnati, 1988.

Dilley, A.U., *Oriental Rugs and Carpets.* Philadelphia, 1959.

Dimand, M.S., and J. Mailey, *Oriental Rugs in the Metropolitan Museum of Art.* New York, 1973.

Dodds, D.R., and M.L. Eiland, Jr., *Oriental Rugs from Atlantic Collections.* Philadelphia, 1996.

Eiland, M.L., Jr., *Oriental Rugs from Pacific Collections.* San Francisco, 1990.

Eiland, M.L., Jr., and M. Eiland III, *Oriental Rugs.* London, 1998.

Ellis, C.G., *Oriental Carpets in the Philadelphia Museum of Art.* Philadelphia, 1988.

Emery, I., *The Primary Structures of Fabrics.* Washington, D.C., 1966.

Erdmann, K., *Seven Hundred Years of Oriental Carpets*, transl. M.H. Beattie and H. Herzog. London, 1970.

Erdmann, K., *Oriental Carpets. An Account of Their History*, transl. C. Grant Ellis. Fishguard, 1976.

Eskenazi, J., *Il Tappeto Orientale dal XV al XVIII secolo.* Milan, 1981.

Eskenazi, J., *L'arte del tappeto orientale.* Milan, 1983.

Ford, P.R.J., *The Oriental Carpet. A History and Guide to Traditional Motifs, Patterns, and Symbols.* New York, 1981.

Gans-Ruedin, E., *The Great Book of Oriental Carpets.* New York, 1983.

Gantzhorn, V., *Il Tappeto Cristiano Orientale.* Cologne, 1991.

Grote-Hasenbalg, W., *Masterpieces of Oriental Rugs*, transl. G. Barry Gifford. Berlin, 1922.

Hawley, W.A., *Oriental Rugs - Antique & Modern.* New York, 1970.

Herrmann, E., *Seltene Orientteppiche*, vols I–X. Munich, 1978–88.

Herrmann, E., *Asiatische Teppich- und Textilkunst*, vols I–V. Munich, 1989–95.

Hopf, A., *Oriental Carpets and Rugs.* London, 1962.

Hubel, R.G., *The Book of Carpets.* New York, 1970.

Jacoby, H., *Eine Sammlung Orientalischer Teppiche.* Berlin, 1923.

Jacoby, H., *How to Know Oriental Carpets and Rugs.* London, 1952.

Kendrick, A.F., *Guide to the Collection of Carpets. Victoria and Albert Museum.* New York, 1973.

Kendrick, A.F., and C.E.C. Tattersall, *Handwoven Carpets, Oriental and European.* New York, 1922.

King, D., and D. Sylvester, *The Eastern Carpet in the Western World.* London, 1983.

Kirchheim, H., and others, *Orient Stars. A Carpet Collection.* London and Stuttgart, 1993.

Lefevre, J., *The Sarre Mamluk and Classical Rugs from the Same Private Collection.* London, 1980.

Mallet, M., *Woven Structures. A Guide to Oriental Rug and Textile Analysis.* Atlanta, 1998.

Martin, F.R., *A History of Oriental Carpets Before 1800.* Vienna, 1908.

McMullan, J.V., *Islamic Carpets.* New York, 1965.

J. Mills, *Carpets in Paintings.* London, 1983.

Mushak, P., 'The Intoduction and Use of Early Synthetic Dyes in Rugmaking', in *Oriental Rug Review*: part 1, III, no. 7, 1983, p. 15; part 2, III, no. 10, 1984, pp. 9–12; part 3, IV, no. 4, 1984, pp. 8–10; part 4, IV, no. 5, 1984, pp. 9–10.

Neff, J.C., and C.V. Maggs, *A Dictionary of Oriental Rugs.* London, 1977.

O'Bannon, G., *Oriental Rugs. A Bibliography.* Metuchen and London, 1994.

Opie, J., *Tribal Rugs*. Portland, 1992.

Pagnano, G., *L'arte del tappeto*. Busto Arsizio, 1983.

Pinner, R., and W. Denny, *Oriental Carpet & Textile Studies I*. London, 1985.

Pinner, R., and W. Denny, *Oriental Carpet & Textile Studies II*. London, 1986.

Pinner, R., and W. Denny, *Oriental Carpet & Textile Studies III/1*. London, 1987.

Pinner, R., and W. Denny, *Oriental Carpet & Textile Studies III/2*. London, 1990.

Pinner, R., and W. Denny, *Oriental Carpet & Textile Studies IV*. Berkeley, 1993.

Polo, M., *The Travels of Marco Polo*, transl. W. Marsden. New York, 1960.

Prayer Rugs. Textile Museum, Washington, D.C., 1975.

Raphaelian, H.M., *The Hidden Language of Symbols in Oriental Rugs*. New Rochelle, 1954.

Riegl, A., *Ein orientalischer Teppich vom Jahre 1202 n. Chr. und die ältesten orientalischen Teppiche*. Berlin, 1895.

Rudenko, S.I., *Frozen Tombs of Siberia*. Berkeley, 1970.

Sarre, F., and H. Trenkwald, *Alt-Orientalische Teppiche*. Vienna and Leipzig, 1926–8.

Schürmann, U., *Oriental Carpets*. London, 1979.

Scott, P., *The Book of Silk*. London, 1993.

Sherrill, S.B., *Carpets and Rugs of Europe and America*. New York, 1996.

Spuhler, F., *Islamic Carpets and Textiles in the Keir Collection*. London, 1978.

Spuhler, F., *Oriental Carpets in the Museum of Islamic Art Berlin*. Munich, 1987.

Spuhler, F., *Carpets and Textiles in the Thyssen-Bornemisza Collection*. London, 1998.

Spuhler, F., H. König and M. Volkmann, *Alte Orientteppiche*. Munich, 1978.

Storey, J., *Dyes and Fabrics*. London, 1978.

Tapis. Présent de l'Orient à l'Occident. Paris, 1989.

Tappeti antichi. Milan, 1991.

Textile Art Research. Vienna, 1983.

Thompson, J., *Carpet Magic*. London, 1983.

Thompson, J., *Silk, Carpets and the Silk Road*. Tokyo, 1988.

Tolomei, U., *Il tappeto orientale*. Novara, 1983.

Viale, V., *Tappeti Antichi*. Turin, 1952.

Viale-Ferrero, M., *Rare Carpets from East and West*. London, 1972.

Walker, D., *Flowers Underfoot*. New York, 1997.

Weeks, J.G., and D. Treganowan, *Rugs and Carpets of Europe and the Western World*. Philadelphia, New York and London, 1969.

Ydema, O., *Carpets in Netherlandish Paintings and their Datings*. Leiden, 1991.

Anatolia

Alexander, C., *A Foreshadowing of 21st Century Art. The Color and Geometry of Very Early Turkish Carpets*. New York and Oxford, 1993.

Antike Anatolische Teppiche. Vienna, 1983.

Aslanapa, O., *One Thousand Years of Turkish Carpets*. Istanbul, 1988.

Balpinar, B., and U. Hirsch, *Carpets of the Vakiflar Museum Istanbul*. Wesel, 1988.

Batari, F., *White-Ground Anatolian Carpets in the Budapest Museum of Applied Arts*, in *Oriental Carpet & Textile Studies II*. London, 1986.

Batari, F., *Ottoman Turkish Carpets*. Budapest, 1994.

Beattie, M.H., *Coupled Column Prayer Rugs*, in *Oriental Art*, XIV vol. 1968.

Beattie, M.H., *Some Rugs of the Konya Region*, in *Oriental Art*, XVII vol. 1976.

Benardout, R., *Turkish Rugs*. London, 1975.

Biggs, R.D., *Discoveries from Kurdish Looms*. Evanston, 1983.

Boralevi, A., *L'Ushak Castellani-Stroganoff ed altri tappeti ottomani dal XVI al XVIII secolo*. Florence, 1987.

Brüggemann, W., and H. Böhmer, *Rugs of the Peasants and Nomads of Anatolia*. Munich, 1983.

Butterweck, G., and D. Orasch, *Handbook of Anatolian Carpets. Central Anatolia*. Vienna, 1986.

Dall'Oglio, M., *White-Ground Anatolian Carpets*, in *Oriental Carpet & Textile Studies II*. London, 1986.

Eagleton, W., *An Introduction to Kurdish Rugs and Other Weavings*. London, 1988.

Erdmann, K., *The History of Early Turkish Carpet*. London, 1977.

Kirchheim, H., and others, *Orient Stars. A Carpet Collection*. London and Stuttgart, 1993.

Iten-Maritz, J., *Turkish Carpets*. Fribourg, 1975.

Lamm, C.J., *Carpet Fragments. The Marby Rug and Some Fragments of Carpets found in Egypt*. Stockholm, 1985.

Landreau, A.N., and R.S. Yohe, *Flowers of the Yayla. Yoruk Weaving of the Toros Mountains*. Washington, D.C., 1983.

Lefevre, J., *Turkish Carpets from the 16th to the 19th Century*. London, 1977.

Mackie, L.W., *The Splendor of Turkish Weaving*. Washington, D.C., 1973.

Morehouse, B., *Yastiks*. Philadelphia, 1996.

Sevi, D., *Anatolian Carpets*. Milan, 1985.

Turkish Carpets from the 13th–18th Centuries. Istanbul, 1996.

Turkish Handwoven Carpets. Ankara, 1987–95.

Vegh, G., and K. Layer, *Turkish Rugs in Transylvania*. London, 1977.

Yetkin, S., *Historical Turkish Carpets*. Istanbul, 1981.

Yohe, R.S., and H. McCoy Jones, *Turkish Rugs*. Washington, D.C., 1968.

Persia

Aschenbrenner, E., *Persian*, II vol. of *Oriental Rugs*. Woodbridge, 1993.

Azadi, S., *Persian Carpets*. Tehran, 1977.

Azadi, S., *Carpets in the Baluch Tradition*. Munich, 1985.

Azadi, S., and P. Andrews, *Mafrash*. Berlin, 1985.

Beattie, M.H., *Carpets of Central Persia*. Sheffield, 1976.

Beck, L., *The Qashga'i of Iran*. New Haven, 1986.

Benardout, R., *Nomadic Persian and Turkoman Weaving*. London, 1977.

Biggs, R.D., *Discoveries from Kurdish Looms*. Evanston, 1983.

Black, D., *Rugs of Wandering Baluchi*. London, 1976.

Black, D., *Woven Gardens - Rugs of Southern Persia*. London, 1979.

Bornet, G., *Gabbeh*, III vol. Switzerland, 1995.

Boucher, J., *Baluchi Woven Treasures*. Alexandria, 1989.

Craycraft, M., and A. Halley, *Belouch Prayer Rugs*. Point Reyes Station, 1982.

Eagleton, W., *An Introduction to Kurdish Rugs and Other Weavings*. London, 1988.

Edwards, A.C., *The Persian Carpet*. London, 1953.

Ford, P.R.J., *The Oriental Carpet. A History and Guide to Traditional Motifs, Patterns, and Symbols*. New York, 1981.

Gans-Ruedin, E., *The Splendor of Persian Carpets*. New York, 1978.

Helfgott, L.M., *Ties that Bind. A Social History of the Iranian Carpet*. Washington, D.C., 1994.

Hillman, M.C., *Persian Carpets*. Austin, 1984.

Housego, J., *Tribal Rugs. An Introduction to the Weaving of the Tribes of Iran*. London, 1978.

Izady, M.R., *The Kurds. A Concise Handbook*. London, 1992.

Lefevre, J., *The Persian Carpet*. London, 1977.

Meister, P.W., and S. Azadi, *Persische Teppiche*. Hamburg, 1981.

Opie, J., *Tribal Rugs of Southern Persia*. Portland, 1981.

Parham, C., and S. Azadi, *Tribal and Village Rugs from Fars*. Tehran, 1986.

Pope, A.U., *A Survey of Persian Art*. London and Oxford, 1938.

Sabahi, T., *Qashqai. Tappeti tribali persiani*. Novara, 1989.

Sameyeh, S., *Exceptional Oriental Carpets*. Hamburg, 1982.

Stanzer, W., *Kordi. Lives, Rugs, Flatweaves of the Kurds in Khorasan*. Vienna, 1993.

Tanavoli, P., *Shahsavan. Iranian Rugs and Textiles*. New York, 1985.

Tanavoli, P., *Bread & Salt - Iranian Tribal Spreads and Salt Bags*. Tehran, 1991.

Tanavoli, P., *Kings, Heroes and Lovers. Pictorial Rugs from the Tribes and Villages of Iran*. London, 1994.

Tattersall, C., *The Carpets of Persia*. London, 1931.

Yassavoli, D., *Persian Carpets. A Survey of the Carpet-Weaving Industry of Persia*. Tehran, 1992.

Caucasus

Battilossi, M., *Arti tessili dell'Azerbaijan dal 1550 al 1850*. Turin, 1996.

Benardout, R., *Caucasian Rugs.* London, 1978.

Bennett, I., *Caucasian Rugs.* London, 1993.

Boralevi, A., *Sumak. Flatwoven Carpets of the Caucasus.* Florence, 1986.

Burns, J.D., *The Caucasus - Traditions in Weaving.* Seattle, 1987.

Cassin, J., *Kelim, Soumak, Carpet & Cloth. Tribal weavings of the Caucasus.* New York, 1990.

Chenciner, R., *Kaitag Textile Art from Daghestan.* London, 1993.

Der Manuelian, L., and M.L. Eiland, Jr., *Weavers, Merchants and Kings. The Inscribed Rugs of Armenia.* Fort Worth, 1984.

Eder, D., *Kaukasische Teppiche,* I vol. of *Orientteppiche.* Munich, 1990.

Ellis, C.G., *Early Caucasian Rugs.* Washington, D.C., 1975.

Frauenknecht, B., *Shahsavan. Sumakh-Taschen.* Nürnberg, 1993.

Gans-Ruedin, E., *Caucasian Carpets.* London, 1986.

Ghazarian, M., *Armenian Carpet.* 1988.

Kaffel, R., *Caucasian Prayer Rugs.* London, 1998.

Kerimov, L., *Azerbaijan Carpet.* Baku, 1985.

Kerimov, L., and others, *Rugs and Carpets of the Caucasus. The Russian Collections.* Leningrad, 1984.

Lefevre, J., *Caucasian Carpets.* London, 1977.

Sabahi, T., *Sumakh. Weft-Wrapped Flat Weaves.* Rome, 1992.

Schürmann, U., *Caucasian Rugs.* Ramsdell, 1974.

Stone, P.F., *Rugs of the Caucasus. Structure and Design.* Chicago, 1984.

Tschebull, R., *Kazak. Carpets of the Caucasus.* New York, 1971.

Wright, R.E., and G.W. O'Bannon, *Rugs & Flatweaves from the Transcaucasus.* Pittsburgh, 1980.

Wright, R.E., and J. Wertime, *Caucasian Carpets and Covers. The Weaving Culture.* London, 1995.

Yetkin, S., *Early Caucasian Carpets in Turkey.* London, 1978.

Kilims

Balpinar, B., *Kilim Cicim Zili Sumak - Turkish Flatweaves.* Istanbul, 1982.

Balpinar, B., and U. Hirsch, *Carpets of the Vakiflar Muse-*
um Istanbul. Wesel, 1988.

Black, D., and C. Loveless, *The Undiscovered Kilim.* London, 1977.

Brüggemann, W., and others, *Yayla. Form und Farbe in türkischer Textilkunst.* Frankfurt, 1993.

Cassin, J., *Anatolian Kelims - Image. Idol. Symbol.* New York, 1989.

Cootner, C.M., *Anatolian Kilims.* London, 1990.

Davies, P., *The Tribal Eye. Antique Kilims of Anatolia.* New York, 1993.

Eskenazi, J., *Anatolian Kilims.* Milan, 1984.

Eskenazi, J., and D. Valcarenghi, *Kilim Anatolici.* Milan, 1985.

Frauenknecht, B., *Early Turkish Tapestries.* Nürnberg, 1984.

Hull, A., and J. Luczyc-Whyhowska, *Kilim. The Complete Guide.* London, 1993.

Landreau, A.N., and R.W. Pickering, *Flat-woven Rugs from the Bosphorus to Samarkand.* Washington, D.C., 1969.

Mellaart, J., U. Hirsch and B. Balpinar, *The Goddess from Anatolia.* Adenau, 1989.

Ölçer, N., *Kilims. Museum of Turkish and Islamic Art,* transl. W.A. Edmonds. Istanbul, 1989.

Petsopoulos, Y., *Kilims. Masterpieces from Turkey.* New York, 1991.

Rageth, J., *Kilim. Primitive Symbols of Mythology.* Rome, 1986.

Rageth, J., *Anatolian Kilims.* Basel, 1990.

Sabahi, T., *Kilim. Tappeti piani del Caucaso.* Novara, 1990.

Valcarenghi, D., *Kilim. History and Symbols.* New York, 1994.

Vok Collection: Woven Art from Anatolia. Munich, 1995.

Vok Collection: Woven Art from the Caucasus and Persia. Munich, 1995.

Vok, I., *Kilims and Other Flatweaves from Anatolia.* Munich, 1997.

Central Asia

Azadi, S., *Turkoman Carpets and the Ethnographic Significance of their Ornaments.* Fishguard, 1975.

Benardout, R., *Turkoman Weaving.* London, 1974.

Bogolyubov, A.A., *Carpets of Central Asia,* transl. J. Thompson. Ramsdell, 1973.

Clark, H., *Bokhara. Turkoman*
and Afghan Rugs. London, 1922.

Felkerzam, A., *Starye Gody.* St. Petersburg, 1914.

Fitz Gibbon, K., and A. Hale, *Ikats. The Guido Goldman Collection.* London, 1997.

Hoffmeister, P., *Turkoman Carpets in Franconia.* Edinburgh, 1980.

Inalcik, H., *The Yuruks. Their Origins, Expansion and Economic Role,* in *Oriental Carpet and Textile Studies II.* London, 1986.

Jourdan, U., *Turkoman,* V vol. of *Oriental Rugs.* Woodbridge, 1995.

King, D., and others, *The Rau Collection.* London, 1988.

The Kirghiz Pattern. Frunze, 1986.

Lefevre, J., *Central Asian Carpets.* London, 1976.

Lindahl, D., and T. Knorr, *Uzbek.* Basel, 1975.

Loges, W., *Turkmenische Teppiche.* Munich, 1978.

Mackie, L., and J. Thompson, *Turkmen. Tribal Carpets and Traditions.* Washington, D.C., 1980.

Moshkova, V.G., *Sovietskaya Etnografiya.* 1946.

Moshkova, V.G., *Carpets of the Peoples of Central Asia in the Late Nineteenth and Early Twentieth Centuries.* Tashkent, 1970.

O'Bannon, G., *The Turkoman Carpet.* London, 1974.

Parsons, R.D., *The Carpets of Afghanistan,* III vol. of *Oriental Rugs.* Woodbridge, 1983.

Pinner, R., *The Rickmers Collection. Turkoman Rugs in the Ethnographic Museum Berlin.* Berlin, 1993.

Pinner, R., and M. Franses, *Turkoman Studies I.* London, 1980.

Rautenstengel, A., V. Rautenstengel and S. Azadi, *Studien zur Teppichkultur der Turkmen.* Hilden, 1990.

Reed, C.D., *Turkoman Rugs.* Cambridge, 1966.

Schürmann, U., *Central Asian Rugs.* London, 1969.

Thacher, A.B., *Turkoman Rugs.* New York, 1940.

Thompson, J., *Carpets from the Tents, Cottages and Workshops of Asia.* London, 1993.

Tsareva, E., *Rugs and Carpets from Central Asia. The Russian Collections.* Leningrad, 1984.

Turkmen and Antique Carpets
from the Collection of Dr and Mrs Jon Thompson. New York, 1993.

Vok Collection: Suzani. A Textile Art from Central Asia. Munich, 1995.

East Turkestan

Bidder, H., *Carpets from Eastern Turkestan.* Tübingen, 1964.

Obendiek, H., *The Tarim Basin Carpet. A Tradition in Transition.* Hong Kong, 1997.

Sabahi, T., *Samarkanda.* Vicenza, 1995.

Schürmann, U., *Central Asian Rugs.* London, 1969.

Tibet

Denwood, P., *The Tibetan Carpet.* Warminster, 1974.

Kuløy, H.K., *Tibetan Rugs.* Oslo, 1989.

Lipton, M., *The Tiger Rugs of Tibet.* London, 1988.

Myers, D.K., *Temple, Household, and Horseback. Rugs of the Tibetan Plateau.* Washington, D.C., 1984.

The Nepal Traveler, a journal published in Kathmandu, had special issues on the Nepalese-Tibetan carpet in 1992 and 1994.

Rutheford, T., and others, *Woven Jewels. Tibetan Rugs from Southern California Collections.* Pasadena, 1992.

China

Antique Chinese Carpets: Masterpieces from the Te-Chung Wang Collection. London, 1978.

Bausback, P., *Alte und Antike Chinesische Knüpfkunst.* Mannheim, 1980.

Dulnay Hyman, V., and W.C.C. Hu, *Carpets of China and Its Border Regions.* Ann Arbor, 1982.

Eiland, M.L., Jr., *Chinese and Exotic Rugs.* London, 1979.

Gans-Ruedin, E., *Chinese Carpets.* New York, 1981.

Hackmack, A., *Chinese Carpets and Rugs,* transl. L. Arnold. Rutland and Tokyo, 1980.

Larsson, L., Jr., *Carpets from China, Xinjiang, and Tibet.* London, 1988.

Leitch, G.B., *Chinese Rugs.* New York, 1928.

Lorentz, H.A., *A View of Chinese Rugs.* London and Boston, 1973.

Ripley, M.C., *The Chinese Rug Book.* New York, 1927.

Rostov, C., and J. Ganyan, *Chi-*

nese Carpets. New York, 1983.
Tiffany Studios: Antique Chinese Rugs. Rutland and Tokyo, 1976.

India

Banerjei, N.N., *Monograph on the Wollen Fabrics of Bengal*. Calcutta, 1899.

Bennett, I., *Jail Birds*. London, 1987.

Black, B., and C. Loveless, *The Unappreciated Dhurrie*. London, 1982.

Chattopadhyaya, K., *Carpets and Floor Coverings of India*. Bombay, 1969.

Gans-Ruedin, E., *Indian Carpets*. London, 1984.

Harris, H.T., *Monograph on the Carpet Weaving Industry of Southern India*. Madras, 1908.

Jayakar, A., *Indian Textiles Through the Centuries*, in *Treasures of Indian Textiles*, 1980.

Mediterranean

Baptista de Oliveira, F., *História e Técnica dos Tapetes de Arraiolos*. Lisbon, 1983.

Dodds, J.D., *Al-Andalus. The Art of Islamic Spain*. New York, 1992.

Ferrandis Torres, J., *Exposición de alfombras antiguas españolas. Catálogo general ilustrado*. Madrid, 1933.

Giacobetti, R.P., *Les tapis et tissages du Djebel-Amour*. Paris, 1932.

Khatibi, A., and A. Amahan, *From Sign to Image. The Moroccan Carpet*. Casablanca, 1995.

Kühnel, E., and L. Bellinger, *The Textile Museum Catalogue of Spanish Rugs: 12th Century to 19th Century*. Washington, D.C., 1953.

Kühnel, E., and L. Bellinger, *Catalogue Raisonné. Cairene Rugs and Others Technically Related: 15th–17th Century*. Washington, D.C., 1957.

May, F.L., *The Silk Textiles of Spain. Eighth to Fifteenth Century*. New York, 1957.

May, F.L., *Rugs of Spain and Morocco*. New York, 1977.

McMullan, J.V., *Islamic Carpets*. New York, 1965.

Pickering, B., W. Russell Pickering and R. Yohe, *Moroccan Carpets*. New York and London, 1994.

Poinssot, L., and J. Revault, *Tapis tunisiens*. Paris, 1932–52 (3 vols: *Kairouan*, 1932; *Tapis*

beduins: haute laine*, 1950; *Tissus décorés de Gafsa et imitations*, 1952).

Revault, J., *North African Carpets & Textiles*. New York, 1973.

Riboud, K., *Samit & Lampas*. 1998.

Ricard, P., *Corpus des tapis marocains*. Paris, 1923–34 (4 vols: *Tapis de Rabat*, 1923; *Tapis du Moyen Atlas*, 1926; *Tapis du Haut Atlas et Haouz de Marrakech*, 1927; *Tapis divers: Rabat, Moyen Atlas, Maroc Oriental, Haut Atlas et Haouz de Marrakech*, 1934.

Sánchez Ferrer, J., *Alfombras antiguas de la provincia de Albacete*. Albacete, 1986.

Stanzer, W., *Berber. Tribal Carpets from the Kingdom of Morocco*. Graz, 1992.

Suriano, C.M., and S. Carboni, *La seta islamica: temi ed influenze culturali*. Florence, 1999.

Quoted Bibliography

Achdjian 1949. A. Achdjian, *Le Tapis - The Rug*. Paris, 1949.

Alexander 1993. C. Alexander, *A Foreshadowing of 21st Century Art. The Color and Geometry of Very Early Turkish Carpets*. New York and Oxford, 1993.

Aslanapa 1988. O. Aslanapa, *One Thousand Years of Turkish Carpets*. Istanbul, 1988.

Azadi 1975. S. Azadi, *Turkoman Carpets and the Ethnographic Significance of Their Ornaments*. Fishguard, 1975.

Balpinar and Hirsch 1988. B. Balpinar and U. Hirsch, *Carpets of the Vakiflar Museum Istanbul*. Wesel, 1988.

Baptista de Oliveira 1983. F. Baptista de Oliveira, *História e Técnica dos Tapetes de Arraiolos*. Lisbon, 1983.

Batari 1986. F. Batari, *White-Ground Anatolian Carpets in the Budapest Museum of Applied Arts*, in *Oriental Carpet & Textile Studies II*. London, 1986.

Batari 1994. F. Batari, *Ottoman Turkish Carpets*. Budapest, 1994.

Bateman Faraday 1990. C. Bateman Faraday, *European and American Carpets and Rugs*. 1990.

Battilossi 1996. M. Battilossi, *Arti tessili dell'Azerbaijan dal 1550 al 1850*. Turin, 1996.

Bausback 1978. P. Bausback,

Antike Orientteppiche. Braunschweig, 1978.

Beattie 1968. M.H. Beattie, *Coupled Column Prayer Rugs*, in *Oriental Art*, XIV vol. 1968

Beattie 1972. M.H. Beattie, *The Thyssen Bornemisza Collection of Oriental Rugs*. Castagnola and Lugano, 1972.

Beattie 1976[1]. M.H. Beattie, *Carpets of Central Persia*. Sheffield, 1976.

Beattie 1976[2]. M.H. Beattie, *Some Rugs of the Konya Region*, in *Oriental Art*, XVII vol. 1976.

Benardout 1975. R. Benardout, *Turkish Rugs*. London, 1975.

Bennett 1978. I. Bennett, *Rugs and Carpets of the World*. London, 1978.

Bernheimer 1959. O. Bernheimer, *Alte Teppiche des 16.-18. Jahrhunderts der Firma Bernheimer*. Munich, 1959.

Bidder 1964. H. Bidder, *Carpets from Eastern Turkestan*. Tübingen, 1964.

Biggs 1983. R.D. Biggs, *Discoveries from Kurdish Looms*. Evanston, 1983.

Bode 1911. W. von Bode, *Anciens Tapis d'Orient*. Paris, 1911.

Bode and Kühnel 1970. W. von Bode and E. Kühnel, *Antique Rugs from the Near East*. London, 1970.

Boralevi 1986. A. Boralevi, *Three Egyptian Carpets in Italy*, in *Oriental Carpet & Textile Studies II*. London, 1986.

Boralevi 1987. A. Boralevi, *L'Ushak Castellani Stroganoff ed altri tappeti ottomani dal XVI al XVIII secolo*. Florence, 1987.

Boralevi 1999. A. Boralevi, *Oriental Geometries. Stefano Bardini and the Antique Carpet*. Florence, 1999.

Brancati 1998. L.E. Brancati, *Questioni sul Tappeto*. Turin, 1998.

Brüggemann and Böhmer 1983. W. Brüggemann and H. Böhmer, *Rugs of the Peasants and Nomads of Anatolia*. Munich, 1983.

Butterweck and Orasch 1986. G. Butterweck and D. Orasch, *Handbook of Anatolian Carpets. Central Anatolia*. Vienna, 1986.

Campana 1969. M. Campana, *Oriental Carpets*. London, 1969.

Clark 1922. H. Clark, *Bokhara.*

Turkoman and Afghan Rugs. London, 1922.

Cohen 1982. S. Cohen, in B. Black and C. Loveless, *The Unappreciated Dhurrie*. London, 1982.

Cootner 1990. C.M. Cootner, *Anatolian Kilims*. London, 1990.

Curatola 1986. G. Curatola, *Four Carpets in Venice*, in *Oriental Carpet and Textile Studies II*. London, 1986.

Dall'Oglio 1986. M. Dall'Oglio, *White-Ground Anatolian Carpets*, in *Oriental Carpet and Textile Studies II*. London, 1986.

Der Manuelian and Eiland 1984. L. Der Manuelian and M.L. Eiland, Jr., *Weavers, Merchants and Kings. The Inscribed Rugs of Armenia*. Fort Worth, 1984.

Dimand and Mailey 1973. M.S. Dimand and J. Mailey, *Oriental Rugs in the Metropolitan Museum of Art*. New York, 1973.

Dodds 1992. J.D. Dodds, *Al-Andalus. The Art of Islamic Spain*. New York, 1992.

Dodds and Eiland 1996. D.R. Dodds and M.L. Eiland, Jr., *Oriental Rugs from Atlantic Collections*. Philadelphia, 1996.

Ellis 1975. C.G. Ellis, *Early Caucasian Rugs*. Washington, D.C., 1975.

Ellis 1988. C.G. Ellis, *Oriental Carpets in the Philadelphia Museum of Art*. Philadelphia, 1988.

Erdmann 1970. K. Erdmann, *Seven Hundred Years of Oriental Carpets*. London, 1970.

Eskenazi 1981. J. Eskenazi, *Il Tappeto Orientale dal XV al XVIII secolo*. Milan, 1981.

Eskenazi 1983. J. Eskenazi, *L'arte del tappeto orientale*. Milan, 1983.

Eskenazi 1984. J. Eskenazi, *Anatolian Kilims*. Milan, 1984.

Eskenazi and Valcarenghi 1985. J. Eskenazi and D. Valcarenghi, *Kilim Anatolici*. Milan, 1985.

Felkerzam 1914. A. Felkerzam, *Starye Gody*. St. Petersburg, 1914.

Ferrandis Torres 1933. J. Ferrandis Torres, *Exposición de alfombras antiguas españolas. Catálogo general ilustrado*. Madrid, 1933.

Fitz Gibbon and Hale 1997. K. Fitz Gibbon and A. Hale, *Ikats. The Guido Goldman Collection*. London, 1997.

Franses 1981. M. Franses, in J. Eskenazi, *Il Tappeto Orientale dal XV al XVIII secolo*. Milan, 1981.

Franses 1993. M. Franses, in H. Kirchheim and others, *Orient Stars. A Carpet Collection*. London and Stuttgart, 1993.

Frauenknecht 1982. B. Frauenknecht, *Anatolische Kilims*. Nürnberg, 1982.

Frauenknecht 1984. B. Frauenknecht, *Early Turkish Tapestries*. Nürnberg, 1984.

Gans-Ruedin 1986. E. Gans-Ruedin, *Caucasian Carpets*. London, 1986.

Gantzhorn 1991. V. Gantzhorn, *Il Tappeto Cristiano Orientale*. Cologne, 1991.

Grote-Hasenbalg 1922. W. Grote-Hasenbalg, *Masterpieces of Oriental Rugs*. Berlin, 1922.

Gülgonen 1997. H. Gülgonen, *Konya Kapadokya Halilari*. Istanbul 1997.

Hasson 1985. R. Hasson, *Shtihim Kavkazim*. Jerusalem, 1985.

Herrmann 1980. E. Herrmann, *Seltene Orientteppiche*, III vol. Munich, 1980.

Herrmann 1981. E. Herrmann, *Seltene Orientteppiche*, IV vol. Munich, 1981.

Herrmann 1985. E. Herrmann, *Seltene Orientteppiche*, VII vol. Munich, 1985.

Herrmann 1988. E. Herrmann, *Seltene Orientteppiche*, X vol. Munich, 1988.

Herrmann 1989. E. Herrmann, *Asiatische Teppich- und Textilkunst*, I vol. Munich, 1989.

Herrmann 1990. E. Herrmann, *Asiatische Teppich- und Textilkunst*, II vol. Munich, 1990.

Herrmann 1991. E. Herrmann, *Asiatische Teppich- und Textilkunst*, III vol. Munich, 1991.

Herrmann 1992. E. Herrmann, *Asiatische Teppich- und Textilkunst*, IV vol. Munich, 1992.

Hubel 1970. R.G. Hubel, *The Book of Carpets*. New York, 1970.

Inalcik 1986. H. Inalcik, *The Yuruks. Their Origins, Expansion and Economic Role*, in *Oriental Carpet & Textile Studies II*. London, 1986.

Jacoby, 1952. H. Jacoby, *How to Know Oriental Carpets and Rugs*. London, 1952.

Jayakar 1980. A. Jayakar, *Indian Textiles Through the Centuries*, in *Treasures of Indian Textiles*, 1980.

Kendrick and Tattersall 1922. A.F. Kendrick and C.E.C. Tattersall, *Handwoven Carpets, Oriental and European*. New York, 1922.

Kertesz-Badrus 1985. A. Kertesz Badrus, *Türkische Teppiche in Siebenbürgen*. Bucharest, 1985.

King and Sylvester 1983. D. King and D. Sylvester, *The Eastern Carpet in the Western World*. London, 1983.

Kirchheim 1993. H. Kirchheim and others, *Orient Stars. A Carpet Collection*. London and Stuttgart, 1993.

Kühnel and Bellinger 1953. E. Kühnel and L. Bellinger, *The Textile Museum Catalogue of Spanish Rugs: 12th Century to 19th Century*. Washington, D.C., 1953.

Kühnel and Bellinger 1957. E. Kühnel and L. Bellinger, *Catalogue Raisonné. Cairene Rugs and Others Technically Related: 15th–17th Century*. Washington, D.C., 1957.

Larsson 1988. L. Larsson, Jr., *Carpets from China, Xinjiang, and Tibet*. London, 1988.

Lefevre 1977. J. Lefevre, *Caucasian Carpets*. London, 1977.

Lefevre 1980. J. Lefevre, *The Sarre Mamluk and Classical Rugs from the Same Private Collection*. London, 1980.

Lorentz 1973. H.A. Lorentz, *A View of Chinese Rugs*. London and Boston, 1973.

Mackie and Thompson 1980. L. Mackie and J. Thompson, *Turkmen. Tribal Carpets and Traditions*. Washington, D.C., 1980.

Martin 1908. F.R. Martin, *A History of Oriental Carpets Before 1800*. Vienna, 1908.

May 1957. F.L. May, *The Silk Textiles of Spain. Eighth to Fifteenth Century*. New York, 1957.

May 1977. F.L. May, *Rugs of Spain and Morocco*. New York, 1977.

McMullan 1965. J.V. McMullan, *Islamic Carpets*. New York, 1965.

Meister and Azadi 1981. P.W. Meister and S. Azadi, *Persische Teppiche*. Hamburg, 1981.

Mellaart, Hirsch and Balpinar 1989. J. Mellaart, U. Hirsch and B. Balpinar, *The Goddess from Anatolia*. Adenau, 1989.

Mills 1983. J. Mills, *Carpets in Paintings*. London, 1983.

Morehouse 1996. B. Morehouse, *Yastiks*. Philadelphia, 1996.

Moshkova 1946. V.G. Moshkova, *Sovietskaya Etnografiya*. 1946.

Opie 1981. J. Opie, *Tribal Rugs of Southern Persia*. Portland, 1981.

Opie 1992. J. Opie, *Tribal Rugs*. Portland, 1992.

Pagnano 1983. G. Pagnano, *L'arte del tappeto*. Busto Arsizio, 1983.

Petsopoulos 1979. Y. Petsopoulos, *Kilims*. Freiburg 1979.

Pinner and Franses 1980. R. Pinner and M. Franses, *Turkoman Studies I*. London, 1980.

Pope 1938. A.U. Pope, *A Survey of Persian Art*. London and Oxford, 1938.

Rageth 1990. J. Rageth, *Anatolian Kilims*. Basel, 1990.

Rautenstengel and Azadi 1990. A. Rautenstengel, V. Rautenstengel and S. Azadi, *Studien zur Teppichkultur der Turkmen*. Hilden, 1990.

Riboud 1998. K. Riboud, *Samit & Lampas*. 1998.

Riegl 1895. A. Riegl, *Ein orientalischer Teppich vom Jahre 1202 n. Chr. und die ältesten orientalischen Teppiche*. Berlin, 1895.

Sánchez Ferrer 1986. J. Sánchez Ferrer, *Alfombras antiguas de la provincia de Albacete*. Albacete, 1986.

Schmutzler 1933. E. Schmutzler, *Altorientalische Teppiche in Siebenbürgen*. Leipzig, 1933.

Schürmann 1969. U. Schürmann, *Central Asian Rugs*. London, 1969.

Schürmann 1974. U. Schürmann, *Caucasian Rugs*. Ramsdell, 1974.

Schürmann 1979. U. Schürmann, *Oriental Carpets*. London, 1979.

Scott 1993. P. Scott, *The Book of Silk*. London, 1993.

Sherrill 1996. S.B. Sherrill, *Carpets and Rugs of Europe and America*. New York, 1996.

Spuhler 1978. F. Spuhler, *Islamic Carpets and Textiles in the Keir Collection*. London, 1978.

Spuhler 1987. F. Spuhler, *Oriental Carpets in the Museum of Islamic Art Berlin*. Munich, 1987.

Spuhler, König and Volkmann 1978. F. Spuhler, H. König and M. Volkmann, *Alte Orientteppiche*. Munich, 1978.

Suriano and Carboni 1999. C.M. Suriano and S. Carboni, *La seta islamica: temi ed influenze culturali*. Florence, 1999.

Tanavoli 1985. P. Tanavoli, *Shahsavan. Iranian Rugs and Textiles*. New York, 1985.

Thompson 1980. J. Thompson, *Centralised Design*, in E. Herrmann, *Seltene Orientteppiche*, III vol. Munich, 1980.

Thompson 1983. J. Thompson, *Carpet Magic*. London, 1983.

Thompson 1988. J. Thompson, *Silk, Carpets and the Silk Road*. Tokyo, 1988.

Tiffany Studios 1976. *Tiffany Studios: Antique Chinese Rugs*. Rutland and Tokyo, 1976.

Tolomei 1983. U. Tolomei, *Il tappeto orientale*. Novara, 1983.

Tsareva 1984. E. Tsareva, *Rugs and Carpets from Central Asia. The Russian Collections*. Leningrad, 1984.

Various Authors 1983. *Antike Anatolische Teppiche*. Vienna, 1983.

Various Authors 1989. *Tapis. Present de l'Orient a l'Occident*. Paris, 1989.

Various Authors 1991. *Tappeti antichi*. Milan, 1991.

Various Authors 1996. *Turkish Carpets from the 13th–18th Centuries*. Istanbul, 1996.

Vegh and Layer 1977. G. Vegh and K. Layer, *Turkish Rugs in Transylvania*. London, 1977.

Viale 1952. V. Viale, *Tappeti Antichi*. Turin, 1952.

Vok 1995. *Vok Collection: Suzani. A Textile Art from Central Asia*. Munich, 1995.

Vok 1997. I. Vok, *Kilims and Other Flatweaves from Anatolia*. Munich, 1997.

Walker 1997. D. Walker, *Flowers Underfoot*. New York, 1997.

Weeks and Treganowan 1969. J.G. Weeks and D. Treganowan, *Rugs and Carpets of Europe and the Western World*. Philadelphia, New York and London, 1969.

Wright and Wertime 1995. R.E. Wright and J. Wertime, *Caucasian Carpets and Covers. The Weaving Culture*. London, 1995.

Yetkin 1978. S. Yetkin, *Early Caucasian Carpets in Turkey*. London, 1978.

Yetkin 1981. S. Yetkin, *Historical Turkish Carpets*. Istanbul, 1981.

cat. no. 5
Bursa
Warps: silk, yellow, Z2S;
depressed 30°.
Wefts: 1 silk, 1 wool, red, Z2;
2 shoots.
Pile: wool, Z2; natural cotton.
Knot: As, open left; v. 52 ×
h. 62 = 3,224 per sq. dm.
Sides: missing.
Ends: missing.

cat. no. 44
**Carpet with Empty
Field and Border**
Warps: wool: 1 natural,
1 brown; Z2S.
Wefts: pinkish wool, Z2
loosely plied S, 4-6 shoots.
Pile: wool, Z2.
Knot: Sy; v. 20 × h. 20 =
400 per sq. dm.
Sides: wool, pinkish, 2 groups
of 2 warps wrapped in figure
8; also the first two knotted
warps are covered.
Ends: missing.
Notes: 2 single occasional
wefts, on surface, yellow wool,
Z4S-Z6S.

cat. no. 45
Mother Goddess Fragment
Warps: wool, natural, Z2S.
Wefts: wool, red, many
shades; Z1-Z2; 2-4 shoots.
Pile: wool, Z2.
Knot: Sy; v. 32 × h. 24 =
768 per sq. dm.

Sides: missing.
Ends: missing.

cat. no. 51
Cartouche Carpet Fragment
Warps: cotton, natural, Z5S;
depressed 45°.
Wefts: cotton, natural, Z3-Z4,
loosely plied S; 3 shoots, 2
taut, 1 limp.
Pile: wool, Z2.
Knot: As, open left; v. 42 × h.
40 = 1,680 per sq. dm; some
jufti knots over 4 warps.

cat. no. 57
**Leaf and Palmette
Carpet Fragment**
Warps: cotton, natural, Z6S;
some threads wool, natural,
Z2S.
Wefts: wool, dark red,
Z1, 3-5 shoots.
Pile: wool, Z2.
Knot: As, open right, in
some areas sym; some rows
in offset knotting;
v. 35 × h. 23
= 805 per sq. dm.
Sides: missing.
Ends: missing.

cat. no. 58
Lattice Carpet Fragment
Warps: cotton, natural,
Z4S; depressed 45°.
Wefts: cotton, natural,
Z2S; 2 shoots.
Pile: wool, Z2S.

Knot: As, open left,
jufti over 4, sometimes
6 warps; v. 89 × h. 48 =
4,272 per sq. dm.
Sides: missing.
Ends: missing.

cat. no. 59
**Durlaeher Tree
and Animal Carpet**
Warps: wool, natural, Z2S.
Wefts: wool, natural, Z2S;
2 shoots.
Pile: wool, Z2S.
Knot: Sy; v. 48 × h. 34 =
1,632 per sq. dm.
Sides: missing.
Ends: wool, natural, flatwoven
0.8–1.5 cm, redone in some
areas.

cat. no. 60
**Carpet with
Stylised Palmettes**
Warps: wool, natural
and brown, Z2S.
Wefts: wool, natural and
pinkish yellow, Z2; 2 shoots.
Pile: wool, Z2.
Knot: Sy; v. 42 × h. 28 =
1,176 per sq. dm.
Sides: missing.
Ends: missing.

cat. no. 61
**Protokurdish Rug
with the Harshang Pattern**
Warps: wool, natural, Z2S.
Wefts: wool, pinkish red,

Z2; 2 shoots.
Pile: wool, Z2.
Knot: Sy; v. 32 × h. 33 =
1,056 per sq. dm.
Sides: missing.
Ends: not original.

cat. no. 81
Shahsavan Confederacy
Warps: natural brown, Z2S.
Wefts: cotton, natural,
Z2 (some wefts in cotton
and wool).
Pile: wool, Z2.
Knot: Sy; v. 23 × h. 32 =
736 per sq. dm.
Sides: missing.
Ends: missing.

cat. no. 108
Hali
Warps: wool, natural and
light-dark natural, Z2S.
Wefts: wool, many shades
of brown, Z-Z2.
Pile: wool, Z2.
Knot: Sy; v. 65 × h. 35 =
2,275 per sq. dm.
Sides: some remnants,
not analysed.
Ends: flatwoven remnants,
reddish brown; some natural
cotton, Z2S, weft shoots
at the lower end.

cat. no. 111
Namazlyk
Warps: wool, natural, Z2S.
Wefts: wool, natural, Z2,

2-4 shoots.
Pile: wool, Z2.
Knot: Sy, v. 66 × h. 36 = 2,376 per sq. dm.
Sides: wool, reddish-green alternated over 4 pairs of warps wrapped in groups of two.
Ends: flatwoven natural wool, blue, red, 1 cm at upper end, 2 cm at lower end; embroidered area at both ends in red and green wool; braiding made up of groups of 4 warps at lower end.

cat. no. 112
Eagle Gul Group II Hali
Warps: wool, natural, Z2S.
Wefts: wool, brown, light-dark, Z; cotton, natural, Z2; 2 shoots.
Pile: wool, Z2.
Knot: As, open right; v. 72 × h. 38 = 2,736 per sq. dm.
Sides: not original, in brown wool.
Ends: flatwoven, wool, reddish brown-blue; top 9 cm, bottom 9 cm; some wool brocading.

cat. no. 123
Ersari Trapping
Warps: wool, natural-light brown, Z2S.
Wefts: wool, natural-light and dark brown, Z2; 2 shoots.
Pile: wool, Z2.
Knot: As, open left, v. 46–31 × h. 30 = circa 1,100 per sq. dm.
Sides: wool, red, wrapped over groups of 3 warps.
Ends: flatwoven, wool, bottom blue-red and blue-orange stripes over natural wool, 7 cm; top wool, natural, 9–10 cm.

cat. no. 145
Ningxia
Warps: cotton, natural, Z3S.
Wefts: cotton, natural, Z3-Z4; 2 shoots.
Pile: wool, Z2-Z3.
Knot: As, open left, v. 22 × h. 27 = 594 per sq. dm.
Sides and ends: missing.
Notes: heavy handle.

cat. no. 152
Peony Carpet
Warps: cotton, natural, Z5S, depressed 45°.
Wefts: cotton, pink, Z2 (some wefts red wool); 3 shoots; 2 taut, 1 limp.
Pile: wool, Z3.
Knot: As, open left; v. 30 × h. 35 = 1,050 per sq. dm.
Sides and ends: not original.

cat. no. 156
Mughal
Warps: cotton, natural, Z10S; deeply depressed.
Wefts: cotton, pink, Z3-Z4; 3 shoots; 2 taut, 1 limp.
Pile: wool, Z2-Z3-Z4.
Knot: As, open left; v. 40 × h. 45 = 1,800 per sq. dm.
Sides and ends: missing.

cat. no. 161
Saf Fragment
Warps: wool, natural, Z2S; depressed 45°.
Wefts: wool, pink-pinkish red, Z2-Z3; 2-3 shoots.
Pile: wool.
Knot: As, open left; v. 40 × h. 36 = 1,440 per sq. dm.
Notes: black deeply corroded.

cat. no. 162
Mamluk Carpet Fragment
Warps: wool, yellow, S3Z.
Wefts: wool, natural, S3Z-S2Z; 3, sometimes 2, shoots.
Pile: wool, S2-S3.
Knot: As, open left; v. 33 × h. 43 = 1,419 per sq. dm

cat. no. 166
Hispano-Moresque Carpet Fragment
Warps: wool, natural, Z2S.
Wefts: wool, natural, Z3; 1 shoot.
Pile. wool.
Knot: Spanish; v. 38 × h. 39 = 1,482 per sq. dm.

Glossary

Abrash. Occurrence of various colour shades especially in large surfaces of one colour, usually as a consequence of irregularly hand dyed batches of wool, but sometimes deliberately applied.

Afshar. A group of Turkish-speaking nomads located primarily in the Kerman area, in Southeast Persia. Many of the rugs commonly called 'Afshar' are actually the work of ethnically different villagers living around Kerman.

Aina gul. *Aina* ('mirror' in Turkish) *gul* is a square or rectangular ornament.

Ak chuval. White *chuval* (*ak* = 'white' in Turkish). See *chuval*.

Arabesque. A form obtained by the complex interlacing of continuous lines of leaves and shoots.

Asmalyk. Five- (or more) sided weaving used to decorate the leading camel in a Turkmen wedding procession. *Asmalyks* were usually woven in pairs.

Arabachi. A Turkmen tribe whose rare weavings are characterised by a dark palette.

Armorial (Admiral) carpet. A group of early Spanish carpets bearing a coat of arms.

Asymmetrical knot. The asymmetrical knot is formed by the thread going around two warps and fully encircling only one of them; it then passes behind the back and one side only of the other warp thread. Also called Persian or Senneh knot.

Avar. Turkic tribe located in the inner valleys of the Dagestan region in Northeast Caucasus.

Avshan. An allover pattern made up of stylised palmettes, rosettes and split-leaf arabesques connected by vine-shoots, seen primarily on a number of Caucasian and Northwest Persian rugs.

Azeri. A Turkic population inhabiting various areas of the Caucasus and some areas of Northwest Persia.

Bakhtiari. Tribal confederacy located in the central-eastern part of the Zagros mountains in Iran, including those settled in the Chahar Mahal district, west of Esfahan.

Baluch. Persian-speaking tribal group located between Eastern Iran, Western Afghanistan and Pakistan. Their rugs are characterised by a predominantly dark palette.

Beshir. Turkmen tribe affiliated with the Ersari; it is also the main weaving centre in the Amu Darya valley.

Blossom carpet. An early Caucasian rug typology, structurally related to the so-called dragon carpets, characterised by an allover pattern of stylised blossoms.

Bohca. Ottoman silk embroidery of square size.

Border. The element that frames the field design. It is supposed to represent a window overlooking the infinite.

Boteh. A leaf-shaped form with a curved top, commonly arranged in infinitely repeating patterns in the field of pile rugs.

Brocaded. Technique where the pattern is not constituted by means of pile knots but by inserting supplementary weft shoots. There are various brocading techniques, the best known of which is the *sumakh* technique.

Bukcha. A square-shaped bag, typically ascribed to the Yomud tribe, having the form of an envelope, and used to contain utilitarian objects.

Cartouche. Ornament having an elongated ovoid, octagonal, or hexagonal form which is typically found on borders.

Chemche gul. Secondary ornament employed on most Turkmen main carpets and tent bags.

Chessboard rug. A group of early carpets typically ascribed to Damascus and distinguished by a field design composed of compartments. Also called compartment rug.

Chintamani. An ornament seen in early Ottoman art composed of three circles arranged triangularly, flanked underneath by a pair of wavy lines.

Chodor. Turkmen tribe whose rare weavings typically feature traditional folk patterns.

Chuval. Large rectangular storage bag found mainly among the weavings of the Turkmen tribes.

Chuval gul. An archetypal ornament seen primarily on the main carpets of the Tekke and Yomud tribes and on certain bags.

Cloudband. A motif shaped like a collar made up of stylised clouds. Also called *tchi*; *yun-chien*.

Cloud lattice. Allover pattern composed by the geometric stylisation of cloudbands. Also called longevity pattern.

Column Ladik. The obsolete definition for a group of coupled-column rugs once ascribed to the village of Ladik.

Compartment rug. See chessboard rug.

Darvaza gul. Hexagonal *gul* related to the *kejebe* composition, in use among the Salor, Ersari and Saryk tribes. Some of the earliest examples are characterised by a central design associated to the Small-Pattern Holbein.

Depressed. Refers to the warp depression created by the tension given by the weft. In extreme cases the second warp will be behind the first one.

Dhurrie. Indian weft-faced cotton flatweave. Also called *drugget*.

Dorje. A ritual sceptre, symbol of spiritual strength in Tibetan Buddhism.

Double niche. A field design obtained by mirroring the image of the shape of the niches.

Dozar. A unit of measure adopted by Persians to indicate rugs of small format (*zar* = arm; *dozar* = two arms).

Dragon rug. A group of structurally distinct early Caucasian rugs characterised by an infinite repeat pattern of dragons alternated to stylised floral forms.

Drugget. See *dhurrie*.

Dyrnak gul. Primary ornament characterising Yomud main carpets (*tyrnak* = 'claw' in Turkish).

Eagle Gul Group. Rare group of Turkmen main carpets decorated by an ornament shaped like addorsed eagles. Their structural feature is a weft shoot in cotton or silk between two wollen wefts.

Egg palmette. A directionally arranged large palmette seen on a distinct group of early Caucasian rugs of the transitional period.

Elem. Additional, often ornamented end border, appearing at one or both ends of different Turkmen pieces.

Endless knot. A motif made up of a pair of continuously interlaced lines.

End. The finish of the horizontal sides of a rug running parallel to the weft.

Ensi. Turkmen term for a rug employed as a tent-door cover.

Ersari. One of the largest Turkmen tribes, and the first one to settle in a specific urban area (that of Bukhara).

Ertmen gul. The primary ornament employed by the Chodor tribe on main carpets and *chuvals*.

Field. The main, central part of the carpet design composition.

Flatweave. Woven fabric lacking knots and constructed according to a number of techniques.

Foundation. The skeleton of the rug, that is the number and type of warps and wefts.

Gabbeh. South Persian tribal rug characterised by a long, shaggy pile, a high number of weft shoots and a series of naively executed designs in bold colour contrast.

Germech. A woven strip placed at the tent door below the *ensi*.

Goklen. Turkmen group affiliated to the larger Yomud tribe.

Gol-e-bolbol. A motif appearing on certain Persian city rugs composed of a flower flanked by a pair of birds.

Gol farang. A design which is based on an adaptation of the rose and is inspired by the European carpet tradition.

Gollu chi-chi. This term is used to define the so-called St. Andrew's Cross design we see often associated with rugs from the Seikhur area.

Ground. See field.

Gul. Primary ornament, usually polygons, in Turkmen carpets, which may have a heraldic meaning or be otherwise specific to one tribe.

Hali. Turkmen main carpet, that is, the largest Turkmen weaving, employed only in situations of particular importance.

Handle. Impression given by the texture of a rug when touched; generally, it refers to the quality of the surface, the feel when gripped, and the consistency of the back.

Harshang. A design seen on certain Caucasian and Northwest Persian rugs composed of a polylobed palmette alternated to an almond-shaped cartouche with split-leaf arabesques sprouting from each end.

Herati. An allover pattern seen on many Persian rugs, composed of small leaves connected to a small palmette.

Holbein. A type of design occurring on an early group of Anatolian carpets, subdivided in Small-Pattern and Large-Pattern. After the name of the painter Hans Holbein, who often depicted rugs with such designs.

Ikat. A complex weaving technique giving rise to warp-faced silk textiles ascribed to the Bukhara area in Central Asia.

Jajim. Stripe flatweave typically produced by the Persian tribes.

Jufti. A knot tied over four (or more) warps instead of two.

Kaitag. Small silk embroidery on cotton ascribed to a Turkic group in the Northeast Caucasian region of Dagestan.

Kapunuk. Tent door surround decorated with colour tassels.

Kejebe. A design seen on some rare trappings ascribed to the Salor and Saryk Turkmen tribes.

Kelleh. A carpet whose length is at least twice its width.

Kepse gul. A primary ornament seen on the weavings of the Yomud tribe.

Kesi. A very fine silk flatwoven textile, either of Chinese or Japanese origin.

Khaden. The name given in Tibet to a rug intended for specific use and of a specific size, namely 70-90 cm × 150-170 cm.

Khalyk. A rare and small U-shaped pile weaving used for decorating the camel during the Turkmen wedding procession.

Khorjin. Double saddlebag.

Kilim. Flatwoven rugs and covers; in most Islamic countries where pile rugs are made, kilims are woven in the slit tapestry technique. The word kilim is also used for the flatwoven end of pile carpets.

Kizil chuval. A red chuval (*kizil* = 'red' in Turkish). See *chuval*.

Kotchak. A motif based on the stylisation of the ram's horns appearing as an ornament mainly on Turkmen rugs.

Lakai. A Turkic Mongolian group.

Lampas. A complex silk textile particularly in vogue in the Mediterranean areas from the late Middle Ages.

Lattice pattern. Allover design of lozenges arranged in a honeycomb fashion.

Lazy lines. Diagonal lines visible on the back of a rug and caused by the discontinuity of the weft; occurs mainly in old Anatolian, but also in other rugs.

Lesghi star. An eight-pointed star with stepped and jagged outlines appearing on various Caucasian rugs.

Longevity pattern. See cloud lattice.

Lori. A native Persian population located essentially in Loristan (West Persia), as well as in some other parts of Persia.

Lotto. A type of arabesque pattern seen on a group of early Turkish rugs. Named after the Italian painter Lorenzo Lotto, who depicted them in some of his works.

Mafrash. Large box-like woven bag employed to store bedding and clothes, made and used by the Turkic tribes of Persia, Caucasus and Anatolia. In Central Asia it refers to much smaller weavings.

Medallion. Ornament, usually having a rounded shape, circular, oval or starlike; mainly in the centre of the field, however often as a vertical repeat or an allover pattern.

Medachyl. The reciprocal trefoil motif seen on the borders of rugs of various origins.

Mihrab. Term used to define the niche in Oriental prayer rugs, adapted from the niche in the interior of mosques which indicates the direction of Mecca. The question whether or not there is such a direct connection between prayer rugs and the *mihrabs* of mosques has still to be answered.

Mina khani. An infinitely repeating floral pattern made up of a large flower head with four small flowers.

Minbar. The pulpit found in mosques.

Mughal. A Mongol dynasty that dominated India from 1526 to 1858.

Namazlyk. Turkmen rug with the niche (prayer) design.

Niche. See *mihrab*.

Ogurjali. Turkmen tribe affiliated to the Yomud.

Offset knotting. A type of knotting where the knot is tied around a single warp. It is employed by certain Kurdish tribes to better execute a number of patterns.

Palmette. Fan-like ornament frequently occurring in Persian art and on Persian carpets; it has either the shape of a richly composed blossom or of a similarly constructed leaf.

Pinwheel. A type of design seen on Anatolian and Caucasian rugs consisting of a wheel motif at the ends of which there are elements pointing in the same direction.

Polonaise. Silk and metal thread Persian rug woven during the period of Shah Abbas, characterised by a soft palette and elegantly rendered curvilinear patterns.

Prayer rug. Small rug typically with a single-niche design.

Qashqa'i Confederacy. Turkic tribal confederacy from Southern Persia.

Radio-carbon. Physical method for determining the age of a textile or carpet based on the degree of deacy of the C-14 isotope in the fiber.

Repeat pattern. Allover design based on the repeat of a single motif.

Rosette. A round motif based on the stylisation of a floral design.

Ru-korsi. Small flatweave of square format used to cover the charcoal ember.

Running dog. A reciprocal

232

latchook motif seen on the outermost borders of rugs from the Caucasus and Persia.

S-spun. Clockwise turn in spinning and plying; if fibres are clockwise spun they will be plied anti-clockwise and vice versa. See also Z-spun.

Saf. Long rug composed of a series of flanking niches.

Salor. A prominent Turkmen tribe known for its rare and fine rugs and trappings.

Saryk. Turkmen tribe, famous for the production of fine artifacts and weavings.

Saz. A floral style in vogue during the 16th-century Ottoman period and seen in various artistic media, such as pottery, ceramics and textiles.

Seljuk. Turkish-speaking tribe who dominated areas between the Bosphorus and the western borders of China in the late 11th and 12th centuries.

Sekme gul. Rectangular ornament with a lozenge inscribed, mainly adopted in Tekke weavings.

Shahsavan. Turkish-speaking tribal confederacy of mixed ethnic origin in Northwest Persia, formerly inhabiting parts of Southern Caucasus.

Shishboluki. A subtribe part of the Qashqa'i tribal confederacy from Southern Persia, known for its fine rugs.

Sides. The finish of the vertical sides of a rug running parallel to the warp.

Silk road. A very important trade route connecting Western China to Anatolia, and hence to the West in general.

Sofreh. Flatweave adopted by tribesmen from Persia and the Caucasus as a ground cloth during meals.

Spandrel. Designation of the corner parts of a prayer rug situated to the left and the right of the arch.

St. Andrew's Cross. A cross motif with two pairs of diagonal arms found on a specific type of Caucasian rugs attributed to the northeastern village of Seikhur.

Star Kazak. A rare type of rug, originating in Southwest Caucasus, decorated by an allover pattern of polychrome stars of various shapes on an ivory background.

Sumakh. Caucasian flatweave

obtained by a weft wrapping technique.

Suzani. Silk embroidery on a cotton or silk background from Uzbekistan, typically woven as a dowry object.

Symmetrical knot. The symmetrical knot bears this name because the thread forming the knot fully encircles two warp threads and reappears between them; occasionally around three or four warp threads; also called Turkish or Ghiordes knot.

Tauk nuska gul. A motif employed by various Turkmen tribes, where the inner part is divided into quarters, each containing two animal forms with two heads.

Tchi. See cloudband.

Tekke. The largest Turkmen tribe, from which originates a good amount of textiles.

Torba. Small Turkmen bag hung inside the tent and used for storage.

Tortoise herati. A border motif composed of a series of large palmettes connected to each other by means of a stylised vinery, found on Persian carpets from various areas.

Transylvanian. A group of 17th-century Turkish rugs usually decorated by a simple- or double-niche design, found in large numbers in the churches of Transylvania.

Trapping. A tribal weaving employed to decorate the camel during the wedding procession.

Tree of Life. A directional design based on a tree from which blossom a series of leaves, flowers and fruits, and sometimes pairs of birds rest on its branches.

Trefoil pattern. See *medachyl*.

Tufek bash. Turkmen gun cover.

Tulu. Long-piled tribal rug from Central Anatolia.

Uygur. Turkic tribe inhabiting the Sinkiang area in East Turkestan.

Vaghireh. A sample rug woven either to familiarize weavers with a specific new pattern, or to promote a certain design to prospective buyers.

Vase carpet. A 17th-century Persian carpet from the Kerman area, woven according to particular technical specifications (number and type of warps and wefts).

Village rug. A type of rug that is

partially influenced by the style of the court carpets from the urban centres, while incorporating certain tribal stylemes.

Warp. The thread forming the vertical part of the foundation of a carpet. The warp is strung on the loom before the weft shoots and the pile knots are inserted.

Weft. The thread forming the horizontal part of the foundation. Weft threads are as a rule not or barely plied. The way the weft shoots are inserted and the number of shoots will determine the structure of a rug.

Weft-loop pile. Early knotting technique, where the pile is obtained by cutting the loop created by the insertion of the weft.

Yastik. Small Turkish rug or textile used as a cushion cover (*yastik* = 'cushion' in Turkish).

Yatak. Turkish rug of square format with a long and shaggy pile employed as a bed by nomadic tribespeople.

Yolam. Turkmen tent band used to decorate the interior of the tribal tent (the *yurt*).

Yomud. A large Turkmen tribe living between West Turkestan and Northeast Persia.

Yun-chien. See cloudband.

Yurt. The Turkic name for the tent used by Turkmen tribes.

Yuruk. A generic term used to refer to groups of nomads especially from East Anatolia. It derives from the Turkish word *yurumek*, which means 'to walk'. This term is often employed to define Anatolian tribal rugs in general.

Z-spun. Anti-clockwise turn in spinning and plying; if fibres are spun anti-clockwise, which is the rule, plying will be done clockwise. Z2S therefore means that the wool thread used for the warp of a rug was spun anti-clockwise and that two strands were then plied clockwise.

Zil-i-sultan. A motif found on Persian city rugs composed of a flowering vase flanked by a pair of birds.